UNDISCLOSED FILES
OF THE POLICE

Opened _____ 192/

Closed 1:30 P.M. Feb. 20, 192/

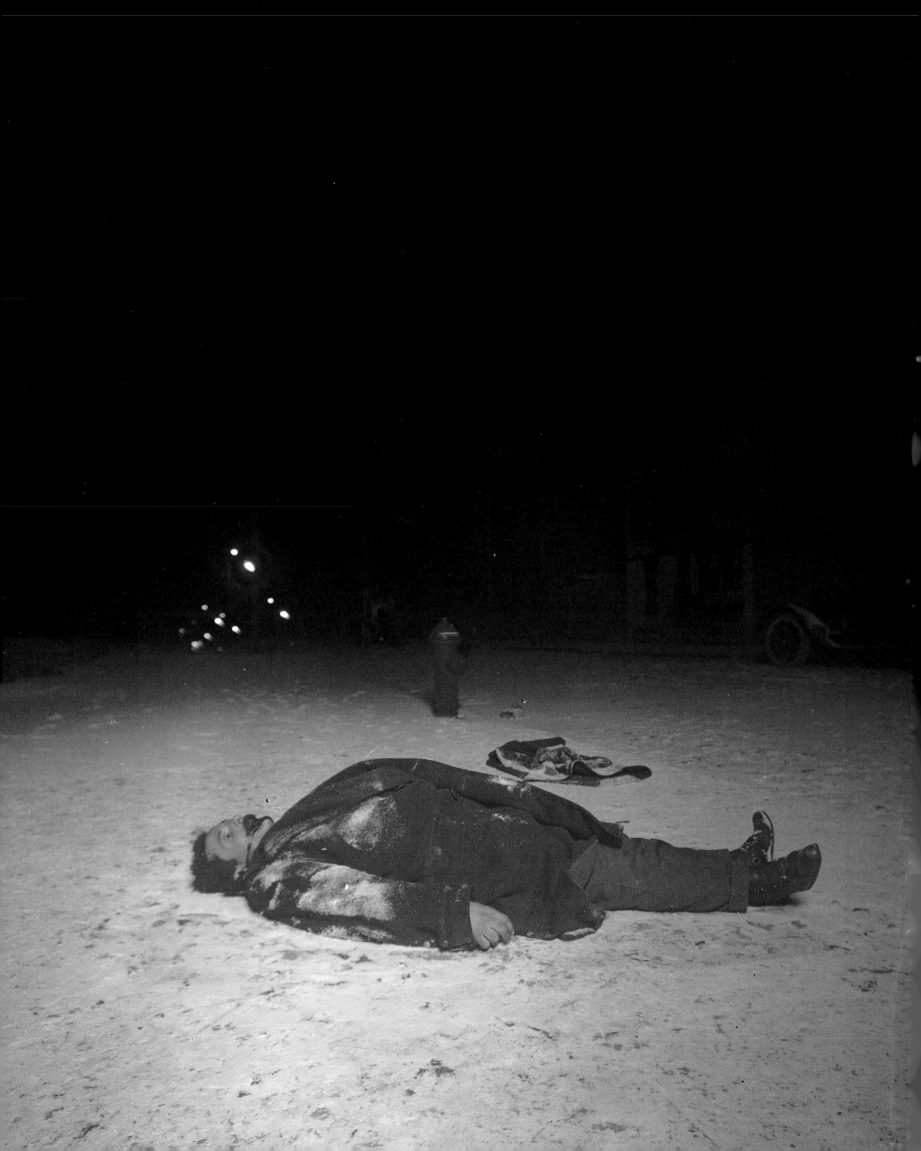

UNDISCLOSED FILES
OF THE POLICE

CASES FROM THE ARCHIVES
OF THE NYPD
FROM 1831 TO THE PRESENT

BERNARD J. WHALEN, PHILIP MESSING, AND ROBERT MLADINICH

BLACK DOG
& LEVENTHAL
PUBLISHERS
NEW YORK

Text copyright © 2016 Bernard Whalen, Philip Messing, and Robert Mladinich

Photo credits appear on page 311

Black Dog & Leventhal Publishers
Hachette Book Group
1290 Avenue of the Americas
New York, NY 10104

www.blackdogandleventhal.com

Printed in China

Cover design by Amanda Kain. Interior design by Kris Tobiassen and Red Herring Design.

IM

First edition: October 2016
10 9 8 7 6 5 4 3 2 1

Black Dog & Leventhal Publishers is an imprint of Hachette Books, a division of Hachette Book Group. The Black Dog & Leventhal Publishers name and logo are trademarks of Hachette Book Group, Inc.

The Hachette Speakers Bureau provides a wide range of authors for speaking events.
To find out more, go to www.HachetteSpeakersBureau.com or call (866) 376-6591.

The publisher is not responsible for websites (or their content) that are not owned by the publisher.

Library of Congress Cataloging-in-Publication Data has been applied for.

ISBNs: 978-0-316-39123-8 (hardcover)

CONTENTS

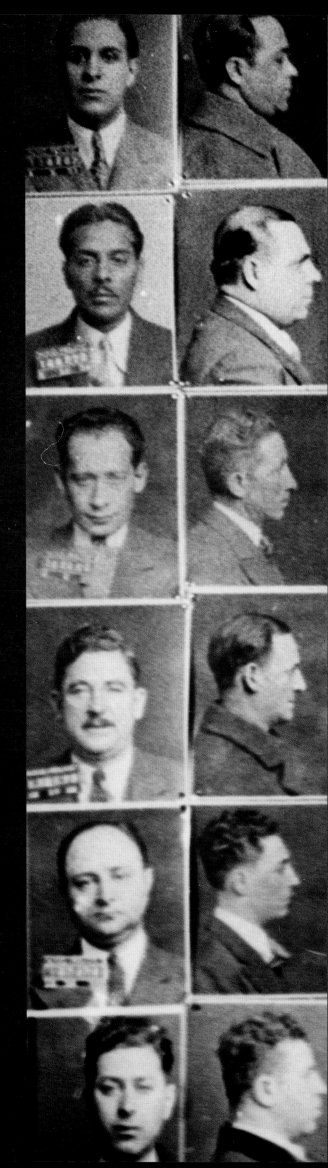

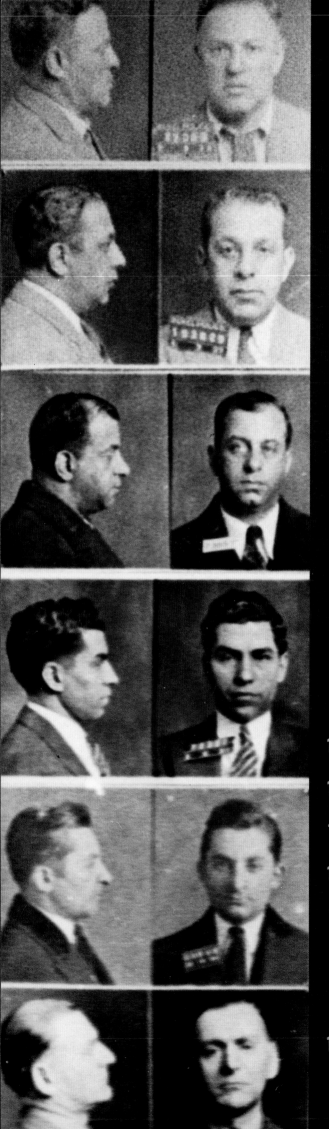

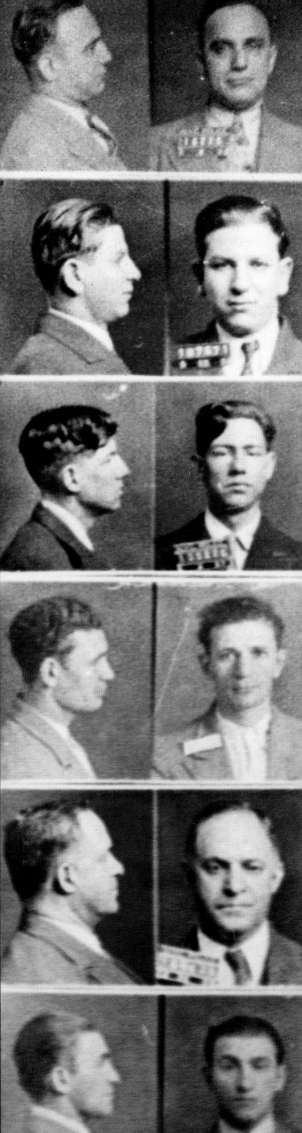

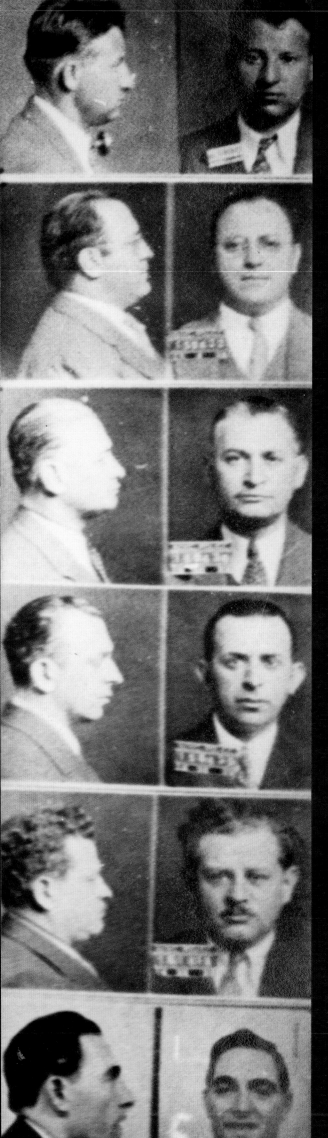

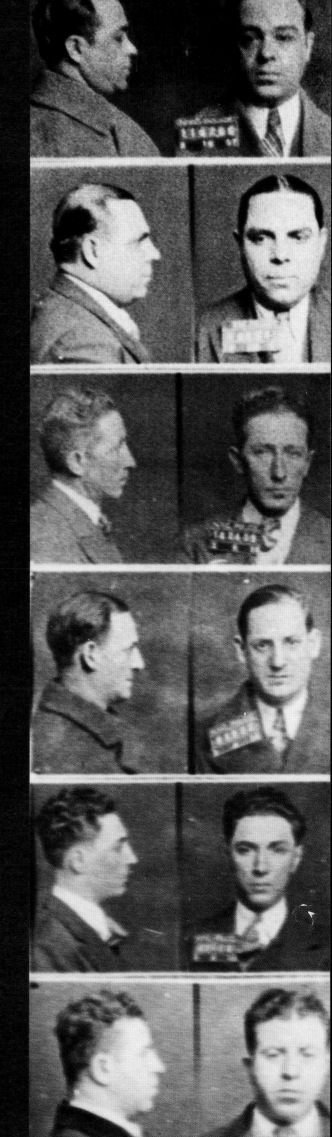

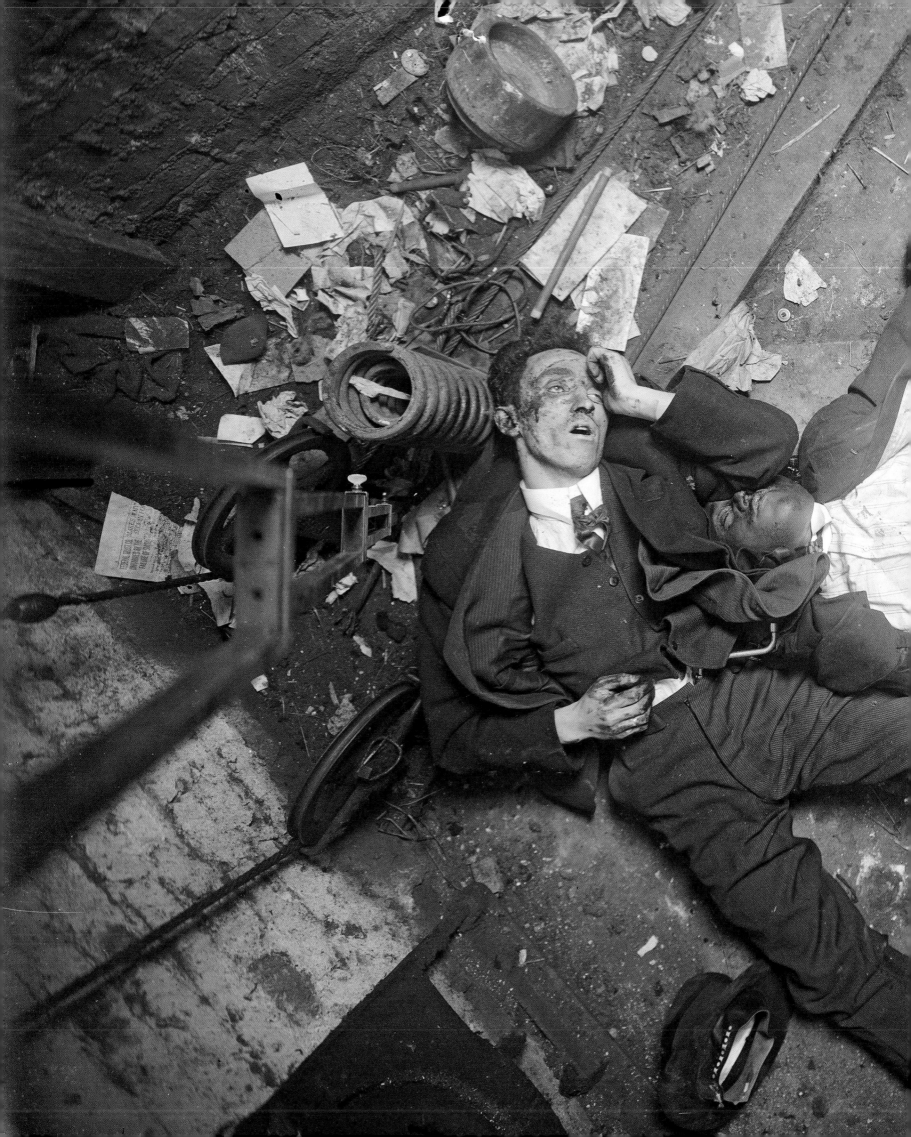

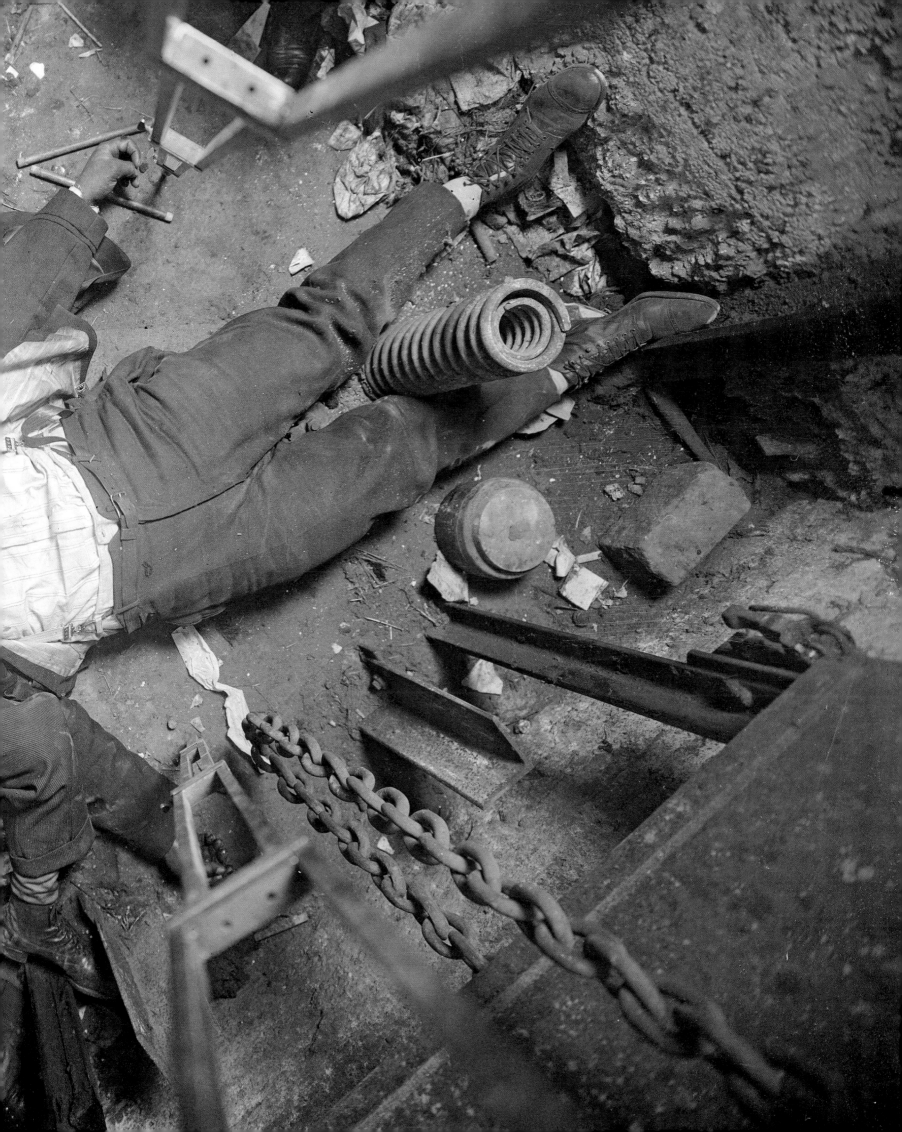

INTRODUCTION

How do you whittle down thousands of crimes that took place in New York City during a span of more than two hundred years into what can fit between the covers of a book?

After much back and forth, we ended up selecting the crimes that were the most interesting, most notorious, most unbelievable, or most disturbing based on Bob's and my many years on the force and Phil's as a crime reporter. They range from the awful to the unbelievable, but no two are the same. Some remain unsolved to this day, such as the disappearance of Judge Joseph Force Crater. In others, the culprit seemed obvious to everyone but the jury, as was the case of El Sayyid Nosair, who murdered Rabbi Meir Kahane in cold blood in front of dozens of eyewitnesses. Some of the men and women in this book convicted of murder were executed, while others were barely punished for their crimes. One thing is certain: The administration of true justice is a lofty goal that is seldom reached.

As we began our research and reviewing records, we sometimes gained a grudging respect for the perpetrators, who went to great lengths to elude the authorities, muddle the facts, or cover their tracks. Some were so clever that it is amazing how often they were caught, especially in the early days of the force. The first detectives in New York City had few tools and often operated on gut instinct and their own personal powers of observation. There were few, if any, rules governing the collection of evidence or the questioning of suspects. In order to gain confessions, the accused were often tricked, which is still legal today, and sometimes coerced by force, which is not.

As criminals got more sophisticated, so did the police. The crimes covered in this book trace the evolution of crime fighting through the tools police developed over the years—the Bertillon method, the Rogues Gallery, the daily lineup, latent fingerprints, undercover operatives, wiretaps, stool pigeons, informants, crime scene documentation, evidence preservation, the police laboratory, criminal profilers, videotape, CompStat, and DNA. But even now, arrests and convictions are more often brought about by good detectives using their wits rather than the tools at their disposal. Longtime retired NYPD Chief of Detectives Joseph Borelli put it best when he told me, "To this day I am still in awe when I read of their accomplishments."

Undisclosed Files also takes an unbiased look at individuals on both sides of the law. This includes great cops, such as the first NYPD chief of detectives, Inspector Thomas Byrnes, the originator of the Third Degree, who compiled a massive book of mug shots and bios of a who's who in New York City criminals, which became a surprising best seller. But it also doesn't shy away from crooked cops, the worst being Lieutenant Charles Becker, who went to the electric chair at Sing Sing for his role in the murder of a Manhattan gambler.

As criminals got more sophisticated, so did the police.

We also look at those who tried the cases. The brilliant defense attorney Samuel Liebowitz's claim to fame was that only one of his clients ever went to the electric chair, although many certainly deserved it, including Robert Irwin, aka "the Mad Sculptor," who is covered in this book. Ironically, after the same Liebowitz became a New York City judge, he had absolutely no problem sentencing convicted murderers to the death penalty.

However, the main focus of *Undisclosed Files* is the criminals, both unknown and infamous. One you've probably heard of is Vietnam veteran John Wojtowicz,

who decided a lark to rob a bank in Brooklyn in 1972. He had an altruistic, albeit highly unusual motive—he desperately needed money to pay for his male lover's sex change operation. The robbery became the basis for the acclaimed motion picture *Dog Day Afternoon*.

One less well known was a sexy femme fatale named Madeline Webb, who was charged with murder in 1942. Fearful her swaying hips would sway the jury when she walked into the courtroom, the prosecutor made sure she was seated before the jury was brought in. She was sentenced to life in prison.

What was also fascinating to us is that many of the crimes, both random and premeditated acts, were interconnected in some manner. For example, the perpetrators of the 1993 World Trade Center bombing and the mastermind behind the 2001 World Trade Center attacks were tied to El Sayyid Nosair, who killed Rabbi Kahane in 1990. Osama bin Laden financed Nosair's successful murder defense by William Kunstler, who also notoriously got drug dealer Larry Davis off the hook after he shot six NYPD cops.

Then there was the story of Abe "Kid Twist" Reles, the infamous hitman turned stoolie, who in 1941 plummeted from a sixth-floor hotel room window while being guarded by six detectives. Reles's untimely death forced Brooklyn District Attorney William O'Dwyer to drop his murder case against underworld figure Albert Anastasia, who had put a price on Reles's head that police were rumored to have accepted. As powerful as Anastasia was, the mobster was assassinated sixteen years later by one of his own, thus accomplishing what the district attorney had unsuccessfully tried to do. Meanwhile, after O'Dwyer became mayor of New York, he became involved in a scandal with notorious gambler Harry Gross that forced him to resign from office. These are but two of the many examples of how one crime seems to lead to another in this book.

Beyond the crimes and the characters, this is a book about New York City. So many of the sites still exist that you can practically do a morbid walking tour. Fraunces Tavern, one of the city's oldest buildings, is the site of the 1975 bombing by the FALN. A few blocks north is the old J. P. Morgan Bank building at 23 Wall Street, which still has pockmarks in the granite wall from a bomb that exploded in 1920. Once you've read this book, you won't be able to walk through Central Park without thinking about Robert Chambers, or Flushing Meadow Park without remembering two detectives blown to bits attempting to defuse a bomb at the 1940 World's Fair. While crime fans would expect

that we would write about a robbery at Tiffany's, few would know that an even a bigger heist of precious jewels took place amid the dinosaur bones at the Museum of Natural History.

As a member of the NYPD for more than thirty-five years, I know how things work in the police department. My background, along with those of my coauthors, provided us with insight and access to the department that few other writers have. In many instances we had firsthand knowledge of the crimes in this book and interviewed actual participants, including victims, to get their side of the story. So not only are you reading about the most notorious atrocities in the world's greatest city, you are getting the stories from insiders who truly know crime.

—*Bernard J. Whalen*

George "The Mad Bomber" Metesky

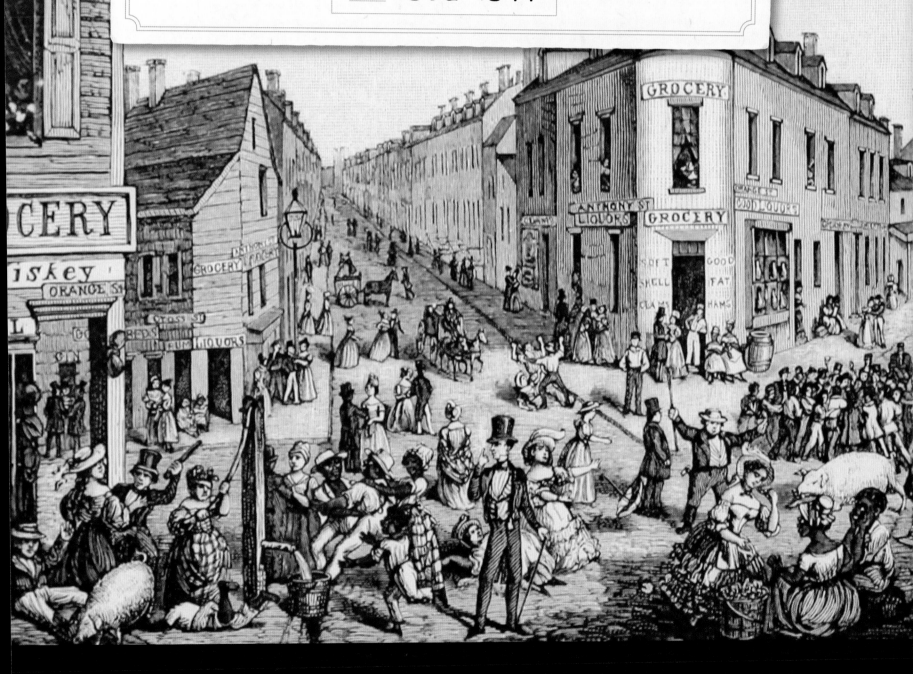

CRIMINALS AND CRIME IN OLD NEW YORK

Years **1802–1844**

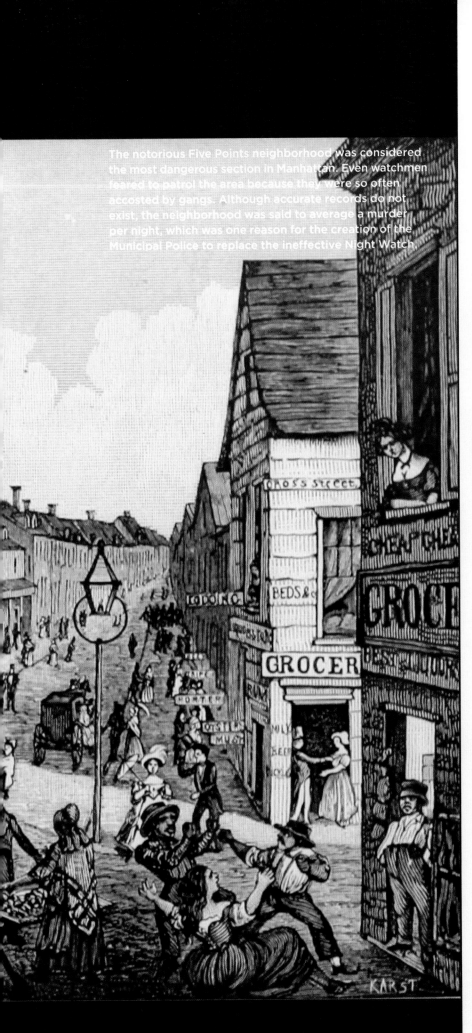

Jacob Hays was the high constable until 1844, when the Night Watch was disbanded. He is generally considered to be New York City's first detective.

Long before Sir Arthur Conan Doyle created the fictional mastermind English detective Sherlock Holmes, the citizens of old New York relied on the wiles of High Constable Jacob Hays to solve their crimes. Even though others would go on to eclipse his fame, Hays is considered New York's first real detective.

Jacob Hays was born during the Revolutionary War in Bedford, New York. His father, David Hays, was a merchant who served under General George Washington and allowed the future president to use his shop to hold staff meetings. As a seven-year-old, young Jacob joined the cause by helping sneak a herd of cattle through enemy lines. In 1798, David asked Aaron Burr to help his son get a position as a marshal in New York City. Jacob's early success led to his appointment as high constable by the mayor in 1802. He oversaw a small constabulary of twenty-eight part-time watchmen who after their day jobs worked from dusk to dawn under a system that was first established by the Dutch in 1658 and kept in place by the English when they gained control of New York City in 1674.

Although the high constable was supposed to handle administrative chores such as processing writs and court orders, Hays expanded his duties to include peacekeeping and crime solving. He spent up to eighteen hours a day patrolling the wards of Lower Manhattan using little more than a wooden staff and a swift kick to enforce the law. He was the first New York policeman to shadow a criminal. His reputation was such that whenever there was trouble, the city fathers would cry, "Set old Hays at them."

It was said that his mere presence coupled with a stern warning to go home was usually enough to quell a street

The high constable was said to reward a suspected liar with a crack on the shin with his staff, shouting, "Good citizens tell the truth!"

brawl and disperse the troublemakers, but more than likely a few well-aimed blows were required to get the message across. The high constable was said to reward a suspected liar with a crack on the shin with his staff, shouting, "Good citizens tell the truth!"

In solving murders of his day, Hays relied on his wits, his powerful recall, and his innate ability to outsmart suspects. Sometime in 1820—the exact date is long forgotten, as is the name of the victim—Hays was called to Coenties Alley in the First Ward, near Coenties Slip and just north of Fraunces Tavern. In those days, dozens of boat slips lined the shore of Manhattan's southern tip. A dead shipmaster had been found with a fatal wound to the head. The victim appeared to have been killed during a robbery. Hays rightly assumed

the perpetrator was a fellow sailor, since the neighborhood teemed with them and so many were of questionable character. He zeroed in on the captain's bunkmate, a sailor named Johnson. He was a capable liar who convinced everyone but Hays of his innocence. Fortunately, Hays had one last trick up his sleeve to prove his theory. In one of the first mentioned uses of psychology to gain a confession, Hays had Johnson brought to City Hall, where the shipmaster's corpse was being kept until burial. Hays pulled off the shroud covering the captain's remains and bellowed, "Look at the body; have you ever seen that man before?"

Johnson turned pale at the sight and blurted out, "Yes, Mr. Hays, I murdered him."

The admission sent him to the gallows, but as the hangman's noose was placed around his neck, Johnson recanted. Hays climbed the scaffold and glared at him until he admitted his guilt. "Get on with it. I killed him... I can't lie while that man has his eyes on me."

As time went on Hays's legend grew, as did the size of the force under him, but it was Hays's exploits that garnered the headlines.

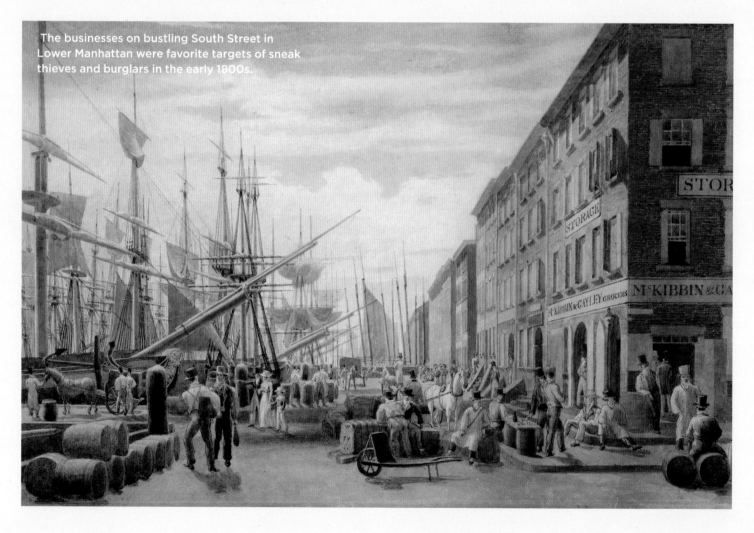

The businesses on bustling South Street in Lower Manhattan were favorite targets of sneak thieves and burglars in the early 1800s.

52 Wall Street was the location of the first recorded bank robbery in New York City.

THE CITY BANK ROBBERY

Year 1831

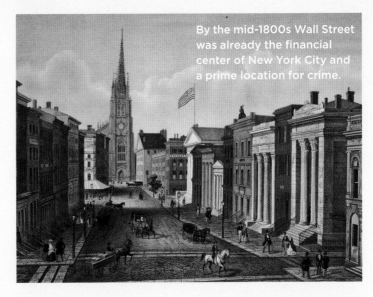

By the mid-1800s Wall Street was already the financial center of New York City and a prime location for crime.

One of the first recorded bank robberies in New York City occurred during the wee hours of March 20, 1831. Two bandits, James Honeyman and William Murray, gained entrance into the City Bank (Citibank today) on Wall Street by surreptitiously making wax impressions of the locks and forging their own set of keys. After rifling through the vault and safe deposit boxes, the pair escaped into the night with $254,000 in bank notes and coins (the equivalent of $54 million today) concealed under their cloaks. When notified of the robbery, Hays immediately suspected Honeyman, a well-known thief of the day, but could find no evidence to act upon until several days had passed.

Honeyman used a portion of the proceeds to take up

This reward notice offers $5,000 for information leading to the recovery of stolen property. Interestingly, it makes no mention of apprehension of the perpetrators.

A sentence of hard labor at Sing Sing prison meant working the rock quarries in upstate New York.

residence in a boardinghouse in Lower Manhattan. His mysterious comings and goings roused the curiosity of the maid. One night she peeked through the keyhole and observed him in the company of a stranger counting a pile of money on the bed. The excited maid told the landlord, who in turn notified Constable Hays. The rules pertaining to search warrants were not yet codified, so Hays simply waited for Honeyman to leave the house before examining his room in the presence of the landlord. Hays recovered approximately $185,000 of the stolen money secreted in a pair of sturdy wooden chests. That still left some $70,000 unaccounted for. From the maid's description of the stranger, Hays believed him to be Honeyman's good friend and fellow thief William Murray. The two had made acquaintance many years before in Australia at the Botany Bay Penal Colony.

Hays had little trouble apprehending Honeyman, but Murray fled to parts unknown. Unfortunately, because he did not recover all the stolen money, there were whispers that Hays had pocketed the balance for himself. It turned out that Honeyman had paid $37,000 to his brother-in-law, a fellow named Parkinson, who also happened to be the locksmith who forged the keys for the robbery. Parkinson was caught when he foolishly tried to exchange some of the notes at the very same bank where they were stolen. Hays searched Parkinson's shop and found his share of the loot stashed under the floorboards. Hays agreed to let him go in exchange for information on Murray's whereabouts. Parkinson said that Murray was hiding out in the City of Brotherly Love. Hays contacted his counterpart in Philadelphia to be on the lookout for Murray.

It took over a year before an arrest was made. Murray and Honeyman were sentenced to five years hard labor at Sing Sing prison. In exchange for a shorter sentence, Murray confessed that he had buried what was left of the money under a tree in Philadelphia. Hays sent his son to the location to dig it up. The remaining banknotes were recovered and returned to the bank, thus saving Hays's reputation.

> **Parkinson was caught when he foolishly tried to exchange some of the notes at the very same bank where they were stolen.**

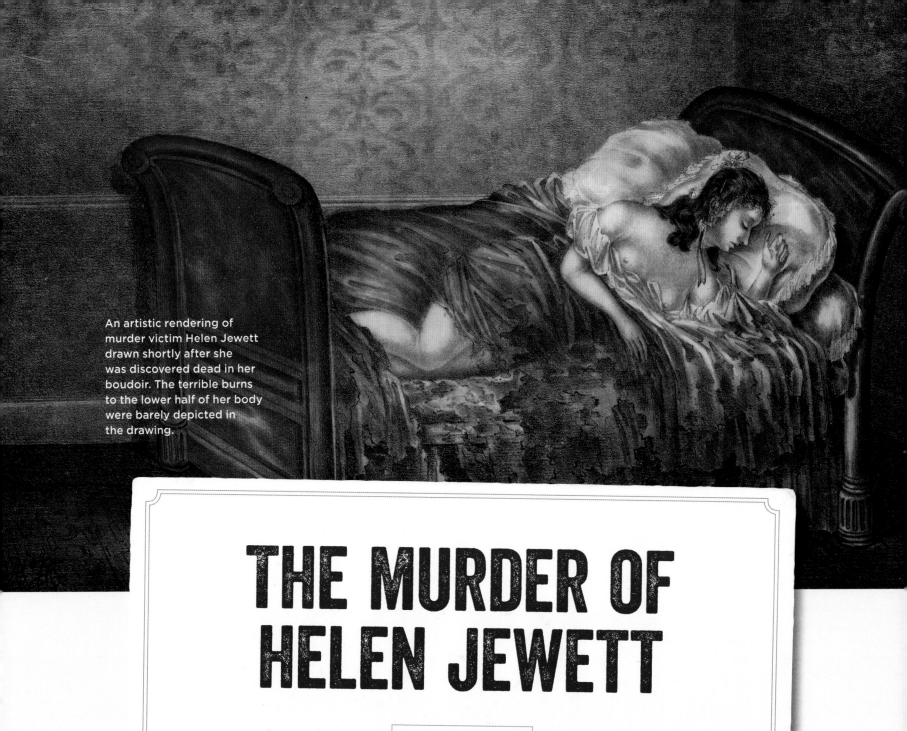

An artistic rendering of murder victim Helen Jewett drawn shortly after she was discovered dead in her boudoir. The terrible burns to the lower half of her body were barely depicted in the drawing.

THE MURDER OF HELEN JEWETT

Year 1836

Early Sunday morning, April 10, 1836. Dorcas Doyen, aka Helen Jewett, an attractive, well-read, twenty-three-year-old prostitute from Maine, was found butchered and burned in her boudoir in Lower Manhattan. A *New York Herald* reporter on the scene wrote of Jewett's beauty, "The body looked as white—as full—as polished as the pure Parisan marble. The perfect figure—the exquisite limbs—the fine face—the full arms—the beautiful bust—all surpassing in every respect the Venus de Medici's."

Several months before her death, Jewett fell hard for a handsome young store clerk, Richard Robinson (who went by the name Frank Rivers), after he rescued her from the clutches of a drunken hooligan. She rewarded him with a private tryst at her elegant quarters at 41 Thomas Street, a brothel that Jewett shared with nine other ladies of the night. (According to Inspector Thomas Byrnes's account

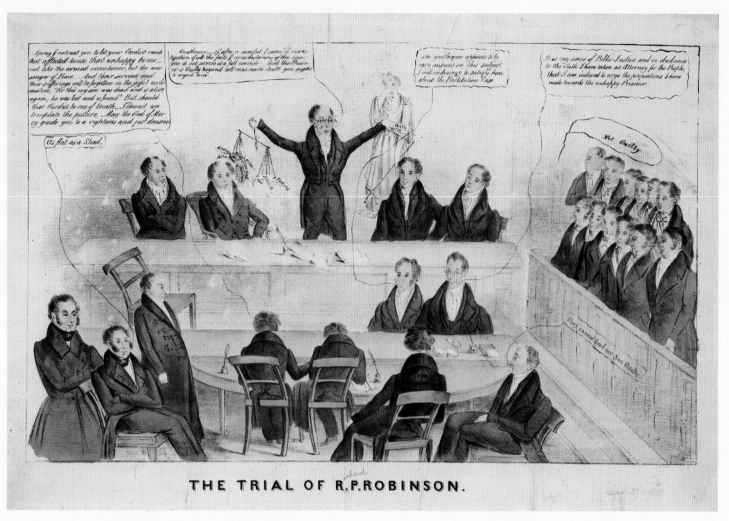

THE TRIAL OF R.P.ROBINSON.

Despite Jacob Hays's efforts to solve Helen Jewett's murder, a jury of his peers declared Richard Robinson "not guilty." After the verdict, Robinson moved to Texas.

As she opened the door to Jewett's room, the rush of air stirred smoldering flames from within and sent dark smoke billowing into the hallway.

many years later, her bedroom "would have done credit to the palace of Cleopatra.") While Jewett was smitten, Robinson was not of the mind-set to limit himself to one mistress, no matter how pretty she was. When Jewett discovered that he was with another woman, she tailed him to a bawdy house several blocks north on Broome Street and violently confronted her rival. She and Robinson soon reconciled, but before long his wandering eye got the best of him. This time she threatened to kill herself and make it appear that he was the culprit. Robinson, whose father was a prominent politician in Connecticut, was so terrified at the prospect of being framed for murder that he agreed to marry her. But it was only a ruse, because he was already courting yet another woman. This time when Jewett found out, she made the mistake of putting her threat in writing.

Robinson paid her a visit on the night of April 9. He arrived at approximately ten P.M. It was drizzling, so he wore a black cloak to protect himself from the elements. Jewett was overheard greeting him at the door by the

bordello madam, Rosina Townsend. "Oh my dear Frank, how glad I am that you have come," she said.

Robinson gave no reply, however, and as he walked past Townsend he took care to conceal his face with his cape. The two then retired to Jewett's room to share a bottle of champagne and a night of lovemaking. At about two A.M., after most of the clients had gone home, Maria Stevens, whose room was directly across the hallway from Jewett's, heard a thud and a moan from inside Helen's chambers. Stevens cracked the door and observed a tall man, obscured by a black cloak and holding an oil-filled lamp, quietly exit Jewett's room and tiptoe down the stairs. Inexplicably, Stevens went back to bed without investigating the noise.

At three A.M. Madam Townsend made a final check of the premise and saw Jewett's oil lamp glowing on a table in the parlor. She also noticed the back door was open and called Jewett's name, thinking perhaps she had ventured outside to use the privy. When there was no answer she went upstairs to return the lamp. As she opened the door to Jewett's room, the rush of air stirred smoldering flames from within and sent dark smoke billowing into the hallway. Her screams of "Fire!" stirred the other female residents. Their shouts in turn alerted three night watchmen in the area. As the watchmen rushed into the dwelling, the remaining patrons beat a hasty retreat into the night.

Fortunately, the watchmen were able to extinguish the fire before it spread to other rooms. When the smoke cleared, they found Jewett's half-burned corpse sprawled out on the mahogany bed clad in the charred remains of a lacy nightgown. There was a deep gash in her right temple. The coroner, an assistant police captain, and a full-time constable who served under Hays were called on to investigate.

That morning the authorities recovered a bloody hatchet in the back alley, presumed to be the murder weapon, along with a long black cloak, which appeared to have been discarded near a high fence that the killer had scaled to escape, as evidenced by scuff marks in the thin whitewash. After questioning Madam Townsend, the officers determined that Robinson was the prime suspect and rushed to his boardinghouse a half mile away to arrest him. They found him asleep with his roommate, James Tew. When asked why his trousers were stained with whitewash, he would only say, "This is a bad business."

After a coroner's inquest, Robinson's trial took place on June 2, 1836. The prosecutor proved that the hatchet came from a store where Robinson clerked. The cloak was positively identified as belonging to him. Even his whitewash-stained trousers were put into evidence. But the witness who saw him leave Jewett's room, Maria Stevens, died under mysterious circumstances before the trial. Another woman who said that she observed Robinson fleeing from the scene vanished before she could offer testimony against him. These were two very fortunate coincidences for the accused.

In his own defense, Robinson's lawyer offered an alibi of sorts. A fellow grocer, whose store was several blocks away from Thomas Street, had sworn to the constable that he was with Robinson at the exact time that Mrs. Townsend said she heard Jewett greet him, and therefore could not have been the killer. Although the grocer committed suicide before the trial, the judge allowed his statements put into evidence but gave little credence to any of the testimony provided by the women of the brothel.

After a short deliberation, the jury came back with a not guilty verdict. Many people thought a juror had been paid off. In either case, Robinson realized he had gotten the break of a lifetime and set off for the Texas frontier, where it was reported that he died several years later.

A PROPER POLICE FORCE

Years 1845–1857

Hays retired from active duty during 1844, but retained the honorary title of high constable until his death in 1850. The constabulary, which had grown to 1,000 watchmen (with 500 working and 500 off each night), by then was disbanded in favor of a new Municipal Police Department created specifically to meet the needs of the growing metropolis. The force was staffed by 889 men assigned to wards (precincts today) who now worked day and night shifts and were directly supervised by captains.

George W. Matsell, a thirty-eight-year-old Englishman who came to America as a boy, spearheaded the reform effort when he was a police magistrate. For his efforts he was named the first chief of police for New York City by Mayor William Havemeyer in 1845.

Upon taking charge he declared that the force would be an efficient organization for the prevention and detection of crime. With that in mind, he set about making changes that many of the watchmen who stayed on did not like. He issued the department's first rule book, a ninety-page tome. According to one officer, "A policeman would not live one year if he acted up to these regulations."

When Matsell decreed each officer wear an eight-pointed brass star over his left breast as a means of identification, most officers ignored his directive because they regarded the badge more as a symbol of servitude than as a symbol of authority. He ordered his men to wear a rudimentary uniform consisting of a blue frock with black buttons starting in 1853. This was contentious, because

patrolmen tended to wear their shabbiest clothes to work rather than chance having whatever good clothes they owned ruined in the performance of duty. Detectives and the men who aspired to become detectives had their own reasons for resisting a uniform. They were referred to as shadows, and they believed that they needed to remain anonymous in order to sneak up on thieves. Matsell insisted, wanting the public to be able to distinguish his patrolmen from the bums that roamed the streets of Manhattan.

One of the young officers aspiring to become a shadow one day was George W. Walling. He was born in New Jersey in 1823 and moved to New York City in 1845 after spending several years at sea working on a freighter. He never gave much thought about becoming a policeman until a friend who was leaving the municipal force offered him an opportunity to take his place. At the time, the recommendation of an alderman and the consent of the mayor was all that was needed. His friend made the arrangements, and in 1847

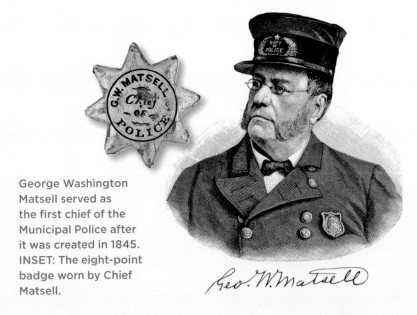

George Washington Matsell served as the first chief of the Municipal Police after it was created in 1845. INSET: The eight-point badge worn by Chief Matsell.

Walling became a patrolman at an annual salary of $600.

The following year, a string of weekend burglaries in Lower Manhattan brought much embarrassment to Matsell and the department. Patrolman Walling made his bones helping to solve it.

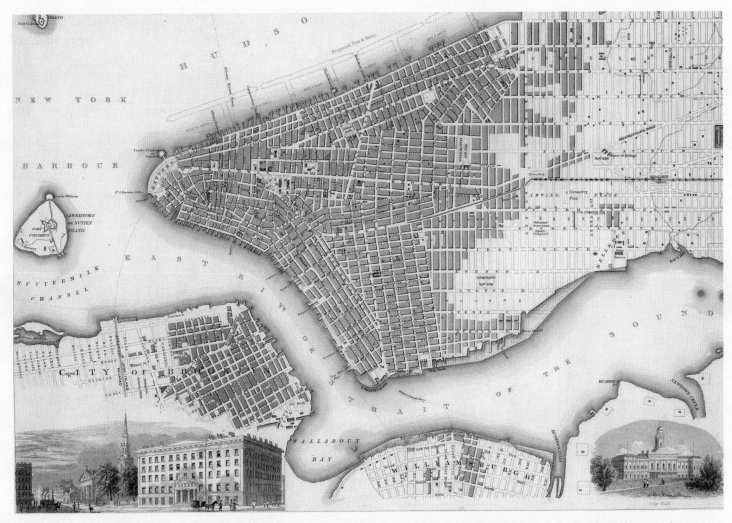

OPPOSITE PAGE: Chief Matsell wanted his patrolmen to wear uniforms to identify them to the public, but it took several years to get them to comply with his order. ABOVE: This 1840 map of New York City shows the business and residential areas patrolled by the Night Watch. As the city expanded northward, the need for a better system of policing became apparent and led to the creation of the Municipal Police in 1844.

THE BUTTON CASE

Year 1848

If the clew is worthless today, it may be more valuable tomorrow.

—George W. Walling

After a series of break-ins at a mercantile shop on Maiden Lane, Chief of Police Matsell dispatched George Walling and two other officers, Theodore Shadbolt and John Reed, to investigate. Among the items missing were three pairs of suspenders, which Walling took to mean that three perpetrators were involved in the theft. Reed then came across an unusual cloth-covered button on the floor. This style of button was commonly used on sack coats, which were just becoming popular. Once they were satisfied that the button did not come from an employee's jacket, the officers paid Matsell a visit and told him that they believed that it came from the overcoat of one of the thieves. Matsell was intrigued. It was the first clue his officers had found since the burglaries started. He alerted the rest of the force to be on the lookout for a man wearing a sack coat missing such a button.

Six weeks passed before Shadbolt spotted three known thieves going into the Chatham Street Theater. What particularly piqued his interest was that one of the men was wearing a sack coat. But Shadbolt had been on the force for many years, and he was certain the men would recognize him if he confronted them. Worse, they might escape. He called Walling on the adjacent post and brought him back to the theater. He pointed out the trio in the balcony and told Walling to sit next to them during the show to get a better look at the sack coat's buttons. Sure enough, Walling observed that one of the buttons on the suspect's sack coat had been replaced. He hurried downstairs to tell his partner and formulate a plan. It was decided that Walling would tail them when they left the theater. Shadbolt stayed behind and waited to hear from Walling.

Walling followed them to a boarding house on Duane Street, and once he was satisfied that they were in bed for the night, he sent for Shadbolt. He asked Shadbolt to find Reed and another cop named John Wade and have them meet him in front of the lodge at daybreak. When the officers arrived that morning, they barged into the rooming house and arrested the three men before they even got out of bed. During a search of the suspects at Chief Matsell's office, it was discovered that each man was wearing a pair of suspenders in the same style as the ones taken from the store on Maiden Lane. The suspenders, however, were a big seller, and the shopkeeper not could swear they were the actual ones stolen that night.

The case was on the verge of falling apart until Walling came up with an idea to have Shadbolt play good cop, pretending to befriend the thieves and advising them it was in their best interest to confess. The ploy worked. Soon afterward, the three men admitted to their crimes, and the police recovered additional goods stolen during seven separate burglaries. Each of the perpetrators received a three-year prison sentence. As a reward for his excellent work, Chief Matsell assigned Walling to work directly for him.

The buttons on sack coats were unique because they were covered with the same cloth as the coat. This knowledge helped Patrolman Walling solve the crime.

OPPOSITE PAGE: The area where several stores in the area of Broadway and Maiden Lane were robbed during 1848.

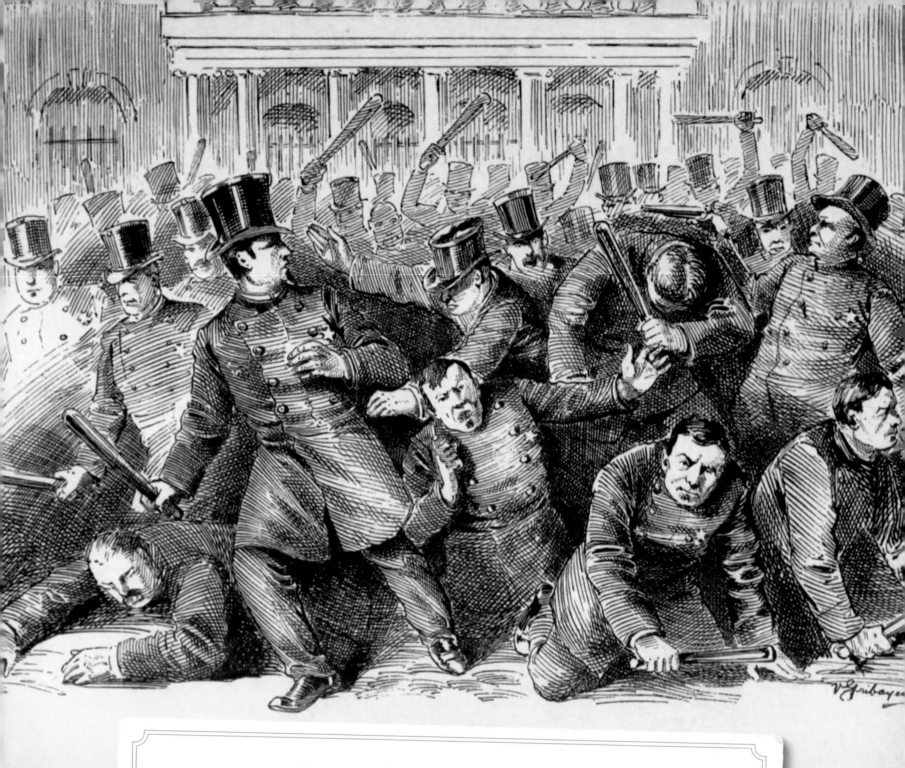

MUNICIPALS VS. METROPOLITANS

Year 1857

OPPOSITE PAGE: With the two police forces battling each other, crime flourished. *Harper's Weekly* wrote, "New York presents to the eyes of her sister cities the disgraceful spectacle of confirmed anarchy." This festering quarrel came to a head with a riot on June 15 that had to be put down by the Seventh Regiment.

THIS PAGE: In 1857 the state-created Metropolitan Police began to patrol Manhattan, Brooklyn, Staten Island, and parts of Westchester. The force was headquartered at 413 Broome Street in Manhattan.

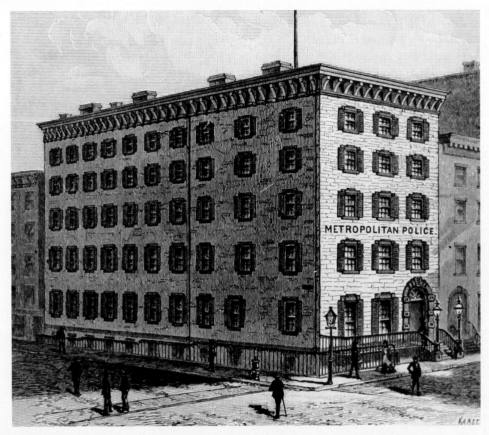

Despite successes like the Button Case, the state legislature did not believe the Municipal Police Department was up to the task of keeping the city safe. Mob rule seemed to be the order of the day. Mayor Fernando Wood, a Democrat aligned with the corrupt Tammany Hall, had final say in all police matters. He seemed to be willing to have the department look the other way when his friends were involved.

This caused the Republican-led state legislature to pass a law in 1857 called the Metropolitan Police Act to supplant the Municipal Police Department. The governor would take control of the police force in New York City as well as the outlying counties of Kings, Richmond, and Westchester, which included the Bronx.

Mayor Wood claimed the law was unconstitutional. He refused to acknowledge the state's authority take away his police, because the law still required the city to pay the patrolmen's salaries. When the State Supreme Court overruled him, it left the members of the Municipal Police in a quandary.

When the Supreme Court declared the law constitutional, George Walling signed on as a captain with the Metropolitan Police. Three hundred Municipal patrolmen followed him. Meanwhile Chief Matsell and the remaining eight hundred or so patrolmen stayed loyal to Mayor Wood. The city was not big enough for two departments, which with new appointments swelled to between 800 and 1,100 members each. The patrolmen fought not only criminals but one another. The violence got so out of hand that a warrant for inciting a riot was issued for Mayor Wood's arrest; it was given to Captain Walling to execute.

Wood and Matsell got wind of the plan and made plans to stop it. On June 16, 1857, hundreds of Municipal patrolmen were waiting outside City Hall when Captain Walling and fifty Metropolitans approached. A fierce battle broke out between the two forces. Twelve patrolmen were severely injured during the melee. Matsell was just about to declare victory when soldiers from the Seventh Regiment intervened and prevented further mayhem. Matsell told the mayor the game was up. Wood reluctantly accepted the writ and ceded control to the Metropolitan Police, although the transition was anything but smooth. Meanwhile, Matsell retired to Iowa and took up farming for a while before returning to New York where he kept his hand in police work as publisher of the *National Police Gazette* magazine.

The patrolmen fought not only criminals but one another.

27

THE DRAFT RIOTS

Year 1863

OPPOSITE PAGE: William Jones was walking down Clarkson Street after buying a loaf of bread. He was set upon by rioters, who lynched him from a tree and then set a fire under his corpse.

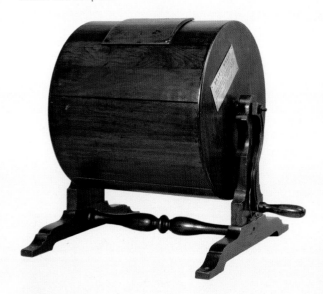

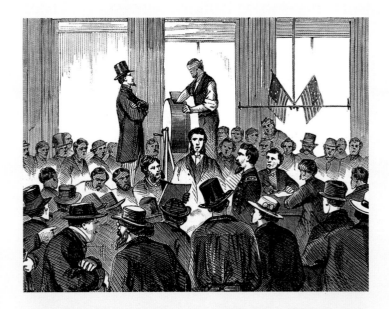

ENROLLMENT!

Office of the A. A. PROVOST-MARSHAL-GENERAL,
SOUTHERN DIVISION OF NEW YORK,
NEW YORK, JUNE 23, 1863.

NOTICE IS HEREBY GIVEN to all persons whose names have been **ENROLLED** in Districts other than those in which they reside, that by calling upon the Provost Marshal in the District in which they have their residence, they can obtain a **CERTIFICATE** of the fact of their enrollment in such Dist., which, upon presentation, will entitle them to have their names taken from the lists where they may have been enrolled elsewhere.

By adopting this course the Provost Marshals will be enabled to perfect their lists and prevent the possibility of names appearing more than once in the enrollment.

APPLICATIONS SHOULD BE MADE TO THE PROVOST MARSHALS, AS FOLLOWS:

1st Congressional District.		Jamaica, L. I.
2d " "		No. 26 Grand Street, Williamsburgh.
3d " "		No. 259 Washington St., Brooklyn.
4th " "		No. 271 Broadway.
5th " "		No. 429 Grand Street.
6th " "		No. 185 Sixth Avenue.
7th " "		No. 63 Third Avenue.
8th " "		No. 1184½ Broadway.
9th " "		No. 677 Third Avenue.

COL. ROB'T NUGENT,
A. A. PROVOST-MARSHAL-GENERAL.

BAKER & GODWIN, Printers, Printing-House Square, 1 Spruce St., N. Y.

T he Civil War had been under way for more than two years, yet by the summer of July 1863, the final outcome was still unknown. As the horrors of battle became more apparent, volunteers in the North willing to join the Union cause were dwindling in numbers. President Abraham Lincoln ordered all able-bodied men to register for the draft. This did not sit well with most New York City residents. Many had Democratic leanings and were sympathetic to the South. Draft offices were vandalized by organized mobs armed with knives and clubs. It was necessary to place them under guard, but the police were severely outnumbered and many suffered beatings at the hands of the gangsters.

During a pitched battle to prevent a mob from taking over a gun shop, Captain Walling ordered his patrolmen to kill everyone with a club fighting against them. After putting down the riot, Walling told his men to position themselves behind a barricade and prepare for another onslaught. Governor Horatio Seymour came to see the situation for himself. He complained to Walling about the number of dead in the street. Walling said that he was only obeying orders, and if they came back, he would attack again.

Despite the best efforts of the police to restore order and the heroic actions attributed to Walling, the Union Army was forced to come to the city's aid and squash the rebellion, but not before fifty soldiers, eighty blacks, and three policemen lost their lives. The situation was far worse for the rioters. Two thousand of them died and another eight thousand suffered serious injuries.

TOP LEFT: The draft wheel used in New York City to pick names during the Civil War. TOP RIGHT: After the draft riots, the draft resumed without incident in August 1863.
ABOVE: The order that led to the draft riots. Of the 750,000 men who registered for the draft, only 45,000 actually served.

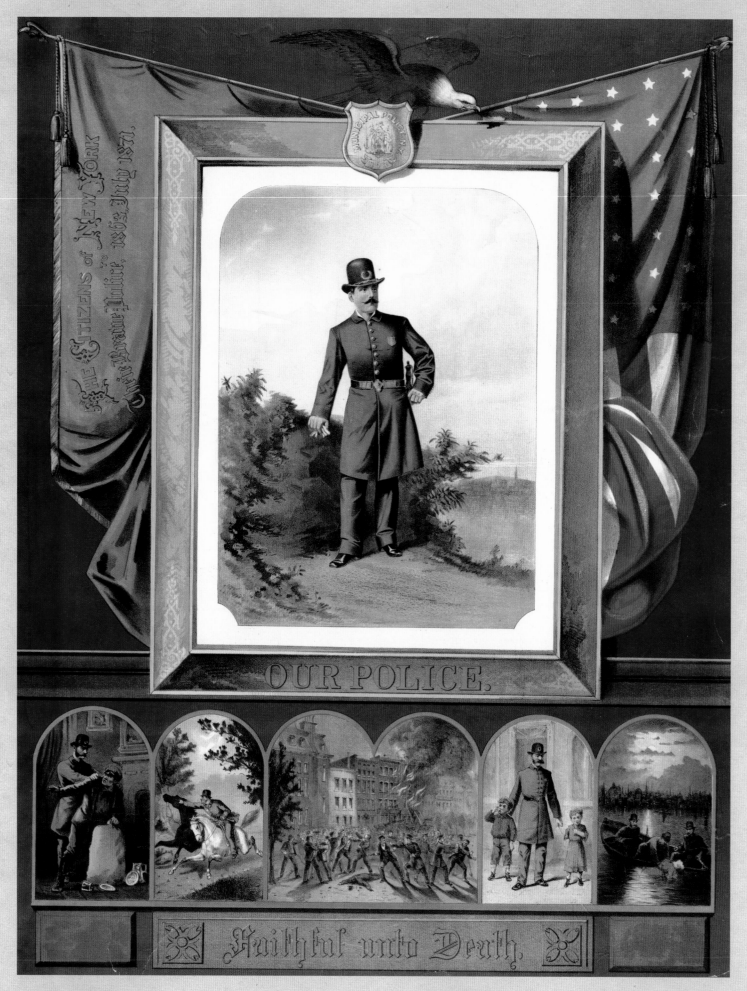

OUR POLICE.

Faithful unto Death.

30

POST-CIVIL WAR POLICING

Years **1865–1890**

After the war, a new generation of police officers joined the department and began moving up the ranks to positions of power. Tammany Hall's William "Boss" Tweed managed to get a city Democrat elected governor. Together they used their political pull to force the state legislature to form a new city charter in 1870. An important part of the legislative act broke up the Metropolitan Police Department and returned control of the police in Richmond and Kings back to their respective counties. The departments in Manhattan and the western portion of the Bronx became what is now called the New York Police Department.

Mayor Havemeyer returned to office in 1873 and brought back his friend George Matsell for a short time to run the new department. During the summer of 1874, the hero of the Civil War draft riots, Captain George Walling, replaced Matsell as superintendent of police. Matsell passed away in July 1877.

During his twelve years in charge of the force, Walling did his best to steer the department clear of politics. It was not easy for him, because he was a Republican in a city that was controlled by Tammany Hall Democrats. He was forced to retire due to age on May 28, 1885. He died seven years later at age sixty-eight.

While extremely competent policemen, neither Jacob Hays, George Matsell, nor George Walling would impact the New York Police Department like its first chief of detectives, Inspector Thomas Byrnes.

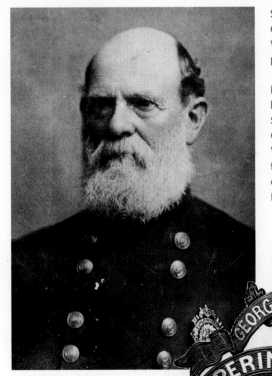

Superintendent George W. Walling in his police uniform

BELOW: The badge worn by Superintendent George W. Walling when he took command of the Municipal Police in 1874.

OPPOSITE PAGE: An 1873 illustration of the duties of police includes the 1871 flag given to police by the citizens of NYC, with the Latin version of the police force's official motto, "Faithful Unto Death," for their courage during the draft riots of 1863 and the Orange riots of 1870–1871.

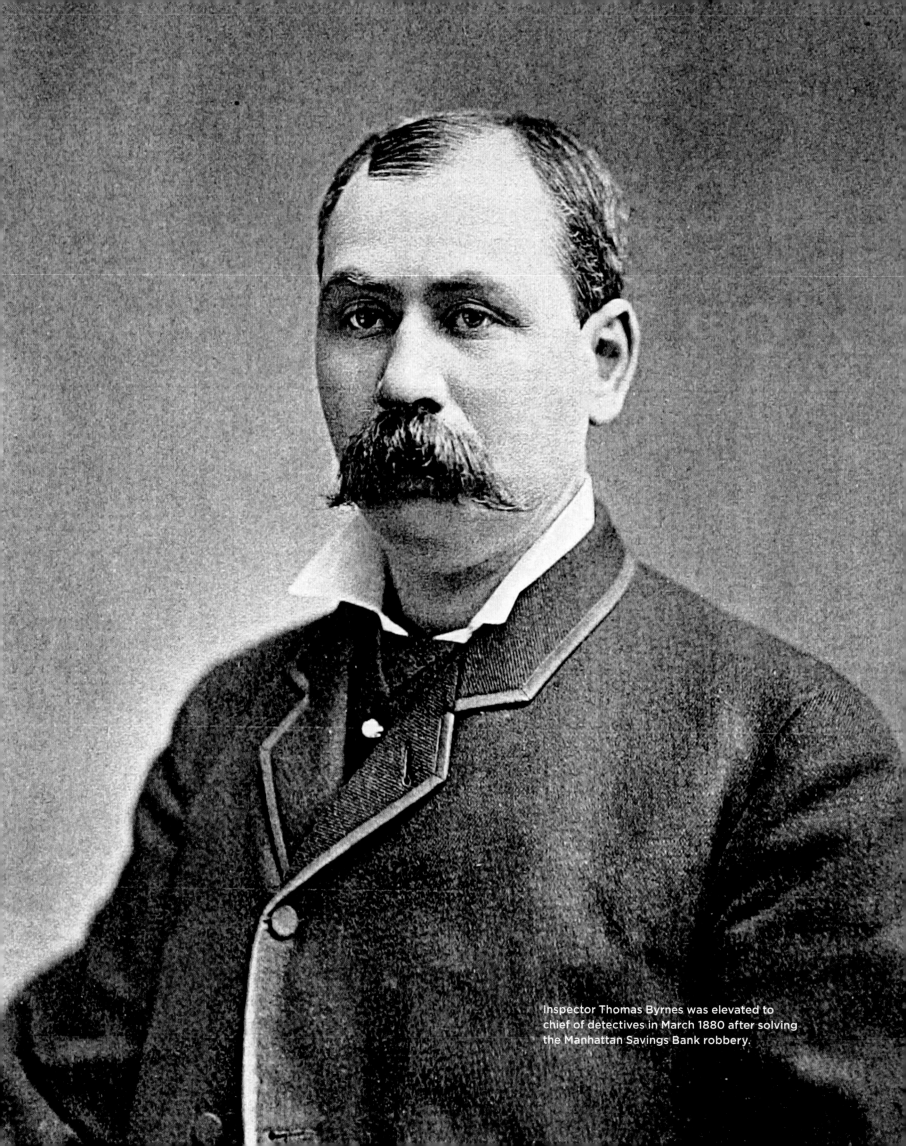
Inspector Thomas Byrnes was elevated to chief of detectives in March 1880 after solving the Manhattan Savings Bank robbery.

THE MANHATTAN BANK ROBBERY

Year 1878

Thomas Byrnes, a twenty-one-year-old Irishman, joined the Metropolitan Police Department in December 1863 after having served in the Union Army during the first two years of the Civil War. In October 1878, as the captain of the old Fifteenth Precinct on Mercer Street serving under Police Superintendent George Walling, Byrne distinguished himself by singlehandedly solving a robbery of the Manhattan Savings Bank in which $3,500,000 in cash and securities was stolen over the course of three hours. Despite the fact that most of the pilfered bonds were nonnegotiable, at the time it was considered the greatest bank heist in the history of the United States.

Byrnes was attending Sunday Mass when he was informed that the venerable bank, located within the thick stone walls of the six-story Manhattan Bank Building at Broadway and Bleecker Street, had been robbed overnight. The elderly bank custodian, who lived in a basement apartment below the bank, said that he had been taken by surprise earlier that morning by six masked gunmen who threatened to kill him, his sickly wife, and his mother-in-law if he did not unlock the door to the bank. Once he let the robbers in, they tied him, his wife, and mother-in-law up and kept them under guard until the job was

> At the time it was considered the greatest bank heist in the history of the United States.

done. Their masks prevented him from identifying them.

As Byrnes surveyed the scene of the robbery, he noticed that ten of the twenty-five safe deposit boxes were still untouched, and the expensive tools specially created to open the safe had been left behind. To his trained mind that meant the gang had been interrupted in the middle of the robbery and fled in haste with whatever proceeds

Manhattan Savings Institution housed the Manhattan Savings Bank that was robbed on October 27, 1878.

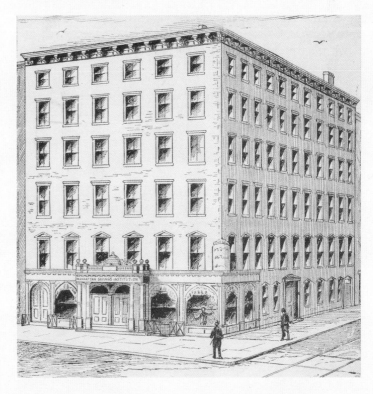

LEFT: Jimmy Hope, career criminal and one of the masterminds behind the Manhattan Savings Bank robbery, never went to jail for this crime. However, a later bank robbery in San Francisco sent to him San Quentin for seven years.

RIGHT: John Hope, Jimmy Hope's son, was caught by Captain Byrnes and sentenced to twenty years of hard labor at Sing Sing for his role in the Manhattan Savings Bank robbery. He was pardoned and released in 1890.

they had at hand. No witnesses, however, reported seeing them inside the bank, despite the large plate glass windows, or leaving the bank with large bundles of cash and bonds.

Byrnes concluded that the robbers could not have pulled off the theft without inside help and outside financing. He immediately suspected Patrick Shevlin, the bank's day watchman, and his own patrolman, John Nugent, who covered the post, to be accomplices. Surely, he thought, any patrolman worth his salt should have spotted the robbers during the course of three hours. But rather than accuse either of them right away, he put plainclothesmen on their tails until he was ready to question them.

In the meantime, Byrnes narrowed the short list of suspects capable of pulling off such a daring break-in to George Leonidas Leslie, "king of the bank robbers," and his gang, whom he believed were being bankrolled by the well-known female fence, Fredericka "Marm" Mandelbaum. The problem was that Leslie's corpse had been found rotting in a wooded lot near the Bronx/Westchester border the previous June. Although the coroner ruled his death a suicide, Byrnes suspected that Leslie had been murdered by one of his cohorts after becoming involved in a love triangle, since the man's wife was also found dead. Mandelbaum paid for Leslie's burial.

As far as Byrnes was concerned, the fact that Leslie was long dead by the time of the robbery did not mean that he was not the mastermind behind it. Leslie was an architect by trade and routinely used blueprints to plan his heists. Before his death, law enforcement authorities connected him to 80 percent of the major bank burglaries in America between 1869 and 1878.

After two months passed with little progress being made, Byrnes decided it was time to bring in the bank's day watchman after his men reported that Shevlin was spotted in the company of Tom "Shang" Draper, a known confidant of the late George Leslie. It took several days of intense questioning and a bit of clever deception on Byrnes's part to get Shevlin to confess. Byrnes arrested two men who had nothing to do with the robbery, but he told Shevlin they were ready to tell all in exchange for immunity. Since Shevlin did not know the identity of the other gangsters, he assumed Byrnes was telling the truth and jumped at the opportunity to save his own skin. Once they served their purpose, Byrnes released the pair without charging them with a crime.

Shevlin admitted to having been approached by Leslie. In exchange for a share of the take, he provided Leslie with access to the bank when it was closed so that he could figure out how to crack the safe. After Leslie died, Shevlin said that gang member Jimmy Hope took over as ringleader and finalized the arrangements for the heist.

Despite his best efforts, Byrnes never was able to apprehend Jimmy Hope, but Hope's son, Johnny, and several of his collaborators were arrested and tried for the robbery. Johnny Hope was sentenced to twenty years of hard labor. Accomplice Bill Kelley received ten years in jail. Somehow, all of the other partners escaped prison, including Patrolman John Nugent, who, for reasons even the presiding judge could not understand, was found not guilty after trial. For his part, Nugent claimed that Byrnes's case against him was "nothing but a concocted conspiracy."

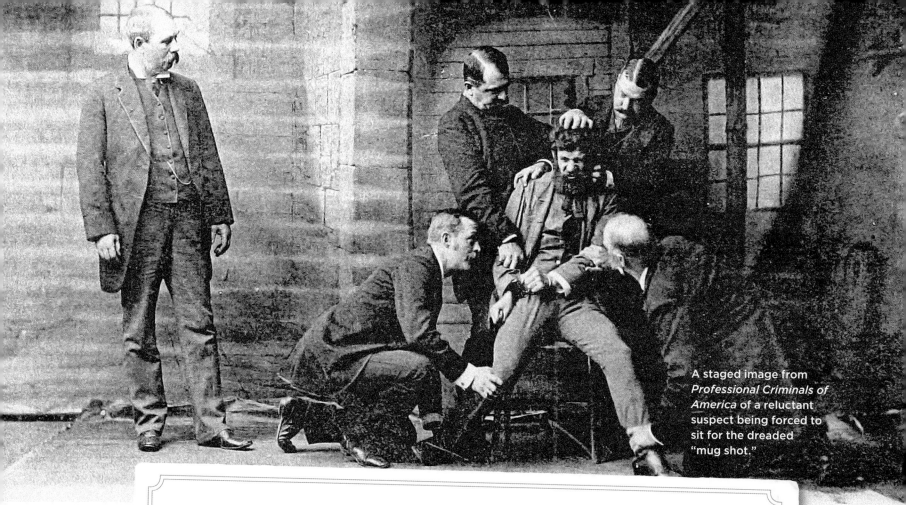

A staged image from *Professional Criminals of America* of a reluctant suspect being forced to sit for the dreaded "mug shot."

THOMAS BYRNES CHANGES THE FORCE

Year 1880

Thomas Byrnes was promoted to chief of detectives in March 1880 and placed in command of the forty-man Detective Bureau. One of his first official acts was to open a special office in the New York Stock Exchange and outfit it with telephone lines connected to all banks. Next he declared the entire area of Manhattan south of Fulton Street and including the Financial District "the Dead Line" for criminals and ordered his men to arrest on sight any known criminal loitering in the zone. Years later Byrnes bragged that not so much as a postage stamp went missing after that. In return, the grateful Wall Street bankers rewarded him with inside stock tips that made him a millionaire.

In 1886 Byrnes wrote the most authoritative book to date, *Professional Criminals of America*, which described the crimes and criminals of New York City. The text was accompanied by remarkably clear photographs of the actual criminals and crimes that they specialized in, whether it be forgery, bank sneak thieving, confidence work, burglary, pickpocketing, or shoplifting. Each crime was explained in detail along with the physical attributes of the individual criminals.

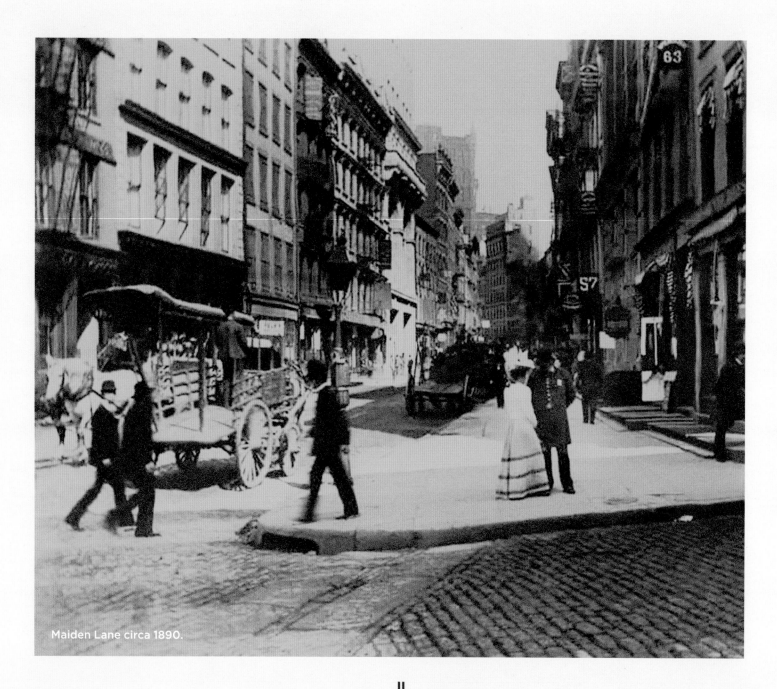

Maiden Lane circa 1890.

At the time, pistols were not readily available to the general public and those that were, were expensive. Inspector Arthur Carey, commanding officer of the first NYPD Homicide Squad, recalled in his autobiography, *Memoirs of a Murder Man*, "A man with a gun was a good capture. Thieves of the old days were not gun carriers."

As a result, few of the murders Inspector Byrnes documented involved a firearm; however, that did not deter people from killing each other, and whenever a dead body was discovered, it was left to him and the men under his command, the Detective Bureau's Central Office at 300 Mulberry Street, to figure out who did it. Sometimes they were successful, sometimes they were not, but in each instance Byrnes ensured that great care was taken to carry out a most thorough investigation.

While gruesome murders and daring robberies certainly captured the public's attention, it was petty crimes that kept Byrnes and his men most busy.

While gruesome murders and daring robberies certainly captured the public's attention, it was petty crimes that kept Byrnes and his men most busy. During the nineteenth century, crime was a way of life for the impoverished. Byrnes once said, "Poverty is held by the world to be the badge of the crime." Many of these criminals could be

Very often the police administered a beating to obtain a confession from a reluctant suspect.

found in Inspector Byrnes's "Rogues Gallery," where mug shots were put on display for policemen to view at Headquarters and printed in his book for the public's perusal. The last thing the criminals wanted was to have their portraits taken because it took away what they treasured most—anonymity. On many occasions they put up fierce struggles to avoid the mugging process, as picture taking was called, compelling detectives to sometimes employ harsh means to compel their cooperation.

While Byrnes preferred to use psychological methods to obtain confessions from reluctant suspects, he was not against using excessive force when the mind tricks failed. This approach became known as the Third Degree, and Byrnes knew better than anyone how to get a suspect to admit guilt.

When the initial round of questioning (the First Degree) by the arresting officer and the second round (the Second Degree) by the assigned detective failed to yield results, Byrnes, who was the third in line in the interrogation process, took over—hence the Third Degree. Very often the police administered a beating to obtain a confession from a reluctant suspect.

The method was covertly sanctioned by the courts. In his 1931 autobiography, *Behind the Green Lights*, NYPD Captain Cornelius Willemse wrote, "When a hold-up mob is brought into court with faces bandaged, it can be assumed that all of them didn't fall down the stairs or roll off a bunk accidently."

When gangsters refused to talk, the Third Degree or just the threat of the Third Degree loosened their lips. Although defense attorneys frequently complained that their clients' confessions were coerced by threats and intimidation, judges tended to side with the police.

Chief of Detectives Byrnes also launched the nation's first daily lineup, in which prisoners were paraded before detectives each morning at Police Headquarters. The practice continued well into the twentieth century and permitted detectives to view suspects up close and in person for the purpose of solving other crimes the defendants were thought to have committed.

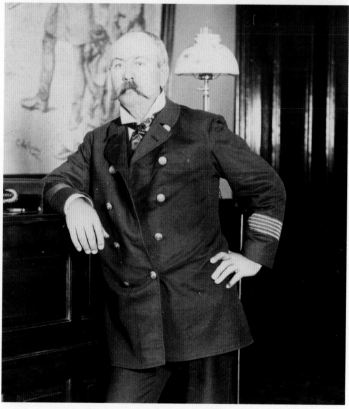

TOP: Rogue's Gallery at the Detective Bureau Central Office at police headquarters, 300 Mulberry Street.

BOTTOM: Thomas Byrnes at the time of his appointment to superintendent of police.

121

MARY ANN WATTS,
PICKPOCKET AND SHOP LIFTER.

122

BERTHA HEYMAN,
CONFIDENCE.

123

ELLEN DARRIGAN,
ALIAS ELLEN MATTHEWS,
PICKPOCKET.

124

ELIZABETH DILLON,
ALIAS BRIDGET COLE
PICKPOCKET.

125

TILLY MARTIN,
ALIAS PHIEFER.
SNEAK.

126

MARY BUSBY,
ALIAS JOHNSON
PICKPOCKET AND SHOP LIFTER.

COMMON CRIMES OF THE NINETEENTH CENTURY

Years **1800s**

Thieves of the nineteenth century tended to specialize in a particular type of crime, especially in large cities like New York where the opportunities were boundless. Lawbreakers often tried several different illicit vocations before they settled on their one true calling.

Professional hotel and boardinghouse thieves, unlike street thugs, were by and large a patient, well-dressed lot. They kept abreast of the comings and goings in the best hotels, often checking in under assumed names in an establishment they intended to burglarize. They would observe the clientele and carefully select their prey. They were experts at picking locks. A good thief could slide a thin two-pronged nipper into the keyhole to open a lock in seconds. Even the seemingly impenetrable slide bolt was no match for a crooked piece of wire and their nimble fingers. When guests reported the thefts in the morning, it was nearly impossible to prove, because the thieves usually slid the bolt back into position before fleeing. The ironic twist was that the innocent lodgers were often accused of making up the robberies to get out of paying the bills.

Even sneak thieves who did not possess the manual dexterity to pick locks were just as successful using other means. They would check into a room at a luxurious hotel and tamper with the door lock mechanism so that it could easily be defeated at a time of their choosing. Then they would lay in wait for a rich guest to check into the room. While the occupant was at breakfast, the thief would pop the loosened lock plate with a screwdriver, make his way into the room, and steal anything and everything of value in a matter of minutes. By the time the guest returned, the thief was on a train heading for parts unknown. Byrnes fully documented no fewer than twenty-one men who made their living in this manner.

Most of the vice in old New York took place in an area nicknamed "the Tenderloin." It got its unique moniker from police captain Alexander "Clubber" Williams. After taking command of the Nineteenth Precinct (after paying a bribe of $15,000 for the assignment), which covered the

LEFT: Captain Alexander "Clubber" Williams was known for his ability to wield the billy club and for giving the Tenderloin precinct its infamous name, after paying a $15,000 bribe to take over the command.

OPPOSITE PAGE: While most criminals were male, Byrnes noted that women had a propensity to shoplift and included them in _Professional Criminals of America_ to make shop owners aware of it.

area from Broadway to Ninth Avenue and Twenty-Third Street to Forty-Second Street, he uttered these famous words, "I've had nothing but chuck steak for a long time and now I'm going to get a bit of tenderloin."

Within the Tenderloin, a one-square-block area bordered by Sixth and Seventh Avenues and Thirty-Second and Thirty-Third Streets, was considered the "Negro" quarter, where black prostitutes wearing wigs passed themselves off as Spanish to naïve visitors to the city and certain locals who would rather not admit they were paying for sex with black women.

Streetwalkers were an unsavory bunch who dabbled in pickpocketing whenever the opportunity arose. It was easy for them to lure drunken johns into dark alleys and rifle through their pockets during the sex act. A john who preferred the safety of a private encounter in a brothel was victimized just as often. If he flashed a large wad of cash, the prostitute took him to a special room, then had him undress and hang his clothes on a hook attached to

the wall. As they engaged in sex, the girl's accomplice pushed against the rigged panel to which the hook was attached; the panel would revolve until the clothes were in the adjoining room. There her partner in crime took most of the money and replaced it with worthless strips of cut paper. A couple of real bills were left on top of the roll before it was returned to the pocket and the wall panel rotated back in place. By the time the victim discovered he had been robbed, the prostitute was long gone, and since disorderly houses were illegal (although tolerated when the proper authorities were paid off), johns got little sympathy from the police. Any attempt to force the police to make an arrest was usually countered by the prostitute threatening blackmail.

The "creeper" was a variation on the same game, except the prostitute's partner creeped into the room through an opening at the bottom of the door and rummaged through the john's pockets for money and jewelry while he was otherwise engaged.

Pickpockets used a variety of techniques. Many worked in teams of two or more, with one acting as the stall, and the other the dip. The stall would typically ingest a great quantity of garlic and approach a potential victim for the intent purpose of distracting him with his bad breath. As the victim retreated in disgust, a third gang member would jostle him at the same moment the dip reached into his pockets. Then the gang would disappear into the crowd and rendezvous at a predetermined location to split the profits.

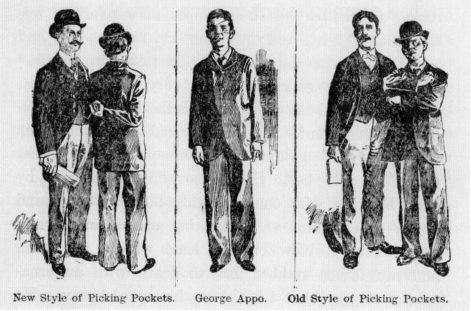

New Style of Picking Pockets. George Appo. Old Style of Picking Pockets.

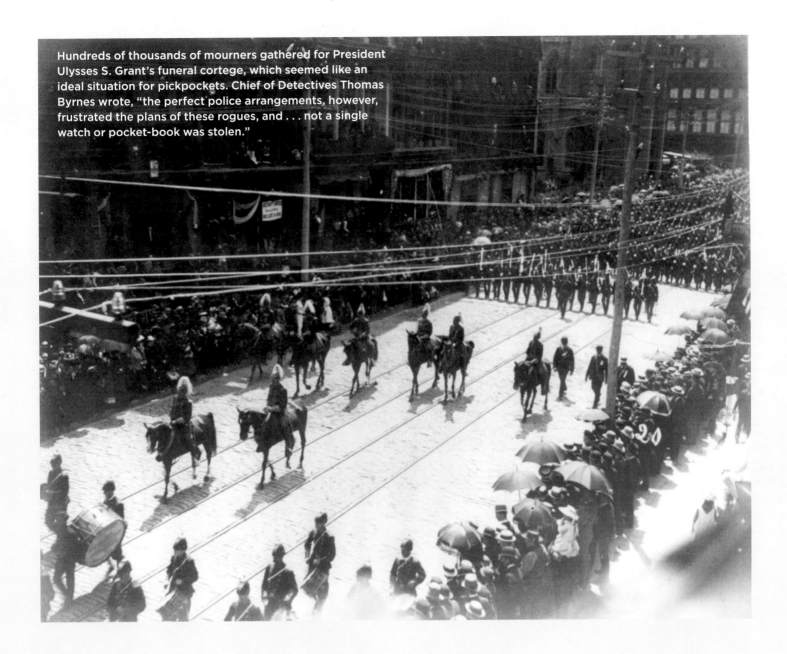

Hundreds of thousands of mourners gathered for President Ulysses S. Grant's funeral cortege, which seemed like an ideal situation for pickpockets. Chief of Detectives Thomas Byrnes wrote, "the perfect police arrangements, however, frustrated the plans of these rogues, and . . . not a single watch or pocket-book was stolen."

Some thieves preferred to work alone and only in specific situations. James Wells, aka "Funeral Wells," liked to mix in with the bereaved friends and family at funerals. The last thing the mourners expected was to be relieved of their prized possessions during a wake, but that was just what Funeral Wells did. He was so good at his trade that he once claimed to have stolen a watch out of an undertaker's pocket while helping him load a coffin into a hearse.

Whenever there was a big event taking place in New York City, Byrnes took extraordinary measures to keep the public safe. Prior to the funeral procession of former president Ulysses S. Grant in July 1885 for example, Byrnes ordered every known pickpocket to be rounded up. Then just to be sure that out-of-town sneak thieves did not come in to take their places, he stationed his men at every train depot to effect arrests on sight. Afterward he reported

that even though there were hundreds of thousands of mourners lined up along the route, not a single pocket watch or purse was lifted.

Byrnes believed that members of the fairer sex had a particular affinity for shoplifting. Of them he wrote, "The female shoplifter has that touch of nature left in her which makes a clothing store, variety bazaar or jewelry establishment the most delightful spot to exercise her cunning." He was also of the opinion that most kleptomaniacs were women. "It is the sex's affinity for finery that nine times out of ten gets them into trouble," he wrote.

To conceal pilfered goods, female shoplifters sewed extra pockets into their billowy ankle-length skirts in which to deposit purloined merchandise. Cloaks, Byrnes said, were good for concealing larger items that women carried out of the stores without paying.

THE END OF AN ERA: POLICE REFORMER THEODORE ROOSEVELT TAKES CHARGE

Year **1895**

After twelve glorious years as chief of detectives, Inspector Byrnes was appointed as superintendent of police in 1892. Despite his prowess at detecting crime, he was required to take a civil service exam in order to gain promotion. He passed, but his term lasted only three years.

In March 1894, a series of hearings chaired by Republican state senator Clarence Lexow, known as the Lexow Committee, began to look into misconduct by members of the New York Police Department. Testimony revealed the department was rife with corruption, especially in its handling of vice crimes such as gambling and prostitution, and its enforcement of the blue laws. Payouts to members of the department at all ranks were a regular occurrence if an operator of such businesses wanted to stay in business.

> **The department was rife with corruption, especially in its handling of vice crimes such as gambling and prostitution.**

Superintendent Byrnes was grilled on the witness stand for nearly five hours. The riches he claimed to have made on the stock tips came back to haunt him. Although Byrnes denied ever taking a dishonest dollar, few believed it was possible for him to amass a fortune of $350,000 on an annual salary of just $5,000.

William Strong, a reform candidate on the Fusion Party ticket, won the mayoral election in the fall of that year. During the same election, voters in the five boroughs were asked if they wanted consolidate into one large city. They voted yes.

The newspapers reported that the mayor elect intended to appoint Theodore Roosevelt as president of the four-man police board that oversaw the department and that major reform would take place. Byrnes saw the handwriting on the wall and tendered his resignation on December 30, 1894, but the incoming mayor refused to accept it.

Byrnes reluctantly agreed to stay on, but it quickly became obvious to him that Roosevelt had his own ideas about how the department should be run. He seemed more interested in purging the force of corrupt officers, shutting down brothels, and stopping the sale of liquor on Sundays than capturing the odious offenders that Byrnes had made his reputation on. By May 1895, Byrnes had enough of Roosevelt's meddling and resigned for good. No other chief of detectives would ever rise to command the Department.

That is not to say that Roosevelt was not interested in apprehending felons; he just preferred the scientific method over the methods employed by Byrnes. Positive identification of criminal suspects has always been problematic, even after Byrnes created the Rogues Gallery.

In the late 1800s, a Frenchman named Alphonse Bertillon developed a new means of identification that was used with success by the prefect of police in Paris,

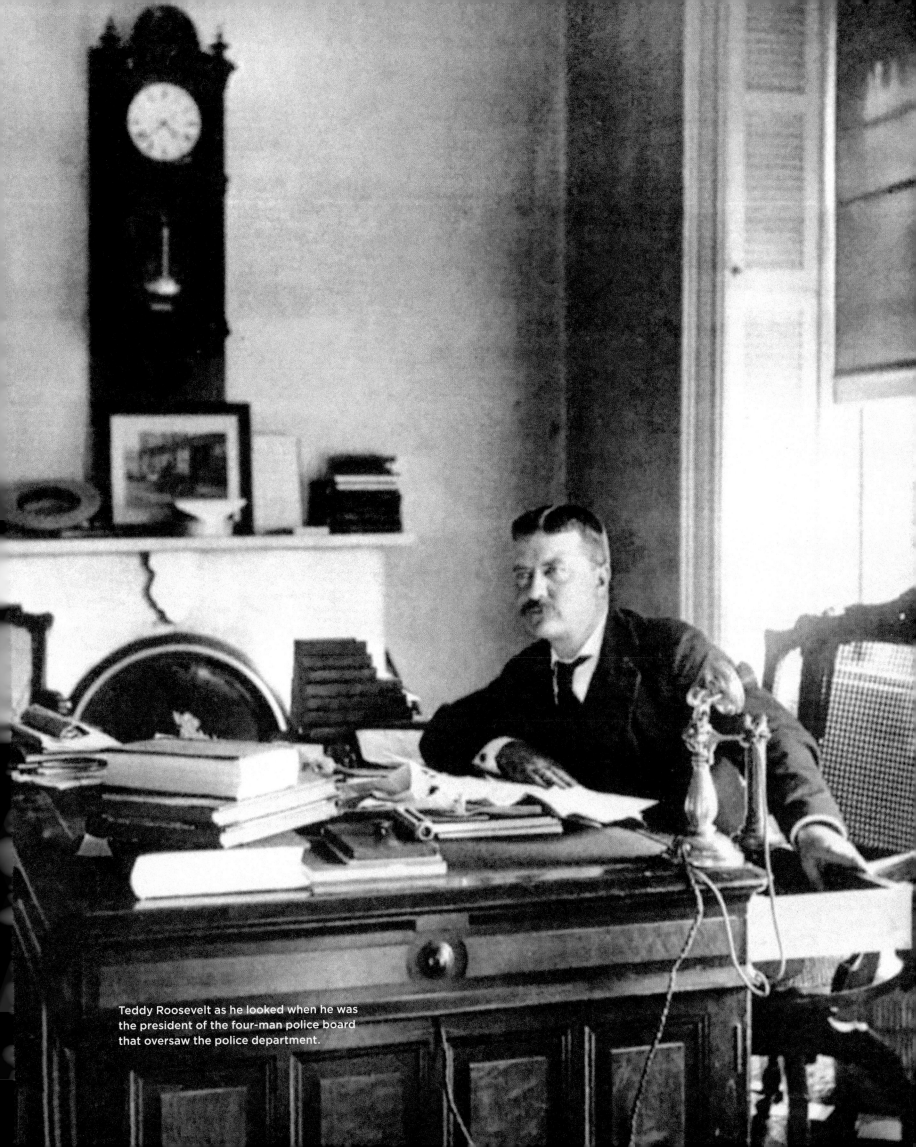

Teddy Roosevelt as he looked when he was
the president of the four-man police board
that oversaw the police department.

1. Stopping a runaway team. 2. Assaulted by roughs. 3. A fight with rioters. 4. Surprising burglars. 5. Taking lost children to Headquarters. 6. Rescuing a woman from the flames. 7. Rescuing a woman from drowning. 8. Arraigning a prisoner at court. 9. Catching a sneak thief.

Familiar Incidents in the Life of a New York Policeman.

France. The Bertillon system relied on anatomical measurements of several different body parts such as circumference of the skull, length of the arm, distance between the eyes, and so on. The measurements, along with photographs of the subject, were recorded on preprinted cards that were kept on file for future reference. In 1895, Roosevelt adopted it for the New York Police Department.

The method, however, had its drawbacks. While the anatomical measurements were fixed, if the person measuring the length of an arm from shoulder to fingertip did not start in the same exact spot as the person who took the previous measurement, the result was different. The same was true for the circumference of the head. Although special tools were developed to improve the accuracy and consistency of the measurements, by the early 1920s the NYPD, along with other jurisdictions, began to phase out the Bertillon system in favor of fingerprints.

Roosevelt carried out many reforms during his two years in office. When he left to become assistant secretary

New York police officers have been officially carrying firearms while on duty since 1887. In 1896, the .32-caliber Colt revolver was adopted as the standard weapon.

of the Navy in 1897, most officers were not sad to see him go. He conceded, "I have done nearly all I can do with the police under the present law…" But his further exploits as a Rough Rider during the Spanish American War in 1898 eventually landed him in the White House, making him the only civilian head of the NYPD to become president.

On January 1, 1898, the law took effect that merged the five boroughs—Manhattan, Brooklyn, Queens, the Bronx, and Staten Island—into the Greater City of New York. With it, eighteen separate police forces in the five boroughs became responsible for patrolling the entire city as one unit: the New York Police Department, or more familiarly, the NYPD. Instead of worrying about crime in an area of about sixty square miles encompassing Manhattan and part of the Bronx, the police officers and detectives now had jurisdiction of more than three hundred square miles, not to mention an additional 1,500,000 people. What follows are their stories.

LEFT: Here a police detective demonstrates how he measures the diameter of a suspect's hand using the Bertillon method.

BELOW: Bertillon measurements were detailed on cards with photographs, such as this example that lists the measurements of Alphonse Bertillon himself.

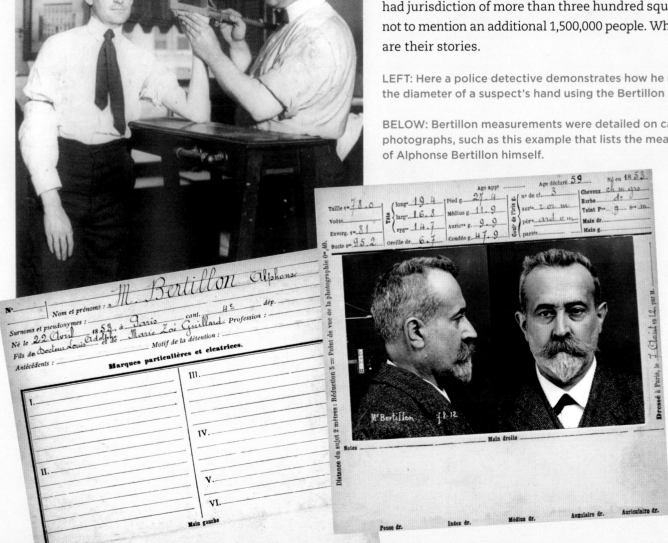

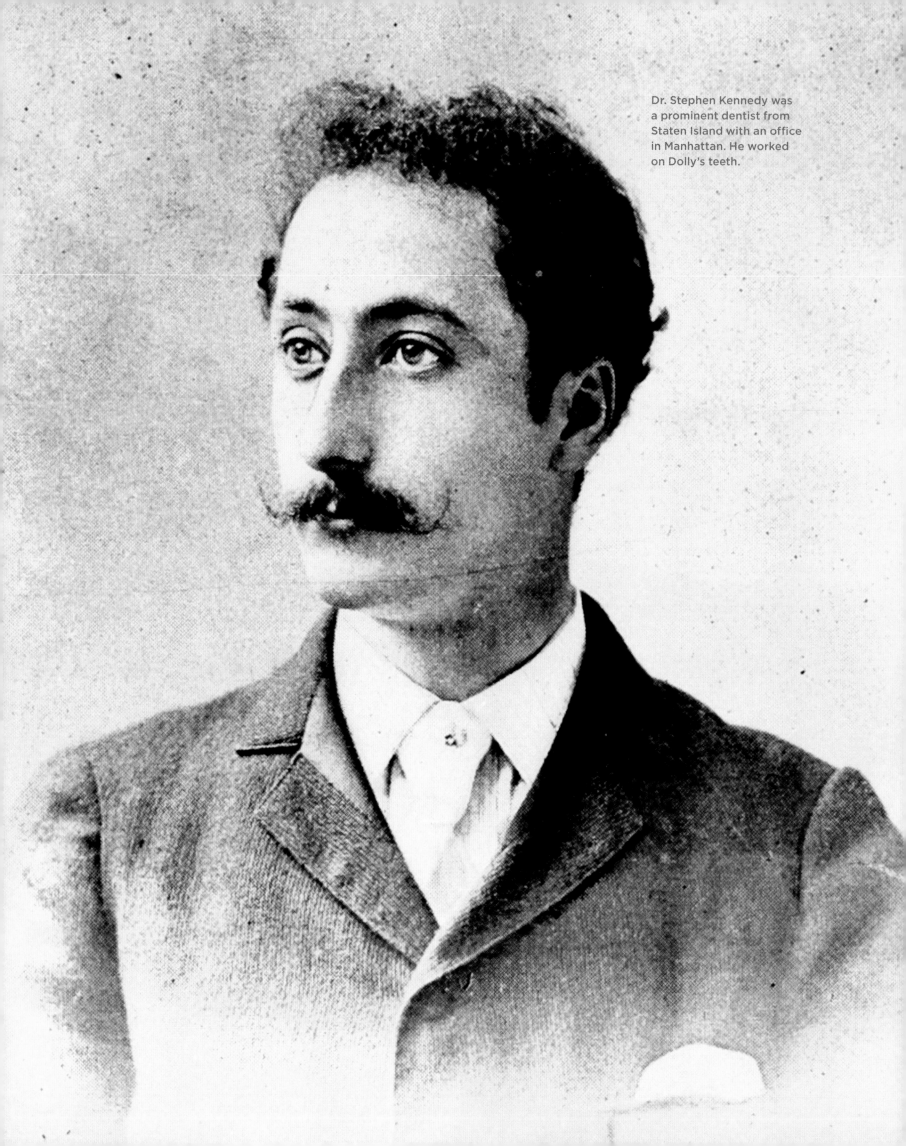

Dr. Stephen Kennedy was a prominent dentist from Staten Island with an office in Manhattan. He worked on Dolly's teeth.

THE MURDER OF DOLLY REYNOLDS

Year 1898

On August 16, 1898, newly minted detective sergeant Arthur Carey was called to room 84 inside the Grand Hotel at West Thirty-First Street and Broadway by Captain George McClusky, head of the Detective Bureau, to handle a murder case. By the time he arrived, the coroner, Dr. Philip O'Hanlon, and Detective Davis had joined McClusky at the scene. According to the front desk ledger, the room had been rented to Mr. and Mrs. E. Maxwell. Whether the dead body of the well-dressed young woman in her early twenties on the floor before them was Mrs. Maxwell they did not know, but they were pretty sure that a homemade bludgeon fashioned from a length of iron and lead pipe lying beside her was the murder weapon.

With the coroner's permission they lifted the body onto a table and sat it in the upright position. They immediately took note of the dead girl's natural beauty. Dr. O'Hanlon carefully removed her bonnet and examined the head. There was very little blood. He determined that the fatal strike had been to the base of her skull, a blow so powerful it severed her spine and caused her to suffocate to death.

Next the doctor unbuttoned her blouse. As he did, eight dollar bills and sixty-seven cents in coins spilled out, along with a check drawn from the Garfield National Bank in the amount of $25,000, payable to Emeline C. Reynolds and endorsed by Dudley Gideon and S. J. Kennedy.

Detective Carey said that he was familiar with a book-maker named Gideon, but his first name was not Dudley; it was Dave. Since the bank was nearby, McClusky dispatched Detective Davis to the location to determine if the check was authentic.

Meanwhile the detectives questioned members of the hotel staff, including the chambermaid who found the victim. The elevator operator recalled seeing the woman the day before in the company of a man wearing a straw hat. The same man was in the hotel room with her when a waiter who had served her lunch went to the room to collect on the bill. She handed him a ten-dollar bill. He gave her $8.67 back. Later that night, a bellhop saw the same man when he delivered a bottle of champagne to the room. Finally, the night clerk noticed the man in the straw hat leave the hotel at half past two in the morning.

Detective Davis reported back that the bank had no depositors by the name of Reynolds or Gideon, but a dentist named Samuel J. Kennedy maintained an account there. Kennedy ran a small dental practice out of an office on West Twenty-Second Street. McClusky ordered Davis to find the dentist and question him about the murder. Davis returned a short time later. He informed them that Kennedy was married and lived on Staten Island. The dentist denied any knowledge of the dead woman in room 84, although it was later learned that she was one of his patients.

> The fatal strike had been to the base of her skull, a blow so powerful it severed her spine and caused her to suffocate to death.

The victim was identified as Emeline Reynolds. She was twenty-two years old and went by the name "Dolly." The police located her mother in Mount Vernon, a suburb just north of the city. She filled in some of the missing details. According to her, Dolly wanted more than anything to be rich and thought New York City offered more opportunities than her hometown. She was very attractive and had a knack for sales, especially books, perhaps other things. Before long, she earned enough money to relocate to Manhattan. Carey had other ideas as to how Dolly financed her move, but he kept them to himself out of respect for her parents. The truth was Dolly had many suitors who paid for her company.

A bad tooth brought her in contact with Dr. Kennedy. While treating the abscess, he told her of a money-making scheme that involved outfitting racehorses with electrified saddles to make them run faster after being shocked. Dolly's father tried to tell her that the dentist was trying to swindle her, but she would not hear of it. Bank records indicated that Dolly withdrew $500 from her bank account the next day. Presumably she gave the money to Dr. Kennedy with the understanding that her share of the winnings would be fifty times that or $25,000, the exact amount of the check the police found tucked in her undergarments. This time Detective Sergeant Carey paid the dentist a visit. Once Kennedy admitted Dolly had been under his care, Carey placed him under arrest.

Back at the station house, the investigation proceeded rapidly from that point forward. Kennedy denied owning a straw hat, but his haberdasher said otherwise. He had sold a straw hat to the dentist the day before the murder. All of the hotel employees picked Kennedy out of a lineup as the man they had seen keeping company with Dolly Reynolds the day before she died. During a strip search of his person after he was placed under arrest, Carey observed a black smudge on Kennedy's underwear, the kind of mark left by lead when brushed against a piece of cloth. A search of Kennedy's home workshop on Staten Island recovered the rest of the iron rod used to fortify the lead pipe. To Carey's mind, there was no doubt that Kennedy had conned Dolly out of $500 and killed her before she had a chance to find out the check he gave her was totally worthless.

The jury saw it the same way. Dr. Kennedy was found guilty and sentenced to die in the electric chair in May 1899. Then things took a strange turn. His lawyer appealed the verdict based on hearsay evidence that was improperly introduced during the trial. Before the second trial got under way, a mystery man interjected himself into the case. The man told the newspapers that he overhead Carey

on the Staten Island Ferry tell another detective that if he found the lead pipe used in the murder it would be a feather in his cap. An inference was drawn that Carey had coerced the detective into manufacturing false evidence against Kennedy. Although the man recanted when placed under oath, the damage was done. The memories of other witnesses faltered as well. Kennedy's second and third trials ended with hung juries leaning toward acquittal. There was no fourth trial. The charge of murder against Kennedy was dropped, and he was set free for good in 1901. He was ready to resume his dental practice. But before he reopened his office, family, friends, and supporters on Staten Island threw him a raucous welcome-home party.

The experience taught Carey early on that the mental picture of a murder he developed in his mind during his investigation often had holes that left the picture incomplete in the minds of others. Those holes were often used to free the guilty party. Nevertheless, he went on to have a long, distinguished career in the NYPD as commanding officer of the Homicide Squad.

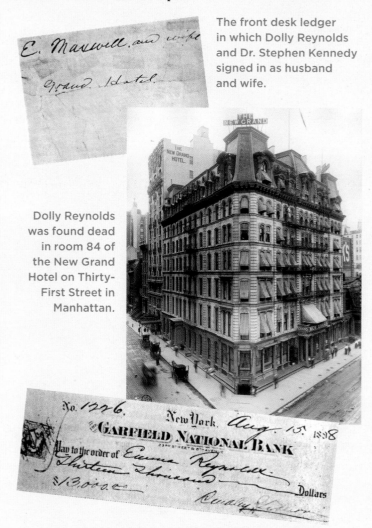

The front desk ledger in which Dolly Reynolds and Dr. Stephen Kennedy signed in as husband and wife.

Dolly Reynolds was found dead in room 84 of the New Grand Hotel on Thirty-First Street in Manhattan.

The worthless check Dolly had tucked away in her blouse allegedly written by Dr. Stephen Kennedy.

THE BARREL MURDER

Year **1903**

In the early days of the Black Hand, gangsters disposed of dead bodies such as Beneditto Madonia's by stuffing them in barrels. The practice continued for many years.

ew cases illustrate how difficult it was for police to gain convictions against Italian criminals at the turn of the century better than the Barrel Murder. In April 1903, the Secret Service deployed agents to Little Italy, the painfully overcrowded and impoverished ghetto in Lower Manhattan, to break up a Sicilian counterfeiting ring. In order to gather evidence against three suspects—Ignazio "the Wolf" Lupo, Tomasso "the Ox" Petto, and Giuseppe Morello—agents set up a secret surveillance

The next morning the police were called to a body found crammed in a barrel in Little Italy.

of a butcher shop they frequented on Stanton Street. While they were watching their comings and goings, a stranger entered the shop on the evening of April 12 and spoke to the suspects. The agents dubbed him "the newcomer" and presumed that he was part of the counterfeiters' distribution network. After the newcomer left, the agents followed him to a pastry shop and then to Morello's small bistro. They stayed a while, but when he did not come out, they called it a night.

The next morning the police were called to a body found crammed in a barrel in Little Italy. The victim's throat had been cut from ear to ear. The chain to his pocket watch was still attached to his vest, but the watch itself was missing. Among the detectives assigned to investigate was Detective Sergeant Joseph Petrosino, one of the few NYPD cops who spoke Italian.

The body had not even a shred of paper from which to identify it, and the police did not know the Secret Service was working the area until their agent came forward. He recognized the victim as the newcomer when he saw his picture in the newspaper. Although the police were still in the dark as to who he was, the barrel provided some clues. It contained sugar, sawdust, and cigar butts. The manufacturer's name was stenciled on the bottom. Several sugar refineries lined the East River back then. The barrel itself belonged to a sugar distribution company in Manhattan. Although the owner of the company did not know where it was shipped, he confirmed that he had only

A rare photo of the Italian Squad, which was formed in 1905.

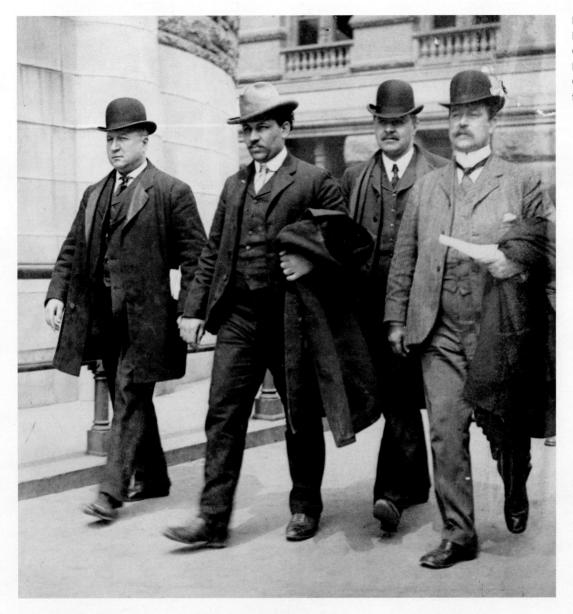

one customer in Little Italy, a pastry shop run by Pietro Inzarillo. Police later learned that it was the same one that the Secret Service agent had seen the newcomer go into.

A second clue was found in the contents of the victim's stomach, which Petrosino found to be typical Sicilian. Although a trip to Morello's restaurant confirmed the floor was covered with sawdust, there was nobody in Little Italy who would speak against him.

Petrosino decided to pay a visit to Giuseppe de Priemo, a Sicilian prisoner in Sing Sing who had been arrested for counterfeiting, to see if he could identify the body from a photograph. At first he refused to cooperate, but when Petrosino showed him the picture, de Priemo said that the victim was his brother in-law, Beneditto Madonia. He lived in Buffalo and moved counterfeit money, but de Priemo heard that he had had a falling-out with the gang. That was all he would say.

As far as the police were concerned, there was enough circumstantial evidence to arrest Lupo the Wolf, Petto the Ox, Morello, and Inzarillo, the pastry shop owner, as well as others in the gang. Petto had a pawnshop ticket for the missing watch in his possession. Petrosino believed the motive for the murder had to do with Madonia's attempt to get out of the business.

During the trial, all of the witnesses changed their testimony. Madonia's own son failed to identify his father's distinctive timepiece. Morello, Lupo, Petto, and Inzarillo were found not guilty of the murder charge, but Morello and Lupo were convicted of counterfeiting and sentenced to long terms in the federal penitentiary. Inzarillo did a short stretch for altering his citizenship papers. Ironically, the two who went to jail lived the longest. Petto and Inzarillo were both gunned down within two years.

Detective Sergeant Joseph Petrosino's war against the Black Hand, the forerunner to the Mafia, made him a living legend. In 1905, he single-handedly convinced Police Commissioner William McAdoo to let him form a special unit called the Italian Branch to go after Sicilian gangsters. Its men were the first to gather reliable intelligence about the inner workings of the Black Hand and its leaders. In December 1908 he was promoted to lieutenant, the first Italian to reach the rank in the NYPD. Also by then, Petrosino had a wife and young daughter whom he adored. He had been on the force since 1883 and his career was winding down. But Police Commissioner Theodore Bingham asked him to take on one more assignment. Bingham wanted him to travel to Sicily and investigate the pasts of Italian criminals who had made their way to the American shores. Bingham hoped the information Petrosino retrieved would help the federal government deport Italians who entered the country with falsified papers. Petrosino reluctantly accepted the challenge. It was supposed to be a secret mission, but when Bingham spilled the beans to a newspaper reporter, the Black Hand sent an assassin overseas to find him.

Petrosino was making progress, but before he left the country, he was gunned down in Palermo on March 12, 1909. He was the first and only officer in the NYPD killed overseas in the line of duty. The informant he was supposed to meet never showed. An unmailed postcard addressed to his wife was found in his pocket. It read, "A kiss for you and my little girl, who has spent three months far from her daddy." It was signed with his shield number 285.

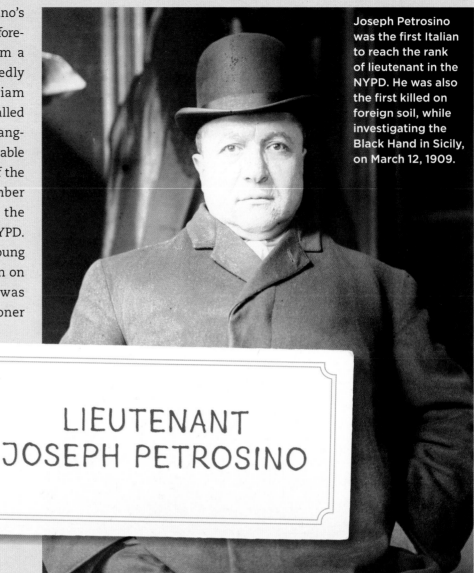

Joseph Petrosino was the first Italian to reach the rank of lieutenant in the NYPD. He was also the first killed on foreign soil, while investigating the Black Hand in Sicily, on March 12, 1909.

LIEUTENANT JOSEPH PETROSINO

PETROSINO'S REMAINS ARRIVING AT HIS WIDOW'S HOME APR. 9/09 679-11

A police honor guard removes Lieutenant Petrosino's casket from the hearse. More than 250,000 people paid their respects as his funeral procession wound its way through the streets of Little Italy.

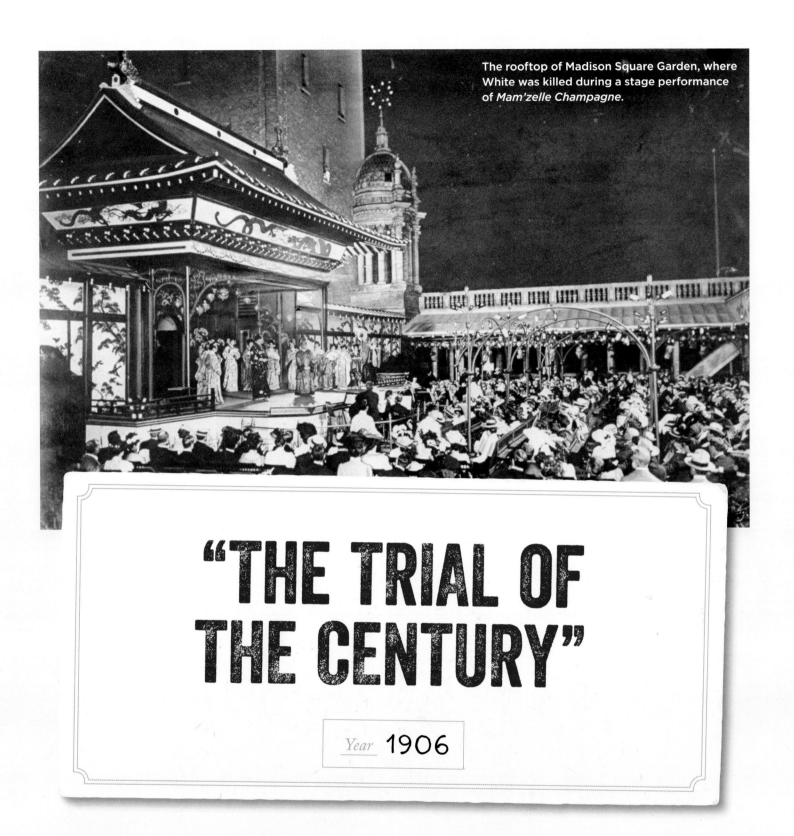

The rooftop of Madison Square Garden, where White was killed during a stage performance of *Mam'zelle Champagne*.

"THE TRIAL OF THE CENTURY"

Year 1906

On Monday evening, June 25, 1906, thirty-five-year-old Harry K. Thaw, the wealthy heir to a Pittsburgh steel fortune, drew a revolver from under his coat. He fired it at point-blank range into the head of renowned American architect Stanford White, age fifty-one, during a performance of *Mam'zelle Champagne* on the rooftop stage at the original Madison Square Garden (which, coincidentally, Stanford had designed). Of Thaw's

crime, there was no doubt. There were dozens of eyewitnesses—including his beautiful young wife, Evelyn Nesbit, who exclaimed in the aftermath, "Oh Harry, what have you done?"

Thaw was apprehended within moments by Patrolman Anthony Debes, whose foot post covered Madison Square Garden. At the Nineteenth Precinct, Thaw initially provided the desk sergeant with a false name, but before long

The Washington Times

NUMBER 4396.　　　　　WASHINGTON, TUESDAY EVENING, JUNE 26, 1906.　　　　　PRICE ONE CENT.

HARRY THAW KILLS STANFORD WHITE IN JEALOUS RAGE OVER ACTRESS WIFE

STANFORD WHITE, NEW YORK ARCHITECT, THE VICTIM OF THAW'S PISTOL

EVELYN NESBIT THAW, ACTRESS WHOSE MARRIAGE TO THE YOUNG MILLIONAIRE CAUSED A SENSATION A YEAR AGO

HARRY K. THAW, YOUNG PITTSBURG MILLIONAIRE WHO KILLED WHITE

THE EARL OF YARMOUTH, THAW'S BROTHER-IN-LAW AND CHUM

THE COUNTESS OF YARMOUTH, THAW'S SISTER

CHARLES F. MORIN, WHITE'S BUSINESS PARTNER

MRS. HARRY THAW FROM PHOTO TAKEN AT TIME OF HER MARRIAGE

MISSOURI FORBIDS TRUST TO COLLECT ADMITTED CLAIMS

Missouri Trust Law

Any purchaser of any article or commodity from any individual, company or corporation transacting business contrary to any provision of the preceding sections of this article shall not be liable for the price or payment of such article or commodity, and may plead this article as a defense to any suit for such price or payment.

ST. LOUIS, June 26.—Judge Ryan of the St. Louis circuit bench, has ruled that the Cahill-Swift Manufacturing Company is a member of the plumbing trust, and, therefore, has forfeited its right to ask the State's aid in the collection of its debts.

Plumber Owed $240.83.

The case was that of the Cahill-Swift

INSANE PATIENT FOUGHT FIERCELY WITH 3 GUARDS

The story of a desperate hand-to-hand fight at St. Elizabeth's in the night between a lunatic on the one side and two able-bodied attendants and a "trusty" on the other side was told today to the special Congressional committee investigating the Government Hospital for the Insane.

It was the story of the encounter between William M. Gartrell, a survivor of the Maine and now insane, and the "trusty" and the two attendants, Cowling and Thorne.

George B. Gartrell, a brother of the insane man, went before the committee and said in tense tones with indignation, that the three men had beaten his brother shamefully and that the asylum authorities knew nothing of the matter until he discovered it and reported it to them at noon the following day, more than twelve hours after it had happened. In fact, he said, prior to his gruesome discovery the asylum physicians had told him his brother had "spent a comfortable night."

On the other hand, the testimony of the asylum authorities was that Gartrell made a murderous attack on his special attendant, Cowling, and Thorne and the "trusty" had to help subdue Gartrell to save Cowling's life.

Mr. Cowling said he choked Gartrell.

(Continued on Fourth Page.)

THE WEATHER REPORT.

There were no temperature changes of consequence.

The weather will continue unsettled tonight in the East and South with quite general showers.

TEMPERATURE.

9 a. m. 69
12 noon 74
1 p. m. 76

DOWNTOWN TEMPERATURE.

Thaw Tells Own Story Of the Killing of White

In Broken Sentences He Indicates Motive to Have Been Jealousy and Revenge---Declares Dead Man Ruined His Wife.

NEW YORK, June 26.—Harry K. Thaw, millionaire assassin of Stanford White, the world famous architect, early this morning told his own story of the killing. Jealousy, hate and revenge were the motives. He said:

"We were all at a party at Martins, the old Delmonico place, Mrs. Thaw and her stepfather, W. J. Holman, a broker, and others were present. You will find out who they were later.

"I was sitting at some distance from my wife. Suddenly I saw her get very pale and begin to shiver. I thought she was ill.

"I made a motion to inquire what was the matter. She called a waiter and wrote a note which she sent around the table to me. The note said: 'That dirty blackguard is here.'

"Then I turned and saw that damned scoundrel sitting there, big, fat and healthy, and there she was all trembling and nervous."

MRS. THAW ALONE WALKS TO COURT TO SEE HUSBAND

Police Had Made An Unsuccessful All Night Search For Her.

NEW YORK, June 26.—Evelyn Nesbit Thaw walked into the detective bureau at police headquarters today a few minutes after her husband, Harry K. Thaw, had been taken from there to Jefferson Market court, where he was arraigned, charged with the murder of Stanford White.

Mrs. Thaw was alone, and evidently walked to headquarters from where she left a street car. She was dressed all in black, with a large black picture hat, and looked strikingly beautiful.

TRAGIC CLIMAX ON ROOF GARDEN BEFORE CROWD

Millionaire Slayer Claims Famous Architect Ruined His Wife Before His Marriage to Her---Held for Murder by Coroner.

NEW YORK, June 26.—Harry Kendall Thaw, the young Pittsburg millionaire and brother of the Countess of Yarmouth, was arraigned in Jefferson Market court, charged with the sensational shooting killing of Stanford White, the millionaire architect, during a performance late last night in Madison Square Roof Garden for some real or fancied wrong that White had done Evelyn Nesbit, the actress artists' model, whose marriage to young Thaw a year ago was a society sensation.

Thaw was quite calm when arraigned this morning. He was dressed in his evening clothes and was somewhat bedraggled from long night in the police station cell.

COMMITTED TO THE TOMBS.

Thaw's arraignment before Magistrate Barlow was over within a minute and he was remanded to the custody of the coroner. Once more the prisoner was bundled into the patrol wagon, after being handcuffed and taken to the criminal courts building, where he was arraigned fore Coroner Dooley. There was a tremendous crowd in the office of the coroner, and Thaw, seeing that several photographers were trying to take his picture, hid his face behind his hat. On an affidavit signed by Patrolman Debs, that Thaw said to him, "I shot him, I held without bail and committed to the Tombs.

his identity was discovered, and the lurid details behind his crime became front-page news.

His wife, Evelyn Nesbit, was, by age sixteen, New York City's most famous model. Photographs of her dressed in skimpy virginal attire, with auburn hair cascading down her bare shoulders, began to appear on penny postcards and in national periodicals. Her innocence and beauty captivated millions of men and one in particular, Stanford White, who had a penchant for virtuous adolescent girls and a wallet large enough to attain them. He first spotted her performing a bit part in a Broadway musical. Since Evelyn was a minor, White befriended her mother. He convinced Mrs. Nesbit that he only had her daughter's best interests in mind and began to shower her with gifts. Evelyn soon became smitten by her much older, married benefactor, whom she affectionately called "Stanny."

Meanwhile, Harry K. Thaw, a younger and more wealthy suitor, began vying for Evelyn's attention. Thaw wanted desperately to marry her. When White learned of their budding relationship, he warned Evelyn that Thaw had experienced several psychotic episodes in the past that his family fortune had made disappear. But Thaw kept that side of himself hidden from Evelyn. Shortly before her eighteenth birthday in 1903, he squired her, along with her mother acting as a chaperone, on a grand tour of Europe. Thaw's plan was to get Evelyn away from White to determine the extent of their romantic involvement.

Halfway through the monthlong sojourn he persuaded Mrs. Nesbit to return home. When she did, he rented a secluded castle for himself and Evelyn in the German countryside. Once they were alone, Thaw convinced Evelyn to open up about her relationship with White. She reluctantly admitted that White had taken her virginity during a night of heavy drinking. Thaw became so unhinged by her disclosure that he violently raped her. In the months that followed their return to America, Thaw begged Evelyn to forgive him and that he was a changed man. She finally believed him. The two were married in April 1905 and settled down in his family mansion in Pittsburgh. Although they were far away from New York City, Thaw could not get past the fact that White had defiled his bride. He began to formulate a plan to make White pay for what he had done.

Thaw took to carrying a pistol, ostensibly for his own protection, but he had other ideas for it. He made arrangements to take Evelyn on a voyage to Europe in the summer of 1906. The night before boarding the ocean liner, Thaw agreed to take Evelyn to see a new show at Madison Square

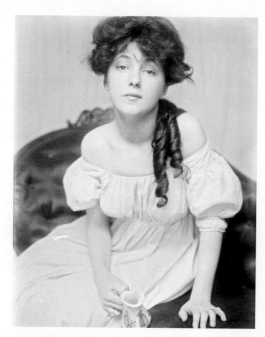

ABOVE: Stanford White and Harry Thaw both vied for the attention of Evelyn Nesbit, considered to be one of the most beautiful women in America in the early 1900s. Penny postcards bearing her image were purchased by the thousands.

OPPOSITE PAGE: *The Washington Times* edition on June 26, 1906, in which Thaw was quoted as saying, "That man ruined my wife! He won't do this anymore, or ruin any more homes. White deserved all he got!"

BELOW: Stanford White, New York City's most prominent architect, had a penchant for young women . . . and also the money to get them. RIGHT: The Stanford White–designed Madison Square Garden in 1906.

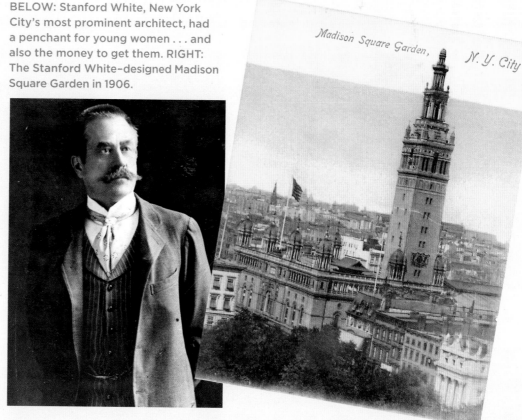

Garden. A combination of happenstance and bad timing put White and Thaw on a collision course that evening. Thaw noticed White's arrival and immediately excused himself. The chorus had just finished singing the song "I Could Love a Thousand Girls" when Thaw walked up behind White and fired his revolver three times. White keeled over on the table. Silverware and wineglasses crashed to the floor. During the pandemonium, Thaw casually made his way to the elevator, where he was arrested by Patrolman Debes.

Thaw pleaded not guilty by reason of insanity. He was remanded to the Tombs prison, where his wealth insured that he would dine on steak from Delmonico's washed down with the finest Scotch money could buy.

The newspapers proclaimed Thaw's 1907 murder trial "the Trial of the Century." The star witness was his beautiful wife, Evelyn. The entire country was riveted to her testimony; unbeknownst to most of them, Thaw's mother had made financial arrangements with Evelyn to insure she portrayed her schizophrenic son in the best possible light. The first trial resulted in a hung jury, the second in a verdict of not guilty by reason of insanity. Thaw spent the next several years in a sanitarium, where he enjoyed regular conjugal visits with Evelyn. Security was so lax that at one point he escaped and made his way to Canada. Eventually he was captured and returned to the United States.

On July 15, 1915, his lawyers finally won Thaw's freedom. One of the first things he did upon his release was divorce his wife. Thaw would go on to have many run-ins with the law. As for Evelyn, her ex-husband's penny pinching ways made her life miserable. Before she passed away in 1967 at age eighty-one, Evelyn told a reporter, "Stanny was lucky he died. I lived."

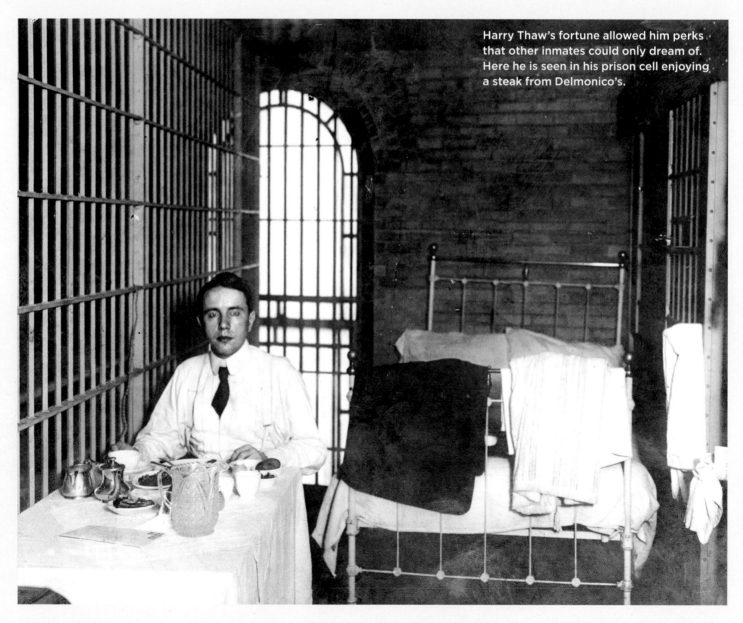

Harry Thaw's fortune allowed him perks that other inmates could only dream of. Here he is seen in his prison cell enjoying a steak from Delmonico's.

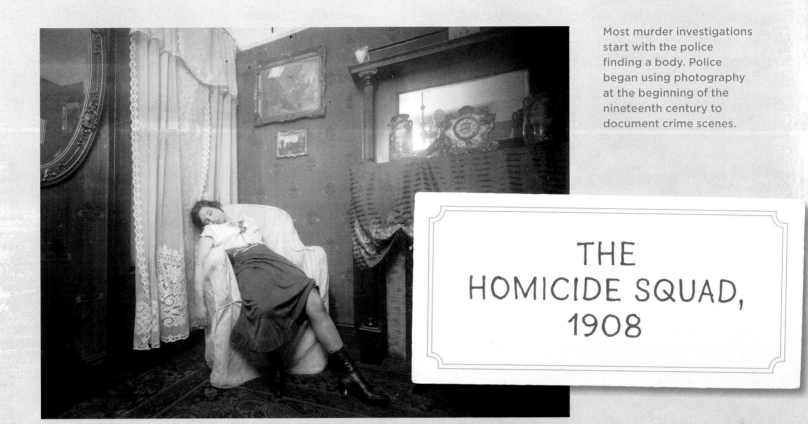

THE HOMICIDE SQUAD, 1908

Fourth Deputy Police Commissioner Arthur Woods was a Harvard graduate who studied special methods of policing abroad before accepting a position with the NYPD in 1906 at the behest of Police Commissioner Theodore Bingham. In 1908 the police commissioner charged him with reorganizing the Detective Bureau. As part of that mission Woods formed the nation's first police squad to specialize solely in homicide investigations. New York cops dubbed the unit "the Murder Clinic" for its reliance on the scientific method to solve crimes.

Prior to that, detectives worked on whatever case their captain assigned them to. Woods believed that the public would be better served by detectives devoted to investigating a specific type of crime. He went on to create other specialty units to deal with pickpockets, missing persons, narcotics, radicals, and safecrackers.

Captain Arthur Carey, a seasoned detective, was placed in command of the new unit. But right from the start his handpicked team was hindered by the fact that under the law, nobody—including police officers—could disturb a dead body until the coroner examined it first. Valuable clues necessary to determine the time of death were lost after blood dried and rigor mortis set in.

In addition, detectives assigned to branch offices in the outer boroughs did not like being told how to do their jobs by specialists from Headquarters and were reluctant to share information with their colleagues.

Nevertheless, Carey set out to teach his subordinates all he knew about the art of murder. To better understand what type of injuries were fatal, he had his men study the effects of bullets (by firing rounds into the shaved heads and bodies of hog and calf carcasses to simulate gunshot wounds), burns, lacerations, punctures, poisonous substances, including chemicals and acids, ex-

plosives, and telltale ligature marks.

Although Carey's detectives became experts in their field, they fell back on the Third Degree whenever their scientific methods failed to identify a suspect. This caused the naysayers in the Department to whisper that they were no better at their craft than any other detective on the force.

With a change in administration in 1910, and twenty-two unsolved homicides on the books, the Homicide Squad was disbanded, and Captain Carey was transferred from plainclothes back to uniform. But four years later Woods returned to the Department, this time as police commissioner, and undid all of the changes made by his predecessor. Carey returned to command the re-formed Homicide Squad and remained in command until he retired in 1928 as an inspector. He went on to write a book about his experiences, *Memoirs of a Murder Man*.

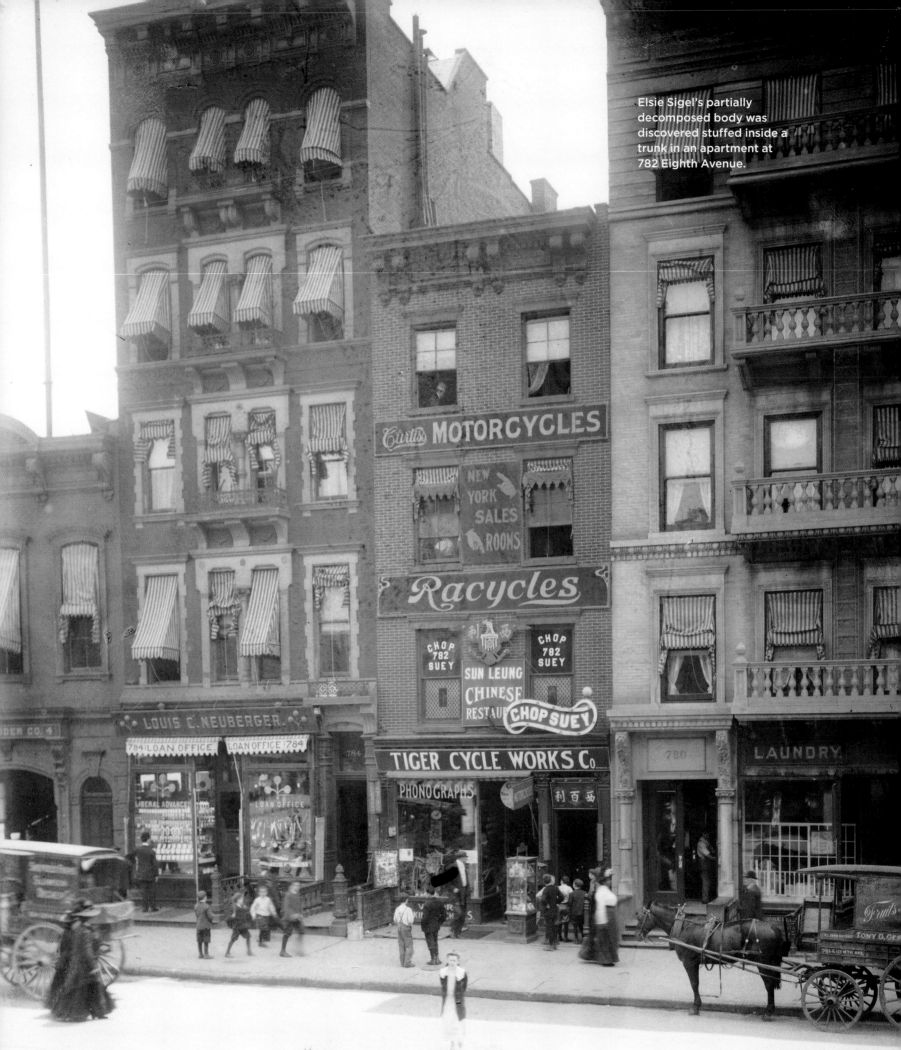

Elsie Sigel's partially decomposed body was discovered stuffed inside a trunk in an apartment at 782 Eighth Avenue.

HOUSE IN WHICH X
MISS SIGEL WAS KILLED

343-15

THE CHINATOWN TRUNK MURDER

Year 1909

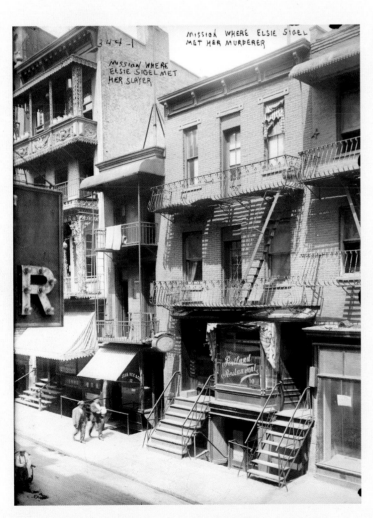

The mission in Chinatown where Elsie Sigel first met her alleged lover and eventual killer, Leon aka William Ling.

Every detective worth his salt has a case that haunts him for the rest of his life. For NYPD Detective Ernest Van Wagner, that case began on Friday, June 18, 1909. While at the West Forty-Seventh Street stationhouse checking precinct records, he observed an elderly Chinese man in traditional black garb shuffle into the stationhouse seeking help. The man called himself Sun Leung and told the desk lieutenant in broken English, "Me tink my cousin him dead in room. Wanta cop to get him out."

In itself, the request was not unusual. In the early 1900s most New Yorkers died at home, but very few Chinese resided so far north of Chinatown. The lieutenant, however, did not ask any questions. Instead he roused a patrolman off reserve and told him, "Go with this Chink. He's got a dead one in his joint."

While Detective Van Wagner returned to his records search, Mr. Leung led the police officer to a four-story building at 782 Eighth Avenue, off West Forty-Eighth Street. The old Chinese man ran a pricey chop suey restaurant on the second floor, one of the city's first Asian eateries to open outside of Chinatown. The upper two floors were occupied by restaurant workers and itinerant Chinese men. The telltale stench of decaying flesh emanated from within the flat that Mr. Leung said belonged to his cousin, but six sturdy padlocks on the door effectively prevented the patrolman from gaining access.

He notified the lieutenant. Van Wagner overheard their conversation and offered to go to investigate. He had no

> ## The telltale stench of decaying flesh emanated from within the flat.

luck getting in, either, until he borrowed an ax from a nearby firehouse and battered down the door. The smell was so bad that several Chinese men, who had been anxiously watching the two policemen tackle the sturdy door, fled the hallway in search of fresh air.

Van Wagner opened the apartment windows and waited for the odor to dissipate before proceeding. A cursory search of the rooms failed to immediately locate the source of the stink, but Van Wagner took note of the expensive Asian furnishings and the luxurious silk garments in the dresser. Upon closer examination he realized that some of the clothing items belonged to women. His curiosity was further aroused when he noticed dozens of photographs of Caucasian females on display throughout the apartment in the company of a handsome, but unknown, Chinese man.

Chang Sing (third from left), William Ling's roommate, arrives in New York City.
He was not charged as an accomplice even though he tried to help Ling get rid of Elsie's body.

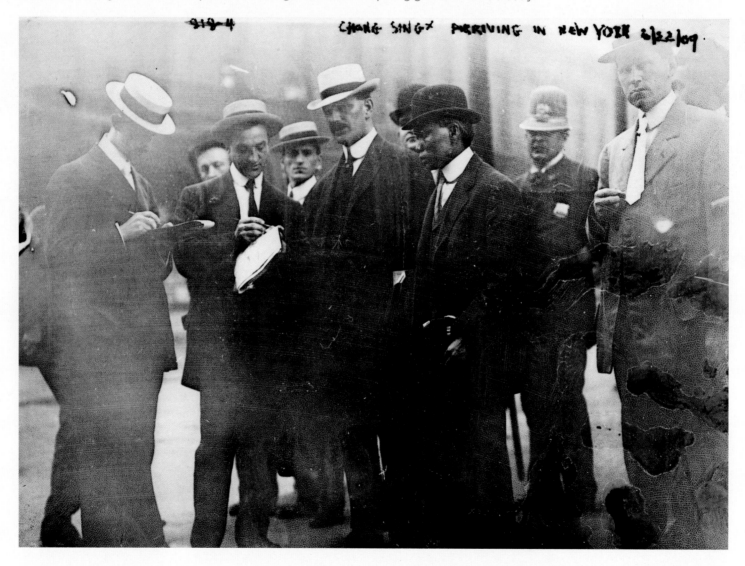

OPPOSITE PAGE: *The Washington Times*'s June 20, 1909 article on the Elsie Sigel murder. Ling was last seen in the capital.

Central Figures and Features of the Elsie Sigel Murder

CHUNG SING,
Roommate of Supposed Murderer of Elsie Sigel.

782 EIGHTH AVENUE,
Where Body Was Found.

WILLIAM L. LEON (LEUNG LING),
Sought as the Murderer of Elsie Sigel.

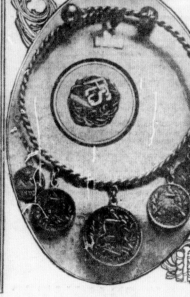

BRACELET AND THE "P. C. S." PIN.
These Bits of Jewelry Aided in Identifying Elsie Sigel.

WHERE BODY WAS FOUND.
The Trunk is That in Which the Corpse Was Hidden.

TIMES DISCOVERS IMPORTANT CLUE IN SIGEL MYSTER

Letter to Missing Chinama
Found at National
Hotel.

MAY GIVE NEW TRACE OF ALLEGED SLAYER

Envelope Bears Name on Back
Sam Wing, New York, as Apparent Sender.

One of the most important clue that has been placed in the hands of the Washington police in their efforts to trace the actions in this city of Leung Ling, alias William L. Leon, the Chinaman accused of the murder of Elsie Sigel, of New York city, was furnished Inspector Boardman, chief of detectives, early this morning by The Times through the discovery at the National Hotel of a special deliver letter addressed to the missing Chinaman, from Sam Wing, of New York city.

The letter was mailed at 6 p. m June 11, and reached the National Hotel the same evening.

Address on Letter.

"Mr. William Lone, care of G. F Schutt, National Hotel, Washington, D. C." is the address on the important letter, while the name of the apparent sender is written on the back as "Mr. Sam Wing, 8? Bayard street, New York city."

A number of Chinese characters preceded the name of Wing.

The day clerk of the hotel refused to give up the letter.

It was called for by the postoffice authorities after application had been made to the police.

Other Developments.

Other important developments in the murder mystery unearthed today by reporters for The Times follow:

Leon and a Chinese companion telephoned to New York city late last Wednesday night from the Fritz Reuter Hotel, near Chinatown district.

An unknown Chinaman telephoned to New York from the National Hotel Thursday night.

Leon and a girl took an automobile ride for two hours with Joe Torrillo, a National Hotel chauffeur, June 9, and went to the depot with the same chauffeur June 12.

The accused Chinaman, with a white girl hanging on his arm, were seen near the Capitol about a week ago.

No direct evidence as to whether Ling stopped at the National Hotel has been disclosed.

Leon told Joe Torrillo, the chauffeur who drove him to the Union Station when he left the city, that he had already sent his trunk to the train.

Wore Different Clothes.

The chauffeur who took the couple riding declares the Chinaman wore a light suit of clothes; the telegraph operator who saw him the same evening declares he wore a black suit.

Leung told the chauffeur at the depot that he had sent his trunk to the station. The hotel authorities do not know of any trunk being received for the Chinaman or sent out at his order.

The evidence of the men who took notice of the presence of the Chinaman and the woman in Washington is somewhat conflicting. Time has passed since they saw the couple and none of them can positively identify the pictures of the accused man which have been shown them. Particular notice of the

H. M. MILLER WINS BIG SOCIABILITY RUN

In Thomas Taxi, Goes It in
54:13 4-5, Against 54:07
Set by Vice President.

ELECTRIC MACHINES SHOW THEIR METTLE

John Bartrem, Second; R. P. Andrews, Third—Event Free
From Serious Mishap.

By HARRY WARD.

The official secret time selected by Vice President Sherman for The Times Sociability Run to Great Falls was fifty-four minutes and seven seconds.

The winner was H. M. Miller, who drove a Thomas taxicab over the 16.3-mile course in 0:54:13 4-5, just six-and-four-fifths seconds ahead of Mr. Sherman's time.

Miller drove his car with consummate skill and when it was announced that he was the winner there was a rousing cheer from the hundreds of motorists who had congregated in front of the Munsey Building to hear the returns. Mr. Miller not only won the handsome silver loving cup offered by The Times, but also the imported Bangkok lid given by Parker, Bridget & Co., as a special prize to the contestant who nearest approached the time named by the Vice President.

Miller is the envy of all his associates and had he been a millionaire owner of a costly touring car, the congratulations he received could not have been more hearty.

Second honors went to John Bartrem, who piloted a Baker electric over the course in 0:54:34 2-5 or seventeen-and-two-fifths seconds behind the official time.

Bartrem's achievement was a notable

(Continued on Page Twelve.)

LONGWORTH'S WIFE IS AGAIN AN AUNT

CINCINNATI, June 20.—Alice Roosevelt Longworth will be told today that she is again an aunt. She will learn of this when a message from Cincinnati reaches her telling that a son was born this morning to Mrs. N. C. Wallingford, a sister of Congressman Nick Longworth. The message reads:

"Alice's godson, Nick, was born last night. Mother and babe doing nicely."

It was stated at the Wallingford home, in the exclusive Grandin road section of this city this morning, that the baby's name will be Nicholas Longworth Wallingford, and that he weighed ten pounds at birth.

GIRL LED TO ALTAR; FATHER IS IN CELL

Arrest of Cashier Moore Does Not Halt Daughter's Wedding.

ST. LOUIS, Mo., June 20.—While her father, Steven A. Moore, cashier of the People's Bank at Benbow City, Ill., was held in his cell here today, pending charges of fraudulent banking, his daughter, Miss Laurette Moore, was led to the altar and became the bride of Harry Hail, a contractor.

The wedding was set for this noon and Mr. Moore was to have given his daughter away. Yesterday he was arrested in the investigation of the People's Bank and he did not witness his daughter's marriage. The ceremony, however, was not delayed. The father's part was omitted and in the presence of

MRS. MYRTLE PLATT TO WED IS RUMOR

DETROIT, June 20.—Mrs. Myrtle Platt, of Chicago, mentioned in the divorce suit brought against Col. William F. Tucker, is in this city at the home of the Rev. William S. Sayres, 163 Willis avenue west. It is rumored that she is about to marry a Detroit man, and this is not denied.

Mrs. Tucker charged that her husband did not support her although she alleged, he traveled about the country for his health with Mrs. Platt as a nurse. The bill declared that the army man met the nurse in the Philippines, where she was teaching, and took her with him to Mt. Clemens, Chicago, and throughout the West.

HOME OF A PRIEST WRECKED BY BOMB

Attack on House and Sunday School Follows Black Hand Trouble.

NEWARK, N. J., June 20.—A dynamite bomb which was placed at the door of St. Rocco's Sunday School early this morning practically destroyed the building.

This followed Black Hand letters that have been received by the pastor, the Rev. Father James Zuccarelli, and it is thought the bomb was exploded in an effort to assassinate him, as he was shot at recently in the street.

The Sunday School adjoins St. Rocco's Church. It is a two-story brick building, the upper floor being occupied as a rectory. Until a few days ago Father Zuccarelli slept in a room on the upper floor facing the street, but with the advent of the warm weather he moved to a room in the rear.

At 3 o'clock this morning he was hurled from his bed by a crash that rocked the building. He hastened downstairs and found the front wall torn out and nearly every window in the place broken. When the police arrived they discovered that two bombs had been placed at the door, but that only one had exploded. The fuse of the other had gone out. It was found to be made of dynamite placed in a tin can. No arrests have yet been made.

Father Zuccarelli has been having trouble with his brother-in-law, Salvatore Musumesce, for some time. Recently Musumesce fired three shots at the priest in the street, but his aim was bad and he missed. He was arrested and found guilty and is now waiting sentence.

Musumesce is an undertaker and lived adjoining the church on the opposite side from the Sunday school. He did not get along with the priest, and when he was arrested in connection with some Black Hand outrages in the vicinity of the church, Father Zuccarelli was called as a witness.

While the priest was on the stand Musumesce cried, "He is an assassin." Father Zuccarelli began suit for slander and the following day Musumesce saw him on the street near the church, whipped out a revolver and shot three times without effect.

JURY STILL FIGHTING OVER CALHOUN'S CASE

Crowds Throng Sidewalks Throughout Night Watchi...

CROWDS AWAIT WORD FROM BALLOON TOUR

Although the entire apartment reeked, the odor was strongest in the bedroom. He separated the heavy bed curtains, expecting to come upon a body, but instead all he saw was sheets in disarray and three articles of ladies' lingerie and a pair of black stockings partially concealed under a pillow. When he looked under the bed, he found an old battered trunk secured with rope. The motion of pulling the chest out from underneath disturbed the contents enough to confirm that it contained human remains. Van Wagner severed the rope and broke the lock. The lid flew up, revealing a naked, trussed, severely decomposed corpse of indeterminate sex, partially covered by a thick wool Army blanket, sprinkled with lime.

The law required Van Wagner to wait until the coroner examined the corpse before he could proceed with his end of the investigation. The coroner determined that the victim was a woman and the cause of death appeared to be strangulation. After the coroner left, Van Wagner conducted his own search of the body and recovered a small, gold, heart-shaped locket that had become deeply embedded in the woman's rotting bosom. It was etched with the initials "EJS," and it provided him with the first clue as to the victim's identity.

Other detectives began to question the restaurant staff, but none of them spoke English. The police brought in a Chinese translator from Columbia University. As Van Wagner listened to the interrogations, he got the distinct impression that the Chinese men knew more than they were telling. He telephoned Police Headquarters, hoping that someone might have reported the dead girl missing. As luck would have it, the detective on duty informed him that a man named Paul Sigel, son of famed Civil War general Franz Sigel, had contacted him earlier that evening seeking advice on how to handle a delicate family matter.

According to the detective, Sigel and his wife worked as Christian missionaries in Chinatown and had always encouraged their daughter Elsie to take part in their crusade. Mr. Sigel now feared that Elsie had eloped with a Chinese man and headed south. Shortly after she disappeared, he received a telegram from her that she was in Washington, D.C., and would return on June 12. A week had passed since that date, but Mr. Sigel did not want to officially report Elsie missing, because of the scandal that the mixed marriage would cause to his family's reputation. He only wanted to know whom he could contact in the nation's capital for help in locating his daughter.

This new information, combined with initials on the locket that matched the name Elsie Sigel, gave Van Wagner a pretty good idea who the victim was. He rushed to the Sigel home. After some cajoling on his part, the husband and wife reluctantly added to what he already knew. They said that Elsie had fallen in love against their wishes with William L. Ling, a young Chinese-American whom they were trying to convert to Christianity. While they refused to believe their daughter was the murder victim Van Wagner found, they confirmed that Ling lived at the address with another Chinese man they knew as Chang Sing. The next morning, the embarrassing scandal the Sigels had hoped to avoid became front-page news.

The police caught a break several days later when Ling's roommate turned up working as a cook in upstate New York. According to Sing, Elsie Sigel was a frequent visitor to their apartment and was friendly with other Chinese men as well. On June 9, he was awakened by a commotion in Ling's bedroom and peeked through the keyhole. He saw his roommate choking Elsie with a stocking, but instead of stopping him, he panicked and fled the apartment. Later Ling asked him to help get rid of Elsie's body. Van Wagner was able to confirm that the body had made it as far as Newark, New Jersey, before the two men returned it to their flat. He also verified that Ling had bought the six padlocks and that Ling had been the man who sent the telegram from Washington, D.C., but he could not discover Ling's whereabouts. He became convinced that the Chinese tong had helped Ling escape.

In January 1910, a new administration took charge of the Police Department. It wanted to distance itself from the embarrassing episode and let the matter quietly fade away without ever making William Ling answer for his crime. As for Detective Van Wagner, he eventually got promoted to captain, but he was forever haunted by the case.

Joseph Faurot, an early proponent of using fingerprint evidence, obtained the first conviction with this evidence alone in the United States.

FINGERPRINTS— JOSEPH FAUROT AND THE CONVICTION OF CAESAR CELLA, 1911

At the turn of the century, the idea that fingerprints could positively identify a criminal was considered a novelty in America, until one New York cop proved otherwise. When William McAdoo became police commissioner in 1904, one of his goals was to improve the department through the use of science. He believed the task could be best accomplished by sending officers to study the scientific police methods used by the largest departments in Europe. With that in mind, Detective Sergeant Joseph Faurot was dispatched to London to work with inspectors assigned to Scotland Yard, where the use of fingerprints as a means of identification was just coming into vogue. He grasped their significance immediately, but by the time he returned to New York, McAdoo had been replaced by a new police commissioner who called fingerprints nonsense. He told Faurot to forget about it.

Despite the order, Faurot remained convinced that fingerprints were far superior to the Bertillon method of criminal identification being utilized at the time. Over the next several years he fingerprinted every suspect he arrested and kept them in his own personal file. His diligence finally paid off in 1911. He arrested a well-known burglar by the name of Caesar Cella after lifting a set of fingerprints from a windowpane at the scene of the crime and determined that they belonged to Cella. During Cella's trial, Faurot tried to explain the scientific theory behind fingerprints, but the judge was skeptical. He called Faurot into his chamber while fifteen individuals in the courtroom were fingerprinted. One of them then touched a small pane of glass which the judge handed to Faurot along with instructions to identify whose fingerprints were on the glass. It took Faurot six minutes to come up with the correct answer and for Cella to suffer the indignity of becoming the first criminal in America to be convicted of a crime based solely on fingerprint evidence.

A sample of an NYPD fingerprint card.

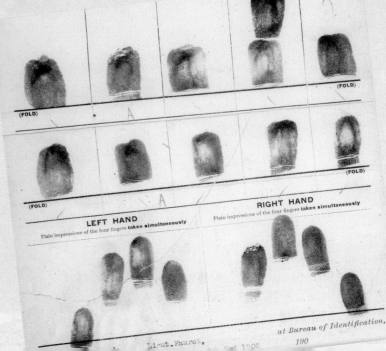

(FOLD) (FOLD) (FOLD) (FOLD)

LEFT HAND
Plain impressions of the four fingers taken simultaneously

RIGHT HAND
Plain impressions of the four fingers taken simultaneously

Lieut. Faurot, at Bureau of Identification,
 190

eno Montani, a thirty-year-old Italian immigrant, made a living driving a motorized taxicab around Manhattan. One of his steady customers was the East River National Bank, located at Third Street and Broadway. Several times a week the branch manager hired him to ferry unarmed messengers to the Financial District to deposit or withdraw large sums of cash from other banking institutions.

On Thursday morning, February 15, 1912, Montani said he chauffeured two messengers to the Produce Exchange National Bank in Lower Manhattan. The messengers withdrew $25,000, secured the money in a brown leather bag, and climbed back into the back of the taxicab. Montani drove north under the elevated train on Trinity Place as he always did. At the intersection of Rector Street and Trinity Place, a drunkard stumbled in front of the taxi. As he applied the brakes, Montani's cab was suddenly overtaken by five robbers in a well-orchestrated, perfectly timed attack. Before he knew it, two of the culprits had pulled open the passenger doors and rendered both messengers unconscious. A third bandit climbed into the front passenger seat and put a gun to his belly. "Put on the speed," he ordered. The fourth and fifth accomplices trailed the car for a short distance. Once it was apparent that their muscle was not needed, they disappeared into the crowd.

> **Three robbers bolted from the cab and into an idling getaway car, taking the $25,000 in cash with them.**

Montani continued driving toward Church Street, weaving in and out of traffic. He was too afraid to alert any of the three patrolmen he passed along the way. The gunman ordered him to stop at Park Place, where the three robbers bolted from the cab and into an idling getaway car, taking the $25,000 in cash with them.

New Yorkers were fascinated by the newspaper reports of the daring robbery pulled off in broad daylight on a crowded city street in the heart of the Financial District, below the so-called Dead Line, the boundary where crooks were forbidden by the NYPD. Second Deputy Commissioner George Dougherty, formerly of Pinkerton fame, was

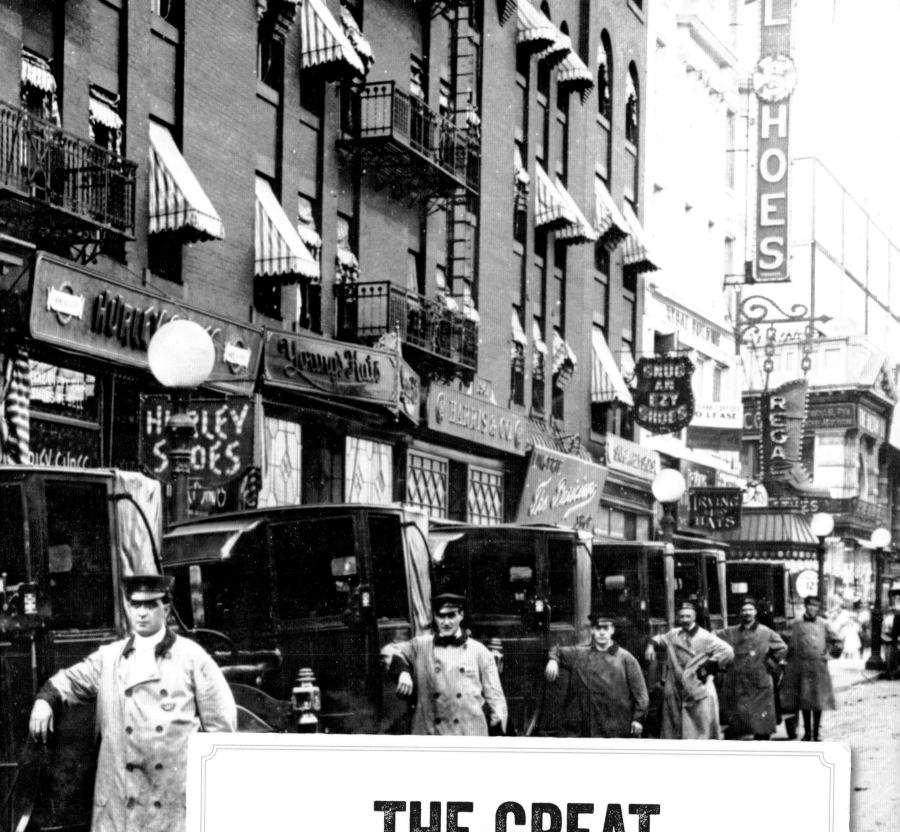

THE GREAT TAXICAB ROBBERY

Year 1912

Most of the loot was never recovered, and one of the bandits became a victim of robbery himself when a prostitute rolled him.

not nearly as enthralled. He was in charge of the NYPD's five-hundred-man detective branch, and he intended to capture the perpetrators before a spate of copycats utilizing getaway cars became a common occurrence. Dougherty knew that the police would have a tough time catching such robbers, because the department only had six automobiles in its entire fleet.

Sixty detectives were dispatched to Lower Manhattan to scour the area for clues, while Dougherty personally interrogated the cabdriver. Although Montani was very cooperative, eyewitnesses failed to corroborate his claim that a drunkard had caused him to slow down. Dougherty became convinced that Montani was involved, but he had no way to prove it. Without evidence, the courts forced him to set the cabbie free.

Fortunately, Dougherty came to the department with a reliable stable of informants he had developed during his Pinkerton days. The next day a stool pigeon contacted him with information about an acquaintance he knew as Eddie Collins. The informant said that Collins had stopped by his boardinghouse to pick up another resident whom

he identified as Collins's sweetheart, Annie Hull, aka "Swede Annie." He also saw Collins flash a large wad of cash to impress her.

Police distributed photographs of "Swede Annie" and her boyfriend, whose real name was Eddie Kinsman, among railroad workers on the theory that they had already fled the city. A conductor recalled having seen the couple board a train in Peekskill bound for Albany. Dougherty sent detectives to the state capital to make inquiries.

Soon afterward the police caught a second break when they talked to Swede Annie's landlady and learned that Hull had her belongings transferred to another boardinghouse on the West Side shortly before she checked out. Dougherty arranged for forty-seven-year-old police matron Isabella Goodwin to go undercover as a maid in the boardinghouse. Eight days later, Annie checked in. Over the next several days Goodwin worked to gain her confidence. She also kept her ear on the door to the room that Annie shared with another moll. Meanwhile Dougherty's men followed leads that took them to Boston, Chicago, and Memphis.

On February 25, Goodwin notified Dougherty that Annie confided that her lover had returned to take her away for good. Police tailed Kinsman and Annie to Grand Central Terminal and placed them under arrest just as they were boarding a train for Boston. The tailor's label in Kinsman's fancy new suit proved that he had been in Chicago, just as the police suspected, and that he had also purchased an expensive new hat for Annie while in Albany. When presented with the evidence, Kinsman confessed that he split the take with his accomplices and implicated Montani. He said that the man who allegedly stumbled in front of Montani's cab never made it off the curb, but Montani stopped anyway and allowed the bandits to

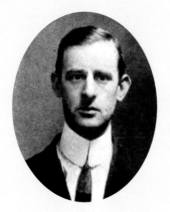 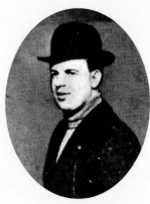 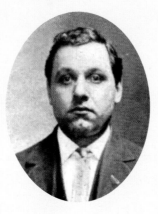 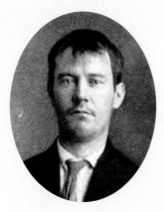

The participants of the taxicab robbery: Gene Splaine, Eddie Kinsman, Geno Montani, Joseph Lamb, and John Molloy.

board. Kinsman was disappointed that they only got away with $25,000, because Montani had assured him that there would be more money. Most of the loot was never recovered, and one of the bandits became a victim of robbery himself when a prostitute rolled him. Kinsman and his cohorts pled guilty in exchange for leniency. Montani, however, insisted that he was innocent. Exactly one month and a day after the bank heist took place, Judge Samuel Seabury, who would one day take down Mayor Jimmy Walker, sentenced Montani to eighteen years in jail after the jury found him guilty.

Before returning to the private eye business, Commissioner Dougherty rewarded Goodwin with a detective's shield and a fifteen-hundred-dollar raise, a far cry from the six dollars a week she was being paid to impersonate a maid. As for her heroics, she said, "It never occurred to me that my life was in danger. There was a job to do."

Second Deputy
George Dougherty

THE FIRST MUNICIPAL WOMAN DETECTIVE IN THE WORLD

Commissioner Waldo Rewards Mrs. Isabella Goodwin with a First Grade Position in Recognition of Her Work in the Famous Robbery Case Below the "Dead Line"---The First of Her Sex to Win Such a Rank.

A QUIET, medium-sized, unassuming woman, dressed neatly in black, sat in her apartment on the top floor of a very unassuming apartment house in the heart of Greenwich Village, and in an unassuming but impressive manner told a tale of detective work that was as thrilling as anything in fiction.

It was the tale that gripped the country within the past week—about this woman's share in the running down of the men concerned in the Trinity Place taxicab robbery, wherein desperate criminals got clean away with $25,000 after beating two clerks into insensibility—all at midday in a thickly populated section of downtown New York.

It has been a long time since such an absorbing crime story was unfolded at Police Headquarters, and because the inevitable woman was concerned not only in the robbery but in the detective work that swiftly followed, the case immediately became unique in police annals.

Mrs. Isabella Goodwin is the unassuming woman detective, and it was not easy to get her to talk at all about her share in the work that was done, and then only after Police Commissioner Waldo and First Deputy Commissioner Dougherty had given her liberty to talk.

Commissioner Waldo has a theory that it interferes with the effectiveness of a detective to have too much publicity thrown about his or her work, for detectives, like criminals, accomplish most in the dark. In Mrs. Goodwin's case, however, he decided that she had fully earned the gratitude of the public, and that the public was entitled to a glimpse

evidence which resulted in the arrest of Cole, the Christian Scientist, and only last Thursday, after she had played her part in the bringing to justice of the taxicab bandits, she was the star witness in the court proceedings against Cole.

"I have already said more than I intended to about the robbery case," said Mrs. Goodwin to a Times reporter, "and I would rather talk about the other things I have been concerned in. Of course the work I have done before this robbery occurred has had no such spectacular results, but it will give a better idea of what kind of training I have had to go through to make me capable of the more responsible work.

"To begin at the beginning, I think I

struck by the article, and said to me:

"'I believe that fellow is a faker. Go up and look him over.'

"I went, and, sure enough, he had an elaborate fortune telling establishment and was proficient in all the various 'stunts.' He told me the most ridiculous things about myself, not one of which was true, and I admitted that he was ____ sincerity that

do was to tell that experience in court and the man was convicted.

"The fortune tellers have a simple way of getting their victims to come to them again and again.

"Many women who think their husbands are not faithful go to these fakers for advice. The faker quickly diagnoses the case and hazards the information that the victim has had a quarrel with

course, a woman detective must be shrewd and quick in expedients. She must seize any little advantage rapidly and turn it to her account. More valuable than all is the quality of intuition, the ability to 'feel' or sense things for which at first you have no actual proof. I think that the reason why a woman sometimes succeeds where a man fails is because she is more strongly endowed with this intuition.

"She must also be a good mixer and be able to make acquaintances easily among all classes. She must also have plenty of self-control and courage, and finally she must have perseverance, the trick of never giving up once the trail is started. I suppose this could be called patience, and it takes experience to develop that trait in the right way. The long, hard schooling I received in my work of detecting fortune tellers and fake healers served me in good stead in the taxicab robbers.

"One morning Commissioner Dougherty sent for me and outlined what he wanted me to do. The Commissioner thought the thing all out, and told me just what I would have to do. Would I take the chance? Well, rather! I don't think I hesitated a moment, for a detective whose heart is in the work must take things as they come.

"I never dreamed there would be any notoriety in it, and I went to work merely out of a sense of duty. My home life is so managed that I can leave at a moment's notice and stay away as long as necessary. I had to live in a low dive for I didn't know how long, and I made up as a servant of all work and applied for the place.

"I haggled over the wages just to show that I wasn't too eager for the job, and accepted it at $6 a week. I wore a plain, dark, rather shabby suit, old hat and shoes, so that I wouldn't look too neat, and then I simulated the walk or ____ of one who was not used

nie would tell me things. In her trouble Myrtle Hoyt would do the same, so I soon became possessed of interesting secrets.

"Of course I had to listen at keyholes and manufacture excuses to get into the room where the women were entertaining their men friends. I picked up many significant bits of conversation in this way. One night after I had been listening at the keyhole of the women's room for hours I heard Swede Annie say: 'Well, Eddie the Boob turned the trick, all right.' That was the turning point in the work, and I redoubled my efforts.

"There were three days in which I did not have eight hours' sleep. Swede Annie and Myrtle Hoyt seldom came in before 3 or 4 o'clock in the morning, and then they were intoxicated. I had to listen to a great deal of disgusting conversation and see sights that were revolting, but I stuck to it with grim determination. I drank coffee to keep awake, but the sleeplessness almost drove me crazy. What with hard manual labor all day and sitting up all night, I felt pretty well tuckered out before the week was up.

"Early one morning I got into Swede Annie's room and discovered that she had returned from Albany with a new hat and suit. I got the names of the dealers and telephoned these facts to the Commissioner, who ascertained in Albany that the purchase had been made with five-dollar bills by a man of Edward Kinsman's description. Then I learned enough to make certain that Kinsman was one of the robbers. I knew when Kinsman returned and learned of his plan to take Swede Annie to San Francisco last Monday. Last Sunday night I was able to give this information to the Commissioner over the telephone.

"My hardest work was to slip out and telephone what progress I was making to Deputy Commissioner Dougherty. I must have spent an entire sleepless night ____ ____ I was always there

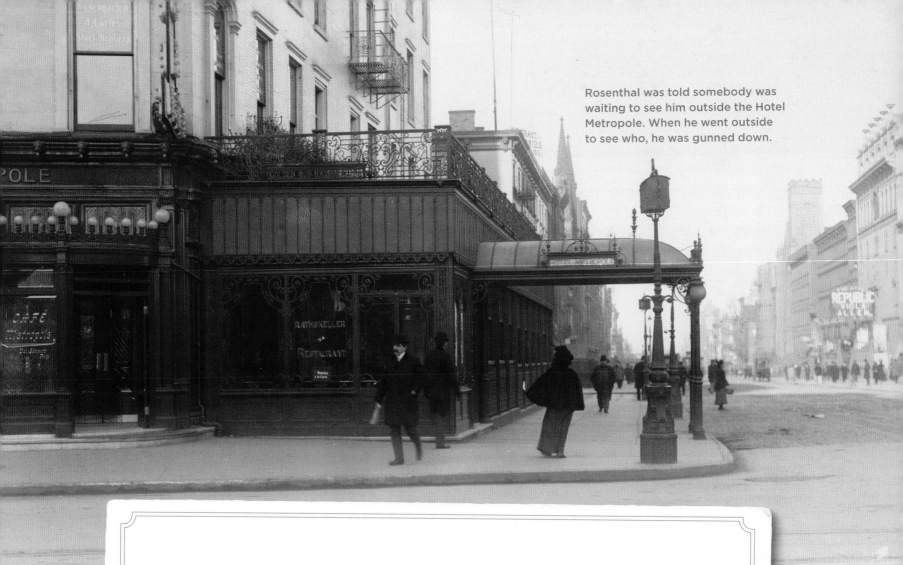

Rosenthal was told somebody was waiting to see him outside the Hotel Metropole. When he went outside to see who, he was gunned down.

LIEUTENANT CHARLES BECKER GETS THE CHAIR

Year 1912

"The old Metropole," brooded Mr. Wolfsheim gloomily. "Filled with faces dead and gone. Filled with friends gone now forever. I can't forget so long as I live the night they shot Rosy Rosenthal there."

—GAMBLER MEYER WOLFSHEIM,
REMINISCING IN F. SCOTT FITZGERALD'S NOVEL THE GREAT GATSBY

Early Tuesday morning, July 16, 1912, New York City was sweating through a brutal heat wave. Gambler Herman "Beansie" Rosenthal was spending his last earthly moments in the Hotel Metropole, a popular gathering spot for the sporting set, at 143 West Forty-Third Street. He was nursing his beverage of choice: a horse's neck—cold ginger ale with a lemon twist. The next day he was scheduled to appear before a grand jury to tell all he knew about the illegal gambling taking place in Manhattan. There were a lot of people on both sides of the law who would have preferred that Rosenthal keep his mouth shut.

Around two A.M. he was told that he was wanted outside. Rosenthal obligingly complied, striding through the lobby toward the street, where he was summoned by name. When he approached a man in the shadows, he was hit by four gunshots—one in the neck, one in the nose, and two in the head. Four gunmen sped off in a gray Packard, leaving Rosenthal to die in the sweltering street.

During the months leading up to his murder, Rosenthal's fortunes were on the downturn. The previous autumn, he borrowed $5,000 from "Big" Tim Sullivan, the powerful Tammany Hall politician who controlled gambling operations in the Tenderloin, the rough-and-tough neighborhood that had expanded to surround Times Square. At one time, Rosenthal had run the popular gaming room at Sullivan's famed Hesper Club. Rosenthal hoped to recapture his lost prestige by opening a new, luxurious casino at 104 West Forty-Fifth Street. The club, however, was shuttered just four days after it opened. Cops, under the command of Inspector Cornelius Hayes, raided the joint because, according to Rosenthal, he refused to pay the policemen the necessary tribute to stay in business.

Since nobody made money when a casino closed down, Rosenthal reluctantly reached out to Lieutenant Charles Becker. He was the commander of one of the NYPD's three Strong Arm Squads, which were special units formed by Police Commissioner Rhinelander Waldo to suppress vice in the Tenderloin. To most casual observers, Becker seemed to perform his job with great enthusiasm, but to those in the know, Becker could be bought. Rosenthal wanted to know if some arrangement could be worked out. Becker agreed, provided Rosenthal cut him in on the action.

Unfortunately, Becker could not give Rosenthal complete immunity from prosecution. When Police Commissioner Waldo gave Becker a direct order to raid Rosenthal's nightclub on April 17, 1912, he had no choice but to comply. Although Becker arranged for Rosenthal to be away from the casino, he arrested Rosenthal's teenaged nephew. The

Herman "Beansie" Rosenthal, who was killed the night he was scheduled to tell a grand jury that Lieutenant Becker had shaken him down for thousands of dollars.

nephew's subsequent indictment, and his own inability to reopen his gambling den, outraged Rosenthal. This set him and Becker on a collision course that would cost both of them their lives.

Since Becker could not, or would not, help him, Rosenthal decided to turn on him. He took his grievances to the Manhattan district attorney, Charles Whitman, a priggish prosecutor with political ambitions. At first, Whitman ignored his caterwauling until Herbert Bayard Swope, a young and ambitious newspaperman for Joseph Pulitzer's *New York World,* obtained Rosenthal's signed affidavit spelling out Becker's outsized appetite for graft.

With Rosenthal now lying on a morgue slab, Whitman was left in an unenviable quandary. Who had killed Rosenthal, and how could Whitman now prosecute Becker, a purportedly dirty cop, without a star witness?

The solution became apparent when Whitman, at Swope's urging, granted immunity to four suspects the police apprehended who admitted playing key roles in the scheme. Three of those suspects—Jack "Bald Jack Rose" Rosenzweig, Louis "Bridgey" Webber, and Harry Vallon—testified that they hired the getaway car and the shooters. They were ostensibly paid $1,000 at Becker's behest to do

> **Joseph Pulitzer's *New York World* obtained Rosenthal's signed affidavit spelling out Becker's outsized appetite for graft.**

the hit. Becker even pointed out Rosenthal in front of the Metropole for the assassins.

Bald Jack's claims were particularly devastating to Becker. He alleged that upon seeing Rosenthal's lifeless body, Becker remarked, "It was a pleasing sight to me to look and see that squealing Jew there, and if it were not for the presence of Whitman, I would have cut out his tongue and hung it up on the Times building as a warning to future squealers."

The four shooters, all members of the Lenox Avenue Gang, were not afforded any leniency by Whitman. Harry "Gyp the Blood" Horowitz, Louis "Lefty Louie" Rosenberg, Francisco "Dago Frank" Cirofici, and Jacob "Whitey Lewis" Seidenshiner were convicted and subsequently electrocuted on April 13, 1914.

Becker was tried separately. Although he did not testify on his own behalf, much was made by the prosecution of the fact that he had deposited nearly $30,000 in several different banks during the months leading up to Rosenthal's murder. His various convoluted explanations about how he accumulated so much money in such a short period of time (on a salary of $2,000 a year) only made him seem more dishonest. He was found guilty and sentenced to die. However, a scathing Court of Appeals ruling in February 1914 tossed out the verdict and ordered a new trial on the grounds that Judge John W. Goff had been biased against him and his defense team.

A new judge, the esteemed Samuel Seabury, presided over a retrial that ended with the same results. Becker was again found guilty and sentenced to death. This time, the courts declined to intervene.

While waiting for his appointment with death in Sing Sing's bleak "Death House," Becker became friendly with a fellow death row inmate as notorious as himself, Father Hans Schmidt, the only Catholic priest in America ever to be sentenced to death.

Becker insisted he was innocent until the very end. "I am not guilty by deed, or conspiracy, or any other way, of the death of Rosenthal," Becker announced, as he prepared to die. Becker's third wife, the former Helen Lynch, a public school teacher, had petitioned the governor to spare her husband's life. Unfortunately for her, the newly elected governor was none other than Charles Whitman, the very same prosecutor who had twice convicted Becker. His

> "I would have cut out his tongue and hung it up on the Times building as a warning to future squealers."

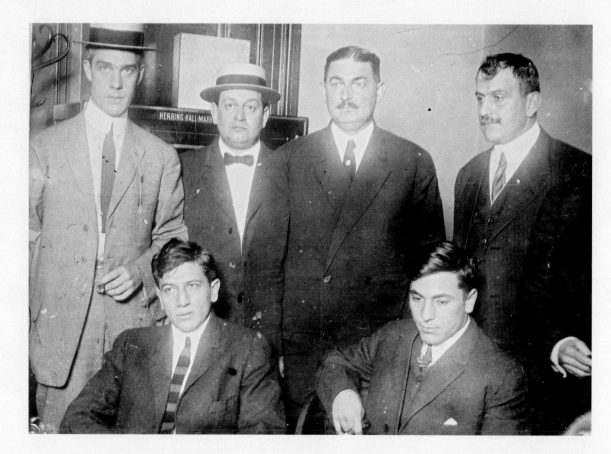

Second Deputy George Dougherty standing behind suspects Louis "Lefty Louie" Rosenberg and Harry "Gyp the Blood" Horowitz, two of the four hit men who carried out the Rosenthal assassination. Like Lieutenant Becker, they also received the death penalty.

sentence was carried out in what witnesses described as a "botched" electrocution because it required more than eight agonizing minutes for Becker to die.

In response, Mrs. Becker became so outraged, she arranged to have a silver plate engraved with the inscription affixed to her husband's coffin. It read, "Charles Becker. Murdered July 30, 1915. By Governor Whitman." It was only after the threat of arrest for criminal libel that the plate was removed prior to Becker's burial at Woodlawn Cemetery in the Bronx.

Several authors have argued how Becker was likely innocent and was framed with manufactured evidence by the opportunists Swope and Whitman. Rosenthal's obstreperousness made him a tempting target, not only for Becker but for other corrupt cops and unsavory gamblers, many of whom were incensed he would take a private spat public, as well as the politicians they paid off to stay in business.

Charles Becker's mugshot from Sing Sing prison.

Lieutenant Charles Becker talking to reporters while being escorted to Sing Sing prison. Some people still believe he may have been framed.

THE BROOKLYN DAILY EAGLE

Complete Stock Market

Volume 73
No. 200

NEW YORK CITY, MONDAY, JULY 21, 1913. ★ 20 PAGES THREE CENTS.

QUIET PUZ...

...DENT

an Ap-
...Mexi-
...ch

...R-NAVY.

Why is Arma...
popular as a s'...
Too lonesome?

ROOSEVELT
OPPOS...

Put Himself on Record Against
Renomination of Mayor
...

...CHURCH ROBBERS
...POLICEMAN

...ahill Murdered at
...atthews Vestry
Door.

HORRIBLY OUT

...Life to Save Church
...ments—Assassins Use
Knife and Gun.

...EW TO ASSAILANTS.

...Fight Attracts No Atten-
tion in Early Morning—Body Dis-

THE STRANGE DEATH OF PATROLMAN JOHN CAHILL

Year 1913

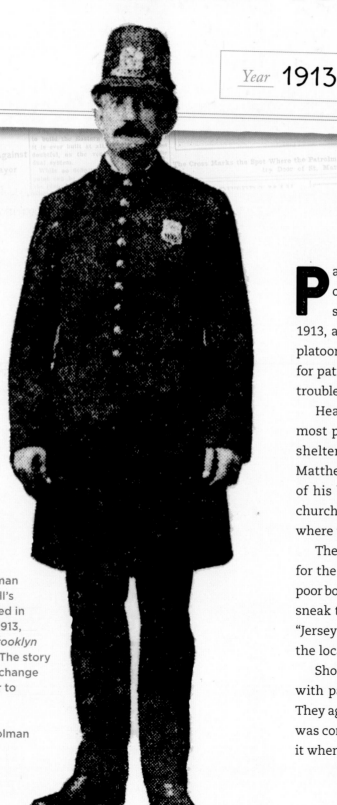

The Cross Marks the Spot Where the Patrolman's Mutilated Body Was Found. In the Background Is the Ves-
try Door of St. Matthew's Church, Jimmied by the Murderers.

TOP: Patrolman John F. Cahill's death detailed in the July 21, 1913, edition of *Brooklyn Daily Eagle*. The story would soon change from murder to suicide.

RIGHT: Patrolman John Cahill.

Patrolman John Cahill, forty-one years old, turned out of the old 152nd Precinct on Atlantic Avenue stationhouse in Brooklyn Monday night, July 21, 1913, along with twenty other members of the midnight platoon. Between them, the officers would be responsible for patrolling thirty-nine miles of linear foot posts in the troubled neighborhood of Crown Heights.

Heavy rain was predicted overnight, which meant most patrolmen would be on the lookout for a place to shelter. Cahill planned to pay special attention to St. Matthew's Roman Catholic Church near the southern end of his beat on Utica Avenue. There had been a rash of church burglaries in the area that included St. Matthew's, where three silver candlesticks were stolen.

The coming rain would provide a perfect opportunity for the robbers to break in again and steal cash from the poor box. Cahill was more than up to the task of dealing with sneak thieves. His quick fists earned him the nicknames "Jersey Lightning" and the "Terror of Chicago Row" from the local troublemakers.

Shortly after two in the morning Cahill rendezvoused with patrolman Walter Raleigh from an adjoining post. They agreed to meet again at four A.M. But by then the rain was coming down so hard that Raleigh thought nothing of it when Cahill did not show.

Meanwhile, several blocks away, Alice Shuldham's night had been racked with labor pains. She clambered out of bed at sunrise and shuffled over to the kitchen window to check on the weather. The rain had stopped and the skies were brightening, a good omen for the baby's impending birth.

From her vantage point on the fifth floor she had a clear view of St. Matthew's rear courtyard five hundred feet away. She woke her husband and told him that it looked like someone was lying down by the church gate to the rear entrance.

Mr. Shuldham went out to investigate. He was surprised to discover Patrolman Cahill, dead with a bullet to the head. He hurried to the rectory and alerted Father John O'Hara. Within an hour, sixty detectives under the direction of Second Deputy Commissioner George Dougherty were combing the neighborhood for clues. Despite the shock, Mrs. Shuldham delivered a healthy baby girl at ten o'clock that morning.

Initially, investigators believed that Cahill had died after interrupting thieves trying to break through the courtyard gate in order to get into the church. There were indications a fierce struggle had taken place. Detectives recovered the revolver believed to be responsible for the fatal shot; a sharp modified Bowie knife that ripped through his uniform shirt and pants, causing wounds to his chest and left leg, and a crowbar used without success to pry open the sturdy wooden gate. Cahill's own pistol was still tucked in his pants pocket. Dougherty fixed the time of death at 3:01 A.M., based on an earwitness account.

The police chaplain broke the news to Cahill's widow and five children, who had been away vacationing at a relative's farm in Hempstead, Long Island. "It was just like Johnny not to flinch when beset by a terrible danger, and I know he died bravely," she sobbed. Fortunately, Cahill had the foresight to purchase several life insurance policies with the various police benevolent associations. Upon his death his wife would receive $2,150, more than enough to satisfy the mortgage on a four-acre farm he recently purchased for her in Staten Island.

Police soon had a twenty-two-year-old Italian in custody, James Sarli. He was a well-known hoodlum in Crown Heights, but the only charge that stuck was carrying a concealed weapon in violation of the Sullivan Law.

Two days after his murder, Police Commissioner Waldo ordered all department flags to be flown at half-staff. Patrolman Cahill received the largest funeral accorded to a New York City patrolman to that date, complete with an honor guard and a long procession of officers led by the Police Band. The pastor of St. Peter's Lutheran Church in Ridgewood reminded the mourners that when they were asleep at the night, it was brave policemen like John Cahill who were awake protecting them.

But just two days later, Deputy Commissioner Dougherty, who paid tribute to Cahill's bravery at his funeral, abruptly closed the investigation. He insisted that Patrolman Cahill had not died a heroic death at all, but had staged his death to seem heroic while actually committing suicide.

He was surprised to discover Patrolman Cahill, dead with a bullet to the head.

The officer's friends and family refused to believe him. Cahill's widow said, "There is absolutely no reason why my husband should shoot himself."

But Dougherty countered, "The looks of things and the actual facts are two different propositions." He said that he had uncovered ample evidence to make his case. Cahill had borrowed the gun found at the scene from his wife's cousin on Long Island the day before he killed himself. Cahill claimed that his own revolver was defective, but ballistics tests indicated the gun was in perfect working order. He also asked a fellow cop to borrow bullets for the gun, which were positively identified by a black band on the shell casings. Some days before he died, Cahill had asked a friend if he could use his grinding wheel, presumably to sharpen the knife that he used to inflict his superficial wounds. The crowbar found at the scene had been taken from the precinct where it was being stored as arrest evidence.

According to Dougherty, Cahill went into the courtyard and scratched the gate with the jimmy to make it appear burglars were attempting to gain entry. Then he used the knife to cut himself before putting the gun to his head and pulling the trigger. The one thing missing from Dougherty's theory was a clear motive. For that he blamed Cahill's mental state on a combination of three different things: The debt Cahill incurred buying the farm could be paid only if his wife collected his life insurance money. He was afraid he would be tried for perjury related to his recent arrest of a young, innocent boy and lose his job. He was also deeply remorseful because he had left the Catholic faith to join the Lutheran church.

POLICEMAN JOHN F. CAHILL AND THE SCENE OF HIS MURDER.

The Cross Marks the Spot Where the Patrolman's Mutilated Body Was Found. In the Background Is the Vestry Door of St. Matthew's Church. Jimmied by the Murderers.

But Mrs. Cahill stated that her husband was a right-minded man, and she implored District Attorney James Cropsey to look into the matter after a jury heard testimony from eighteen witnesses at the coroner's inquest. He concluded that despite what Dougherty had said, Cahill could not have committed suicide because he was right-handed and the gun used to kill him was found on the left side of his body. As a result Dougherty was forced to continue looking for Cahill's killer, but in reality his mind was already made up. For all intents and purposes, no further work on the case was ever done by the Police Department. And Patrolman Cahill's name has never been listed with the hundreds of other NYPD officers who have made the ultimate sacrifice.

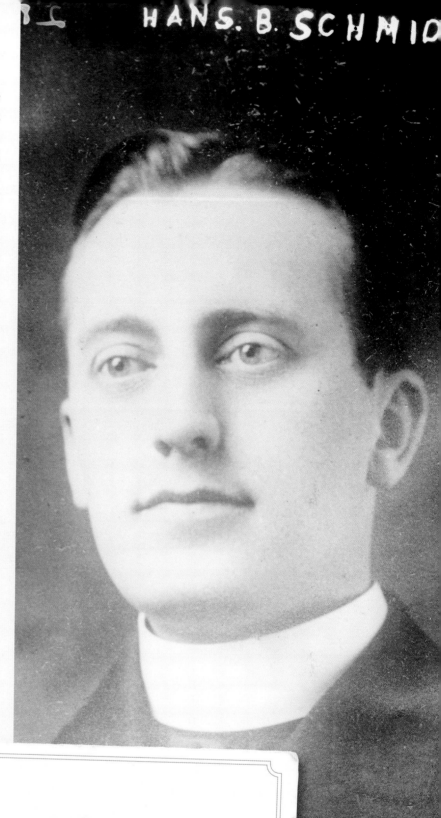

On Friday afternoon, September 5, 1913, across the Hudson River from Morningside Heights in Manhattan, three children from Cliffside Park, New Jersey, were swimming off a dock. Eleven-year-old Mary Bann noticed what appeared to be a brown-colored bundle bobbing in the water between the pilings. Curiosity got the better of her, and with help from her little brother and her girlfriend, she managed to drag the waterlogged parcel onto shore. Upon closer inspection they saw that the bundle was secured with baling wire, and under the sodden brown paper was a blue bedsheet. To find out what was inside, they pulled the wire off. Mary grabbed one end of the linen and tugged to release the contents. To their shock, the upper half of a female torso, naked, gray, and pasty, and without arms, legs, or head, tumbled out of a pillowcase along with some rocks and waterlogged pages of newspaper. The children stood motionless for a moment before running off screaming for help.

> **To their shock, the upper half of a female torso, naked, gray, and pasty, and without arms, legs, or head, tumbled out of a pillowcase**

The Hudson County Police responded to the scene. As the officers examined the grisly remains, they traded theories on what might have

Father Hans Schmidt, the only Catholic priest sentenced to death in the United States, befriended Lieutenant Charles Becker while they were incarcerated in the Sing Sing prison death house.

THE DEADLY SINS OF FATHER HANS SCHMIDT

Year 1913

happened to the woman. It was true that swimmers occasionally got decapitated by the gigantic propellers of ocean liners, but they never washed ashore trussed in bedsheets. No, it was evident that this woman's body had been skillfully cut in half and dumped into the river. The rocks had been meant to keep her submerged.

Why she was killed they had no idea. Who she was, given her condition, would be hard to determine. But there were clues. The newspaper was legible enough for the police to make out the date, August 31. Then there was the bloodstained linen and pillowcase that still had the manufacturer's label attached: "Robinson-Broder Company, Newark, New Jersey." Unfortunately, they assumed, the company sold thousands of pillowcases each year.

Two days later and two miles south of where the woman's torso had washed up, two fishermen, Joseph Hagmann and Michael Parkman, rowed out into the Hudson River to retrieve the crab traps that they had set along the piers the day before. It was a good morning for crabbing and, as it turned out, for finding human body parts.

The coroner determined that the lower portion of the torso the fishermen discovered and the upper section the children recovered came from the same woman. In fact the two body parts fit together so perfectly that the medical examiner declared it one of the neatest pieces of surgical work he had seen in years. A leg belonging to the same body and a nightgown with pronounced bloodstains around the collar were found in the river on September 10. By then the Hudson County Police had been in contact with a representative from Robinson-Broder and were informed that twelve pillowcases similar to the one recovered had been sold to a retailer in New York. Since it was possible that the victim had been killed in New York and dumped into the Hudson River, New Jersey authorities alerted the NYPD.

Inspector Joseph Faurot, chief of detectives for Manhattan, took charge of the case. Faurot had joined the department in 1896 and made a name for himself early on as a proponent in the use of fingerprints as a form of identification. In this instance, however, his area of expertise would be of little value, as neither hand had been recovered.

Fortunately Faurot was also a skilled investigator. He directed two of his detectives to pay a visit to George Sachs, the furniture store owner who bought linen from

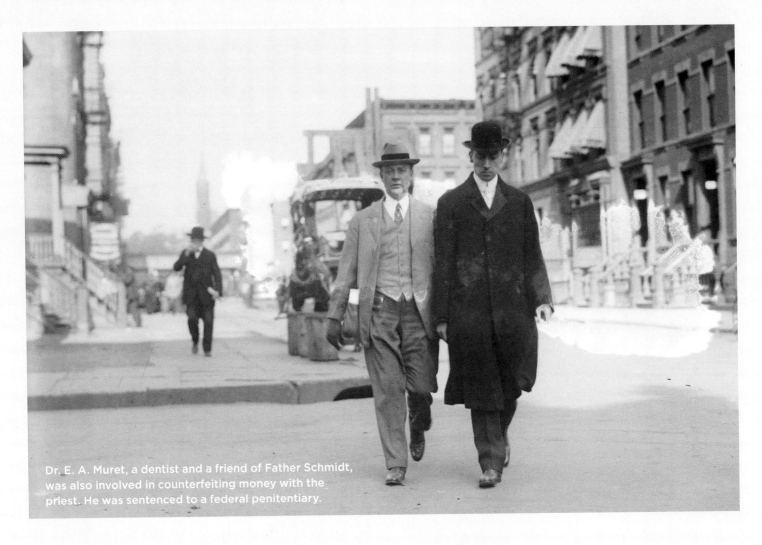

Dr. E. A. Muret, a dentist and a friend of Father Schmidt, was also involved in counterfeiting money with the priest. He was sentenced to a federal penitentiary.

the Robinson-Broder Company. Mr. Sachs recalled having sold a pair of pillowcases two weeks before, along with a secondhand mattress and bedspring, to a Mr. A. Van Dyke. They were delivered to 68 Bradhurst Avenue in Harlem. The detectives hurried to the address and talked to the superintendent of the building, Carlton Booker. Mr. Booker told them a married couple rented the vacant third-floor apartment on August 26 and that the husband paid for it in cash, nineteen dollars. The new tenant called himself H. Schmidt. The detectives knocked on the door, but there was no answer.

Anna Aumuller met Father Hans Schmidt when he worked at St. Boniface Church on 47th Street in Manhattan. He told detectives, "I was in love with the girl, and I wanted her to go to heaven. It was necessary to make a sacrifice, and the sacrifice had to be consummated in blood."

The apartment was vacant, but there were bloodstains everywhere.

When informed of the development, Faurot ordered a stakeout of the apartment, but after three days of inactivity, he decided to wait no longer. Accompanied by an officer from Hudson County, his men climbed the backyard fire escape and pried open the rear window. They let Faurot in through the front door. The apartment was vacant, but there were bloodstains everywhere—on a knife, a saw, the area rug, the wood floor, the bathroom tile, and the iron bed frame. There was also evidence that the killer had tried to mop up the blood.

Although the mattress was missing, the receipt for delivery was on top of the icebox. Detectives found a half spool of baling wire, the same kind used to tie up the floating bundles. Among the clothes still hanging in the closet was a man's overcoat that had the name A. Van Dyke stitched into the lining. But the most important lead came when detectives recovered a metal box atop a small chest in the closet. Inside were dozens of letters handwritten in German from Anna Aumuller to Hans Schmidt at St. Boniface Church.

After speaking to people in the New York area that some of the letters were addressed to, detectives learned that Anna had immigrated to the United States from Germany five years ago, when she was sixteen, to pursue a career in music. When that did not pan out, she took a job as a domestic at the rectory of St. Boniface Church on East Forty-Seventh Street and Second Avenue in Manhattan. Those who knew her well described her as popular and pretty, a girl who had little trouble attracting young men.

Faurot paid a visit to St. Boniface and found out that Anna was no longer employed by the parish. Father John Braun told him that she was particularly fond of a German-born priest who had transferred to St. Joseph's on West 125th Street little over a year ago. Although the monsignor did not think much of the priest, Anna followed him there. Braun identified the cleric as Father Hans Schmidt.

Although it was well past midnight, Inspector Faurot and Detective Frank Cassassa raced to St. Joseph's to have a talk with Father Schmidt. When they arrived it took several minutes of banging on the rectory door before Father Daniel Quinn answered. Faurot flashed his inspector's shield and explained that he was there on a serious police matter that involved Father Schmidt. Father Quinn rushed upstairs to wake him.

A few minutes later Schmidt appeared in Father Quinn's office wearing his cassock and collar. He was a handsome man, thirty-two years old. Faurot showed him a photograph of Anna Aumuller. For the next thirty minutes the priest denied that he knew her, but Faurot knew otherwise. He waited for just the right moment and then accused Schmidt of killing her, even though his evidence was mainly circumstantial.

To his surprise, Schmidt broke down and began to sob. "I killed her because I loved her." Before asking for a lawyer, he admitted that he married her (after having performed the ceremony himself in February 1913) and that he was torn between his love for her and his love of the priesthood. In the end he decided that he could not be married and decided to end the unholy union by slashing Anna's throat after being commanded by God's voice.

Schmidt decided to end the unholy union by slashing Anna's throat after being commanded by God's voice.

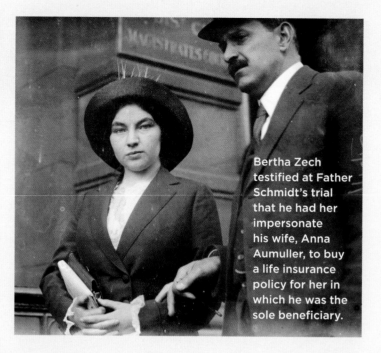

Bertha Zech testified at Father Schmidt's trial that he had her impersonate his wife, Anna Aumuller, to buy a life insurance policy for her in which he was the sole beneficiary.

Then he dismembered her and disposed of her body parts in the Hudson River.

Catholics throughout the diocese took up a collection to pay for Father Schmidt's defense. They looked upon him as a sinner more than a murderer, and therefore worthy of their pity. But as more facts came to light, they began to regret their decision.

Further investigation revealed that he stole money from the church poor box, impersonated a doctor, and ran a counterfeiting operation from an apartment he rented on St. Nicholas Avenue. The police arrested Schmidt's partner in the money scheme, a dentist named Ernest Muret, who ended up doing time in a federal penitentiary. There was even speculation that in 1909, shortly after his first posting in the United States, Schmidt had murdered a nine-year-old girl in Louisville, Kentucky, although in that case the parish janitor was convicted.

After speaking to Schmidt, his lawyers became convinced that an insanity plea was the only way to save him from the electric chair. Both the defense and the prosecution hired their own teams of alienists to examine Schmidt at length. Each side agreed that the priest was mentally unbalanced, as did a number of witnesses who told tales of his bloodlust. But in New York State, to prove insanity, a killer must not know that what he was doing was wrong at the time of commission. The prosecutor argued that Schmidt, despite his admissions about his past conduct, must have known what he did was wrong, or he would not have taken such drastic measures to dispose of Anna's body and conceal his identity. The prosecutor even pointed out that Father Schmidt said Mass the morning after the murder so as not to arouse suspicion.

The first trial in December 1913 resulted in a hung jury: ten in favor of guilt, two who held out, believing he was insane. The second trial took place just a month later, and the testimony was almost identical in nature, except for the introduction of a surprise witness by the prosecution, Miss Bertha Zech. She testified that she met Father Schmidt through the dentist a year ago, and that she accompanied him when he bought a $5,000 life insurance policy for Anna Aumuller, in which he was the sole beneficiary. Anna never knew about it, because Bertha forged her signature.

This time the jury took only seven hours to reach a guilty verdict. Father Schmidt was remanded to Sing Sing prison to await execution by the electric chair. While there, Schmidt tried to change his story. On appeal he said that he was not insane, but that Anna had died during a botched abortion. He claimed he covered it up only because he was a priest who should not have been involved with a woman in the first place. He insisted that he had not killed his wife and provided the name of the doctor whom he alleged performed the operation.

Although the doctor denied it, Schmidt's lawyer arranged to have Anna's body exhumed. The second postmortem indicated that Schmidt might have been telling the truth. There were indications that Anna had been pregnant, but the court ruled against him, because his statements alone did not constitute new evidence. Schmidt's last hope for a reprieve was dashed when the Manhattan district attorney who oversaw his case, Charles Whitman, was elected governor.

As he was being strapped into the electric chair shortly before dawn on February 18, 1916, Father Schmidt begged forgiveness and forgave all who offended him. He was reciting the Lord's Prayer as the state executioner turned the dial that sent 1,700 volts of electricity pulsating through his body. After the coroner confirmed Schmidt was dead, the chaplain at Sing Sing claimed his body. The burial plot of Father Schmidt, the only Catholic priest to be executed in the United States, remains a secret to this day.

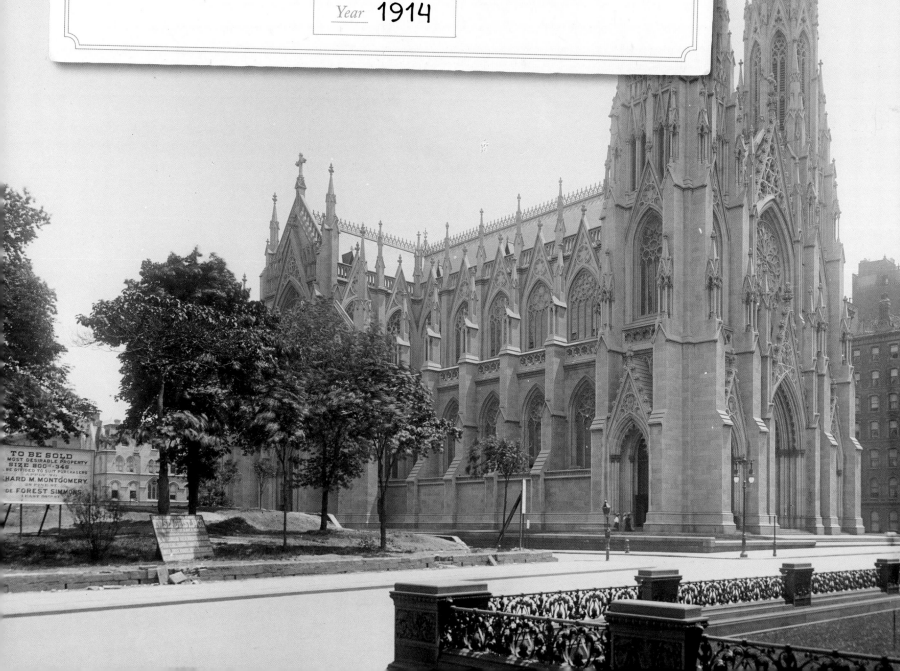

Majestic St. Patrick's Cathedral as it looked in 1914.
The twin spires appear to point to heaven.

THE ATTEMPTED BOMBING OF ST. PATRICK'S CATHEDRAL

Year 1914

The axiom "An ounce of prevention is worth a pound of cure" was never more true when considering the devastation that would have been caused if anarchists had been successful in their attempt to blow up St. Patrick's Cathedral in 1914.

Captain Thomas Tunney (cousin of future heavyweight boxing champ Gene Tunney) was placed in charge of the thirty-six-man Bomb Squad by Police Commissioner Arthur Woods. His job was to "suppress the activities of persons using explosives to destroy life and property."

> **They wanted to kill the gentry, overthrow the government, and destroy any institution that held sway in America.**

Tunney's predecessor, Lieutenant Joseph Petrosino, had lost his life in Sicily investigating the Black Hand, an early version of the Mafia that had been terrorizing Italian immigrants with homemade bombs if they refused to pay the gang for protection. A dangerous band of terrorists grew from within the ranks of the Black Hand called anarchists. These men were not satisfied with stealing money from their countrymen. They wanted to kill the gentry, overthrow the government, and destroy any institution that held sway in America. Among their favorite targets was the Catholic Church.

There was one particular faction that Tunney thought particularly dangerous: "the Circle of Brescia." The sect took its name from Gaetano Brescia, an anarchist who assassinated King Umberto I of Italy in 1900.

By 1914 police estimated membership in the Circle to be some six hundred disgruntled men and women from Italy, Russia, Germany, Austria, Spain, and the United States, along with a smattering of disaffected Jews. Their meetings took place in the rundown basement of a tenement at 310 East 106th Street in Manhattan. Tunney believed he needed inside information to accomplish his mission, but he was reluctant to rely on stool pigeons as Lieutenant Petrosino once had. He wanted to plant a cop of his own inside the Circle. His first undercover officer did not fare well. The detective spoke only English, but when important business was discussed, it was always in Italian.

On October 12, 1913, a bomb exploded in St. Patrick's Cathedral to mark the anniversary of the execution of legendary anarchist Francisco Ferrer. His death in 1909 was blamed on the Catholic Church in Spain, because it supported King Alfonzo XIII, whom Ferrer was accused of plotting to kill. There was little damage and only minor injuries, but another bomb detonated the following day outside the rectory of St. Alphonsus Church on West Broadway that blew out the windows.

Tunney decided to try another undercover. This time he selected rookie patrolman Amedeo Polignani. He was fluent in Italian and had not been on the force long enough to become engrained in its ways.

Tunney told him, "Your name from now on is Frank Baldo. You are an anarchist. Join the Brescia Circle and report

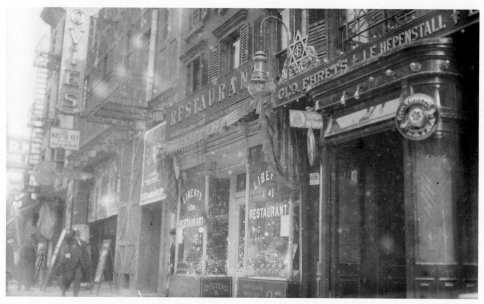

Undercover police officer Amedo Polignani rented an apartment at 1341 Third Avenue for Arbarno and Carbone to build the bombs.

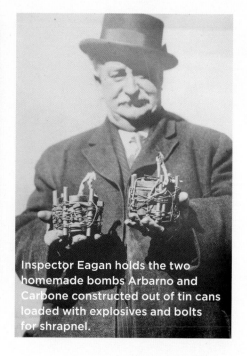

Inspector Eagan holds the two homemade bombs Arbarno and Carbone constructed out of tin cans loaded with explosives and bolts for shrapnel.

to me every day." After saying good-bye to his family in the Bronx, Polignani took a room at a boarding house on Third Avenue and 105th Street in Manhattan and got a job laboring at a factory in Long Island City. Before long he was attending meetings of the Brescia Circle, reporting everything that was said back to Tunney.

In mid-December, Polignani joined members of the Circle in a good-natured wrestling match. His police training came in handy. His swift victories caught the eye of Carmine Carbone, a man of influence within the Circle. He invited Polignani to take a walk with him. Carbone complained that his fellow members talked too much and acted too little. "What they ought to do," he said, "is throw a few bombs and show the police something." Then he raised his right hand, showing five fingers that were little more than stumps. "I got that making a bomb."

Polignani finally had a lead. Two weeks later Carbone introduced him to fellow anarchist Frank Abarno and revealed that they intended to try to blow up St. Patrick's Cathedral again. "This time it'll be a good one too, not like before." Over the next several weeks, Carbone taught Polignani everything he knew about bomb making. He even provided him with a sixty-page anarchist booklet, which Polignani passed on to Tunney to be photographed as evidence.

Carbone set March 2, 1914, as the date for the bombing. Polignani rented a room at 1341 Third Avenue in which the trio could construct a pair of bombs. The explosive material was placed inside tin cans with bolts to serve as shrapnel. Each bomb had a cloth fuse designed to burn long enough for them to escape and establish alibis.

On the morning of March 2, the trio was to meet at the rented room and retrieve the bombs, but Carbone was a no-show. Abarno decided not to wait for him. He handed one bomb to Polignani and took one himself. "Put it under your coat," Abarno said, as they began the long walk downtown, unaware that Tunney was waiting for them. A team of undercover officers disguised as scrubwomen and ushers were already waiting for them at St. Patrick's Cathedral.

As Polignani and Abarno entered the cathedral and settled into the pews, a scrubwoman rested her mop and began to dust around them, all the while keeping a careful eye on Abarno, who pretended to be praying. When Abarno got up he signaled Polignani to follow. Then he put his bomb on the floor beside a pillar and lit the fuse with the end of his cigar. As he turned to leave, the undercover scrubwoman and usher pounced on him. A second scrubwoman, Detective Patrick Walsh, pinched out the fuse, rendering the bomb useless.

Abarno immediately suspected that he had been set up by Carbone. He gave the police Carbone's address. They found Carbone at home and arrested him. Initially, both suspects exonerated Polignani until they discovered that he was an undercover officer. Then they cried "Frame-up!" Fellow anarchists formed a committee to solicit funds for their defense. Lawyers did their best to rattle Polignani on the witness stand, but in the end, both men were declared guilty and sentenced to jail for their conspiring to blow up the cathedral.

Shortly thereafter, the Brescia Circle disbanded. As for Patrolman Polignani, he was promoted to detective sergeant and enjoyed a long, successful career in the NYPD.

On February 13, 1917, Henry Cruger contacted detectives in Upper Manhattan to report that his seventeen-year-old daughter, Ruth, had failed to return to their home at 180 Claremont Avenue. She was just one of hundreds of young women who went missing every year. While some were victims of foul play, the vast majority turned up safe and sound within a short time. As a matter of policy, the NYPD refused to act on Mr. Cruger's missing-person report until twenty-four hours passed. When Ruth was still not back the next day, the police finally opened a case.

Ruth's sister told police that the last time she saw her, Ruth said that she was going to have her ice skates sharpened at a motorcycle repair shop on 127th Street. Detectives interrogated the proprietor of the garage, Alfredo Cocchi, an Italian immigrant who lived above the shop with his wife and son. Cocchi admitted that Ruth picked up her ice skates but insisted that he did not know where she went after that. Nevertheless, detectives conducted a perfunctory search of the garage, including the basement workshop, and were satisfied that no harm had come to Ruth while she was there.

Cocchi disappeared the very next day without telling his wife, but detectives did not consider it suspicious because he was well known to several patrolmen assigned to the Motorcycle Squad. A livery driver told police that a girl matching Ruth's description got into his cab near Cocchi's shop the day she vanished and asked to be taken to the nearest subway station. The police concluded that Ruth had left home of her own accord and closed the case.

Mr. Cruger was so upset that the police were willing to take the word of a stranger over his own that he hired a lawyer, forty-six-year-old Grace Humiston, to pursue the matter for him. Humiston's persistent badgering of the detectives assigned to the case finally got the attention of Police Commissioner Arthur Woods. He agreed to have Cocchi's shop searched a second time. After Humiston provided evidence that a man had seen Cocchi covered in

THE MYSTERIOUS DISAPPEARANCE OF RUTH CRUGER

Year 1917

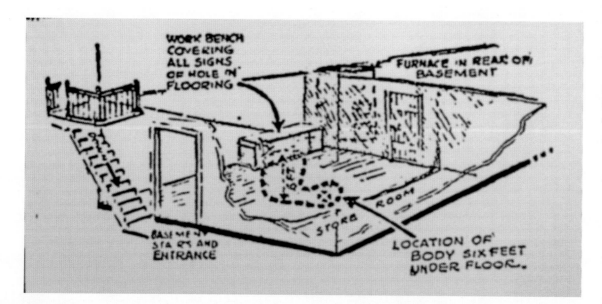

A diagram of the basement in Cocchi's repair shop where Grace Humiston helped police locate Ruth Cruger's body buried under the cement floor.

dirt on the night Ruth disappeared, Woods allowed her to be there for the search.

A team of detectives and private investigators conducted a thorough search of the premises on June 16, 1917, under Humiston's watchful eye. They noticed that a workbench in the basement appeared slightly off-kilter because the concrete underneath it had been broken apart. Humiston told them to dig there. Ruth's remains were discovered in the same outfit she had worn the last time she was seen alive.

Solving the horrific crime under these circumstances proved extremely humiliating to the NYPD. To make matters worse, Cocchi turned up alive and well in Italy living with his brother, but under international law he could not be extradited.

A grand jury convened by Manhattan District Attorney Edward Swann revealed that the bungled investigation went well beyond mere incompetence on the part of the police. Cocchi's cozy relationship with the motorcycle officers, which helped eliminate him as a suspect, was actually a moneymaking scam. Whenever these particular motorcycle patrolmen issued a summons for a traffic infraction, they steered the violator to Cocchi's shop to settle up rather than have the offender go to court. Cocchi would take a cut of the fines, and the balance would go directly into the patrolmen's pockets instead of the city coffer. The officers involved were indicted, along with acting captain Alonzo Cooper, who had headed the investigation into Cruger's disappearance.

Cocchi confessed to Italian authorities that he had murdered the pretty teenager because she had resisted his advances. Then he recanted and blamed the murder on his wife back in America. He avoided a death sentence when the Italian court sentenced him to twenty-seven years in jail, thus bringing an end to one of the more embarrassing episodes in the history of the NYPD.

OPPOSITE PAGE: Claremont Avenue c. 1919

RIGHT: A motorcycle patrolman stands behind the type of motorcycle Alfred Cocchi repaired for the NYPD.

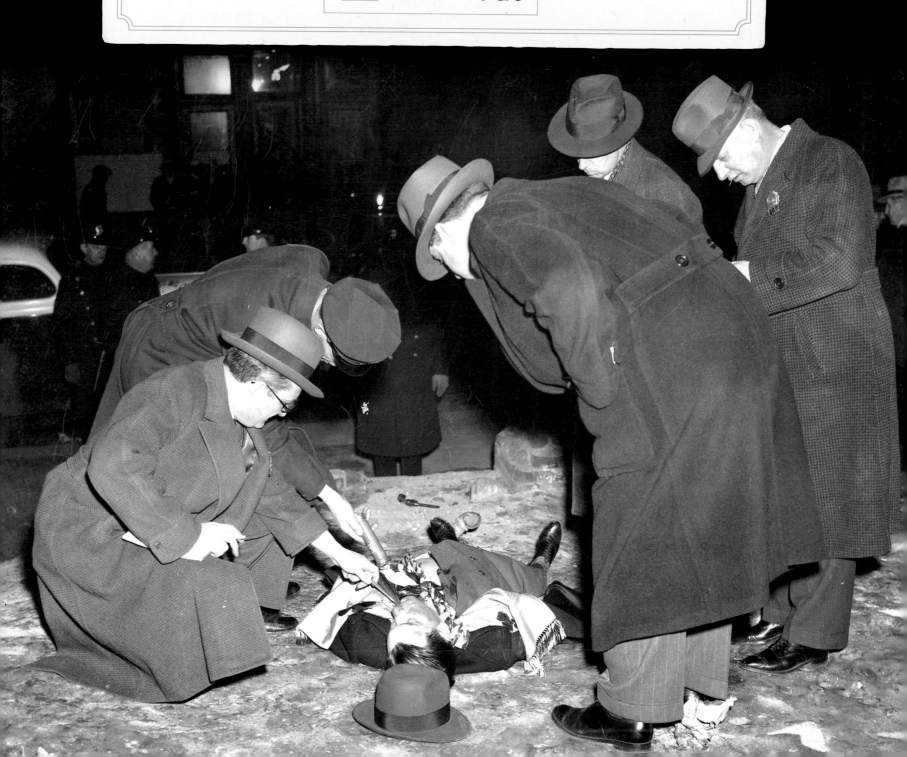

"KID DROPPER" AND "LITTLE AUGIE," THE DEADLY RIVALS

Years 1920–1923

I n the spring of 1920 Police Commissioner Richard Enright called Captain Cornelius Willemse into his office and gave him strict orders to rid the Lower East Side of a pair of notorious Jewish gangsters with long rap sheets: Nathan Kaplan, called "Kid Dropper" for his ability to knock opponents out with one punch, and Jacob Orgen, a diminutive terror known as "Little Augie." Although the two were in all the same rackets, they were bitter rivals.

Among their specialties was providing muscle during labor disputes. If management hired the Kid to get scabs through the picket lines, the strikers hired Little Augie to keep the scabs out. The gangsters extorted shopkeepers and forced them to pay protection money, often from each other. They robbed merchants of their inventory and told them to file for bankruptcy. Then they would sell the stolen swag and kick back a small portion of the illicit profits to the destitute storeowner to keep him in business just so they could rob him again.

With the onset of Prohibition, they expanded their businesses into rum running and dope dealing. Neither man cared how he got his money, so long as the other did not. In the process, many innocent people fell victim to their violent gun battles.

Captain Willemse quickly discovered that his usual tactic of dragging in their henchmen to beat useful information out of them did not work. Kid Dropper had advised his underlings to take their medicine. "There isn't a chance of you being convicted," he assured them, "because I can

fix a juror or two, and witnesses are made to order." He spoke from experience, having beaten the rap several times himself despite strong cases against him. The best Willemse could do for the next three years was keep tabs on the gangs through a network of informants that he developed with the help from the city's chief medical examiner, Dr. Charles Norris. Willemse convinced him to treat the poor residents in the neighborhood for free. Naturally, the grateful patients wanted to return the favor. Before long Willemse's telephone was ringing off the hook with anonymous tips about each gangster's doings, but there was never enough evidence to convict them.

Finally in August 1923, a call came in about a strike that Kid Dropper was contracted to break. The informant told Willemse where the gangsters were going to assemble. More than likely they would be carrying concealed firearms in violation of the Sullivan Law. Willemse and his men caught the entire Dropper gang off guard, except for the Kid. His .38 was on the floor. Willemse arrested him anyway. At a police lineup the next day, thirteen members of Dropper's gang were identified as participants in violent crimes and remanded to the Tombs. The Kid, however, skirted the law again and was set free, but without his gang to protect him, he knew he would be killed the moment he stepped out of jail. He cut a deal with District Attorney Edward Swann and agreed to leave New York for good on a noon train out of Grand Central Terminal, as long as the police escorted him out of the city.

That night, Willemse received a disturbing phone call. Little Augie already knew about the Kid's arrangement and was none too happy. The next morning, Willemse detailed eighty detectives to ensure that Dropper left New York alive. His men rounded up Little Augie and every one of his known associates and had them safely under lock and key. Willemse arranged to have the Essex Market Courthouse completely cordoned off as he personally ushered Dropper to a waiting taxicab. As Dropper got into the backseat, Willemse let him know what he thought of him. "If I had my way, I'd throw you out on the street and get you croaked... Don't ever come back to New York—" Suddenly, a bullet smashed through the rear window of the

> **Without his gang to protect him, he knew he would be killed the moment he stepped out of jail.**

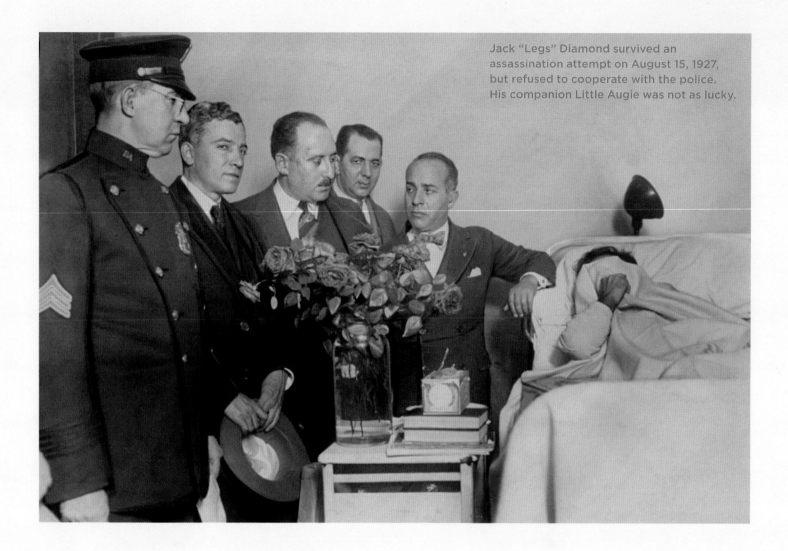

taxicab and shattered Dropper's skull. A second bullet ripped through Willemse's straw hat. As Dropper collapsed, two more bullets pierced his backside. A final round caught the driver.

The killer was a young immigrant, Louis Cohen, recruited by Little Augie to make the hit. The police had frisked him for a weapon, but he concealed the pistol in a newspaper that he had raised over his head.

When Cohen appeared for arraignment the next day, his pockets were stuffed with newspaper accounts of his deed. Although he had no money and could not read, he was smart enough to ask the court to appoint State Senator Jimmy Walker of the Warren and Walker law firm as his attorney. Jimmy Walker would go on to become mayor, and his partner, Joseph Warren, would become his police commissioner.

To most everyone, it seemed like an open-and-shut case that would result in Cohen being sentenced to death, but Walker was a very clever lawyer. As part of Cohen's defense, he convinced the jury that poor misguided youth had done the world a favor by killing the notorious Kid Dropper. The fact that he had nearly killed a police captain was barely mentioned. Cohen escaped the electric chair and was sentenced for murder in the second degree to twenty years in prison. After the verdict, Walker became inundated with gangsters seeking his counsel.

Little Augie also beat the charges against him. Willemse tried to convince him to go straight, but Little Augie would not hear of it. He told Willemse, "If it wasn't for the likes of us, you wouldn't have a job."

For all his bravado, Little Augie met the same fate as Kid Dropper in October 1927. He and his lieutenant, Jack "Legs" Diamond, were ambushed. Little Augie took four bullets to the head. Diamond survived his wounds and went onto become a legend in his own right. Little Augie's killers were never apprehended, but his death paved the way for Louis "Lepke" Buchalter and his notorious band of marauders, dubbed Murder Incorporated, to take over Orgen's criminal enterprises.

The covered bodies of the victims of the Wall Street bomb, September 16, 1920. Thirty-nine people were killed and another two hundred were injured by flying shrapnel.

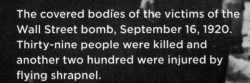

THE WALL STREET BOMBING

Year **1920**

In early September 1920, a former mental patient and self-proclaimed psychic named Edwin Fisher warned friends to stay away from the Wall Street area because a bomb was going to blow it up. Whether he had inside information or true psychic powers was never determined, but his eerier prediction did come true. At noon on Thursday, September 16, 1920, a bomb exploded in the heart of New York's Financial District, causing more than $2,000,000 ($25,000,000 today) in property damage. Thirty-nine people

were killed and another two hundred maimed. It remained the single most deadly terrorist attack in the United States until April 1995, when a bomb in Oklahoma City claimed 168 innocent victims.

Within an hour, 1,700 patrolmen supplemented by a regiment of army regulars from Governors Island were on the scene to restore order. It took several hours for the police department, working in conjunction with the federal government's Bureau of Investigation (forerunner to the

ABOVE: The corner of Wall Street and Broad Street, the location where the Wall Street bombing took place. JP Morgan Bank is on the right.

LEFT: The twisted wreckage of the horse-drawn wagon after the bomb went off. Police tried to trace the wagon's owner by questioning the blacksmith whose horseshoes were found still attached to the severed hooves of the horse.

Federal Bureau of Investigation) to actually decide whether or not the explosion was an accident or a bomb.

According to several eyewitnesses, shortly before noon, an old, rickety, horse-drawn wagon, commonly used to ferry butter and eggs, pulled up to the curb in front of the Morgan Bank located at 23 Wall Street directly across from Federal Hall. The back bed contained a large wooden crate. Messengers and deliverymen were a constant presence in the area, so no one gave it a second thought when the driver and his helper climbed down and disappeared into the crowd.

The police sketch of the operator of the horse-drawn wagon that carried the bomb to Wall Street. He was never identified.

The concussion shattered windows and rained shards of plate glass down on the crowd.

Minutes later, as workers from the Stock Exchange and nearby brokerage houses sat across the street on the steps of Federal Hall eating their lunch, a powerful blast erupted from the very same wagon, in effect making it one of the first car bombs in history. The concussion shattered windows and rained shards of plate glass down on the crowd. The impact of the iron shrapnel against the bank and hall's facades left deep pockmarks still visible today.

Some evidence was inadvertently destroyed when the bankers arranged to have the streets swept of debris so that they could reopen for business as usual the next morning.

The Bomb Squad was still able to reconstruct the device and determined that it contained one hundred pounds of dynamite and five hundred pounds of iron, but had no luck tracking down the origin of the materials. Detectives tried to locate a possible accomplice by tracing the shoes that were still attached to the severed hooves of the horse, but they were unable to prove the blacksmith had any connection to the bombers. Although he provided a description of the men who hired him to shoe the horse, he was too afraid of reprisal from the bombers to answer any more questions.

Police examined circulars printed up by radicals advocating violence discovered in a mailbox in Lower Manhattan shortly after the explosion, but they failed to identify which group was responsible. Eventually, law enforcement authorities concluded that the Morgan Bank was the target of

Italian anarchists affiliated with Luigi Galleani, who had been deported to Italy in 1919 for advocating an overthrow of the United States government, and while arrests were made, not one person was convicted.

Authorities later thought that the anarchist responsible for the Wall Street bomb was Mario Buda. Two days before the bombing, two of his associates, Nicola Sacco and Bartolomeo Vanzetti, were arrested for the murder of two payroll guards in Braintree, Massachusetts. He may have ordered the bombing of Wall Street in retaliation, but it was never proven. Buda, however, went into hiding shortly after the explosion and was not heard from again until 1928 when he resurfaced in Italy, a full year after Sacco and Vanzetti were executed for the murders of the payroll guards.

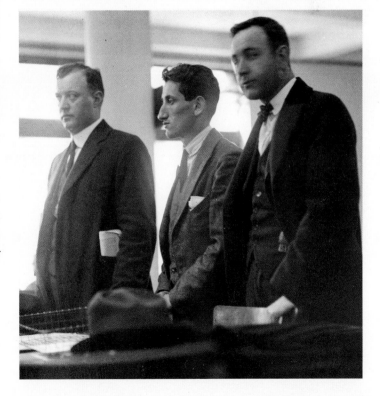

Noah Lerner, a suspect in the Wall Street bombing, appears in court on May 23, 1923. He was not convicted.

Average net paid circulation of THE NEWS, Dec., 1927:
Sunday, 1,357,556
Daily, 1,193,297

DAILY NEWS

NEW YORK'S PICTURE NEWSPAPER

Copyright, 1928; by News Syndicate Co., Inc. Reg. U. S. Pat. Off.

Entered as 2nd class matter Post Office, New York, N. Y.

EXTRA EDITION

Vol. 9. No. 173 56 Pages

New York, Friday, January 13, 1928

2 Cents IN CITY LIMITS 3 CENTS Elsewhere

DEAD!

Story on page 3

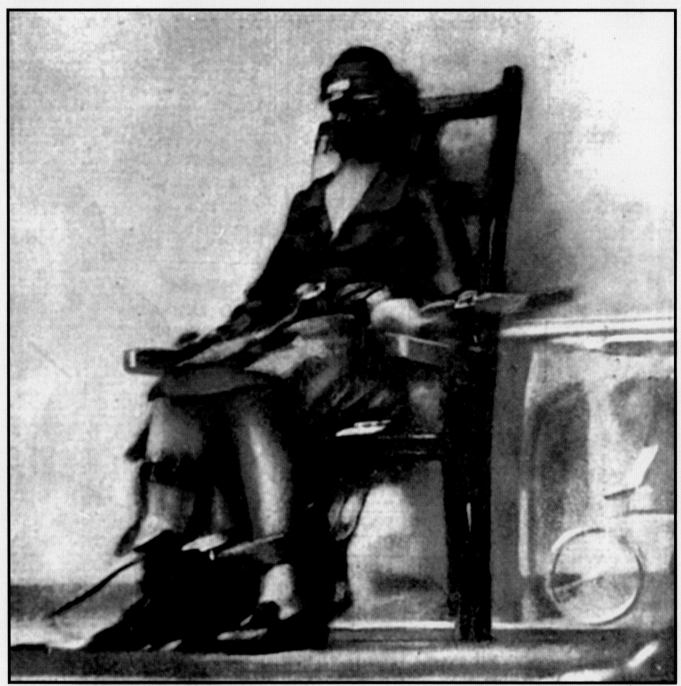

(Copyright: 1928: by Pacific and Atlantic photos)

RUTH SNYDER'S DEATH PICTURED!—This is perhaps the most remarkable exclusive picture in the history of criminology. It shows the actual scene in the Sing Sing death house as the lethal current surged through Ruth Snyder's body at 11:06 last night. Her helmeted head is stiffened in death, her face masked and an electrode strapped to her bare right leg. The autopsy table on which her body was removed is beside her. Judd Gray, mumbling a prayer, followed her down the narrow corridor at 11:14. "Father, forgive them, for they don't know what they are doing?" were Ruth's last words. The picture is the first Sing Sing execution picture and the first of a woman's electrocution. *Story p. 3; other pics. P. 28 and back page.*

DOUBLE INDEMNITY

Year 1927

Early Sunday morning, March 27, 1927, in the quiet hamlet of Queens Village, nine-year-old Lorraine Snyder woke to her mother Ruth's desperate cries for help. Lorraine found her mom lying in the upstairs hallway in her nightgown. Her feet were tied. A piece of wire that had been used to bind her hands and a cloth that had been used to gag her were on the floor beside her. Lorraine ran to the neighbor's house for help.

The next-door neighbors rushed over. Ruth told them that she had fainted when confronted by a burglar in the middle of the night. The neighbors went into the master bedroom to check on Ruth's husband, Albert. He was dead, apparently from a blow to the head. Rather than tell Ruth, the neighbors carried her into Lorraine's bedroom and called for help.

There had been several reports of break-ins in the neighborhood during the previous week, so detectives initially assumed that it had been a burglary gone bad. But several things bothered Inspector Arthur Carey of the Homicide Squad when he got to the scene. For example, Albert's pillow was covered with blood, whereas Ruth's pillow next to Albert's was perfectly clean. Ruth had no injuries, not even a slight bump on her head—impossible, considering that she claimed to have been unconscious for five hours. The doctor who treated Ruth told Carey that nobody fainted that long. Albert's hands and feet were bound like Ruth said hers had been, but there were no marks on her delicate wrists to indicate that she had been tied up at all. The killer also garroted Albert with a strand of picture wire to finish him off but left Ruth alive to possibly identify him. Why would he do that, Carey wondered? Albert's .38-caliber pistol was on the bedroom floor, but inexplicably only three bullets were in the chamber. The other three rounds spilled onto the floor. Albert's valuable gold watch, attached to a platinum chain, was on the floor in the middle of the bedroom next to his empty wallet. Surely a burglar would have taken the watch along with the cash. But what bothered Carey most was Ruth's behavior. She never asked once about her husband, and when she was finally told he was dead, she barely shed a tear.

Carey brought her in for questioning. The new police commissioner, George McLaughlin, an accountant by trade, took an immediate interest in the case and responded to

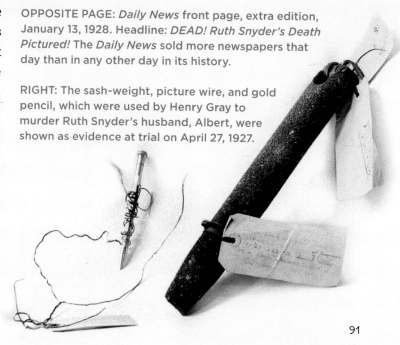

OPPOSITE PAGE: *Daily News* front page, extra edition, January 13, 1928. Headline: *DEAD! Ruth Snyder's Death Pictured!* The *Daily News* sold more newspapers that day than in any other day in its history.

RIGHT: The sash-weight, picture wire, and gold pencil, which were used by Henry Gray to murder Ruth Snyder's husband, Albert, were shown as evidence at trial on April 27, 1927.

the station house in person to take part in the interrogation. He too was skeptical of Ruth's story.

According to Ruth, she, her husband, and her daughter had gone to a bridge party earlier that night. They took Lorraine along because Ruth's mother, who lived with them, worked that night. Albert had had a lot to drink, and when they got home he passed out in bed shortly after two A.M. Ruth was lying next to him when she heard a noise in the hall, and she thought that maybe her daughter had gotten up. When she went into the hallway to check on Lorraine, a dark, swarthy-looking man, possibly Italian, grabbed hold of her tight. She fainted and must have hit her head on the floor. The burglar tied her up when she was unconscious. When she finally came to after five hours, she freed her hands, pulled the gag out of her mouth, and called for help. The burglar, she said, must have killed Albert while she was out cold. There was evidence that the burglar also helped himself to some of Albert's liquor and took time out from ransacking the house to smoke a cigarette, leaving the telltale butt in the ashtray, along with clippings from an Italian-language newspaper that appeared to corroborate Ruth's story.

When Carey asked Ruth if her husband carried an insurance policy, she lied and said he carried only $1,000. In truth he had a $45,000 insurance policy that she took

out on his life without his knowledge; it had a double indemnity clause that provided in the event he succumbed to a violent death like murder, she would receive twice the money. From that point on, things unraveled fast for Ruth Snyder.

Police learned that for the past two years she was cheating on her husband with a ladies undergarments salesman named H. Judd Gray. His alibi, that he was in Syracuse, fell apart nearly as fast as hers.

Gray had traveled downstate that afternoon and, as per his plan with Ruth, was hiding inside the Snyder house until the family returned. While he was waiting, he became nervous and braced himself with a few shots of Albert's liquor. After Albert and little Lorraine fell asleep, he joined Ruth and told her that he had second thoughts about going through with the murder. She gave him an ultimatum—kill Albert or never see her again. Newly resolved, he tiptoed upstairs to the master bedroom and clubbed Albert on the head with a five-pound iron bar that they had hidden in the basement. Once Albert was knocked out, he tied him up, gagged him, chloroformed him, and garroted him until he was dead. Before he left to catch a train back to Syracuse, he and Ruth set the stage to make it appear as if a burglary had taken place. It was Ruth's job to sell the story to the police. She failed miserably and blamed Gray.

LEFT: Bespectacled Henry Judd Gray, a hapless corset salesman, conspired with his lover Ruth Snyder to murder her abusive husband.

RIGHT: Ruth Snyder's mugshot at Sing Sing.

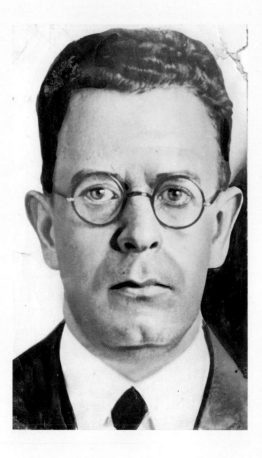

Once in custody, Gray explained his side of the story. He and Ruth happened to meet by chance though a mutual friend in June 1925. He found her very attractive and was immediately captivated. They began to see each other whenever he was in town. As they grew closer, she confided that she was very unhappy in her marriage, but she could not divorce Albert because of her daughter. Gray said that he also felt trapped in a loveless marriage, although later he would claim that he had a fine wife and daughter.

She gave him an ultimatum—kill Albert or never see her again.

Ruth told him that Albert was a brute who often beat her. It was true they had quarrels that sometimes escalated to violence. Ruth was several years younger and still liked to party with friends. At times she stayed out all night. Albert was more of a homebody, who for the most part was happier tending to his garden than hanging out with other people. He also did not care for Ruth's spendthrift ways. Ruth told Gray that the double indemnity insurance policy on Albert's life would allow them to start over. The night of the murder was the last time the two of them were together.

Ruth Snyder and her lover, H. Judd Gray, were pronounced guilty of first-degree murder and sentenced to die in the electric chair at Sing Sing prison. While awaiting her fate, Ruth wrote, "Judd and I sinned together, and now it looks as though we'll go together—God knows where." Gray felt somewhat different about his situation. He told a friend that he did not think of himself as a criminal, but rather as someone who just let circumstances get the better of him.

More than 1,500 newspaper reporters from around the country requested to be present to witness the executions, which were scheduled to take place one after the other on January 12, 1928. Due to seating limitations, the prison warden could permit only twenty. Before the convicted lovers were strapped into the electric chair, he warned the reporters that no cameras would be allowed.

In hindsight, he should have had them searched. He never thought that the New York *Daily News* would hire a photographer from Chicago named Thomas Howard to pose as a reporter in order to sneak in a single-shot camera attached to his ankle. The shutter control was wired to a switch in his pants pocket.

Ruth was strapped in the electric chair first. Howard's iconic photograph capturing the exact moment she died

Ruth Snyder on her way to the courtroom in Long Island City for the start of her murder trial.

appeared on the front page of the January 13, 1928, edition of the *Daily News*. It set a single-day sales record for newspaper sales—1.5 million copies. Gray passed with much less fanfare. As it had been during the trial, Ruth was the one who seemed to get all the attention.

The infamous murder went on to become the basis for several Hollywood blockbusters, including *Double Indemnity*, starring Barbara Stanwyck and Fred MacMurray, and *Body Heat*, with Kathleen Turner and William Hurt in the lead roles.

Arnold Rothstein ran his gambling empire like a corporate business.

ARNOLD ROTHSTEIN GAMBLED WITH HIS LIFE

Year 1928

Manhattan's Park Central Hotel with 'A' marking the room where Arnold Rothstein was shot on November 8, 1928, and 'B' marking where the alleged revolver was found.

Arnold Rothstein was born in New York City in 1882 to Jewish immigrants who made a decent living running a rag shop on the Lower East Side. Young Arnold had a sharp mind for business but absolutely no interest in the cloth trade. He later claimed he made his fortune in real estate, but in reality it was from running gambling houses and poolrooms. He always knew the odds and how to rig them, saying, "I knew my limitations when I was fifteen years old, and since that time I never played any game with a man I knew I couldn't beat."

Rothstein was alleged to be the mastermind behind the infamous Black Sox scandal of 1919, in which eight Chicago White Sox teammates took money to throw the World Series against the Cincinnati Reds. But he was too smart to get in a position where he could get caught. Instead, he simply let the real fixers believe he would finance the venture. Then he bet the house on Cincinnati without contributing a nickel of his own money. When Chicago lost as expected, he reaped the profits, escaped persecution, and earned the nickname "the Slick Jew."

Prohibition and the drug trade provided more opportunities for him to diversify and become even wealthier. He used his ill-gotten gains to ingratiate himself to New York City's Tammany Hall by sharing his profits with the Democratic politicians. This association made him virtually impervious to the law. Such was his sway that he even got away with shooting at two policemen who attempting to break up one of his poker games.

But just because lawmen could not touch him, it did not mean he was invincible. During the summer of 1928, he took part in a marathon poker game. Over the course of three days, he lost $320,000. He sensed the game had been fixed and refused to honor his chits. When that did not work, he tried to stall. Word of his predicament reached the NYPD, including reliable information that if he did not satisfy his obligation very soon, he would be rubbed out. He told the police to mind their own business.

Two months later on Sunday evening, November 4, 1928, Rothstein joined in on a floating card game in Room 349 of the Park Central Hotel at 200 West Fifty-Sixth Street. Although there was no reliable account of that night, hearsay had it that one of the players, presumed to be fellow high-stakes gambler George "Hump" McManus, called Rothstein a welsher for not paying his debts.

> **"I never played any game with a man I knew I couldn't beat."**

Normally such an insult would have sent Rothstein into a rage, but he was poised to make a half million dollars on the upcoming presidential election after betting on Herbert Hoover over Tammany Hall's favorite son, Governor Al Smith. Rothstein told McManus to come back and say that when he sobered up. McManus pulled a gun from his pocket and aimed it at Rothstein. Whether he intended to shoot him or simply try to scare him was not known, but the gun discharged, and the bullet lodged in Rothstein's lower abdomen.

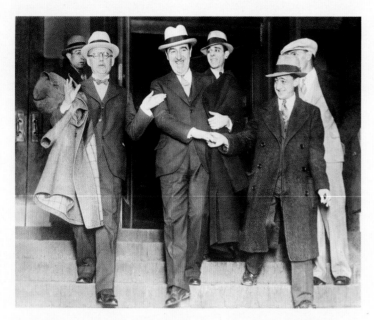

George McManus rolled the dice and was acquitted of the murder of Arnold Rothstein. McManus is seen here leaving the Criminal Courts building in New York, all smiles.

Responsibility for the homicide fell under Inspector John Coughlin, commanding officer of the Detective Bureau, but since gamblers were involved, Deputy Chief Lewis Valentine of the Confidential Squad was also summoned to the scene. The poker players were long gone, but Valentine reported that the room still reeked with tobacco smoke when he arrived. Inspector Coughlin's detectives removed whiskey bottles and shot glasses from the card table with the idea of dusting them for fingerprints to identify the players, but they failed to print Rothstein's corpse, so they could not put him in the room at the time of his murder. Since they recovered an overcoat with the name "George McManus" stitched into the label, he immediately became the prime suspect. Unfortunately, he was in the wind.

Inexplicably, Inspector Coughlin left the city in the middle of the investigation for a nine-day vacation. Without his direct involvement, the case languished, and this brought about whispers of a police cover-up.

Three weeks after the shooting, Detective John Cordes, who knew McManus from past encounters, received a telephone call from the gangster offering to surrender. The pair arranged to meet at a barbershop on upper Broadway. Although there was little in the way of tangible evidence against him, a grand jury indicted McManus for first-degree murder. He was freed on $50,000 bail pending his court date.

It took a year for the district attorney to bring George McManus to trial. A number of the prosecutor's key witnesses had sudden memory lapses. After the state rested, the defense motioned for a dismissal based on lack of evidence. Judge Charles Nott Jr. concurred. Fifteen minutes later, McManus walked out of court a free man. He stayed out of the spotlight for the rest of his life. McManus died in 1940 from a heart attack. He was forty years old. No one else was ever charged with Rothstein's murder.

Rothstein reportedly winced and muttered, "Is that all?" as he staggered out of the room clutching his stomach. McManus threw the gun out of the third-floor window and fled. Three other players thought to be in the game disappeared along with him.

The wound was serious, but Rothstein managed to hobble down three flights of stairs. When he reached the street he called out to a passerby, "Get me an ambulance. I've been shot."

Rothstein was taken to Polyclinic Hospital on West Fiftieth Street. Although he was conscious when detectives arrived to question him, he refused to identify his assailant. Even as his condition deteriorated, he still would not talk. He lapsed into coma and died on Election Day, November 6, of sepsis. Rothstein was forty-six years old.

Rothstein's corpse being carried out of Polyclinic Hospital. Even though he knew he was dying, he refused to tell police the identity of his killer.

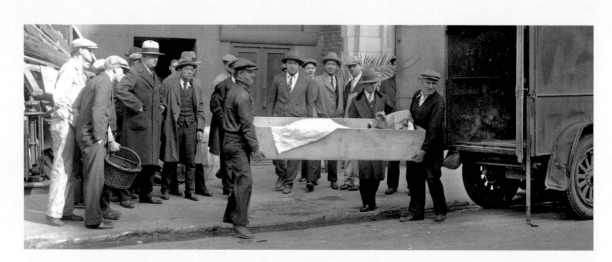

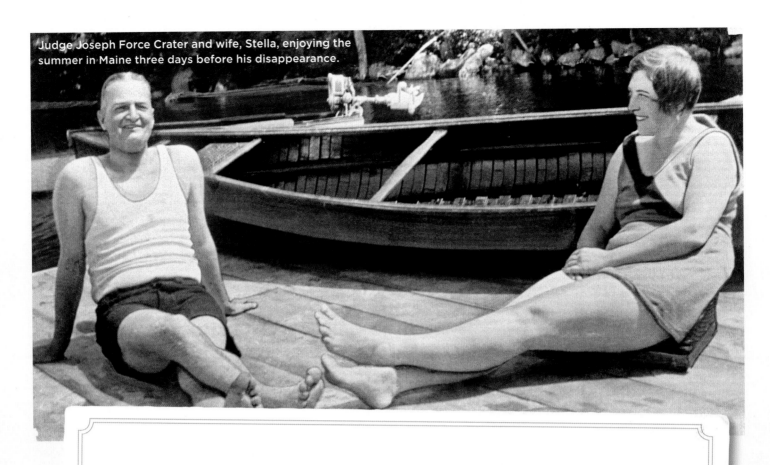
Judge Joseph Force Crater and wife, Stella, enjoying the summer in Maine three days before his disappearance.

JUDGE CRATER GOES MISSING

Year 1930

On Wednesday evening, August 6, 1930, New York City was in the grips a stifling heat wave. Shortly after nine P.M. Judge Joseph Force Crater, fanning his head with his Panama hat, said goodnight to two companions at a restaurant on West Forty-Fifth Street. He told them that that he was off to catch a Broadway show, but was never seen nor heard from again, despite being the subject of the most intensive missing-person search the NYPD had ever conducted to that point. The mystery might have been possible to solve if the judge's wife, Stella Mance Wheeler Crater, had not waited several weeks before informing the police that her forty-one-year-old husband had disappeared.

Judge Crater was a well-connected Tammany Hall Democrat. Governor Franklin Roosevelt had appointed Crater to the New York Supreme Court just months before he vanished. Although the judge's public persona was that of a devoted husband, in reality the police discovered that he was a cad who regularly cheated on his wife, not that Stella seemed to care very much. They had met at a dance when he was a law student at Columbia University. Later he helped her with her divorce from her first husband.

Judge Crater and his wife lived in a swanky Fifth Avenue apartment.

Now she enjoyed the perks that went along with being married to a prominent public figure. The couple lived on Fifth Avenue and had a summer cabin near Belgrade Lakes, Maine. They were in Maine on August 3 when Crater told her he had to return to New York for a couple of days to take care of a problem. She was smart enough not to ask about the problem. His wife was aware of his dalliances, so at first she was not particularly concerned when she did not hear from him. After several days she made inquiries, only to be assured by his chauffeur (Crater did not drive) that the judge would return soon. When that did not happen, she hired a private investigator to look into the matter. He more or less confirmed what the chauffeur had said. Only when Judge Crater failed to appear at court after the summer recess did his colleagues notice his absence, but even they did not report it right away. They were far more worried about their own careers. Governor Roosevelt had recently appointed Justice Samuel Seabury to determine whether or not a city judge, George Ewald, had paid Tammany Hall $10,000 to secure his appointment. Most of Crater's colleagues already knew the answer, because they had done the same.

Finally, after almost a month had gone by without word from her husband, Mrs. Crater contacted the police. In an instant, Judge Crater's disappearance became front-page news.

The police distributed thousands of flyers bearing the judge's likeness. The Board of Aldermen posted a $5,000 reward for information on his whereabouts. Within a week detectives from the Missing Persons Squad had a pretty good idea of what the judge had been up in the months leading up to his disappearance. They learned that he had taken his mistress to Atlantic City for an overnight stay after he left his wife in Maine. They knew that he visited the courthouse at Foley Square the day before he disappeared to remove files from his office. Later that same day, he withdrew $5,150 from his bank account. However, after Crater got into a cab that night, the trail went cold.

After Crater got into a cab that night, the trail went cold.

There was also evidence that Crater had paid someone connected to Tammany Hall $22,500, or the equivalent to a Supreme Court judge's annual salary, for the privilege of serving on the bench. This payment was believed to be tied in with an investigation being conducted by Judge Seabury. In the end, Ewald and several other municipal judges connected to Tammany Hall would lose their posts.

Crater was spared being called to the stand to explain the payment only because he was missing. His disappearing act lent credence to the theory that he decided to go into hiding rather than suffer the humiliation of his colleagues. Others however, insisted that he had been murdered for fear that his testimony could ruin the careers of several high-ranking Tammany Hall officials.

Back in Maine, police dredged the lake near his summer cabin. A special grand jury was convened by Manhattan District Attorney Thomas Crain to gather information about the judge. (Ironically, Crain was later recommended for removal by Judge Seabury for general incompetence, but Governor Roosevelt let him finish out this term.)

During the months following his disappearance, Crater's wife, friends, coworkers, political associates, and even paramours were questioned. Although the NYPD tracked thousands of leads over the course of several years, it was all for naught. The court declared Judge Crater legally dead in 1939. The NYPD finally closed case #13595 forty years later, his whereabouts still a mystery.

There was a brief reexamination of the case after the death of Stella Ferucci-Good at age ninety-one in 2005. Her granddaughter found a faded handwritten letter among her belongings. The note said that Mrs. Ferucci-Good's husband once confided in her that he overheard two men in a bar, one of whom claimed to have been the cab driver who picked up Crater the night he went missing, and said that the judge had been killed and buried in sand dunes under the boardwalk at Coney Island. When the Coney Island Aquarium was being constructed on that same site in the 1950s, workers recovered unidentified human remains that were interred in potter's field. Whether or not the bones were those of Judge Crater was never ascertained, but one thing is certain—he became much more well known after he disappeared than he ever had been when he was alive.

Judge Samuel Seabury's investigation into corruption in the city court system may have had something to do with Judge Crater's mysterious disappearance.

THE MURDER OF VIVACIOUS VIVIAN GORDON

Year 1931

Police remove Vivian Gordon's body from the roadside ditch in the Bronx's Van Cortlandt Park where it was found.

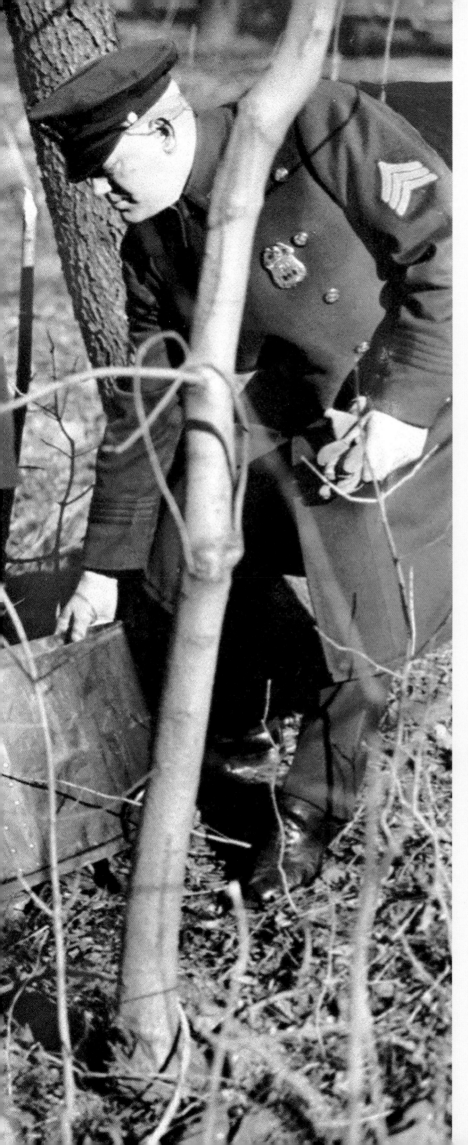

A year after New York state senator Samuel Hofstadter formed a bipartisan commission to investigate corruption in the municipal courts of New York City headed by Judge Samuel Seabury, the focus of the investigation shifted to the illicit practices of NYPD. Tales of shakedowns and false arrests were so sordid that the stodgy Seabury forbade women to be present in the courtroom, lest they hear the horrible details.

One woman not put off was an attractive forty-year-old divorcée who contacted Seabury with an offer to testify against a vice cop who did her wrong.

Vivian Gordon was the stage name that Benita Franklin of Joliet, Illinois, took as a teenager when she became a chorus girl. In 1912, at age twenty-one, she left show business to marry a well-to-do accountant named John Bischoff. The marriage faltered. As far as she was concerned the only good that came out of the relationship was her daughter, Benita. In 1923 Patrolman Andrew McLaughlin caught Vivian in a seedy Times Square hotel sharing the bed with another man. Vivian claimed that she was a lonely housewife who had an extramarital affair only because her husband was too busy to spend time with her. However, she was charged with prostitution, which Vivian believed her husband had bribed McLaughlin to claim.

Magistrate H. Stanley Renaud was not sympathetic. He awarded Mr. Bischoff custody of their daughter and remanded her to the Bedford Hills Correctional Facility for Women for three years. It was an extremely long sentence for a first-time offender, even if the charges had been true. Vivian had one objective when she got out—to get Benita back. But female ex-convicts in the 1930s had limited opportunities to make legitimate money, so she traded on her beauty and body to become what she called "a lady of the evening, with a morning glory's beauty."

Vivian quickly became well known to police as a high-priced call girl to some of the most prominent men in New York, as well as the moll of gangster Jack "Legs" Diamond. There were also reports that she extorted money from her more wealthy clients to finance her own criminal enterprises, which were said to be numerous and quite lucrative.

Along the way she spent a small fortune trying to regain custody of her daughter, but even with her powerful connections, Vivian could not get her conviction overturned, which was a huge stumbling block. So when she heard that Judge Seabury was looking for witnesses to testify against dirty cops, she saw an opportunity to get back at the man who had done her wrong.

Vivian met with Seabury's assistant, Irving Cooper, on

Friday, February 20, 1931. After their conversation, Cooper realized that she came forward only because she had an ax to grind. But her story included the names of several important people on the take, names that included judges, gangsters, and, most important, the popular mayor of New York, Jimmy Walker. The collateral damage he suffered would eventually force him out of office.

When Vivian left Cooper that afternoon, she promised to return the following week with corroborating evidence. She never kept that appointment. Six days later she was

Vivian Gordon's letter to the Seabury Commission offering to testify.

Six days later she was found dead in the Bronx at seven o'clock in the morning.

found dead in the Bronx at seven o'clock in the morning. Emmanuel Kamma was walking through Van Cortlandt Park when a white glove snagged on a bramble bush caught his eye. It belonged to Vivian Gordon. She was lying dead at bottom of a roadside ditch.

To detectives it appeared that she had been strangled to death with a six-foot cord before being dumped. The police gleaned from the doorman of her apartment building on East Thirty-Seventh Street that she had left around 11:30 P.M. the night before, wearing a mink coat and expensive jewelry, and carrying a small velvet purse, all of which were missing.

Police discovered a diary in her apartment that listed her clients and other damaging information, including a copy of the letter she wrote to Seabury accusing Patrolman McLaughlin of corruption. While McLaughlin might have had a motive to keep Vivian quiet, he was cleared in her murder, because he was on vacation in Bermuda when it happened. But the mere implication that he was involved caused Police Commissioner Edward Mulrooney to take a closer look at him.

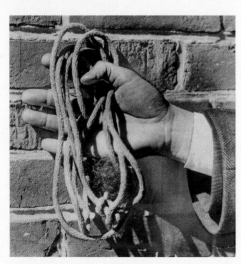

Clothesline and strands of hair that were around the neck of Vivian Gordon when she was found strangled in Van Cortlandt Park. Army deserter Harry Stein was charged with the crime, but acquitted.

McLaughlin was ultimately fired for refusing to answer questions about the $35,800 he deposited in his bank account during the two previous years, when his total salary for that same period equaled only $6,000. So in a sense, Vivian got her revenge against McLaughlin, but at an even steeper cost than she could ever have imagined. Her sixteen-year-old daughter, Benita, was so distraught by the salacious newspaper accounts of her mother's illegal activities that she committed suicide.

In the meantime, Mulrooney pushed his men to solve the murder case, if only to avoid further embarrassment brought on by McLaughlin's association with Vivian Gordon. He called what happened to her "a blot on the shield of every member of the police department."

Detectives zeroed in on several suspects mentioned in her diary. One was Charles Reuben, whom Vivian lent $1,500 to start a business—in Oslo, of all places. Mulrooney ordered his men to check passenger manifests of all ships voyaging to Norway from the date of the entry in the diary forward. Sure enough, a Charles Reuben had sailed out of New York to Norway in July 1929. It turned out that Reuben was the alias for Harry Stein, an army deserter who had done a stretch in Sing Sing. Mulrooney put a tail on him. Detectives soon learned that Stein hung out with another shady character, Samuel Greenberg, whom they overheard in a phone booth talking to a man named Harry Harvey, aka Harry Schlitten. The subsequent tapping of Schlitten's phone led police to a fence, David Butterman, who admitted that Reuben/Stein had tried to sell him Vivian Gordon's missing jewelry and mink coat. More important, the wiretap

revealed that Schlitten had rented and driven the car the night Vivian was murdered.

The police picked up Schlitten. In exchange for immunity, Schlitten admitted that Stein had paid him $1,000 to pose as a chauffeur that night. Stein told him, without mentioning Vivian by name, that he had to get a certain party out of the way to keep a friend out of jail. Schlitten drove Greenberg up to the Bronx, where they rendezvoused with Stein and Vivian Gordon.

Stein had told Vivian that he needed her help. Greenberg was a "sucker" with a quarter million dollars' worth of diamonds to unload. Vivian began to flirt with Greenberg as they shared a bottle of champagne in the backseat. Stein slipped a rope around her neck and, with help from Greenberg, strangled her to death and muttered, "She's finished now." Schlitten drove the car to Van Cortlandt Park, where the trio dumped Vivian's body into a drainage ditch.

Both Stein and Greenberg were taken into custody the next day but refused to talk. Even without their confessions, they were indicted for Vivian Gordon's murder. Mulrooney was thrilled. He said the work of his men reflected the highest credit on the department.

Unfortunately, Mulrooney failed to consider how Schlitten would fare on the witness stand. He wilted under cross-examination. Defense attorney Samuel Leibowitz made the most out of the fact that Schlitten was a thug himself with a long arrest record, who associated regularly with criminals, failed to pay child support, often used an alias, and had received immunity to testify for the state.

Schlitten's credibility was so damaged that Stein and Greenberg got off. Afterward, the Bronx county district attorney was so disgusted by the jury's decision that he called the verdict "the rankest miscarriage of justice I have ever known."

The *Daily News* declared Vivian Gordon's murder solved, but her accused killers went free.

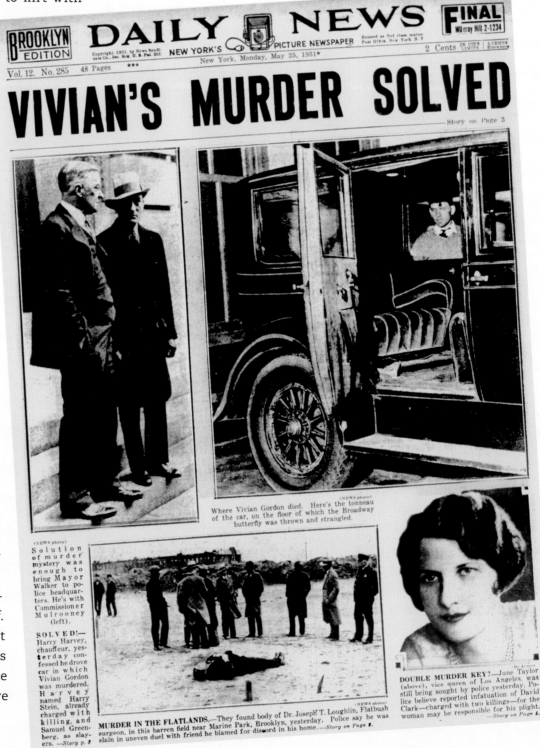

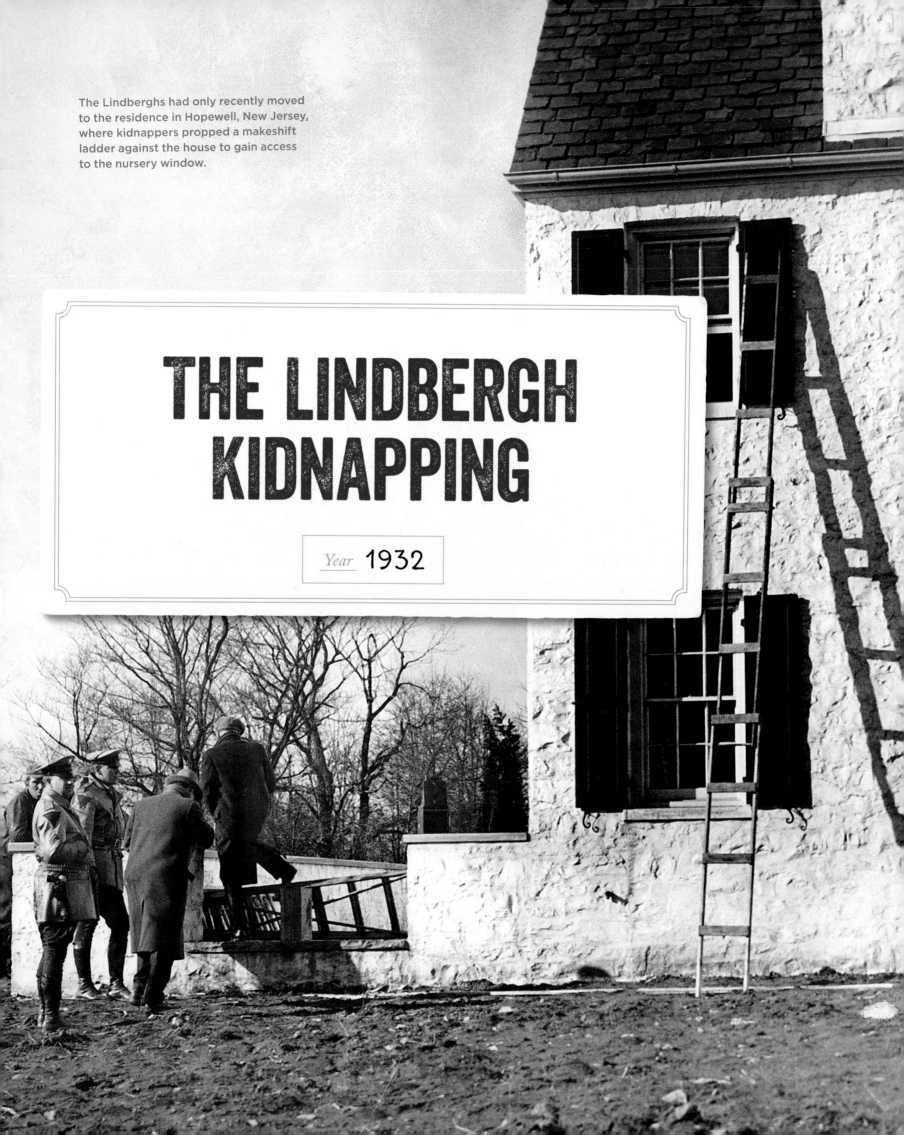

The Lindberghs had only recently moved to the residence in Hopewell, New Jersey, where kidnappers propped a makeshift ladder against the house to gain access to the nursery window.

THE LINDBERGH KIDNAPPING

Year 1932

Charles Lindbergh Jr., son of the most famous aviator in the world, was only twenty months old when he was kidnapped from his second-floor nursery at the family estate in Hopewell, New Jersey. A ransom note left behind on the evening of March 1, 1932, demanded $50,000 for the toddler's safe return. Although the Lindbergh residence was seventy-five miles west of New York City, the NYPD sprang into action. Patrolmen checked every car that entered the city by bridge or tunnel. Detectives scoured hospitals, hotels, and houses, anywhere the abductor might think to hide.

Within several days Lindbergh received two more ransom notes, both postmarked in Brooklyn. Police Commissioner Edward Mulrooney told him that he wanted to stake out mailboxes in the borough and put a tail on anyone who looked suspicious. If the plan panned out, he said the suspect would lead the police right to the baby. But for all of his bravado, Charles Lindbergh was afraid that his son might get killed if a police raid took place. He used his clout to get Mulrooney to back off the idea.

Instead, Lindbergh put his trust in a law enforcement outsider, John F. Condon, a retired grammar school principal who managed to contact the alleged kidnapper through a series of newspaper ads. Condon used the alias "Jafsie," an amalgamation of his own initials with the letters *sie* representing the C of his last name. To make matters worse, Lindbergh purposely kept the police in the dark about his decision to rely on a novice. After receiving the toddler's pajamas as proof of identity, Lindbergh and Condon went to St. Raymond's Cemetery in the Bronx on the night of April 2, 1932, with $50,000 in gold certificates to pay the ransom as per the instructions Condon received. Lindbergh waited in the car while Condon passed the money to a man who identified himself only as "John." The man was too far away for Lindbergh get a good look at him, and although Jafsie was right next to him, he later claimed that he could not make out his features in the dark. John walked away with the money, but the information he provided about the location of the boy proved worthless. It was only after Lindbergh realized that he had been duped that he notified the police about what had transpired. By then it was too late.

TOP: First and second ransom notes sent to Charles Lindbergh were postmarked from Brooklyn.

BOTTOM: New Jersey State Police poster seeking information about the boy's kidnapping.

WANTED

INFORMATION AS TO THE WHEREABOUTS OF

CHAS. A. LINDBERGH, Jr.
OF HOPEWELL, N. J.
SON OF COL. CHAS. A. LINDBERGH
World-Famous Aviator

This child was kidnaped from his home in Hopewell, N. J., between 8 and 10 p.m. on Tuesday, March 1, 1932.

DESCRIPTION:

Age, 20 months	Hair, blond, curly
Weight, 27 to 30 lbs.	Eyes, dark blue
Height, 29 inches	Complexion, light

Deep dimple in center of chin
Dressed in one-piece coverall night suit

ADDRESS ALL COMMUNICATIONS TO
COL. H. N. SCHWARZKOPF, TRENTON, N. J., or
COL. CHAS. A. LINDBERGH, HOPEWELL, N. J.

ALL COMMUNICATIONS WILL BE TREATED IN CONFIDENCE

COL. H. NORMAN SCHWARZKOPF
Supt. New Jersey State Police, Trenton, N. J.

March 11, 1932

On May 12, 1932, baby Lindbergh's corpse was discovered in a shallow grave in the woods surrounding the Lindbergh estate by a trucker who stopped by the roadside to relieve himself. The cause of death was a sharp blow to the head.

Fortunately, for all of his mistakes, Lindbergh had the foresight to write down the serial number of every single bill in the ransom packet. That information was circulated to banks throughout the country. For the next two years, whenever one of the gold certificates turned up, Lieutenant James Finn, who was in charge of the NYPD Task Force handling the case, marked the location on a map in his office. Although some of the bills were spent as far away as Chicago, Finn noticed a definite pattern develop in the Fordham section of the Bronx and in the Yorkville section of Upper Manhattan.

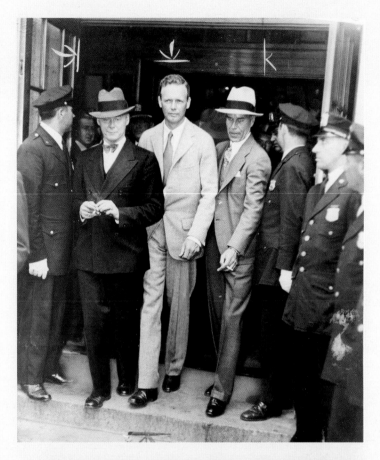

> **Baby Lindbergh's corpse was discovered in a shallow grave in the woods surrounding the Lindbergh estate.**

Even so, the case might never have been solved if the government had not recalled all the gold certificates in circulation in 1934 when it switched American currency to the silver standard. Citizens were advised that any gold certificates in their possession might become worthless if they were not exchanged for the new bills. Businesses that dealt in cash became particularly concerned. So when a customer pulled into a Bronx gas station on September 15, 1934, and paid for ninety-eight cents of gasoline with a ten-dollar gold certificate, the attendant took the precaution of jotting down the license plate number of the blue Dodge in case the bill was rejected by the bank. The bank informed the police that the certificate had come from the Lindbergh ransom money.

Four days later, Police Commissioner John O'Ryan announced to the world that the NYPD had solved the "Crime of the Century." Bruno Hauptmann, age thirty-four, was arrested trying to flee from his Bronx home. Police found more than $13,000 in ransom money hidden in his garage along with other incriminating evidence. Although Hauptmann maintained his innocence to the end, he was put to death on April 3, 1936, in the electric chair in New Jersey, where he committed the crime.

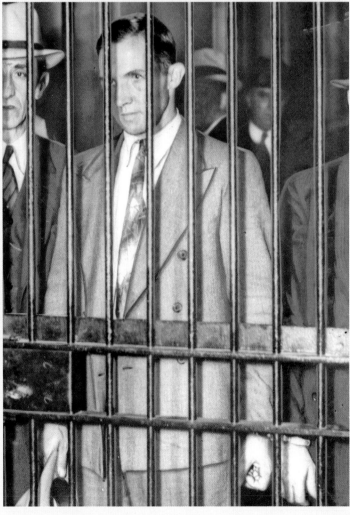

TOP: Charles Lindbergh leaving the Bronx courthouse during the trial of Bruno Hauptmann. BOTTOM: Bruno Hauptmann stares glumly at the bars of his jail cell after his arrest for the kidnapping and murder of Charles Lindbergh Jr.

VENDING MACHINES AND SLUGS

Years 1930s

The Horn and Hardart coin-operated restaurants were among the most popular eateries in New York City and were often victimized by customers using slugs instead of coins.

I n 1888, Thomas Adams wanted to sell his chewing gum products on elevated railroad platforms in New York City. But there would be little profit in hiring a man to stand in the station selling penny gum sticks, so he invented a coin-operated vending machine to tackle the job instead. The idea was a great success. By the 1930s, coin-operated vending machines throughout the five boroughs were dispensing just about every product imaginable.

For a few nickels, a hungry diner could buy a complete meal from a vending machine at any one of the fifty Horn and Hardart Automats in New York City. Each day, more than 5 million subway riders deposited nickels to activate turnstiles to get into the transportation system. Pay phones were more prevalent than home phone lines, and each local call cost a nickel.

As lucrative as the market was for retailers, it was more lucrative for the racketeers who sold the fake, coin-sized metal slugs by the pound to the public for a fraction of the cost of the real thing. During the Depression, when money was tight, people who would not normally commit criminal acts bought and used slugs with nary a thought of the harm it caused legitimate businesses. Each day, thousands of dollars in revenue were lost when customers purchased products in vending machines with worthless slugs instead of coins.

In 1935 alone, the three primary victims of the slug racket in New York City were Horn and Hardart, which lost $44,000 in revenue to slugs; the IRT and the BMT and other city subway lines, which lost $132,000; and the New York Telephone Company, which lost a whopping $300,000. All three companies implored the police to do something about it. The NYPD put a task force together that included two of its best men: Detectives John Cordes, the first cop to be awarded two Medals of Honor; and Bill Quaine, an Irishman known as the "Scourge of Harlem" for his two-fisted, no-nonsense approach in dealing with thugs in Harlem.

But gathering evidence was tricky. The metal disks were ostensibly manufactured as identification tags attached to key rings. Every hardware store in the city that cut keys sold them. So detectives had to work around the subject and gain the clerk's confidence before asking if the key tags could also be used as slugs. If the clerk said yes, the detectives asked for a demonstration. That was not a problem, since most hardware stores had pay phones. In one instance detectives recovered three hundred pounds of slugs in a single hardware store. In all, nineteen arrests were made in one fell swoop that put a temporary dent in the slug racket. Although slugs continued to plague coin-operated businesses in the city, once the slug rejecter was invented in 1937, it reduced losses significantly.

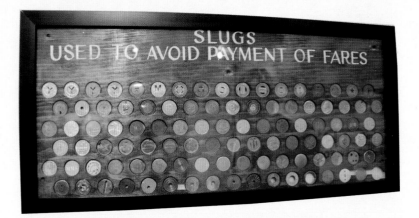

A sample of the many types of slugs customers used instead of tokens to avoid subway fares in New York City.

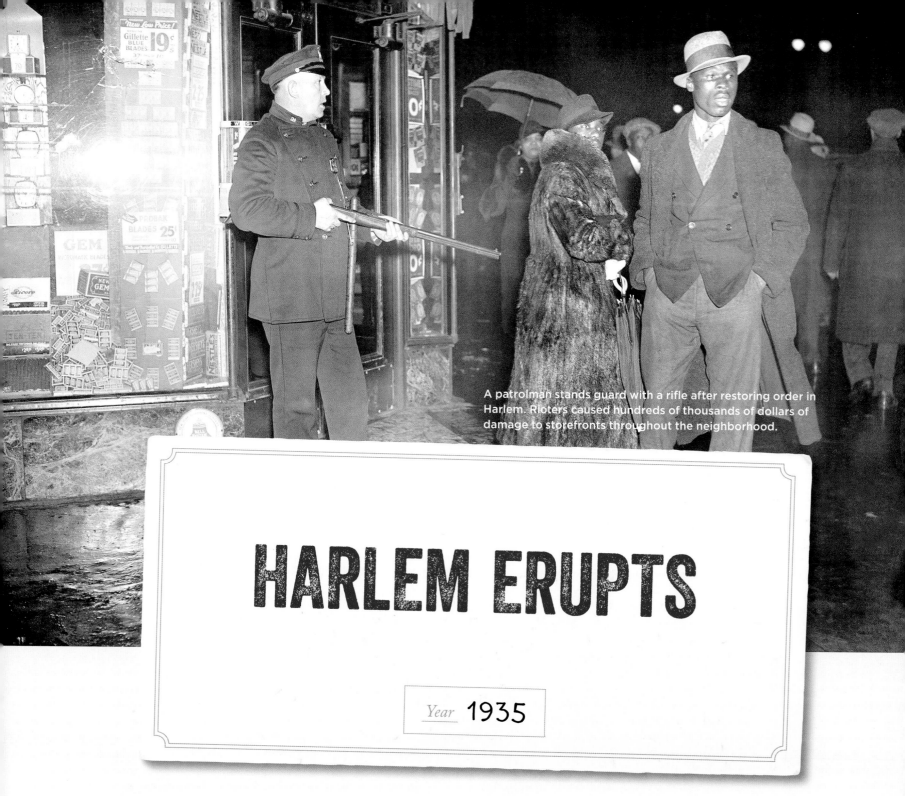

A patrolman stands guard with a rifle after restoring order in Harlem. Rioters caused hundreds of thousands of dollars of damage to storefronts throughout the neighborhood.

HARLEM ERUPTS

Year 1935

The Great Depression following the stock market collapse in October 1929 created a financial crisis in America that caused many people, especially those on the lowest rung of the economic ladder, to question their elected leaders. Communist agitators took full advantage of the situation to further their movement. This was particularly true at Union Square in New York City during the 1930s, where massive, violent demonstrations against the government were a regular occurrence.

Uptown in Harlem, unemployment and poverty were higher than in any other part of the city. On the afternoon of March 19, 1935, the violence exploded when a minor crime gave rise to a major riot that cost four black men their lives and caused $4,000,000 of property damage, the equivalent to $70,000,000 today.

The trouble started at 2:30 P.M. when Lino Rivera, a sixteen-year-old black Puerto Rican, was caught stealing a ten-cent pocketknife from the E. H. Kress five-and-dime on West 125th Street. As he was being searched, Rivera bit the hands of the store manager and a floor guard. The employees subdued him and summoned Patrolman Raymond Donohue to the scene. As the officer took Rivera to the

109

back room for questioning, a female customer ran out onto the street and began screaming hysterically that a policeman was beating the boy. In reality, Donohue had sent Rivera on his way through the rear door with just a warning. Nevertheless, the woman's yelling began to draw a large crowd to the front of the store. A short time later, an ambulance responded to the scene to treat the employees Rivera bit. When it left empty, some in the crowd speculated that Rivera was dead. To make matters worse, a hearse inadvertently parked outside the store added to the confusion.

Patrolman Donohue attempted to defuse the situation by assuring the crowd that no harm had come to Rivera. However, since he had let the boy go, he could not prove it. His gruff manner did not help the situation. Suddenly the unfounded rumor became a fact. As the news spread through Harlem, more and more residents, some four thousand in all, were drawn to the store on 125th Street. The Young Liberators, a black radical group, along with members of the local Young Communist League saw this as an opportunity to advance their cause. They began distributing leaflets with the specific intent to incite action against the police and the white merchants.

More than 125 people were arrested by police for taking part in the 1935 Harlem race riot.

The NYPD was criticized for posing Lino Rivera beside the highest-ranking black officer on the force, Lieutenant Samuel Battle, to prove the boy was alive and well.

CHILD BRUTALLY BEATEN

WOMAN ATTACKED BY BOSS AND COPS

CHILD NEAR DEATH

..........

WORKERS! NEGRO AND WHITE.

PROTEST AGAINST THIS LYNCH ATTACK OF

INNOCENT NEGRO PEOPLE.

..........

STOP POLICE BRUTALITY IN HARLEM

JOIN THE PICKET LINE

By 6:30 that evening, the police could no longer control the situation. The crowd, inflamed by communist rabble-rousers, began smashing windows and looting stores in the neighborhood. Black shop owners desperately tried to protect their property by placing placards in their store windows—RUN BY COLORED PEOPLE—while white merchants frantically posted signs informing the mob that they employed Negro workers. It did not stop their businesses from being attacked.

Three hundred heavily armed police reserves flooded

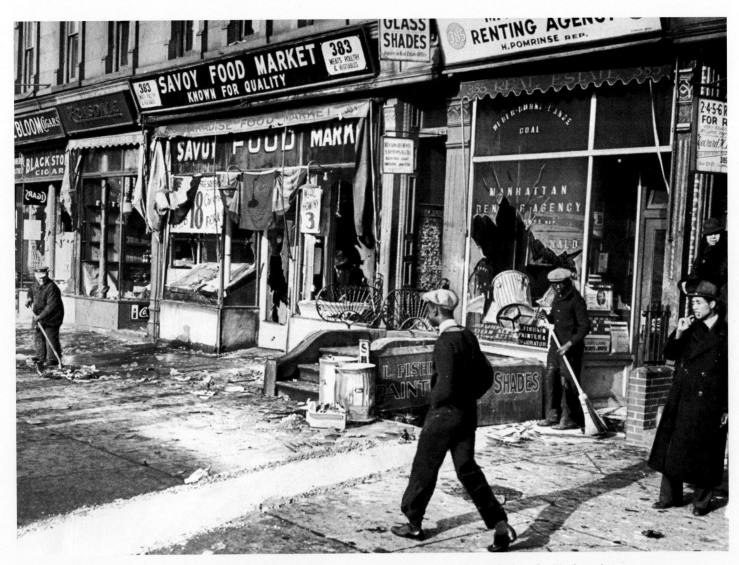

Work crews clean up broken glass from businesses that were looted on Lenox Avenue during the Harlem riot.

the area. Patrolmen waded into the crowd, swinging batons and rifle butts, while snipers on rooftops fired down at the rioters. It was not until two A.M. that police were able to locate Rivera and bring him back to Harlem. In order to prove to the Harlem residents that Rivera was alive and well, the department released a photograph of him smiling beside Lieutenant Samuel Battle, the highest-ranking black officer on the police force.

By the time calm was restored, more than one hundred men, mostly black, had been beaten, shot, or stabbed. Four lost their lives. Another 125 people were arrested for taking part in the riot. Despite the carnage, Police Commissioner Lewis Valentine told the newspapers that his men had shown "discipline, tact and courage" during the melee.

Mayor Fiorello La Guardia was not so sure. He appointed a biracial panel to review the police response. In their report, the panel ignored the false report and the role the communist agitators had played in stirring the crowd into a frenzy, and instead placed the blame for the mob's actions squarely on the NYPD. The panel even went so far as to ridicule the police department for circulating a picture of an uninjured Lino Rivera in the company of a black lieutenant, claiming it used it only as a means to justify its own brutal behavior.

Nine days after the riots, Lino Rivera was brought before the Brooklyn adolescent court on an unrelated charge of using a slug he fashioned out of the foil wrapper in a cigarette pack to get onto the subway. He received a year's probation for using the slug and an admonishment from the judge for stealing the knife that touched off the riot.

> By the time calm was restored, more than one hundred men, mostly black, had been beaten, shot, or stabbed.

Nancy Titterton murder suspect John Fiorenza is escorted out of the Titterton apartment building by Seventeenth Precinct detectives after he reenacted his crime.

THE BATHTUB MURDER

Year 1936

Nancy Evans was a slender, shy twenty-three-year-old college graduate from Dayton, Ohio, when she moved to New York City in 1925. Although she dreamed of becoming a writer, she eked out a living as a bookseller for Lord and Taylor. In that capacity she met Englishman Lewis Titterton, an executive with Macmillan Publishing. Their mutual love of books kindled a romance. The couple married in 1929 and, after living in Hell's Kitchen for a spell, settled into a fashionable East Side apartment on the fourth floor of 22 Beekman Place.

Mr. Titterton left publishing to become an executive with the National Broadcasting Company as well as a respected reviewer of books for the *New York Times*. Although his wife was more of a homebody, she became a noted book reviewer in her own right, while continuing to pursue a career in writing using her maiden name. In early April 1936, she inked a contract to write her first novel.

Shortly after four P.M. on April 10, 1936, two deliverymen, John Fiorenza and his boss, Theodore Kruger, arrived at the Tittertons' address to deliver a loveseat Mrs. Titterton had sent to Kruger's shop to be re-covered. They knew that she was expecting them, so when she did not answer the doorbell in the vestibule, they went upstairs anyway. The door to the apartment was slightly ajar. They entered and called her name, but Mrs. Titterton did not answer. All the blinds were drawn. Both the living room and kitchen were dark and quiet. They moved into the bedroom. The bedspread on one of the twin beds was rumpled and the light in the adjoining bathroom was on. When they peeked in, they were shocked to find Mrs. Titterton dead, lying on her side, half naked in the bathtub. Her pajama top was knotted tightly around her neck and her stockings were bunched down around her ankles. The moving men ran out to find the superintendent, who called the local precinct.

Within minutes the apartment was swarming with police. A closer examination by Homicide Squad detectives indicated that Mrs. Titterton's wrists had been tied and that she had been raped. Any possible prints that could have been lifted off her body or clothing were compromised by water dripping from the showerhead. But a thirteen-inch strand of cord, found under her body, seemed to be a match for ligature marks on her wrists. Police theorized that the cord had been used to bind them together and somehow fell off.

Cops put the time of death between 11:00 and 11:30 A.M., based on a telephone conversation Mrs. Titterton had with a girlfriend shortly before eleven. This was coupled with a statement by a delivery boy for a local tailor, who reported that Mrs. Titterton did not answer the doorbell when he stopped by at 11:30 to drop off her husband's suit.

Since the apartment door was partially open, detectives assumed the perpetrator had entered and exited through it, leading them to believe that Mrs. Titterton knew her killer. They questioned all of the tenants, Titterton's friends, the superintendent, the janitor, the furniture delivery men, and four painters who had been sprucing up the building earlier that week. None of them were considered suspects, at least at first.

Meanwhile, technicians at the NYPD Police Laboratory at 72 Poplar Street in Brooklyn spent the next ten days examining the cord found at the scene. They finally

They were shocked to find Mrs. Titterton dead, lying on her side, half naked in the bathtub.

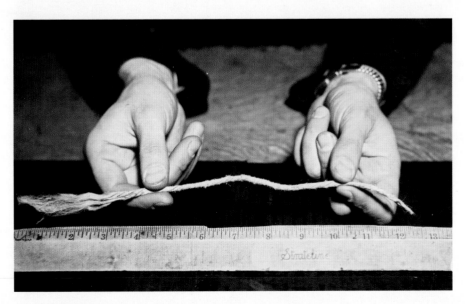

The cord found at the scene of the crime.

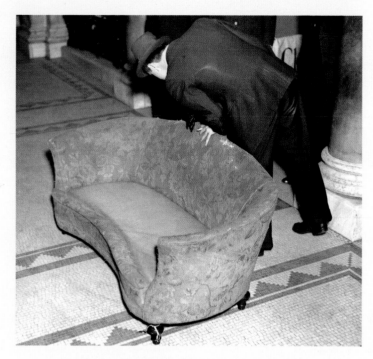

The loveseat Nancy Titterton wanted recovered brought her into contact with her murderer, John Fiorenza.

determined that it was a type commonly used in the upholstery business. The police had also recovered a single strand of horsehair from the rumpled bedspread that matched the horsehair used in the stuffing of the reupholstered loveseat. Suddenly, the list of potential suspects shrank from hundreds to the movers Fiorenza and Kruger. Fiorenza was the more promising of the two. He had already been in trouble with the law and had done a stretch at Elmira for grand larceny. Detectives started keeping a close eye on him and even paid him a visit or two to ask who he thought killed Mrs. Titterton. More important, they learned that on the morning of the murder, he called Kruger to tell him he would be late for work because he had an appointment with his probation officer in Brooklyn. It was a lie.

On April 21 the police pounced. At first Fiorenza denied any involvement and pointed out that he had no reason to kill Mrs. Titterton, because he was engaged to a lovely girl of

Nancy Titterton on the cover of the *New York Post*.

his own. However, he was no match for the detectives interrogating him. They kept at him day and night until he began to waffle. They knew they had their man when he uttered, "I can't admit that; it would be the electric chair." His confession soon followed.

According to Fiorenza, he first laid eyes on Mrs. Titterton on April 9, when he went to her apartment to pick up the loveseat. He was strangely attracted to her and was at the same time obsessed by the idea of causing her bodily harm. He could not get the insane thought out of his mind. He returned the next morning, several hours before he was scheduled to return with the loveseat, planning to have his way with her and then kill her.

Mrs. Titterton was alone and still in her pajamas when she let him in. Fiorenza pretended that he wanted to know where she wanted him to put the settee when he brought it back later that afternoon. While they were discussing the options, Fiorenza attacked without warning. Her pleas for mercy fell on deaf ears. He gagged her, shoved her face down onto the bed, and tied her hands to the bedposts with the upholstery cord he had brought with him just for that purpose. He ripped off her pajama bottoms, yanked down her stockings, and raped her. When he was done, he knotted her pajama top around her neck and strangled her to death. For some reason he decided to make it look like she drowned. He cut her loose and carried her to the bathtub, but had trouble getting the water faucet on. In his haste, Fiorenza inadvertently left the thirteen-inch strand of upholstery cord under her body. Without that mistake, the police might never have been able to solve the case.

After exhausting his appeals, Fiorenza died in the electric chair on January 21, 1937, just ten months after he committed the murder. He was only twenty-five years old.

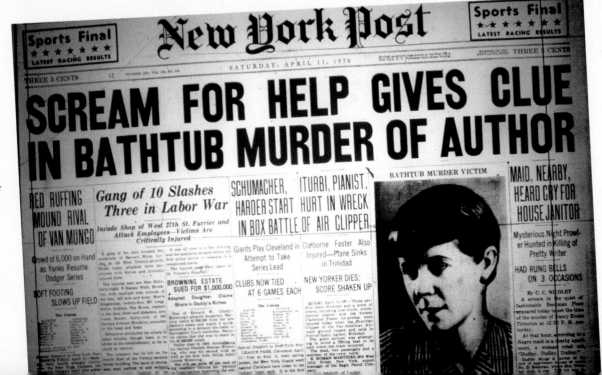

114

THE BUNGLED APPREHENSION OF HARRY BRUNETTE

Year 1936

Many assume that the FBI and the NYPD have always had a close working relationship. However in the early days of the Bureau, J. Edgar Hoover realized that to make his agency a force to be reckoned with, the Bureau needed to make spectacular, headline-grabbing arrests of America's most wanted criminals. In order to do that, it might mean unnecessarily endangering innocent civilians and upsetting other law enforcement authorities.

Twenty-five-year-old Harry Brunette was a small-time hood looking to make a big name for himself. A string of bank robberies in New Jersey coupled with the kidnapping of New Jersey state trooper William Turnbull, who had pulled him over for a traffic violation, fulfilled his wish. By November 1936 he was one of the most wanted men in America. The trooper survived the ordeal when Brunette dumped him out of the car on a rural Pennsylvania back road, without his uniform and pistol, before speeding away. A law enacted after the Lindbergh baby kidnapping made Burnette's crime a federal offense and brought the FBI in on the case. Fortunately, Turnbull remembered the car's Michigan license plate number and the pretty face of Brunette's female companion.

Several weeks later the New Jersey state police got a lead that the car in question had been in for repairs at a shop in Manhattan on West 108th Street. The troopers contacted the NYPD in early December for assistance.

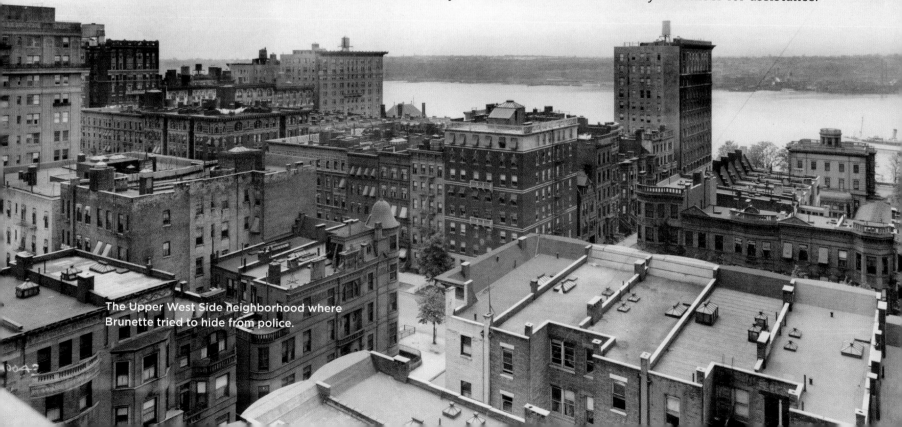

The Upper West Side neighborhood where Brunette tried to hide from police.

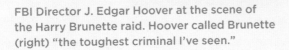
FBI Director J. Edgar Hoover at the scene of the Harry Brunette raid. Hoover called Brunette (right) "the toughest criminal I've seen."

Employees at the garage identified Harry Brunette as the owner of the car from a police mugshot. A canvass of the neighborhood revealed that Harry had recently married Arline LeBeau and the pair resided on the ground floor of a five-story apartment building on West 102nd Street. Trooper Turnbull eyeballed LeBeau from a safe distance and positively identified her as the woman who was riding with Brunette the night he was abducted. From that point the police had LeBeau and the apartment under constant surveillance. Brunette himself was more elusive and was seldom seen. A plant inside the apartment building told them that he was a night owl who slept most of the day. Since the police considered Brunette armed and extremely dangerous, they decided to wait until they were sure he was asleep before conducting a raid.

The New Jersey State Police and the FBI agreed that the NYPD would handle the capture, since Brunette was hiding out in their jurisdiction. As a courtesy, Police

Commissioner Lewis Valentine notified Director Hoover of the exact time and date so he could be present during the apprehension, which was set for two o'clock Monday afternoon, December 14.

Valentine never expected Hoover to double-cross him. Hoover arrived the night before with two dozen agents and personally took over the operation. His second in command, Clyde Tolson, would effect the arrest.

At 1:30 A.M., Hoover gave his men orders to blast apart the lock on Brunette's apartment door with a shotgun. But Brunette, who police knew was always awake at night, was ready for them. He opened fire with a .45-caliber automatic and a pair of .45-caliber revolvers. Even though he was outnumbered twenty-five to one, Brunette refused to surrender.

Hoover ordered tear gas to flush him out. But when the canisters erupted, the curtains caught fire, putting the lives of every resident in the building in danger. Despite the thickening smoke, Brunette fought on, only ceasing fire for a moment so his wounded bride could be helped out of the burning apartment by the agents.

A fire company responded to the scene unaware that a pitched gun battle was under way. The firemen suddenly found themselves dodging bullets in conjunction with dousing flames. They bravely raised their aerial ladder, ready to pour water down on the building if the fire spread. The only member of the NYPD to take part in the shootout was Sixth Deputy Commissioner Byrnes MacDonald, who inexplicably decided to climb a fire ladder leaning against the building in order to shoot down at Brunette through the front-floor window. (Several weeks later Valentine permanently removed MacDonald from night duty after learning how he bragged about his foolhardy actions.)

It took thirty-five minutes for Brunette to run out of ammunition. When he emerged from the smoky haze with his hands up in the air, not a single G-man's bullet had found its mark. "What a brave bunch of guys," he sneered as he surrendered. He was led out of the smoldering vestibule toward a crowd of photographers by Clyde Tolson.

The firemen raced inside and put out the fire. Fortunately, the damage was limited to Brunette's apartment. Miraculously, with the exception of his wife—who had taken a round to the back—no other tenant was injured.

Despite the chaos Hoover was thrilled with the results. He called Brunette "the toughest criminal I've ever seen," but both the fire commissioner and Police Commissioner Valentine were furious with him for endangering so many innocent lives.

Valentine claimed that Hoover did not even know where Brunette was hiding out until he told him. In addition, he accused Hoover of concocting a story of NYPD detectives sleeping on the job to justify his own actions. Hoover later conceded that Valentine's men had only left the scene momentarily to get a cup of coffee. There also appeared to be validity in Valentine's statement about Hoover's lack of knowledge of Brunette's whereabouts, because Hoover refused to disclose how he got his information.

Brunette pleaded guilty and was sentenced to life in prison just four days after his capture. His wife recovered from her wounds and was sentenced to serve time in a women's reformatory for her part in her husband's crimes. Although Valentine and Hoover were forced to cooperate again many times after that, especially during World War II when the FBI was in charge of hunting down spies, their relationship never fully recovered from what happened that night on the Upper West Side.

Police Commissioner Lewis Valentine wrote that the NYPD plan of arrest was "ignored by the federal men who, evidently without concern for the public welfare or for the many families residing in the large apartment house, with tear gas bombs and gunfire staged a raid over the protest of the New Jersey state police and contrary to the agreement entered into by the three departments."

117

Robert Irwin, aka "The Mad Sculptor," in a
picture that seems to capture his mental state.

THE MAD SCULPTOR

Year 1937

Easter Sunday is a day of rejoicing for Christians around the world. But in Beekman Place on March 28, 1937, a beautiful young girl, Veronica Gedeon, was found strangled to death in her mother's flat. She was the first of three homicide victims that were discovered in the apartment that day.

The vivacious twenty-year-old, known by her friends as "Ronnie," made a living as a photographer's model, often posing in the nude. Her pretty face and scantily clad body graced the covers of the popular detective pulp magazines of the day.

Veronica's parents, Joseph and Mary Gedeon, were separated, in part because her father, a stern Hungarian immigrant, did not approve of his daughter's livelihood. As a result, Veronica lived with her mother and a boarder, a deaf Englishman, in a fourth floor walk-up on East Fiftieth Street in Manhattan. Veronica's older sister, Ethel, had recently married and moved to Astoria with her husband.

The family planned to have supper together for Easter. Mr. Gedeon arrived at the lobby around three P.M. and rang the doorbell to the upstairs apartment. There was no answer. A few minutes later Ethel and her husband arrived. Mr. Gedeon left them downstairs and went up to get his wife and daughter. He knocked on the apartment door. There was still no answer, but from inside he could hear the incessant yapping of the family dog, a Pekinese named Touchi. He tried the door. It was unlocked so he let himself in. Mr. Gedeon noticed was that there was food on the kitchen table, but other than the dog, the apartment appeared vacant. On the off chance that his wife and daughter were napping, Mr. Gedeon checked the bedrooms. What he saw sent him reeling. Veronica's naked, lifeless body was splayed on top of the bed with bluish strangulation marks around her neck. He found the English lodger also dead in another bedroom, his pillow covered with coagulated blood. Mr. Gedeon raced down the stairs and told his daughter and son-in-law what he had found. As Ethel burst into tears, Mr. Gedeon took off to find the police.

Within minutes, detectives from the nearby Seventeenth Precinct arrived on the scene. They discovered Mrs. Gedeon's corpse shoved under the bed, strangled just like her daughter. Although she was wearing a housedress, her underwear was missing. This led detectives to believe that both women had been raped, although forensic examination would prove otherwise. Nevertheless, the initial salacious details surrounding the triple homicide would captivate New Yorkers for months to come.

The police determined that each woman had put up a fierce struggle against her attacker, but that the deaf boarder had probably been stabbed as he slept and never heard the commotion just outside his bedroom door. Among the items investigators recovered in the living room were shavings from a bar of soap, a bloody towel, a single gray glove, and the tattered negligee that had been torn from Veronica's body. Since there were no signs of forced entry, detectives assumed the victims knew their assailant.

During a search of the apartment, detectives recovered Veronica's diary. It contained a long list of acquaintances. Most of them were well-to-do men. There were also mysterious entries in which she identified an unknown individual by the single letter B. During the next forty-eight hours detectives questioned as many of her contacts as they could find, including Veronica's ex-husband, Robert Fowler, and her escort from the night before her murder, Stephen Butter. Since Bob was short for Robert, and Butter's last name started with a B, police wanted to ascertain if either man was the person she was writing about in a peculiar entry that indicated she had a problem with B.

Butter admitted that he and Veronica went out together

Veronica Gedeon was a beautiful young model who often found work posing in the nude. In her diary police found entries that indicated she feared Robert Irwin.

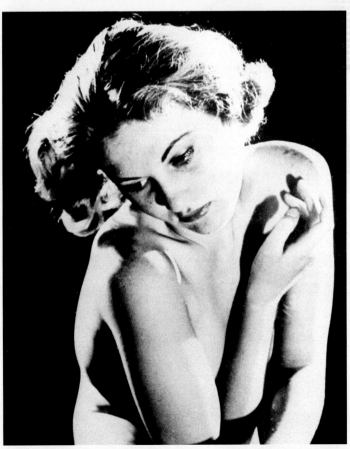

the night before, and both had far too much to drink. He dropped her off around three A.M. and tried to call in the morning to take her to church, but nobody answered the telephone. After detectives eliminated him and her former husband as suspects, they shifted their focus onto Veronica's father.

Mr. Gedeon's alibi for the night of the murder had holes in it. The fact that he was estranged from his wife and expressed an aversion to his daughter's occupation added to their suspicions. But what really piqued their interest was what they found during a search of his upholstery shop/residence on East Thirty-Fourth Street. There were several lewd pictures of naked women tacked to the wall, and a long, sharp upholstery needle was missing from his sewing kit. Since its characteristics were similar to those of the murder weapon that killed the Englishman, Mr. Gedeon was brought in for questioning.

Seventeenth Precinct Detective Thomas Tunney was assigned to extract his confession. Despite an intense thirty-hour interrogation, during which Mr. Gedeon's lawyer claimed that his client was subjected to the brutal Third Degree, Veronica's father maintained his innocence. The police finally released him, but not before replacing his busted eyeglasses.

Frustrated detectives turned to his daughter Ethel and asked if she knew anyone else Veronica could have been referring to in her diary with the letter B. Ethel hesitantly mentioned Robert Irwin, a sculptor who had once boarded with the family, but she insisted that he was incapable of committing murder. Despite Ethel's assurances, detectives decided to look into Irwin's background.

As this was going on, in a rented room just two blocks from the crime scene, the same Robert Irwin was following the police investigation with great interest. Three years earlier he had become smitten with Ethel and wanted to marry her. Although she enjoyed the attention, his feelings were not reciprocated. In desperation, he attempted to castrate himself with a razor in order to devote his life to art instead of the pursuit of unrequited love. Ultimately, the self-inflicted wound did not alleviate all of his feelings for Ethel. He was remanded to Bellevue Hospital and after several months transferred to a mental institution in Rockland County. Eventually Irwin's condition improved enough that he was allowed to enroll in a divinity school at St. Lawrence University, far north in upstate New York.

While at the university he honed his craft, but Irwin's temperament often alternated between brilliance and belligerence. Finally the staff could no longer take his mood swings, and he was expelled. Irwin decided that Ethel was to blame for his erratic behavior, and he returned to the city to fix the problems in his life by sacrificing hers.

The night before Easter, he paid a visit to the Gedeon household in search of his old flame, but her mother was alone in the apartment. She let him in. The pair exchanged pleasantries while she started to prepare dinner. After the Englishman came home and retired to his bedroom, Mrs. Gedeon tried to get Irwin to leave, but he insisted on waiting to see Ethel. Mrs. Gedeon scolded him, saying he was not thinking right, that Ethel was happily married. Irwin became enraged. He blamed her and Veronica for his failed relationship with Ethel. He latched on to her neck and started to squeeze. Mrs. Gedeon clawed his face as they

LEFT: In one of Robert Irwin's sculptures found at the crime scene, he depicts a woman's head and breasts on the curling body of a venomous cobra. RIGHT: Police dusting items in the Gedeon apartment for fingerprints in hopes of identifying the killer.

fell to the floor, but in the end Irwin's hands, hardened from years of working with stone, were too strong. Still, it took twenty minutes for him to choke the life out of her. He dragged her body under the bed and removed her underwear. Then in a display of complete depravity, he urged Touchi the dog to desecrate her.

Irwin was surprised the noise did not rouse the Englishman. He decided to leave him alone for the time being and wait for Veronica to come home. To pass the time he began carving a bar of soap. When finally she opened the door, he ducked into the shadows and watched her tiptoe into the bathroom, careful not to disturb her mother. As Veronica slipped into a negligee, Irwin fashioned a makeshift bludgeon out of the bar of soap and a sock. When Veronica stepped out of the bathroom, he clubbed her from behind, but the soap was too soft to knock her unconscious. Irwin grabbed her around the neck. Rather than choke the life out of her, he prolonged her agony by tightening his grip and then releasing it just long enough for her catch a breath, until she gasped, "I know it's you, Robert." With that, he crushed her windpipe, stripped her naked, and carried her to the tiny bedroom. Although he realized the Englishman had not heard anything, he did not want him talking to the police in the morning, so he creeped into his bedroom and jabbed an ice pick into his skull as he slept.

By the time the police zeroed in on Irwin, he had vanished. Nevertheless, Police Commissioner Lewis Valentine insisted that Irwin was still in the city. He ordered a massive manhunt until a detective undertook his own search of the lockers at Grand Central Terminal. His gut feeling panned out. The detective located a satchel bearing Irwin's name and an alarm clock that had been missing from the apartment. The NYPD transmitted a teletype message to the surrounding states to be on the lookout for him.

The publisher of *Inside Detective*, a magazine that Veronica once posed for, wrote a story about her murder and offered a reward for anyone who had information that would lead to Irwin's arrest and conviction.

Irwin spent the next three months working in anonymity at a hotel in Cleveland under the alias Robert Murray. On Wednesday night, June 23, a young coworker of his named Henrietta Koscianski thumbed through the latest copy of her favorite true-crime magazine before going to bed. She happened upon the article about Veronica Gedeon's murder and an advertisement promising a substantial reward for information leading to the arrest of Robert Irwin. She could not help but think how much Irwin looked like her workmate. Two more days passed before she mentioned the

ABOVE: The command log entry in the Seventeenth Precinct by Captain Curry indicating he left at 3:15 P.M. for the Gedeon apartment to view the homicide.

LEFT: After his triple murder conviction, Robert Irwin was sentenced to Sing Sing prison but was soon transferred to a mental institution, where he served out his life sentence.

uncanny resemblance to him. Murray suddenly became agitated and skipped out of work. Henrietta told her boss, who in turn notified the authorities. The Cleveland police rushed to the bus terminal only to find that a man fitting Irwin's description had already boarded a Greyhound for Chicago. The Chicago police were notified to pick him up.

But Irwin was shrewd. He got off the bus before it arrived in Chicago and placed a telephone call to the *Chicago Herald-Examiner*. In exchange for five thousand dollars, he offered to sell the Chicago daily exclusive rights to his life story, including the reason he committed the three murders. The editor agreed to his terms. After Irwin's sensational confession, the newspaper turned him over to the NYPD. When he reached New York, Irwin used the money to hire the best lawyer in the city, Sam Leibowitz, whose claim to fame was that not a single one of his clients had ever received the death penalty. Irwin's strategy paid off. While he should have been executed in the electric chair, he spent the rest of his life as a celebrity patient in an asylum for the mentally insane until his death from cancer in 1975.

Thousands gathered at the German American Bund's Americanization Rally at Madison Square Garden to praise Hitler in February 1939.

NAZIS IN NEW YORK

Years 1935–1941

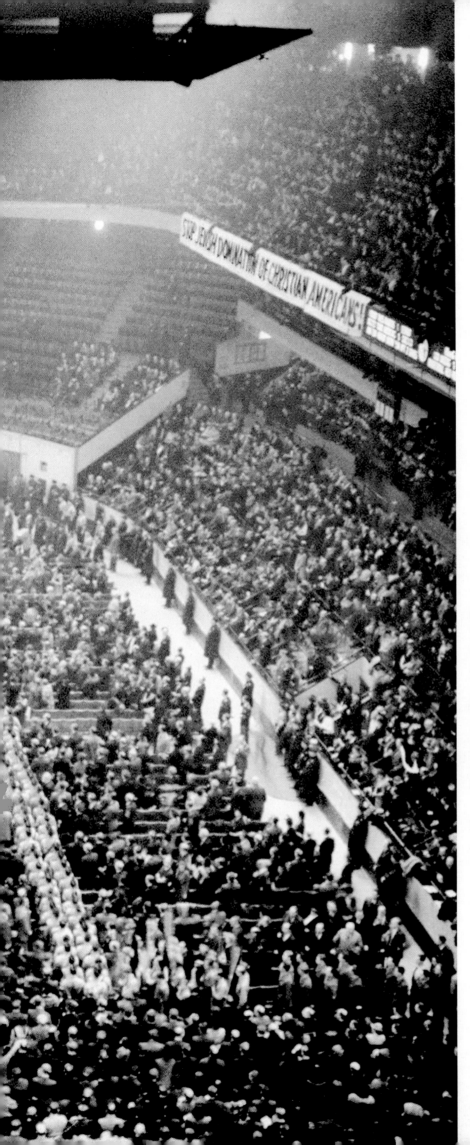

America was in the throes of a great depression during the 1930s. For many Americans there appeared to be no way out of it. But in Germany a man had come to power who seemed to know how to create prosperity. His name was Adolf Hitler. Among his many admirers in the United States were aviator Charles Lindbergh, chairman of the American Olympic Committee Avery Brundage, automotive pioneer Henry Ford, Catholic Church radio personality Father Charles Coughlin, and newspaper magnate William Randolph Hearst.

A majority of American citizens were of German descent, so it was only natural that some of them would want to emulate the success of Hitler and his Nazi party. Early on they formed the Friends of New Germany in 1933. Two years later the movement's leader, Jackson Heights resident Fritz Kuhn, a native German and former chemist in the automobile industry, rebranded the organization as the German American Bund. Although Kuhn claimed the organization aims were to promote Christian values, defend the Constitution, and see to it that the hundreds of millions of Americans with ties to Germany had a voice in this country's affairs, it was his anti-Semitic, anti-communist, pro-Nazi views that attracted most of the

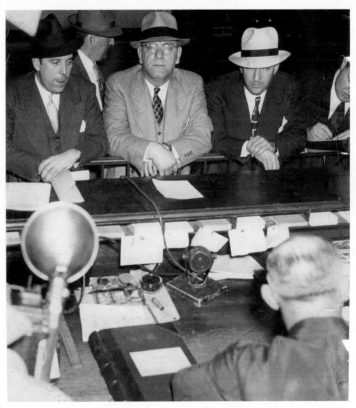

Fritz Kuhn, leader of the German American Bund, was arrested and convicted of embezzling the organization's funds. He spent the entire war in jail. After his release he moved to Germany and found work as a baggage handler.

123

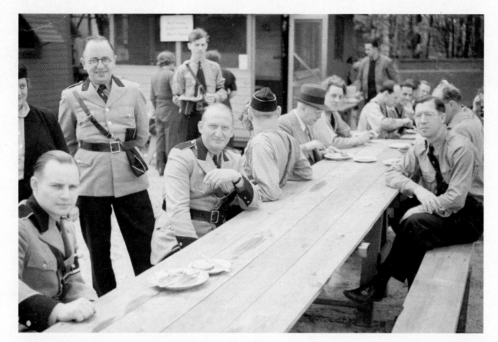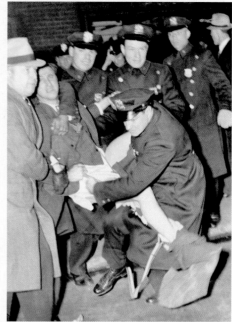

LEFT: Before the war, Camp Siegfried was a popular German American Bund recreation center in Yaphank, Long Island, where Nazi sympathizers gathered on weekends. RIGHT: Isidore Greenbaum, a Jew, tried to jump on the stage at the German American Bund extravaganza at Madison Square Garden. He wanted to denounce the pro-Nazi organization but was taken away by police.

attention. At its height, Kuhn claimed the Bund had 200,000 active members (government officials put the number at 25,000) and up to eighty separate posts scattered across the country.

From 1935 until the start of World War II, Bund camps were popular summer destinations for German Americans. Visitors to these camps paraded around in Nazi-style uniforms, exchanged *Sig Heils*, and held pro-Nazi rallies. They also drank a lot of beer. On Long Island, just fifty miles east of New York City, at Camp Siegfried, in a newly formed exclusive German community, the streets were named after Nazi leaders and the flowers in the garden blossomed into the shape of a giant swastika.

In New York City, Mayor Fiorello La Guardia, whose mother was Jewish, had little use for the Bund or its thousands of followers who resided in Yorkville. As reports of Nazi atrocities in Europe began to reach the American shore, there was growing concern that the Bund harbored spies and saboteurs for Nazi Germany. But as a liberal politician, La Guardia was wholly committed to free speech, even speech he did not approve of. In February 1939, Kuhn scheduled a rally replete with storm-trooper uniforms at Madison Square Garden on George Washington's birthday to celebrate America. LaGuardia ordered the NYPD to protect the group against socialists, anti-Nazi protesters, and even the gangs of Jewish mobsters Meyer Lansky, Bugsy Siegel, and Mickey Cohen.

Police Commissioner Lewis Valentine assigned 1,700 patrolmen to the security detail commanded by the department's first Jewish chief inspector, Louis Costuma.

Twenty-two thousand Bund members attended the rally. Loud cheers emanated from within the crowd when Fritz Kuhn said that he intended to do everything he could to protect the country from the Bolsheviks, while the mere mention of President Roosevelt—whom other guest speakers called President Rosenfeld while they referred to his New Deal as the "Jew Deal"—brought out the boos.

Although the rally was considered a success by those in attendance, it harkened the beginning of the end for the organization. Shortly afterwards, Fritz Kuhn was indicted for embezzlement of Bund funds sent to Sing Sing. His successor was not able to keep the Bund afloat. Many of its most ardent members joined America First, an organization dedicated to keeping America out of the war, a process that aided the Nazi cause abroad. But by the time the United States entered World War II, neither America First nor what was left of the Bund held much sway.

After his release from jail, Kuhn was detained in a prisoner-of-war camp for the rest of the war. In 1946 he was declared a "useless" Nazi prisoner along with 50,000 others and sent back to Germany as an undesirable alien. Although he was a trained chemist, the only work he could find until he died in 1951 was that of a baggage handler at a train station.

In July 1940 the Germans seemed poised to defeat England. At home Americans were divided on what to do, with each combatant having its share of supporters. President Roosevelt desperately wanted to help the English before it was too late. Others wanted the country to stay out of Europe's affairs.

For the millions who visited the 1940 World's Fair in Flushing Meadow Park, it provided a pleasant diversion from the realities abroad. The International Zone at the Fair housed pavilions from many of the European nations that were at war. A display of captured Nazi contraband in the British Pavilion was a particularly popular exhibit that summer. Although the fair had been trouble-free, the police had reason to be concerned as Independence Day approached. The switchboard operator at the British Pavilion reported receiving several anonymous telephone calls

THE WORLD'S FAIR BOMB

Year 1940

The scene at the 1940 World's Fair in Flushing Meadow Park after a bomb exploded and killed NYPD bomb squad detectives Joseph Lynch and Freddy Soccha.

days before from a man with a German accent claiming that the exhibition hall would be bombed. On the Fourth of July, the NYPD posted several detectives in and around the pavilion to keep an eye on the crowd for possible wrongdoers.

Despite the precautions, a new threat was called in on July 4. During a search of the building, an electrician reported finding a small suitcase in the upstairs ventilation control room. It was ticking. Detective William Morelock picked up the suitcase and carried it to the edge of the fairgrounds. The Emergency Services Squad cordoned off the area with rope. Two detectives from the Bomb Squad, Joseph Lynch and Ferdinand Socha, were called in to investigate. They received a briefing from police brass before approaching the suitcase. At the time, they had no protective clothing and their tools were limited to a pocket knife, a pair of pliers, and a screwdriver. Still, they had a job to do, and it required them to look inside the suitcase. Socha carved out a small hole in the thin wood veneer. Lynch then peered in and uttered his last words: "It looks like the real deal." The

> ## Lynch then peered in and uttered his last words: "It looks like the real deal."

Detective Ferdinand Socha (left) was killed along with his partner, Detective Joseph Lynch, while attempting to defuse the bomb.

bomb suddenly exploded, killing Lynch and Socha instantly. The blast, equivalent to sixteen sticks of dynamite, also severely injured four other detectives and a patrolman in the immediate vicinity.

Mayor Fiorello La Guardia cut short his summer vacation and rushed back to the city to take charge of the investigation. Within hours the NYPD launched the largest manhunt in department history for the suspected bomber. It was presumed to be the handiwork of a Nazi

Detective William Morelock explains to Mayor Fiorello LaGuardia and Police Commissioner Lewis Valentine how he carried the bomb away from the British Pavilion by hand after it was discovered.

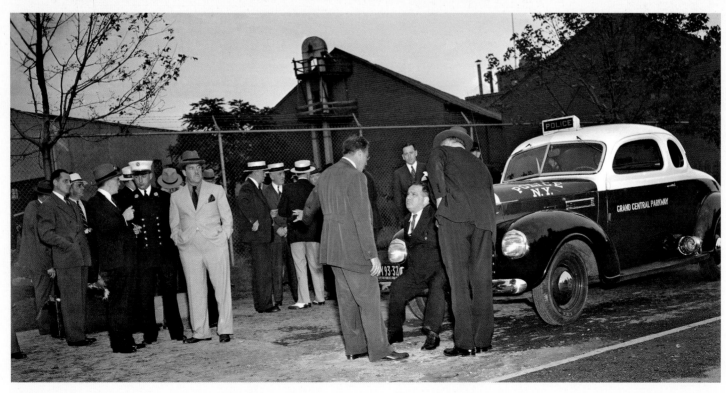

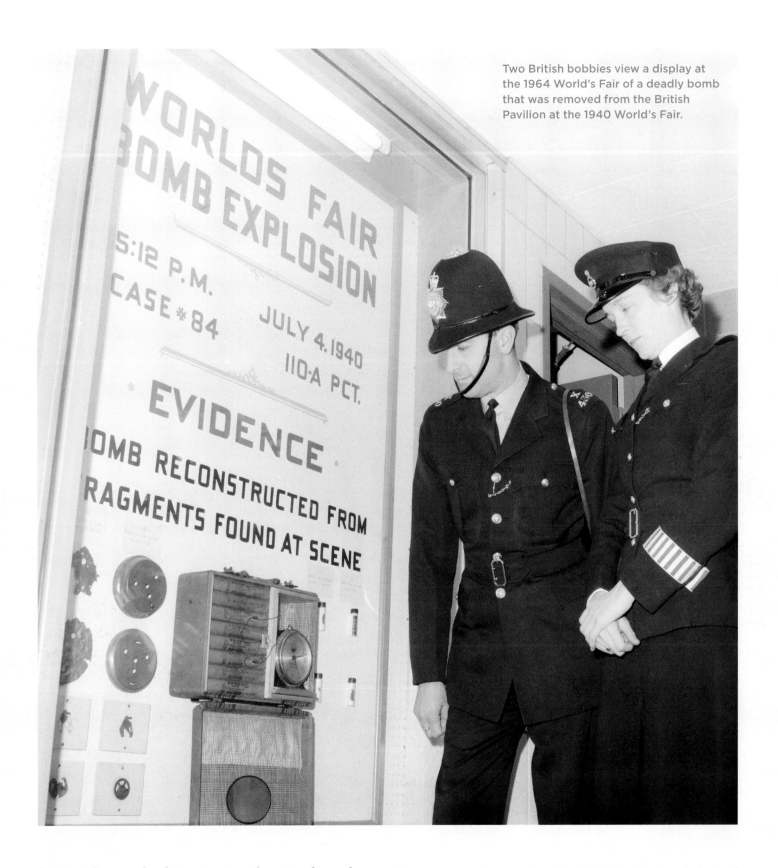

WORLDS FAIR
BOMB EXPLOSION
5:12 P.M.
CASE #84
JULY 4, 1940
110-A PCT.

EVIDENCE
BOMB RECONSTRUCTED FROM
FRAGMENTS FOUND AT SCENE

saboteur. Thousands of German American Bund members were rounded up, along with hundreds of communists, anarchists, fascists, and IRA sympathizers. The Board of Aldermen posted a $25,000 reward for information leading to the capture of the perpetrator.

No one was ever charged with the crime. The Cold Case Squad re-examined the case in the late 1990s to no avail.

The case remains unsolved to this day. The tragic loss of life, however, led to the creation of the world's first bomb disposal vehicle, the La Guardia-Pyke bomb carrier truck (named after Mayor La Guardia and the vehicle's designer and NYPD Bomb Squad commander, Lieutenant James Pyke), so that suspected explosive devices could be safely transported to secure areas to be detonated.

Members of the Bomb Squad utilize an iron-mesh sealer to remove an explosive device planted in the Paramount Theater.

"THE MAD BOMBER"

Year 1940

On November 16, 1940, a crude explosive device secreted inside a wooden box was discovered on a window sill at the West Sixty-Fourth Street power plant of Consolidated Edison. Alongside the bomb was a note that read in capital block letters, "CON EDISON CROOKS, THIS IS FOR YOU." It was signed, "F.P." Fortunately the bomb turned out to be a dud. Nevertheless, the NYPD was very concerned. Four months earlier a bomb had detonated at the New York World's Fair and killed two detectives. The case was still open, and the police wondered if the two incidents were related.

In September 1941, another explosive device was found near Con Ed's offices at East 19th Street and Irving Place. There was no note, and it was hidden in a woolen sock. The fuse was unlit, leading the police to believe the bomb suspect might have been scared off by a patrolman walking the beat.

The police initially thought the bombs targeting the electric plants were the handiwork of Nazi saboteurs. However, shortly after America entered the war, the department received an anonymous letter in the same block-letter format that allayed those fears: "I WILL MAKE NO MORE BOMB UNITS FOR THE DURATION OF THE WAR—MY PATRIOTIC FEELINGS HAVE MADE ME DECIDE THIS—LATER I WILL BRING THE CON EDISON TO JUSTICE— THEY WILL PAY FOR THEIR DASTARDLY DEEDS…F.P."

"Later" came some six years after VE Day. In March 1951, police received a new letter stating that a bomb would explode at Grand Central Terminal. Fortunately, the Bomb Squad located the device and defused it before it detonated. But a month later, a fourth device became the first to blow up, this time in front of the New York Public Library. Nobody was hurt. That August, another bomb placed inside Grand Central Terminal exploded, but once again, luckily there were no injuries.

In October 1951, the *New York Herald Tribune* received a letter in the familiar block letter format that pronounced, "BOMBS WILL CONTINUE UNTIL THE CONSOLIDATED EDISON COMPANY IS BROUGHT TO JUSTICE FOR THEIR DASTARDLY ACTS AGAINST ME. I HAVE EXHAUSTED ALL OTHER MEANS. I INTEND WITH BOMBS TO CAUSE OTHERS TO CRY OUT FOR JUSTICE FOR ME."

The link between all of the bombs was now conclusive. Newspapers dubbed the unknown perpetrator "the Mad Bomber of New York."

Over the next three years, more bombs were found inside Penn Station, the Port Authority Bus Terminal, and the Oyster Bar at Grand Central Terminal. Although the damage they caused was minimal, the public was nervous. In 1954 several people were injured by explosions in a Grand Central Terminal men's room and at Radio City Music Hall. The bomber sent a letter to the *New York Herald Tribune*, apologizing for the injuries he caused, but claiming, "IT CANNOT BE HELPED—FOR JUSTICE WILL BE SERVED"— signed "F.P."

Throughout 1956 the Mad Bomber intensified his campaign. A device planted in a Penn Station restroom exploded and seriously injured an elderly attendant. Over the Christmas holiday another bomb left inside the Paramount Theater in Brooklyn wounded six people during a showing of the film *War and Peace*.

Police Commissioner Stephen P. Kennedy called the bomber's actions "an outrage that cannot be tolerated," and he promised "an immediate good promotion" to whoever apprehended him. Then he ordered what he described as

A detective dusts for fingerprints inside a telephone booth where a gunpowder-packed pipe was found at the New York Public Library.

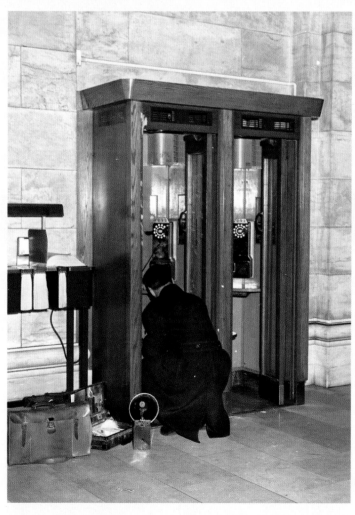

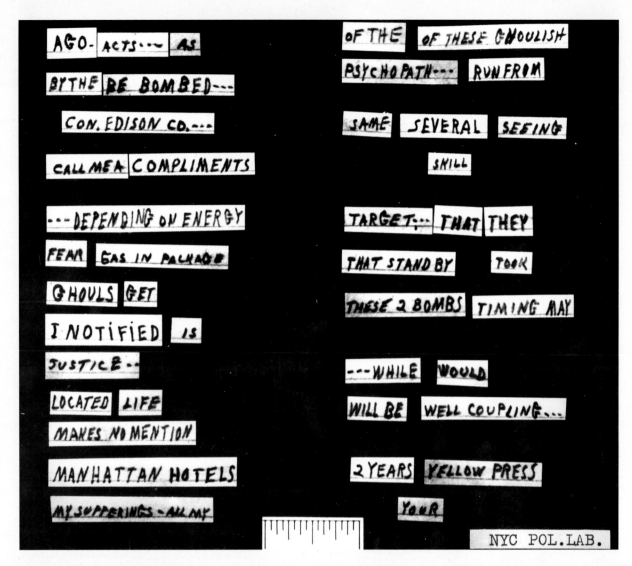

"the greatest manhunt in the history of the police department" to get under way. The New York City Board of Estimate and the Patrolmen's Benevolent Association offered a joint reward of $26,000 for the Mad Bomber's capture.

The NYPD became so desperate that it hired a psychiatrist named Dr. James Brussel to prepare a "profile" of the bombing suspect. At the time many police experts viewed the use of such a methodology as quackery. Dr. Brussel described the bomber as an unmarried, middle-aged man who probably lived with a woman who filled a maternal role in his life; he also said the bomber suffered from progressive paranoia. He believed the subject might possibly reside in Connecticut, because many of his letters had been mailed from White Plains, New York, a midway point between New York City and the border of the Constitution State. He also went out on a limb and predicted that the culprit would be wearing a double-breasted suit when he was apprehended.

Dr. Brussel further exhorted the police, who were traditionally tight-lipped while conducting investigations, to heavily publicize the profile he created. He believed that it would result in the bomber writing back in order to set the record straight for any mistakes he made. The more he wrote, Dr. Brussel explained, the more information he would be able to glean.

The police asked the publisher of the *New York Journal-American*, Seymour Berkson, to print an open letter to the bomber urging him to surrender and promising that he would be treated fairly. Key information was purposely misstated in the letter to goad the bomber into sharing more about himself and his motives. The Mad Bomber responded that he blamed Con Ed for an on-the-job injury that led him to developing tuberculosis. It was the clue the police were looking for.

In January 1957, a Con Ed secretary searching the company files discovered similarities between the letters

from F.P. and information in a former employee's old personnel file. That information led police to the Waterbury, Connecticut, home of George Metesky, a fifty-three-year-old bachelor who lived with his two sisters. Although Metesky often wore double-breasted suits, the former Marine answered the door in his pajamas when detectives called on him.

"I know why you fellows are here," he said calmly. "You think I'm the Mad Bomber."

Metesky confessed that he was responsible for the sixteen-year reign of terror in New York City. He explained that many years earlier he had been employed by the United Electric Light and Power Company, which later became Consolidated Edison. In 1931, he was permanently injured by a boiler explosion at the uptown Manhattan electric plant near Hell Gate. Metesky lamented, "I did not get a single penny for a lifetime of misery and suffering." Con Ed representatives countered that Metesky would have been treated fairly had he filed for disability benefits within the allotted time period.

Metesky went on to admit that he planted a total of thirty-three pipe bombs in Manhattan and Brooklyn,

The "Mad Bomber" responded that he blamed Con Ed for an on-the-job injury.

twenty-two of which exploded, resulting in fifteen injuries. After his arrest he provided the location of an unexploded device concealed in a scooped-out seat in a movie theater, where it had lain dormant for several years.

Metesky was diagnosed as a paranoid schizophrenic and sent to the Matteawan Hospital for the Criminally Insane in upstate New York. He was released in December 1973 and returned to Waterbury, where he lived quietly until his death in 1994.

By the time of his death, the use of bombs as a terrorist tool had become common, as had the use of criminal profilers to apprehend suspects. As for Metesky's sign-off of F.P. in all of his written correspondence, he said the initials stood for "Fair Play."

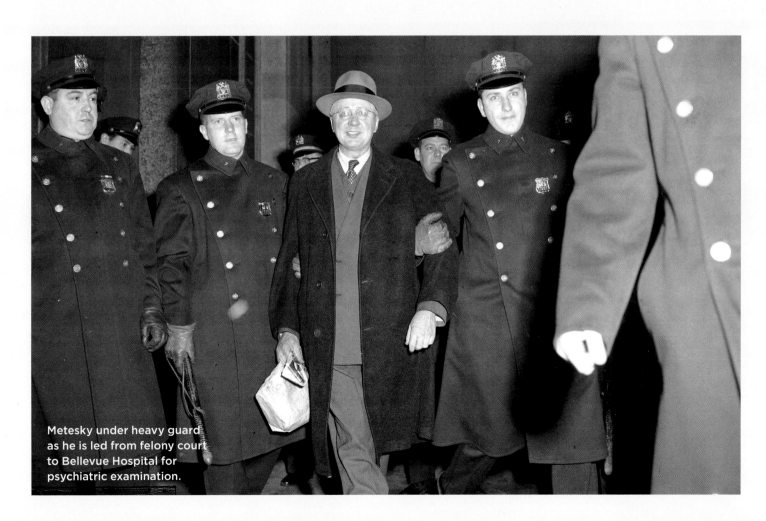

Metesky under heavy guard as he is led from felony court to Bellevue Hospital for psychiatric examination.

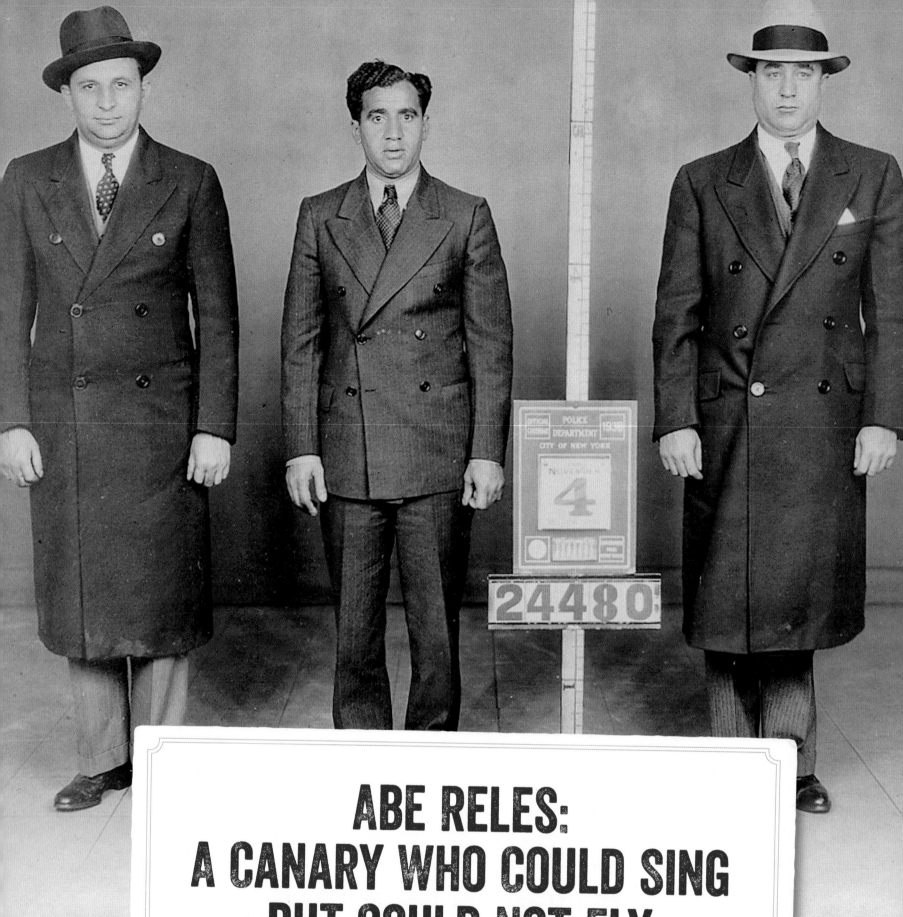

ABE RELES:
A CANARY WHO COULD SING
BUT COULD NOT FLY

Year 1940

Until it became gentrified, the Brownsville section in Brooklyn was a poverty-stricken, crime-ridden neighborhood that most outsiders avoided at all costs. It spawned the likes of fearsome heavyweight boxer Mike Tyson, who was born there in 1966 and had an arrest record before he reached puberty. Fifty years before his birth, Brownsville was a Jewish bastion that produced entertainment heavyweights Danny Kaye, Larry King, Steve Lawrence, and Phil Silvers. It was also home to a treacherous criminal enterprise comprised of Jewish gangsters and Italian mobsters that the press dubbed Murder Incorporated.

The organization was run out of Midnight Rose's Candy Store at 779 Sutter Avenue by labor racketeer Louis "Lepke" Buchalter. Its function was to perform contract killings for La Cosa Nostra, the Italian organized crime network that took over the rackets after its gangsters elbowed out their Jewish brethren.

Throughout the late 1920s and 1930s, Italian chieftains such as Albert "Lord High Executioner" Anastasia and Charles "Lucky" Luciano would relay their contracts to Buchalter, who would pass on the orders to minions that included Abe "Kid Twist" Reles, Harry "Pep" Strauss, Albert "Tick Tock" Tannenbaum, and Martin "Buggsy" Goldstein.

Over the course of fifteen years, Murder Incorporated was believed to have been responsible for more than a thousand executions. While many of the assassins were prolific, none was more adept at murder than Abe Reles, a small, squat brute born in 1906 to Jewish parents who had emigrated from Austria in search of a better life. Although diminutive in stature, Reles grew up to become a cold and calculating killer who could wield an ice pick as well as a boxer used his fists. He was known for slamming the sharp picks into the ears of his victims so hard that the cause of death was often erroneously reported as a cerebral hemorrhage by the coroner.

Reles's nickname, Kid Twist, stemmed from his seemingly inhuman ability to completely twist the necks of his victims as he killed them. Although Reles was arrested numerous times by the police, for years he managed to stay out of jail by bribing jurists and intimidating witnesses.

His luck ran out in February 1940. Brooklyn District Attorney William O'Dwyer implicated him in eleven homicides. This time the charges were strong enough to put him in the electric chair, and Reles knew it. To avoid a death sentence, he became one of the first notable mob turncoats to sing like a proverbial canary. Reles broke the underworld code of silence in exchange for immunity and gave damning evidence against his friends and colleagues.

Reles proved to be as effective a fink as he was a killer. He provided information that led to the arrests and convictions of six underworld bigwigs, including his boss, Louis Buchalter, and his childhood pal, Buggsy Goldstein. All six gangsters would eventually be put to death in "Old

OPPOSITE PAGE: The short and squat Abe "Kid Twist" Reles (center) was a brutally efficient contract killer for Murder, Inc.

RIGHT: Abe Reles (seated, second from right) and his cohorts Harry Strauss, Martin Goldstein, and Harry Maione being grilled by detectives Albert Beron and Harry States.

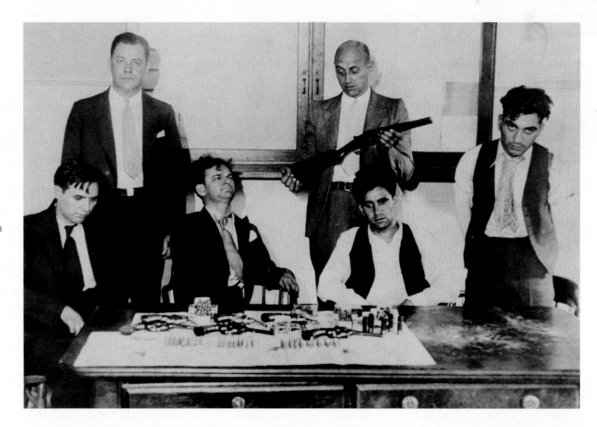

A detective examines a combination of sheets and wire used by Abe Reles in his unsuccessful attempt to escape from police custody on the sixth floor of the Half Moon Hotel in Coney Island.

from tuberculosis, and when he was really bored, he would spit contagious, blood-filled sputum at them.

As tough as it was to babysit Reles, nailing Anastasia was a top priority, and the officers felt that they would be rewarded with promotions if they put up with his shenanigans long enough to see Anastasia get the chair.

Reles was scheduled to offer evidence against Anastasia on November 12, 1941. The police checked on him at three A.M. He was sound asleep in his bedroom, but when they went to arouse him in the morning, they found his bed empty. A makeshift rope ladder fashioned out of knotted bedsheets tied to the radiator was hanging out the open window. Approximately forty feet below the window, Reles lay fully dressed, alive but unconscious on the roof of a restaurant. Within an hour he was dead. Cynical cops snickered that the only law Reles did not break was Newton's law of gravity, but without his testimony, O'Dwyer felt compelled to drop the charges against Anastasia.

> **Reles grew up to become a cold and calculating killer who could wield an ice pick as well as a boxer used his fists.**

Police Commissioner Lewis Valentine was furious. He demoted three detectives, James Boyle, Victor Robbins, and John Moran, and transferred two patrolmen, Frank Tempone and Harvey McLaughlin, for failing to safeguard the witness. Curiously, the lieutenant in charge of the security detail, Frank Bal, was a close personal friend of the district attorney. Despite his ineptitude, Bal was promoted to deputy police commissioner when O'Dwyer became mayor in 1946.

What really happened to Reles that night has provided fodder for crime and conspiracy buffs to this day. Some believe the bodyguards killed him for the reward money Anastasia put on his head. Others believe that for a fee, the officers let gangsters in the room to do their dirty work. Still others suggested the trajectory of the body indicated that Reles was hurled out the window and the bedsheets were nothing more than an amateurish attempt by the police to make it look like a botched escape attempt. Whatever happened will never be known for certain, for the truth as well as the case went out the window with Reles.

After his death, the press gave Kid Twist a new moniker: "The canary who sang but couldn't fly."

Sparky," a euphemism for the electric chair at Sing Sing. Right before the switch was pulled, a defiant Goldstein snarled, "I wish I could hold Reles's hand."

Although Reles gave a trove of intelligence to law enforcement, the man O'Dwyer wanted most was Albert Anastasia, the future kingpin of the Gambino crime family. As one of the founders of the American Mafia, Anastasia's ruthlessness was obscured by the duplicitous veil of respectability he possessed as a leader of the International Longshoreman's Association.

O'Dwyer planned on using Reles to prove Anastasia was responsible for the 1939 murders of Morris Diamond, a trucking union official, and Peter Panto, a renegade longshoreman. But Anastasia had no intention of letting Reles ever reach the witness stand. He put out a $100,000 contract on his head.

Reles was placed under round-the-clock police protection. Holed up on the sixth floor of the Half Moon Hotel in Coney Island, he was allowed to leave his room only to testify against his former cohorts. For the six officers guarding him, it was not easy duty. Reles was a mentally unstable eighth-grade dropout who liked to amuse himself at the expense of others—or in this case his police protectors. He would laugh uproariously after dousing their food with hot pepper, tossing wet paper towels in their faces, or lighting matches that he stuck in the soles of their shoes. To make matters worse for the guards, Reles suffered

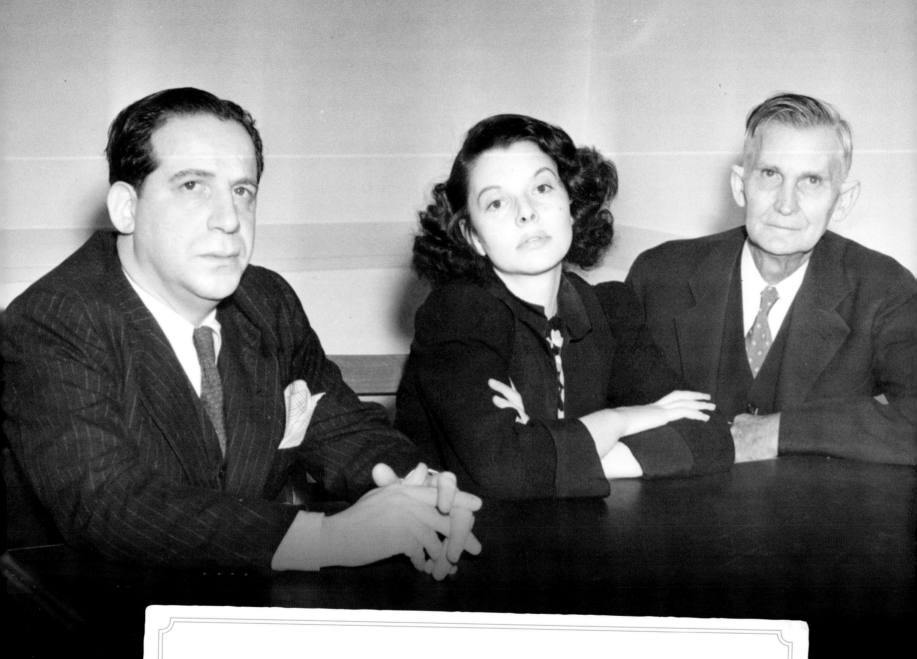

MADELINE WEBB, THE FEMME FATALE

Year 1942

Madeline Webb was a naïve twenty-six-year-old with a college degree in acting when she left her hometown of Stillwell, Oklahoma, in 1939 to pursue her lifelong dream of becoming a Broadway star. She was attractive enough to find occasional work as a pin-up model and chorus girl, but real fame eluded her.

Then she met a thirty-two-year-old con artist named Eli Shonbrun, a want-to-be big band singer whose own musical career never took off. Madeline fell hard for Shonbrun, even though he dabbled in petty crime to make ends meet. Shonbrun was still married when he proposed to Madeline, albeit with a stolen diamond ring. Together they would achieve notoriety, but not the kind Madeline had come to New York hoping to find.

On February 20, 1942, Madeline and her boyfriend registered under false names, Mr. and Mrs. Ted Leopold, at the swanky Sutton Hotel on East Fifty-Sixth Street in Manhattan. The alias would make it easier for them to skip out when the time came, but Shonbrun wanted to make a big score first. He contacted his uncle, Murray Hirschl, and his good friend, John Cullen. For hours the three men racked their brains trying to come up with a potential victim. Then Shonbrun remembered that Madeline had recently met a wealthy, fifty-two-year-old, Jewish patron of the theater, with whom she became friendly. The woman's name was Susan Reich. Perhaps they could lure her to the hotel and rob her. That afternoon they set their plan in motion.

Two days later, on March 4, Susan's husband, Dr. Marian Reich, reported his wife missing. Mrs. Reich's elderly aunt told police of receiving a phone call a day or two before from a woman who identified herself as Madeline Webb. Madeline said that she wanted Mrs. Reich to drop by the Sutton Hotel to meet her new husband and join them for lunch. Detectives followed up the lead, but when they arrived it was too late. A maid had already found Mrs. Reich dead on the floor, her mouth covered with adhesive tape. Her hands were bound behind her back, and a black-and-white scarf was still wrapped tightly around her neck. A $1,500 diamond ring, set in a platinum band, had been snipped from her finger. It was missing along with an expensive watch valued at $500.

It was a sad ending for Mrs. Reich. She and her husband had managed to escape their native Austria before the Nazis had a chance to ship them off to a concentration camp, only for her to be brutally murdered in America a few years later.

Detective Thomas Tunney of the Seventeenth Precinct worked the case. Five years before, he had helped solve a triple homicide committed by Robert Irwin, aka the Mad Sculptor. He was as determined to bring Mrs. Reich's killer to justice.

The Leopolds had snuck out of the hotel the day before, still owing seventeen dollars. Several workers described the couple as a tall, thin man in his thirties with a younger, beautiful wife. The search for the suspects' identities was over almost as soon as it began. Hirschl walked into the Seventeenth Precinct later that night and told detectives that his nephew wanted to sell him some jewelry that matched the stolen items described in the newspapers as having belonged to Susan Reich. Hirschl identified his nephew as Eli Shonbrun and his girlfriend as Madeline Webb. Hotel employees confirmed Shonbrun's identity from photographs in the Rogues Gallery and Madeline Webb from a modeling picture she once posed for. Police tracked Shonbrun and Madeline to an apartment building in the Bronx. When they were arrested on March 10, 1942, she told Detective Tunney, "I lived through the toughest week of my life. I had to live like a rat, ducking in and out of doorways, expecting to be arrested at any moment."

Detectives recovered the stolen diamond, which was hidden among Madeline's possessions. The third accomplice, John Cullen, was apprehended a short time later. Although Madeline claimed to have no part in or prior knowledge of the crime, she confirmed the scarf around Mrs. Reich's neck belonged to her.

The trial would be newly elected Manhattan district attorney Frank Hogan's first death penalty case. His assistant, Jacob Grumet, warned him, "Madeline has the sexiest walk of any girl I've ever seen," to which Hogan replied drily, "Then get her seated before they bring in the jury."

Mrs. Reich's aunt testified that it was Madeline's voice she heard on the phone inviting Susan to the hotel. That was enough to make her an accomplice even if she was not present, the district attorney said.

When Shonbrun took the stand, he said that the uncle was more deeply involved than he claimed. Hirschl helped plan the robbery and imitated Madeline's voice to lure Mrs. Reich to the hotel. He was the one who struck Susan in the head and tied her up and only got cold feet after they were unable to pawn the stolen jewelry. Shonbrun said Hirschl was trying to pin everything on him and Madeline and Cullen to save his own skin.

"As God is my judge, Madeline is innocent!" Shonbrun swore when asked about Madeline's role in the crime. "I sent her shopping before Mrs. Reich arrived." He also claimed that his friend John Cullen was not there, either.

Madeline tried to testify on her own behalf and that of her lover, but Grumet's line of questioning got her so upset that she started screaming vulgarities at him from the witness box. Jury members were appalled. One juror said, "We decided no innocent girl could act like that in public." They lost whatever sympathy they had for her, but agreed to spare her life.

Shonbrun and Cullen were sentenced to die in the electric chair. Madeline got life in prison. Hirschl was tried separately and found guilty of manslaughter. Shonbrun and Cullen were executed at Sing Sing prison on April 29, 1943.

Madeline served twenty-four years at Bedford Hills. After some initial hysteria, she settled in and became a model inmate. She used her college education to teach others. As a result, Governor Nelson Rockefeller commuted her sentence on Christmas Eve, 1967. Madeline returned to Oklahoma, where she died in anonymity in 1980.

LEFT: The *New York Post* story about the murder.

BELOW: Eli Shonbrun testified that Madeline was shopping when "Murray and I murdered the woman entirely alone" at the Hotel Sutton.

Woman Found Slain In E. 56th St. Hotel; Dancer Is Sought

By LAURENCE GREENE

Because a telephone went unanswered, the management of the Hotel Sutton, 330 E. 56th St., today discovered a strange murder.

A bellboy, sent to the rooms of Mr. and Mrs. Ted Leopold, on the second floor, found the body of Mrs. Susie Flora Reich, 52, a Pole who fled from Lwow two days after the Germans attacked Poland. Her hands and feet had been bound with rubber insulated telephone wire. Her mouth was sealed with adhesive tape, which also tightly bound her throat. Her skirt had been pulled over her head and her body bore marks of a frightful beating.

There was no answer when Harry Pearson, the bellboy, knocked on the door of Room 207. He opened it with a passkey. A radio was playing. He pushed at the door of 208, the

'Not a Pound'

BLOCK· 55 TO 56 STS; FIRST AVE TO SUTTON PLACE. NEW YORK· LOOKING S.E. AT EASTERLY SIDE FIRST AVE. NOS. 1020 TO 1006 ·NOV. 15. 1950·

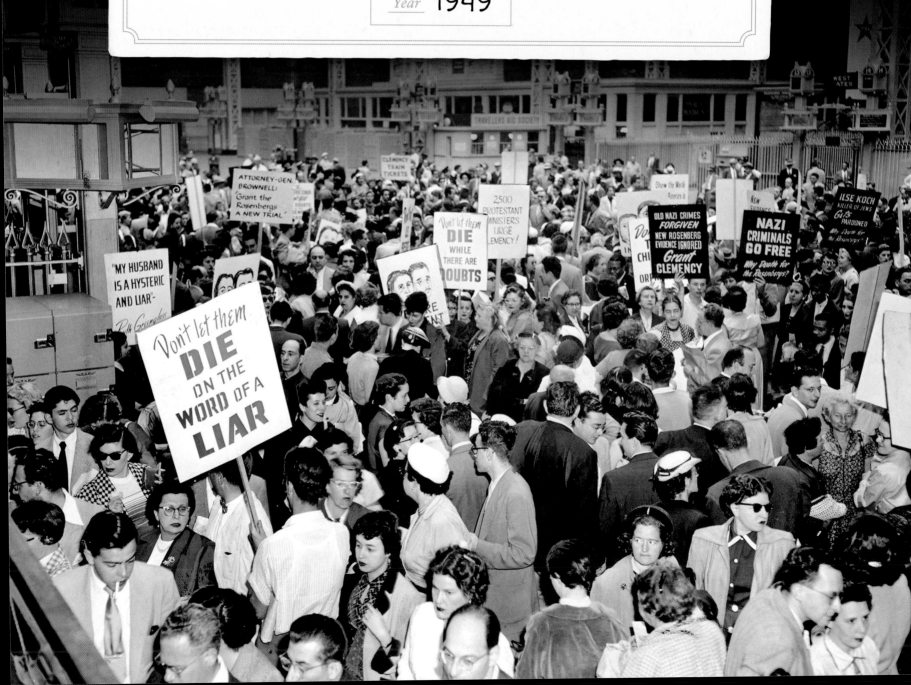

THE ATOMIC SECRETS OF JULIUS AND ETHEL ROSENBERG

Year 1949

In the years leading up to World War II, Soviet leader Joseph Stalin formed an alliance with Adolf Hitler, only to be betrayed by the Führer when Germany invaded Russia in 1941. Stalin came to view Germany as a greater threat than capitalism. He allied communist Russia with capitalist United States, a decision that ultimately culminated with the Allied powers forcing a German surrender in May 1945.

While many people throughout the world presumed that the shared victory over Germany would bring peace, the continuing spread of communism by the Soviet Union resulted in the advent of the Cold War. An anticommunist fervor in the United States reached a fever pitch in the 1950s. However there were legions of communist sympathizers in the United States. Many were newly arrived immigrants who blamed their failure to attain the American Dream on corporate greed and the exploitation of workers.

Julius Rosenberg was born to Jewish immigrant parents in New York in May 1918. He attended Seward Park High School on Manhattan's Lower East Side and went to City College to study electrical engineering. While there he became a leader in the Young Communist League.

His future wife, Ethel Greenglass, was also born to a Jewish family in New York in September 1915. She had aspirations of being an actress or a singer, but took a secretarial job at a shipping company. After observing several labor disputes firsthand, she developed a sympathy for the working man and joined the Young Communist League. She met her future husband in 1936. They married three years later.

Despite his communist leanings, Julius joined the Army Signal Corps in 1940. While assigned to a laboratory at Fort Monmouth, New Jersey, he conducted crucial research on military electronics used in radar, communications, and guided missiles. In 1942, he was recruited by Russian spymasters in the United States to pass military secrets on to his Soviet handlers.

During the war, Julius's brother-in-law, David Greenglass, worked as a machinist on the top-secret Manhattan Project, which was developing the atomic bomb at the Los Alamos National Laboratory in New Mexico that ended World War II.

The American government had gone to great lengths to keep information about the bomb classified. It was surprised to learn that the Soviets had established their own atomic capabilities by early 1949. A subsequent investigation into how the Soviet Union did it resulted in David Greenglass being identified as a key player in the espionage

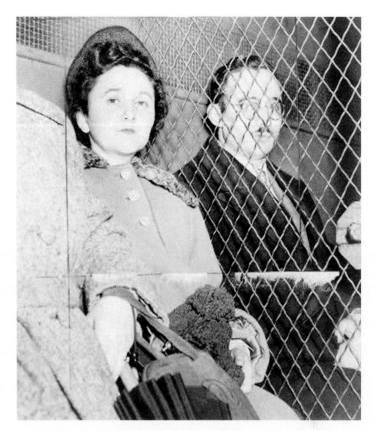

The Rosenbergs appear calm after being convicted of espionage and transported back to their separate prison cells. They would be executed at Sing Sing prison two years later.

activities. Under FBI interrogation, Greenglass confessed to having passed secret information on to the Soviets. He said that he did so at the encouragement of his naïve wife, Ruth Greenglass, who was unwittingly acting at the behest of Julius Rosenberg. He also told authorities that Julius himself had provided a trove of classified information to the Soviets. He initially stated that his sister Ethel was not involved in the conspiracy, but later changed his story.

A federal grand jury was convened in August 1950. Among the witnesses called were Ruth Greenglass and Ethel Rosenberg. When Ethel refused to answer questions, she was summarily arrested as she left the courthouse. One prosecutor later told the press that there "is ample evidence that Mrs. Rosenberg and her husband have been affiliated with Communist activities for a long period of time."

While the case against Julius was strong, the one against Ethel was much weaker. However, ten days before the trial, David and Ruth Greenglass dramatically altered their stories, a decision that would change Julius's and Ethel's fates.

David Greenglass had initially admitted to passing documents to Julius on New York street corners. His revised story alleged the transfers had taken place inside the Rosenbergs' Knickerbocker Village apartment on the

Lower East Side. He also told federal agents that after he passed them to Julius, his sister Ethel typed them up before they were forwarded to the enemy. Ruth Greenglass said she personally observed Julius enter and exit the bathroom with the documents and that he ordered Ethel to immediately type up the pertinent data.

The case against the Rosenbergs—as well as another conspirator named Morton Sobell, who had attended City College with Julius—began on March 6, 1951. Outside of key prosecution witness David Greenglass, there was only

> **Outside of key prosecution witness David Greenglass, there was only circumstantial evidence.**

circumstantial evidence. However, twenty-three days later, on March 29, both Rosenbergs were convicted of espionage. On April 5, they were sentenced to death by Judge Irving Kaufman, who called their crimes "worse than murder," saying, "I believe your conduct in putting into the hands of the Russians the A-bomb years before our best scientists predicted Russia would perfect the bomb has already caused, in my opinion, the Communist aggression in Korea, with the resultant casualties exceeding 50,000 and who knows but that millions more of innocent people may pay the price of your treason."

On Friday, June 19, 1953, Julius and Ethel were put to death. In a final letter to their sons, Robert and Michael, who were six and seven respectively, they wrote, "Your lives must teach you, too, that good cannot flourish in the midst of evil; that freedom and all the things that go to

Rosenberg family members traveled to the White House to make a last-ditch effort for clemency from President Dwight D. Eisenhower. They are Rabbi Abraham Cronbach, sons Michael and Robert Rosenberg, and Sophie Rosenberg, Julius's mother.

make up a truly satisfying and worthwhile life, must sometimes be purchased very dearly."

Morton Sobell served more than eighteen years in prison and continued to advocate for socialist causes after his release in 1969. In a 2008 interview, he admitted to being a spy but said the information he and others provided was not of great strategic value.

David Greenglass, who died in July 2014, served nearly ten years in prison for his treasonous activities. In the 1990s he admitted that he lied under oath about Ethel typing the data, telling reporter Sam Roberts that it was his wife, Ruth, who had done it. Still, he expressed no regrets about sending his own sister to her death. "My wife is more important to me than my sister," he said. "I would not sacrifice my wife and my children for my sister."

After Robert and Michael Rosenberg's biological relatives refused to take them in, they were adopted by singer, songwriter, and social activist Abel Meeropol and his wife, Anne. The boys took the surnames of their adoptive parents. Michael is a retired professor of economics and author of many books and scholastic articles. Robert is an attorney, who between 1980 and 1982 was managing editor of the *Socialist Review* in the San Francisco Bay Area.

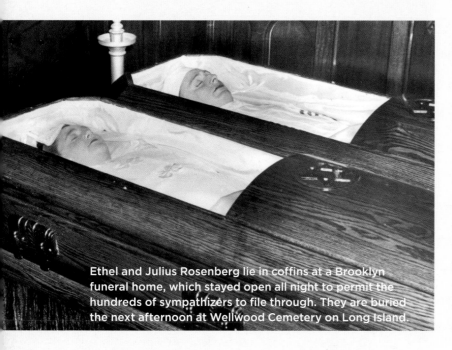

Ethel and Julius Rosenberg lie in coffins at a Brooklyn funeral home, which stayed open all night to permit the hundreds of sympathizers to file through. They are buried the next afternoon at Wellwood Cemetery on Long Island.

HARRY GROSS, THE KING OF THE CONS

Year 1950

405
ABC

GRAND JURY

The youthful Harry Gross (center) encounters a horde of reporters after leaving a grand jury session in which he implicated scores of police officers in a mammoth corruption probe.

The September 1950 arrest of a thirty-four-year-old Brooklyn bookmaking czar named Harry Gross had a seismic effect on the New York Police Department. Although he was a seventh-grade dropout, Brooklyn District Attorney Miles McDonald described him as a "smooth, suave individual with gentlemanly manners." He reigned over a $20-million-a-year gambling empire that paid out a million dollars annually among beat cops, plainclothesmen, and even the department brass.

Although gambling was illegal in the 1940s, it was generally viewed by the public as harmless as the sale and consumption of liquor was during Prohibition. The underworld, as well as some members of the NYPD, viewed it through the same prism, although to their own ends. And Gross, the son of a Russian immigrant father and a Jewish mother who barely made ends meet by operating a makeshift laundry service out of their tenement apartment, was a wunderkind who learned how to play the odds and win early on in life.

After dropping out of middle school, Gross did odd jobs in luncheonettes and sweet shops where owners took bets or ran illegal but seemingly innocuous lotteries to make some extra cash. Gross was as enterprising as he was

He reigned over a $20-million-a-year gambling empire that paid out a million dollars annually among beat cops, plainclothesmen, and even the department brass.

intelligent, and he had a keen sense for numbers. He started taking action while still in his teens, and by the time he was in his early twenties, he opened several of his own bookmaking locations. He learned an invaluable lesson in 1941, when a cop caught him red-handed taking a bet from a customer on the street. The officer told him he was "a sucker" for working without an "okay," which Gross quickly learned meant making regular payoffs to police in order to avoid unwanted scrutiny.

By the late 1940s, Gross's gambling empire had expanded to include horse parlors and wire rooms throughout the city and Long Island as well as New Jersey.

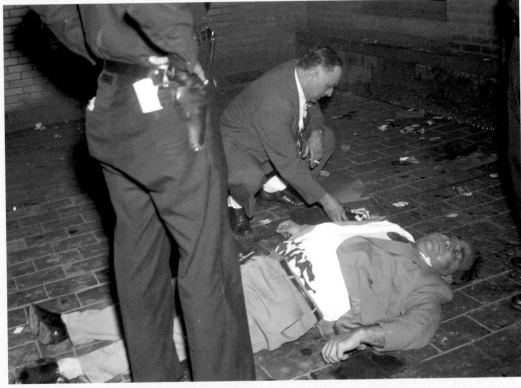

LEFT: Police Commissioner William O'Brien, a 35-year NYPD veteran, was forced to resign amid the Harry Gross scandal, telling reporters, "I find it my regretful duty to turn in my shield." RIGHT: Captain Alfred Panarella, who was not implicated in the scandal, examines the body of his brother Charles Panarella, who leaped to his death from the sixth floor of the Brooklyn court building minutes before going on trial.

While in police custody in advance of giving testimony in the police graft case, Gross was allowed to visit his home in Atlantic Beach, New York. There he escaped through a side door and traveled to Atlantic City. He was picked up days later betting on horses at a racetrack.

Gross and his top aide, Morton Kapelsohn, delivered regular payments in $50 and $100 bills to a Brooklyn restaurant called the Dugout. The payoff money, which Gross referred to as "ice," was given to trusted colleagues who distributed it through an organized chain of command to law enforcement personnel of all ranks. But even regular payoffs could not protect him forever.

Wiretaps captured Gross discussing the names of numerous police recipients of his graft, and District Attorney McDonald convened a grand jury to look into the matter. As the grand jury mulled over the evidence, Police Commissioner William O'Brien and Chief Inspector August Flath denounced the proceedings as a waste of taxpayers' money. However, on the day that Gross was finally arrested, O'Brien and Flath were called into the chambers of Kings County judge Samuel Leibowitz and were forced to listen to the wiretap evidence against the bookmaker and the department.

When Leibowitz demanded to know what action the officials were going to take, O'Brien ranted that he would not stand for anyone "besmirching" the name of the police department, to which the judge responded, "Ice! Ice! Ice! An honest police department could stop bookmaking in this city in twenty-four hours."

Gross initially refused to cooperate with prosecutors, saying that many of the recipients of his patronage were close, personal friends. However, faced with a lengthy prison term, he soon came clean. Once he did, McDonald said, "His information flowed like water."

The effects of the investigation had reached the highest echelons of municipal government. Mayor William O'Dwyer, who had been recently reelected, was forced to resign amid the furor. Police Commissioner O'Brien, a thirty-five-year NYPD veteran, described his position as "untenable" and also called it quits. Chief of Detectives William Whalen and Inspector John Flynn of the Confidential Squad soon followed the commissioner out the door. The entire 336-member Plainclothes Division was disbanded.

In June 1951, just minutes before the trial of more than twenty police officers was to commence, retired patrolman Charles Panarella leaped to his death from the window of a sixth-floor courtroom. Everyone in attendance, which included members of Panarella's family, heard him land with a sickening thud on a setback three stories below.

By the time the dust settled twenty-two policemen were convicted, while 240 others were either terminated or forced to resign from the department. Gross himself pleaded guilty to sixty-six charges and served eight years in prison. After his release in 1958, he relocated to the West Coast. Although he was not prone to violence in New York, he was sentenced to three years in a California prison for manslaughter after beating his wife's grandfather to death in 1959. He was also arrested several times for gambling offenses.

> By the time the dust settled twenty-two policemen were convicted, while 240 others were either terminated or forced to resign from the department.

In March 1986, Gross was collared at a Los Angeles hotel for attempting to sell heroin to a federal undercover agent. The following month he committed suicide by slashing his wrists at his home in Long Beach, California. Found near his body were numerous pills, as well as a suicide note stating that he would rather die than go back to prison. He was sixty-nine years old.

Miles McDonald, the man who had prosecuted Gross so vigorously in Brooklyn and later became a State Supreme Court justice, told the New York Times after Gross died that he was "smart as a whip." While his own investigation gave the perception that much of the NYPD was on the take, McDonald implied that the giver was as culpable as the takers. "Without Harry, there was no graft," he said.

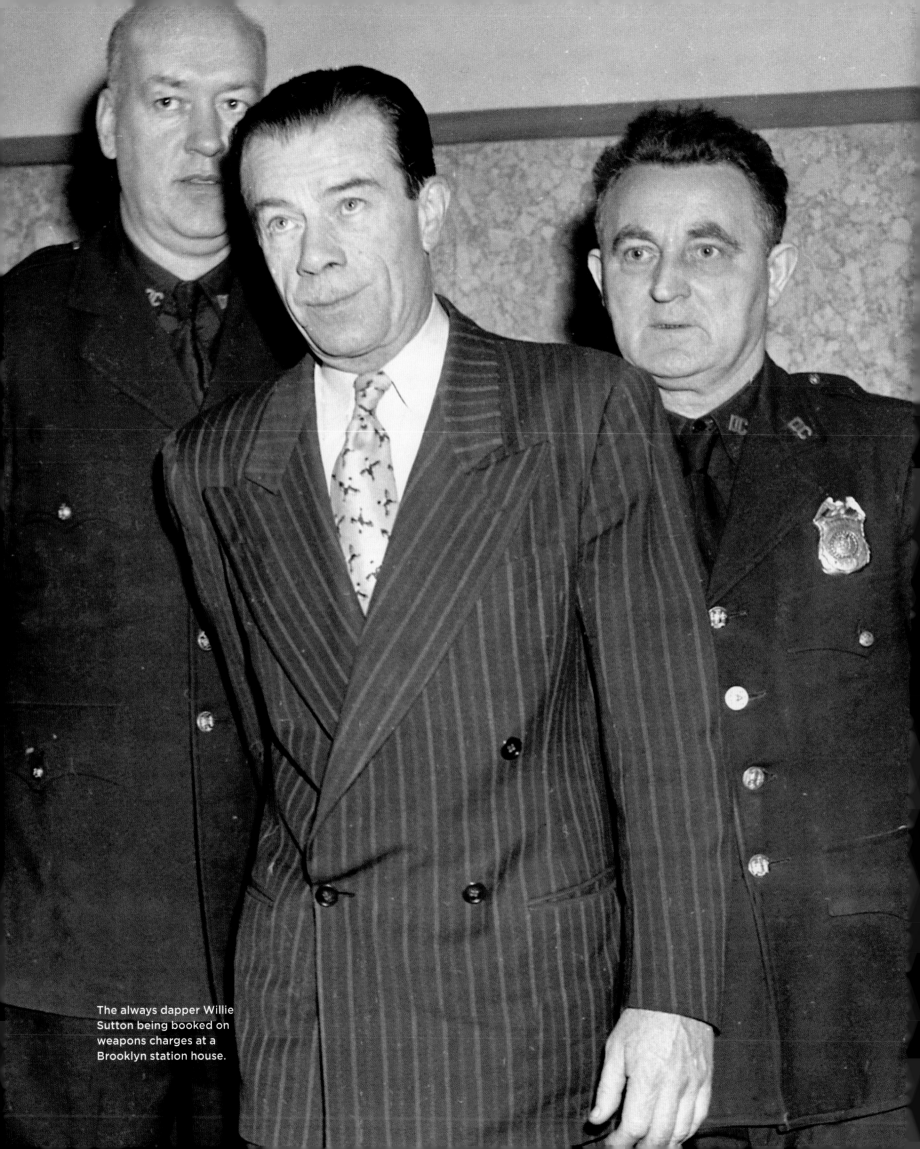

The always dapper Willie Sutton being booked on weapons charges at a Brooklyn station house.

WHERE THE MONEY IS

Year **1950**

William Francis Sutton Jr., better known as Willie, was born in Brooklyn in 1901. Although he did not attend school after the eighth grade, he was considered by authorities to be a criminal mastermind. Over a twenty-five-year period, it is estimated that he made off with $2 million from forty different banks. Despite the fact that he always carried a gun during his holdups, Sutton attributed his success more to his vast array of disguises. At one time or another he masqueraded as a police officer, a mailman, a maintenance worker, and a telegraph messenger. As a result Sutton was considered a gentleman bandit and nicknamed "the Actor" and "Slick Willie" by both the authorities and his criminal counterparts.

While his reputation as an innovative robber is indisputable, Sutton was also a prolific escape artist who broke out of prison three times. His methods for escape, much like his robberies, often relied on disguises. During one particularly brazen escape from a Pennsylvania penitentiary in February 1947, Sutton and several other inmates dressed up as guards and carried ladders to the prison wall. When the searchlights from the watchtower shined down on him, he yelled back to the guards, "It's okay," before climbing over the wall to freedom.

Three years later, in March 1950, Sutton found himself one of the FBI's Ten Most Wanted, just a week after J. Edgar Hoover created the list for publicity purposes. Even with his face on display at post offices throughout the country,

Sutton still managed to elude authorities for two more years.

New York cops had been carrying tattered copies of his wanted flyer in their memo books ever since his escape from the Pennsylvania prison; however, it was an eagle-eyed citizen who helped nab him. Arnold Schuster, a twenty-four-year-old clothing salesman from Brooklyn, observed a man he believed to be the notorious Willie Sutton and reported his sighting to Patrolmen Donald Shea and Joseph McClellan of the Sixty-Sixth Precinct. He told the officers that he had followed Sutton to a gas station. There the attendant told the officers that he had just sold a car battery to the same man and that he had last seen him walking up Dean Street. Sure enough, the patrolmen spotted the well-dressed man Schuster described toiling under the hood of a 1951 Chevrolet. They asked him for identification. He very politely identified himself as Charles Gordon and pointed to a nearby house where he said he resided.

"He was a very cool guy, very calm," recalled police officer Shea in a 2012 interview with the *New York Post*.

Although Shea carried a flyer with Sutton's face in his

> **Over a twenty-five-year period, it is estimated that he made off with $2 million from forty different banks.**

memo book, the picture had faded too much over the years for him to make a positive identification from it. While his partner waited with the man, Shea returned to the Sixty-Sixth Precinct and got Detective Louis Weiner. The two cops returned to Dean Street and after a few more questions asked Mr. Gordon to accompany them to the stationhouse.

"Sure," Gordon said obligingly.

Back at the precinct, the man answered all their questions, until the police said they had to fingerprint him. That's when he shrugged and told them, "Okay, you got me. I'm Willie Sutton."

During the arrest processing, Sutton feigned embarrassment when told that he had to be strip-searched. "Now, come on," he said in an effort to discourage the officers from doing their duty. He had a good reason to do so, as there was a handgun secured between his legs by a woman's sanitary belt.

After the arrest Police Commissioner George Monaghan came to to the precinct, where he unabashedly hugged the three cops and promoted them on the spot to the rank of detective first grade. For Shea and McClellan that amounted to a $1,100 raise.

Arnold Schuster was not nearly as fortunate. His fame was very short-lived—just seventeen days, in fact. After boasting on television about his role in Sutton's capture, Schuster was gunned down outside his Brooklyn home.

Sutton was never implicated in the killing. While the homicide was never officially solved, it was widely believed to have been committed on the orders of Albert Anastasia, the boss of the Gambino crime family, because he detested squealers.

Sutton was convicted of robbing a bank in Sunnyside, Queens, during the time he was on the lam and received a sentence of up to 120 years in prison. Although it has

Detectives searched Willie Sutton's furnished rented room and recovered $2,955 in cash and a loaded revolver.

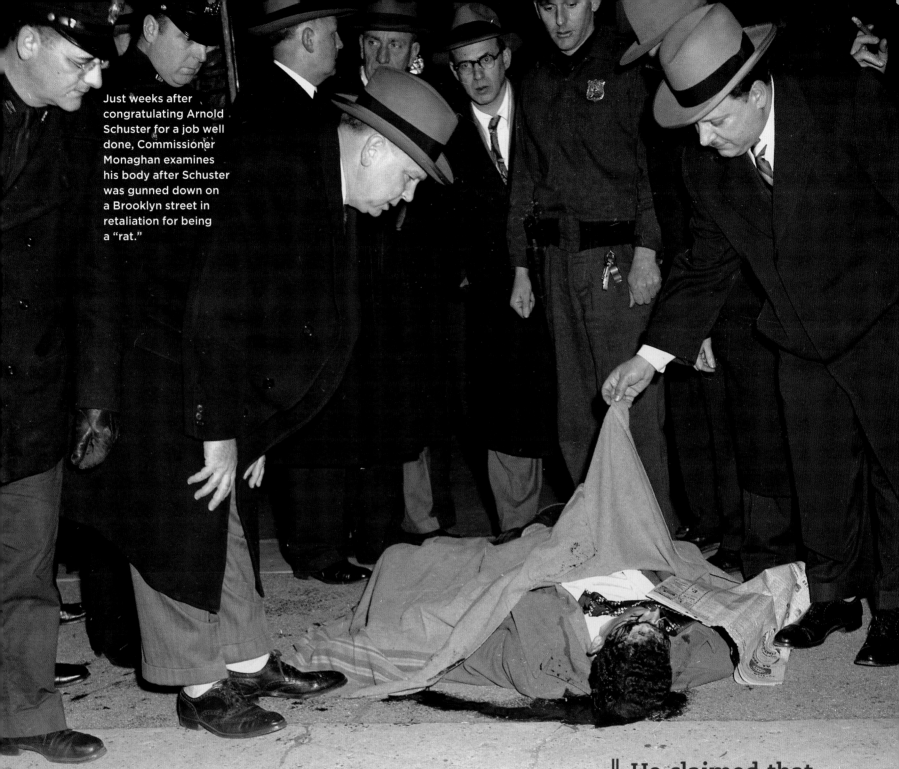

Just weeks after congratulating Arnold Schuster for a job well done, Commissioner Monaghan examines his body after Schuster was gunned down on a Brooklyn street in retaliation for being a "rat."

been widely reported that Sutton said that he robbed banks "because that's where the money is," he always maintained that it was a newspaper reporter who actually mouthed the words long attributed to him.

Sutton's legacy is that of a likable, charming, impeccably dressed Fancy Dan who, despite leading a life of crime, never resorted to violence. Although it was hard to prove, he claimed that he only carried unloaded firearms during his heists, because "you can't rob banks on charm and personality." In a moment of self-reflection, he said, "I was never a big-shot criminal, only a notorious criminal."

Sutton was released from prison on Christmas Eve, 1969, after developing emphysema. A year later he did a television commercial for a Connecticut bank, where he touted their new photo credit card program.

Sutton died in relative anonymity in Florida in November 1980. He was seventy-nine years old. His sister shipped his body to New York, and he was buried in Brooklyn. His tomb bears no name, which his sister said was the way he wanted it. "He had enough publicity during his lifetime," she explained.

> He claimed that he only carried unloaded firearms during his heists, because "you can't rob banks on charm and personality."

147

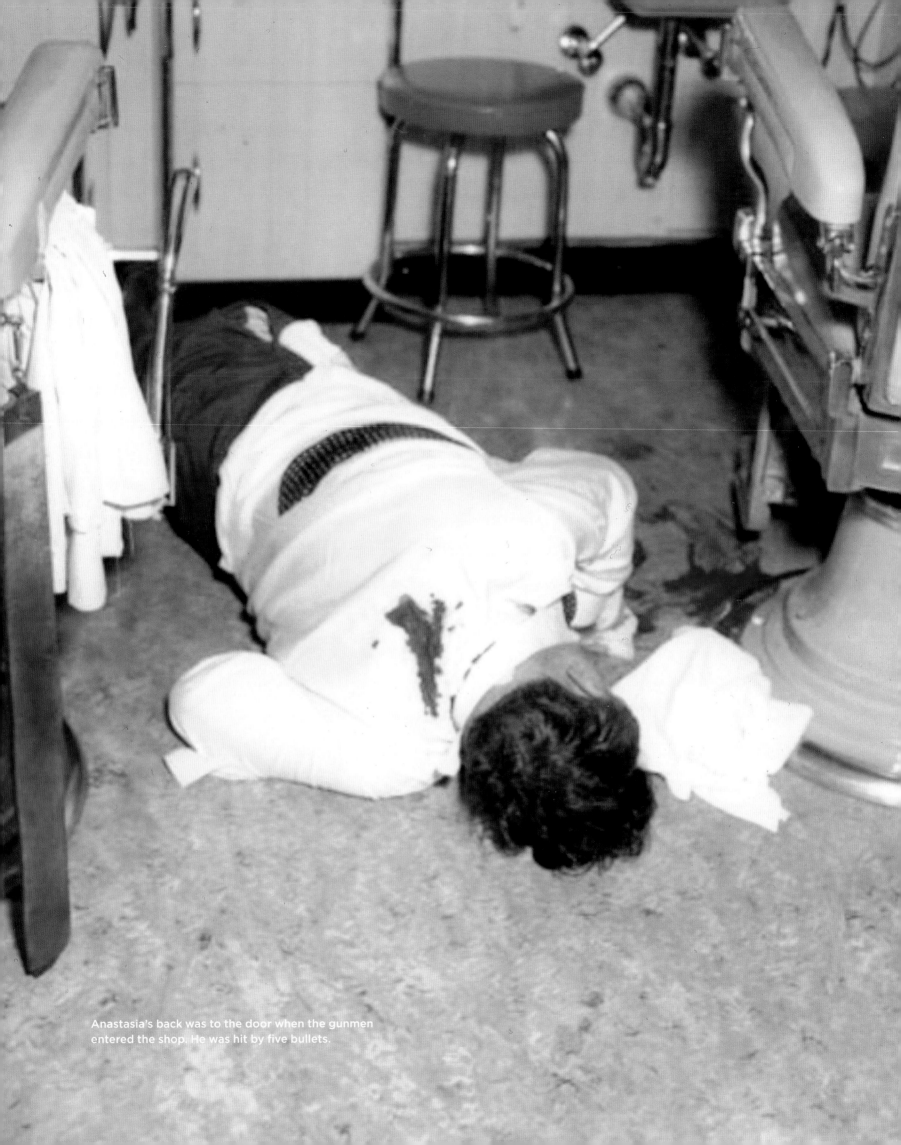

Anastasia's back was to the door when the gunmen entered the shop. He was hit by five bullets.

THE HIT ON ALBERT ANASTASIA

Year 1957

Few murder victims were more deserving of the epitaph "Live by the sword, die by the sword" than fifty-five-year-old Mafia boss Albert Anastasia. He rose to prominence working on the Brooklyn docks while simultaneously freelancing with Louis "Lepke" Buchalter as a member of Murder Incorporated, a nefarious criminal organization suspected of committing between four hundred and one thousand contract murders across the country during the 1930s and '40s. The Federal Bureau of Investigation attributed sixty-three murders in the New York area to him between 1931 and 1940 after his colleague Abe Reles turned informant. Reles did not live to rat on anyone else, and the charges against Anastsia were dropped.

Albert was born Umberto Anastasio in the fishing village of Tropea, in Calabria, Italy, on September 26, 1902. In 1919, Anastasia and three of his brothers signed on as crew for a freighter sailing to America. Once they were in port, they jumped ship. Albert changed his last name from Anastasio to Anastasia and found work on the waterfront.

But he had a bad temper. The newspapers called him "the Mad Hatter." Anastasia killed a man during a dispute in 1921 and was sentenced to die in the electric chair. But he got off on a technicality. Before Anastasia could be tried again, a key witness returned to Italy. The state's case evaporated, and he walked away free and clear.

Meanwhile, Anastasia joined Brooklyn Local 1814 of the International Longshoremen's Association, the labor organization that represented longshoremen employed by stevedore companies. The mob's stranglehold on the union provided myriad opportunities for theft, loan-sharking, graft, and other schemes that swelled the coffers of the city's five Mafia families.

Anastasia's younger brother, Anthony "Tough Tony" Anastasio, took over the Brooklyn local in 1932. He ascended to the national ILA vice presidency five years later, but it was Albert who provided the muscle.

Anastasia joined the Army in 1942 and rose to the rank of sergeant. He secured American citizenship by virtue of his military service. After the war, he returned to his criminal ways and rose to underboss in the eponymous Mangano crime family, headed by Vincent Mangano, with whom he clashed. Mangano mysteriously disappeared in 1951. A short time later Mangano's brother and aide-de-camp, Philip, was found dead, shot three times in the head, in a marshy area of Sheepshead Bay. Anastasia became the head of his own family.

By the mid-1950s, he was at the apex of his powers, living large in a palatial home in the Palisades section of Fort Lee, New Jersey, guarded by two fierce Doberman pinschers. On Friday morning, October 25, 1957, Anastasia's chauffeur-bodyguard, Anthony Coppola, drove him to the Park Sheraton Hotel for his weekly haircut from his favorite barber, Arthur Grasso. As Albert settled into the barber chair and waited for a shave, he failed to notice that his trusted bodyguard had not returned from parking the car. A pair of masked assassins rushed in, shoved the barber

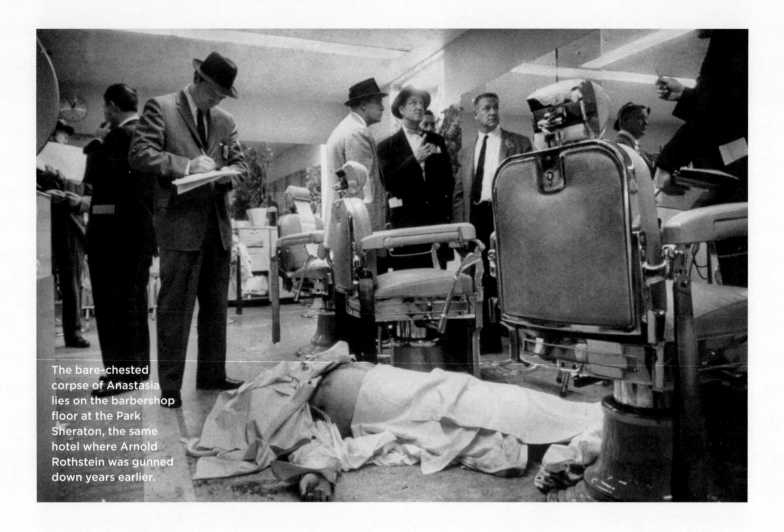

The bare-chested corpse of Anastasia lies on the barbershop floor at the Park Sheraton, the same hotel where Arnold Rothstein was gunned down years earlier.

A pair of masked assassins rushed in, shoved the barber out of the way, and unleashed twin barrages of deadly gunfire.

out of the way, and unleashed twin barrages of deadly gunfire. The mortally wounded mafioso stumbled about in his death throes like a punch-drunk fighter, futilely swinging at his fleeing attackers without realizing he was chasing their reflections in the mirror. He collapsed at the pedestal of the barber chair and died—shrouded in a crumpled barber's cloth.

Police never conclusively determined the identities of the triggermen; two other gunners suspected of hovering nearby gave rise to the quip about a murderous "barbershop quartet." The most likely suspect was up-and-comer Joseph "Crazy Joe" Gallo, although it has been suggested Gallo took credit for the slaying to boost his status among his mob cohorts.

Albert Anastasia's funeral lasted twenty minutes. For all his power and money, he had few mourners, aside from

his immediate family and a handful of friends. He was buried in a nine-hundred-dollar casket and interred in Greenwood Cemetery, not far from Brooklyn's Prospect Park. He was mourned most audibly by his heartbroken widow, Elsa, who sobbed convulsively.

Anastasia is perhaps best remembered for inspiring the frighteningly venal character Johnny Friendly, the mob-connected union boss played by actor Lee J. Cobb in the 1954 movie *On the Waterfront.*

A .38-caliber Colt was recovered from the corridor outside the barber shop, and a .32-caliber Smith & Wesson was found at the 57th Street BMT station.

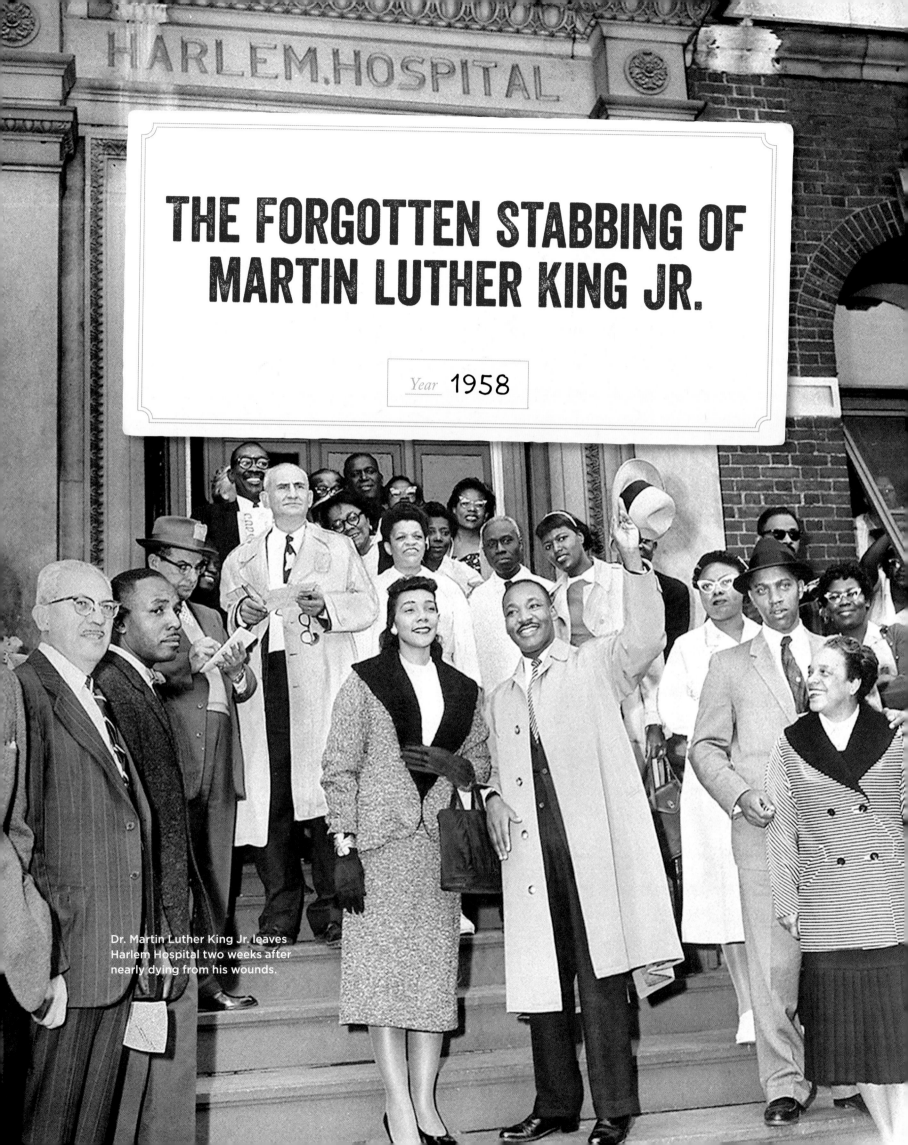

THE FORGOTTEN STABBING OF MARTIN LUTHER KING JR.

Year 1958

Dr. Martin Luther King Jr. leaves Harlem Hospital two weeks after nearly dying from his wounds.

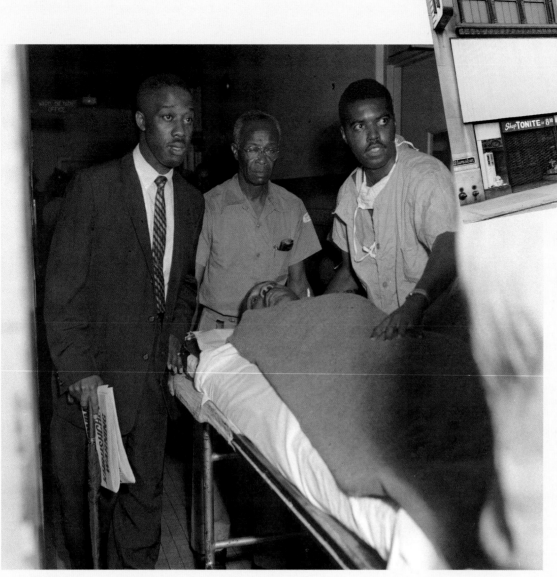

ABOVE: Blumstein's Department Store was a neighborhood institution in Harlem. It was the first store of its kind to employ a black Santa Claus, and welcomed a young Dr. Martin Luther King Jr. to sign books there.

LEFT: With the letter opener still protruding from his chest, Dr. Martin Luther King Jr. is wheeled into Harlem Hospital for treatment after being stabbed.

On the afternoon of September 20, 1958, Dr. Martin Luther King Jr., by then a renowned social activist in the civil rights movement, was seated at a table autographing copies of his first book, *Stride Toward Freedom*. The line stretched through Blumstein's Department Store, located at 230 West 125th Street, on the same block as the hallowed Apollo Theater in the heart of Harlem. Amid the crowd was a well-dressed, pleasant-looking forty-two-year-old black woman named Izola Ware Curry, who waited patiently for her turn to meet the charismatic twenty-nine-year-old minister.

When she reached the front of the line, she suddenly and inexplicably became unhinged and began screaming. She plunged a seven-inch steel letter opener into the upper left side of King's chest and just stood there. Curry made no attempt to flee and, when arrested, was found to be in possession of a loaded firearm. Because of the proximity of the blade to King's heart, responding patrolmen Al Howard and Phil Romano carried him out to the ambulance in the chair he was seated in. "Don't sneeze, don't even speak," Patrolman Howard told him. King was rushed to nearby Harlem Hospital, where doctors said the blade had been dangerously close to his aorta.

Curry, a native of Adrian, Georgia, had moved to New York two decades earlier to work as a cook and a housekeeper. She soon began experiencing paranoid delusions, resulting in her making dangerous, psychotic associations between King, other civil rights leaders, the National Association for the Advancement of Colored People (NAACP), and the Communist Party.

When questioned at the Twenty-Eighth Precinct in Harlem, Curry accused civil rights leaders of personally "boycotting" and "torturing" her and forcing her to change her religion. When asked to be more specific, she was unable to do so. After being advised that she was being charged with attempted murder, she replied, "I'm charging him [Dr. King] as well as he's charging me. I'm charging him with being mixed up with the Communists."

While recovering in the hospital, King received a get-well letter from a white, female ninth-grade student who attended White Plains High School in suburban New York. "I read that if you had sneezed, you would have died, and I'm simply writing to say that I'm so happy that you didn't sneeze."

After several weeks, King returned home to Montgomery, Alabama, to continue his recovery. Of Curry he said, "I bear no bitterness toward her and I have felt no resentment from the sad moment that the experience occurred. I know that we want her to receive the necessary treatment so that she may become a constructive citizen in an integrated society, where a disorganized personality need not become a menace to any man."

The following month Curry was diagnosed as a paranoid schizophrenic and committed to Matteawan State Hospital for the Criminally Insane for fourteen years.

In King's final speech, he referenced the stabbing that occurred nearly a decade earlier at Blumstein's. "You know, several years ago I was in New York City autographing the first book that I had written," he recalled. "And while sitting there autographing books, a demented black woman came up. The only question I heard from her was, 'Are you Martin Luther King?' And the next minute I felt something beating on my chest. And that blade had gone through, and the X-rays revealed that the tip of the blade was on the edge of my aorta, the main artery. And once that's punctured...that's the end of you...I'm so happy I didn't sneeze." He was shot by James Earl Ray in Memphis the next day.

Curry's final decades were spent in anonymity. Nothing was heard from or about her until she passed away on March 7, 2015, at the Hillside Manor nursing home in Queens. She was ninety-eight years old.

> ## "I'm simply writing to say that I'm so happy that you didn't sneeze."

A deranged Izola Ware Curry is arrested after stabbing Dr. Martin Luther King Jr. at a Harlem book signing.

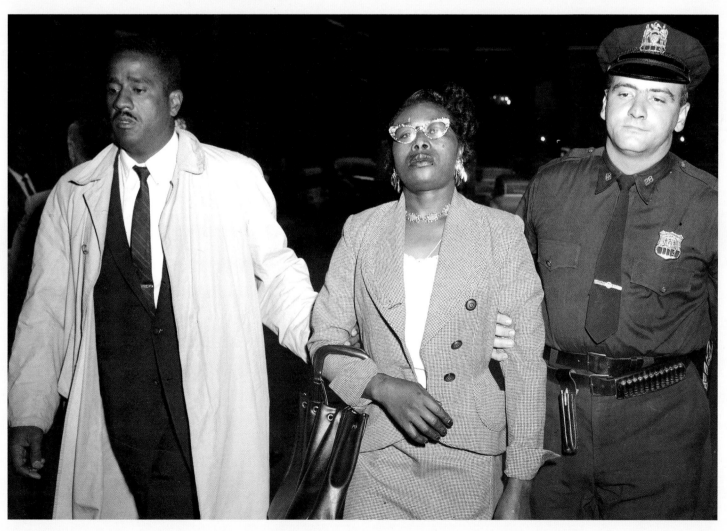

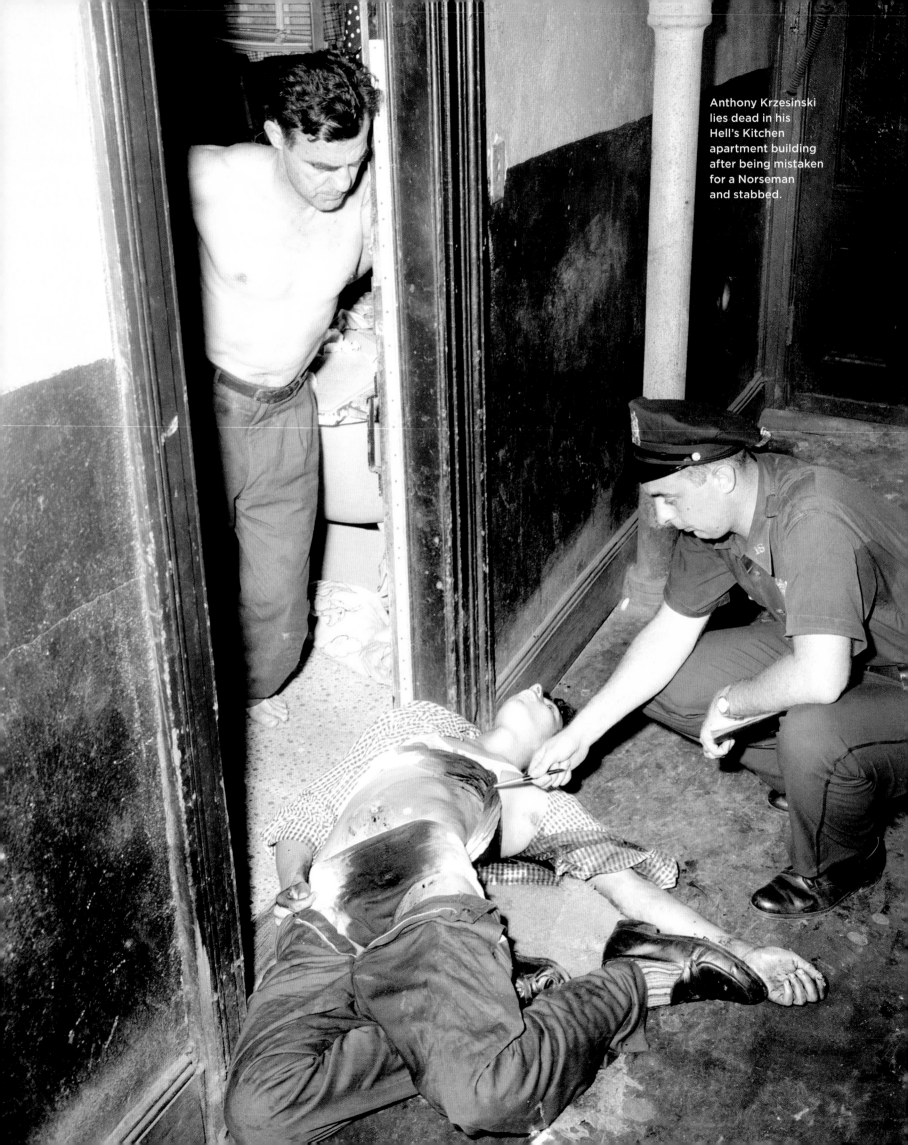

Anthony Krzesinski lies dead in his Hell's Kitchen apartment building after being mistaken for a Norseman and stabbed.

"THE CAPE MAN" AND "THE UMBRELLA MAN"

Year 1959

Scores of blacks from the American South, as well as Hispanics who hailed mainly from Puerto Rico, had migrated to New York during World War II to work on the docks and the factories that supported the war effort. This influx lead to ethnic rivalries, which resulted in a proliferation of violent street gangs that became a public scourge in the 1950s. White gangs in Brooklyn such as the Halsey Bops often rumbled with the black DeKalb Chaplains or the Hispanic Mau Maus or Apaches.

Former New York State Supreme Court Justice and author Edwin Torres was born in the 1930s to Puerto Rican parents in Spanish Harlem. During his childhood, Torres recalled, "Puerto Ricans were not supposed to go east of Park Avenue. Our area was between Ninety-Ninth to 116th Streets," he said. "The blacks were west of Fifth. There was a tough Italian gang called the Red Wings, who had the entire area east of Park." When Torres ventured over to the Jefferson Pool in that area, he was set upon by the Red Wings, who beat him with bicycle chains and stickball bats. For safety, it was best to stay with your own.

Salvador Agron learned this early on. Born into a troubled family in Puerto Rico in 1943, he spent the next sixteen years shuttling back and forth between his native island and New York. He joined the Mau Maus in 1958, but after meeting Tony Hernandez, the charismatic president of a Spanish Harlem gang called the Vampires, he quickly switched allegiances.

On the night of August 30, 1959, the Vampires were en route to a rumble against a predominantly Irish-American gang called the Norsemen. The flamboyant Agron was wearing a red-lined silk black cape, while Hernandez was armed with a sharpened umbrella that he planned to use for a weapon. Upon entering DeWitt Clinton Park, they mistook a group of innocent white teenagers for Norsemen. During the ensuing brawl, two youngsters, Anthony Krzesinski and Robert Young Jr., neither of whom had any gang affiliations, were stabbed to death. Another innocent bystander, Ewald Reimer, was tripped, stomped, and stabbed, but was saved from being killed when a benevolent Vampire intervened and said, "He has had enough."

The nation was transfixed by the sheer savagery of the crime. Although thirteen gang members were arrested, the primary killers,

> When asked by police why he stabbed the youngsters, an unrepentant Agron snapped, "Because I felt like it."

Agron and Hernandez, became tabloid fodder after being dubbed "the Cape Man" and "the Umbrella Man" by the press. When asked by police why he stabbed the youngsters, an unrepentant Agron snapped, "Because I felt like it." While he was in jail awaiting trial, his mother sent him a Bible, which Argon promptly returned.

"I don't care if I burn—my mother can watch me," he boasted when discussing the possibility of receiving the death penalty.

The trial was as spectacular as the crimes. Edwin Torres, by this time the first Puerto Rican assistant district attorney ever hired by Manhattan District Attorney Frank Hogan, served as the second seat on the prosecutorial team. One day in court, Torres said, "The hacks [guards] were taking the 'Cape Man' out of the courtroom. As he passed by, he snarled at me and called me a Spanish name that means stool pigeon or traitor. He was a punk and a half, so I jumped up. I still had the ghetto in me back then."

After a widely publicized trial, Agron and Hernandez were both convicted and sentenced to death in the electric chair. At the time, Agron was the youngest prisoner ever put on death row in New York State. Both had their sentences commuted when New York abolished the death penalty in 1962 for all but cop killers. Hernandez subsequently had his conviction overturned when it was proven that he never actually stabbed anyone. He was released from prison in 1969, and afterward he resided in relative anonymity in the Bronx.

In a 1997 interview with the New York *Daily News*, Hernandez admitted that he and his gang "destroyed so much that night." Asked to be more specific, he explained, "Ourselves. The other kids. Maybe the city. We were such fools. I died that night, too."

Nearly illiterate when imprisoned, Agron earned a college degree from the State University of New York at New Paltz. He became a model prisoner and was allowed to attend college during the day and return to jail at night. Although he absconded from the program in 1977 and was captured in Phoenix, Arizona, two weeks later, he was found not guilty of escape due to mental illness, and was paroled in 1979. Shortly before his release, he described his transformation to a reporter as a "re-humanization." Agron found work as a youth counselor, but he died of pneumonia and internal bleeding in April 1986 at the age of forty-two.

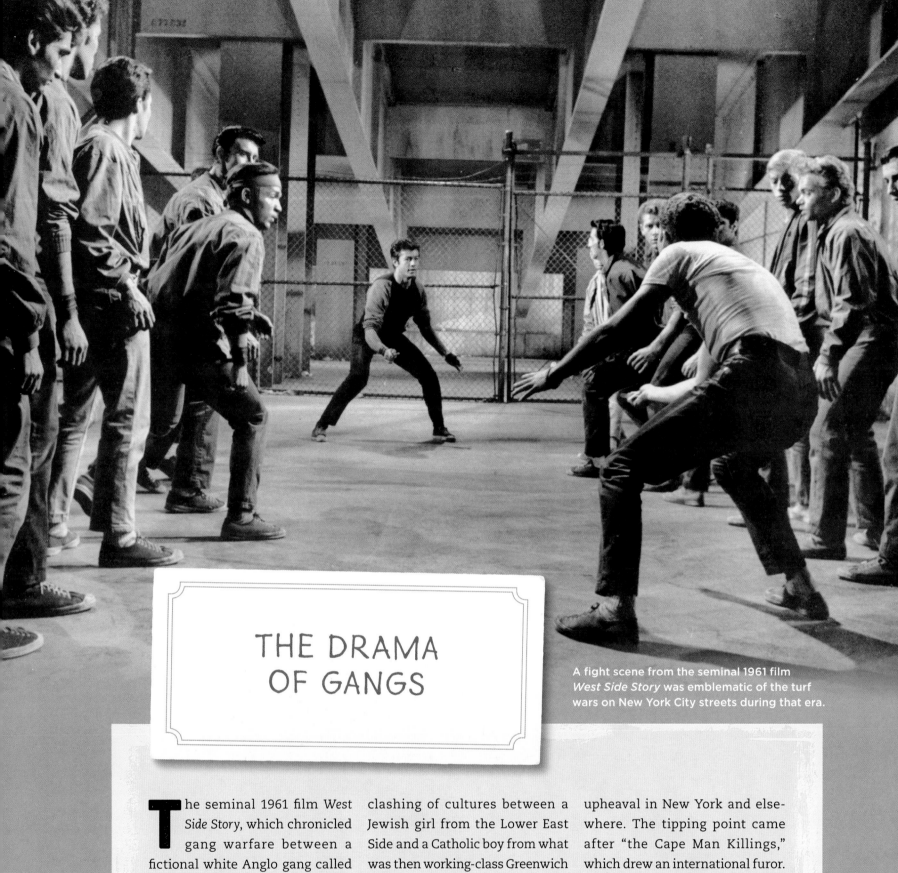

THE DRAMA OF GANGS

A fight scene from the seminal 1961 film *West Side Story* was emblematic of the turf wars on New York City streets during that era.

The seminal 1961 film *West Side Story*, which chronicled gang warfare between a fictional white Anglo gang called the Jets and a Puerto Rican group called the Sharks, was initially conceived in 1949 by director and choreographer Jerome Robbins as *East Side Story*. It was a more innocent love story depicting the clashing of cultures between a Jewish girl from the Lower East Side and a Catholic boy from what was then working-class Greenwich Village.

The production languished until the late 1950s, when Robbins adapted the film to reflect the gang activity, classism, and racial discord that was causing social upheaval in New York and elsewhere. The tipping point came after "the Cape Man Killings," which drew an international furor. Musician Paul Simon conceived and wrote a Broadway play based on Agron's life called *The Cape Man*. It opened to poor reviews at the Marquis Theater in 1998 and closed after just sixty-eight performances.

Beginning in the 1930s, Corsican gangsters established scores of illegal heroin laboratories in the area around Marseille, France, one of the busiest ports on the Mediterranean Sea. It proved to be an ideal location for the manufacture and transport of heroin, much of which was shipped to North America via what became known as "the French Connection." By the late 1940s, heroin had become a fixture in New York. It would soon become an epidemic as shipments and seizures from French ocean liners grew exponentially after World War II.

"It seemed like everyone was doing junk [heroin] in those days," said Bobby Bartels, a onetime gang member from Astoria, Queens, who turned professional boxer to avoid the drug's lurid temptations. "It was very easy to get into trouble. A lot of my friends wound up dead from that crap."

> Up to five thousand pounds of high-grade heroin got past customs agents each year to be pushed and peddled in the poorer neighborhoods of New York

Up to five thousand pounds of high-grade heroin got past customs agents each year to be pushed and peddled in the poorer neighborhoods of New York. It was addictive and so potent that the NYPD recorded nearly sixteen hundred fatal overdoses between the years 1950 and 1961.

Detectives Edward Egan and Salvatore "Sonny" Grosso were assigned to a joint state and federal drug task force. Late one night in early October 1961, they stopped by the Copacabana, a popular Manhattan nightclub, to visit Egan's girlfriend, who was employed as a hatcheck girl. After saying hello, they went downstairs to have a drink and catch the show. It was there that they first observed Pasquale "Patsy" Fuca hosting a boisterous private party. They did not know who he was at the time, but their police instincts suggested he was connected.

They decided to tail him and his wife, Barbara, after they left the club that night. There were stops in Little Italy and a change of cars. By the time the couple pulled up to a luncheonette in Brooklyn, put on aprons, and opened the shop for business, it was morning. Egan and Grosso were exhausted. Although they called it a day, they were determined to learn everything they could about Fuca. It turned out he was the nephew of Angelo "Little Angie" Tuminaro, a high-ranking mafioso in the Lucchese

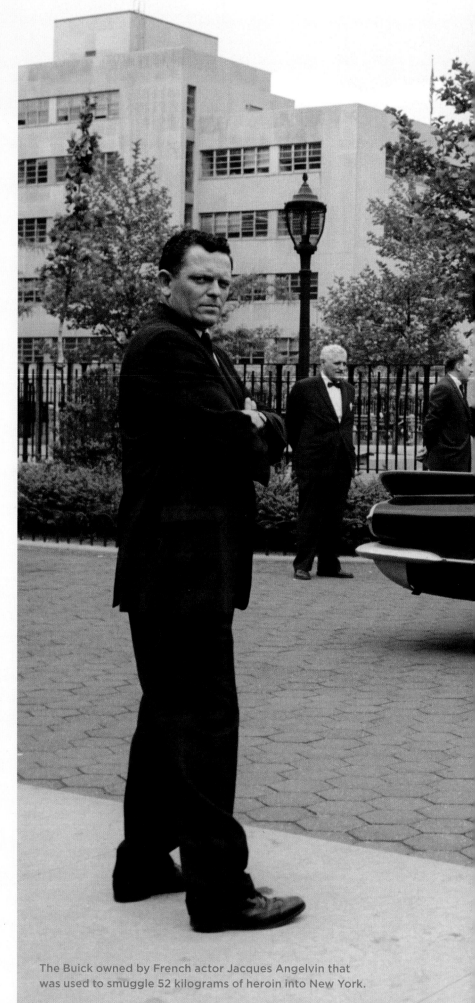

The Buick owned by French actor Jacques Angelvin that was used to smuggle 52 kilograms of heroin into New York.

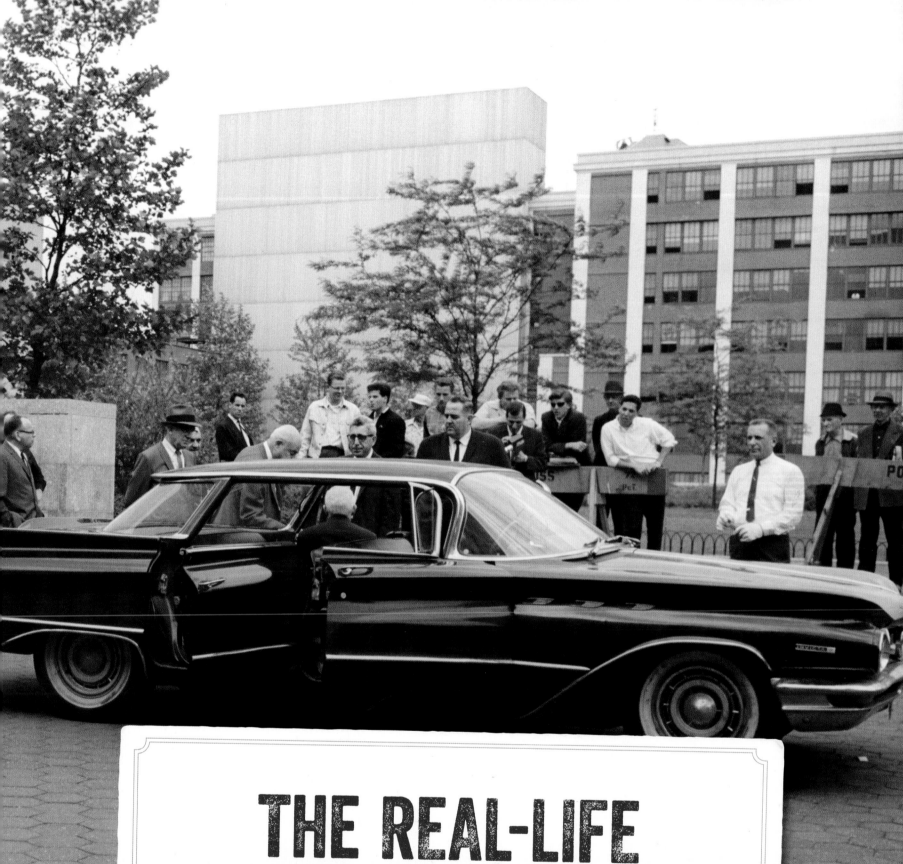

THE REAL-LIFE
FRENCH CONNECTION

Year 1961

French actor Jacques Angelvin is escorted from court by Detective Edward Egan.

crime family. He was heavily involved in the heroin trade and had gone into hiding.

From that point on, Fuca was seldom out of their sight. They also arranged for the luncheonette and Fuca's home phone to be wiretapped. After three months, the long hours of surveillance finally paid off. Fuca led them to an international drug cartel originating out of France. Fuca was arrested in January 1962, along with his wife, father, and brother. Two days later, Jacques Angelvin, a French television star who made extra money as a drug courier, was also arrested. Police recovered 112 pounds of high-grade heroin secreted in Angelvin's car when it was shipped to New York from France. With a street value of $90 million, it was the largest narcotics seizure in history at the time.

With a street value of $90 million, it was the largest narcotics seizure in history at the time.

Fuca's uncle, Angelo Tuminaro, turned himself in to authorities in Florida, but the leader of the cartel, a mysterious Frenchman by the name of Jean Jehan who was said to have been a member of the French underground during World War II, escaped. In 1984, the *New York Times* reported that he was finally apprehended by French authorities. By then he was eighty-two years old.

After the big bust, Detective Egan got in trouble with the department and was terminated. He sued and was vindicated. He retired and moved to California with his girlfriend. There he capitalized on his involvement in the French Connection case and became an actor. He died in 1995 at age sixty-five. His partner, Detective Sonny Grosso, retired and became a famous television producer.

Gene Hackman won an Academy Award for his portrayal of a character based on Detective Edward Egan in the 1971 film *The French Connection.*

STEALING THE STOLEN DRUGS

On March 6, 1962, Detectives Egan and Grosso delivered the French Connection heroin to the office of the NYPD Property Clerk, at 400 Broome Street, adjacent to Police Headquarters in Lower Manhattan. The drugs were stored in fifty-one bags that were contained in a blue suitcase and a black steamer trunk, and were to be kept as evidence in the event the cases went to trial. After its initial analysis, the heroin sat untouched for years locked in a metal cage.

An unrelated incident in 1972 involving missing property led to an internal audit of the Manhattan property clerk facility. It was discovered that between March 1969 and January 1972, a detective named Nunziata or Nunziato signed out narcotics envelopes containing the heroin on six separate occasions using fake shield numbers. As per police procedure, narcotics evidence was routinely withdrawn from the property clerk to be produced as evidence at court. An officer in plainclothes only needed to show his shield and sign for it. Unbeknownst to the officers at the property clerk, the evidence returned was not heroin. It had been replaced with flour and cornstarch, resulting in a red flour beetle infestation that led to the discovery. What had been the largest drug seizure in history suddenly became the largest drug theft in history and a monumental embarrassment to the NYPD.

Numerous police officers and several organized crime members were suspected in taking part in the heist. There was an actual plainclothesman named Joseph Nunziata, but his shield number did not match any of those listed on the property clerk withdrawal slips. He was, however, in a position to access the drugs, since he was assigned to the department's Special Investigation Unit, which handled high-profile narcotics investigations.

In March 1972, Detective Nunziata was found dead in his unmarked police car from what appeared to have been a self-inflicted gunshot wound. He had been questioned by the United States Attorney earlier in the day about the missing heroin. The coroner ruled his death a suicide, but his family believed the evidence could have been fabricated.

Another suspect, mafioso Vincent Papa, was jailed in late September 1972 for narcotics conspiracy and tax evasion. While serving his sentence, he was visited by another prosecutor looking into the theft of the heroin. Papa provided the names of several corrupt NYPD officers he claimed were involved in the heist. Although he had squealed only on cops and not on his criminal associates, word got out. His fellow inmates would not give him a pass. He was stabbed to death at the Atlanta federal penitentiary in July 1977. The drugs were never recovered.

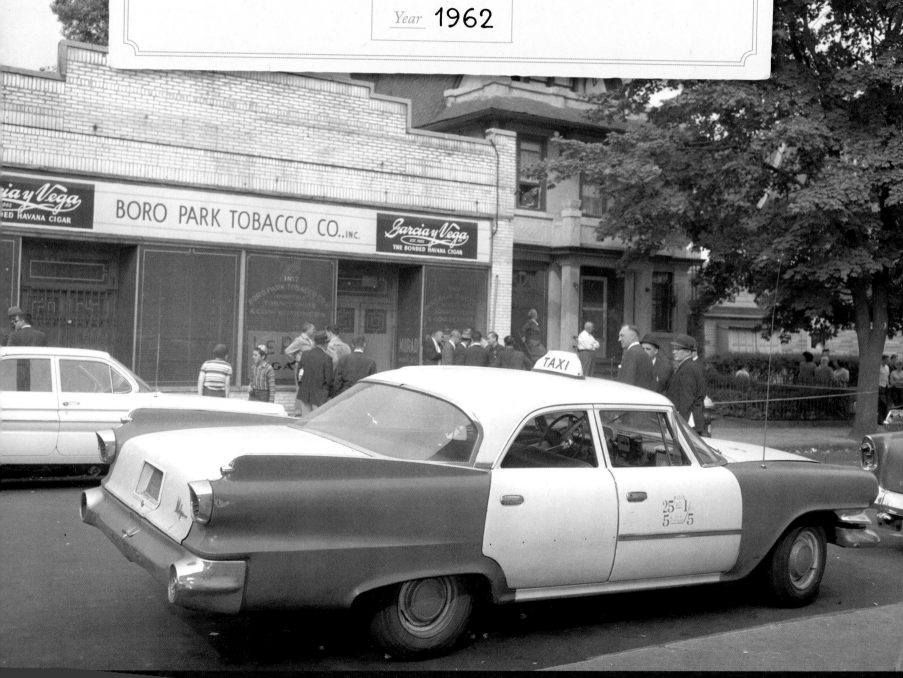

"JERRY THE JEW"

Year 1962

On an unusually hot Friday, May 18, 1962, a radio call was broadcast to patrol cars at 3:48 P.M. The dispatcher said it was a 10-30—or, in NYPD parlance, a robbery in progress—at 1167 Forty-Eighth Street in Borough Park, a working-class Jewish and Italian neighborhood in Brooklyn. A follow-up transmission at 3:50 P.M. further revealed that two males had been shot at the scene. Moments later the radio crackled again; this time the dispatcher advised that it was "two MOFs," or "members of the force," who had been shot.

Albert Seedman, the detective district commander in Brooklyn, and his driver were the second unit on the scene at the Boro Park Tobacco Company, a small brick and mortar warehouse that sold tobacco and confectionary items. Although he was Jewish, Seedman could not help but cry out, "Holy Jesus!" when he walked in the door. Lying dead, facedown on the floor, was Luke Fallon, one of Seedman's best veteran detectives. His partner, Detective "Big" John Finnegan, was lying faceup with eyes open, but just as dead.

The tobacco wholesaler was owned by two brothers, Robert and David Goldberg. Because the Goldbergs dealt with so much cash, their business was deemed a "robbery prone location," by the NYPD. As such it was closely monitored by the local precinct cops and plainclothesmen. Moments before their deaths, Fallon and Finnegan had stopped in to make a purchase. Fallon bought cough drops, Finnegan a box of chocolates for his young wife.

The two detectives had been on decoy patrol in the neighborhood that day in a taxicab. It was later determined that as Fallon and Finnegan exited the location they observed two suspicious men, one taller and much heavier than the other, loitering around the corner from the warehouse on New Utrecht Avenue. Both were wearing dark sunglasses and brimmed hats to conceal their faces. The detectives drove away as if they had not noticed them. After a few minutes they returned in the cab. The men were not there. Something told them to check the warehouse. They immediately became suspicious after looking in through the front window. It was eerily quiet. They drew their service revolvers and took a position just outside the entrance. If the place was being robbed, they thought it was more prudent to catch the bandits as they fled rather than barge in and put the lives of the workers and customers in danger.

Their instincts were right. During the short time it took for Fallon and Finnegan to circle the block, the two suspects had covered their faces with handkerchiefs, drawn their guns, and entered the location to announce a stickup. They separated David Goldberg from Robert and the staff, and locked them up in the rear storage room. Then the pair marched David Goldberg to the office and demanded he open the safe.

The thinner of the two thieves returned to the storage room, planning to fleece the employees of their personal property. Unbeknownst to him, there was a slide lock on the inside of the storage room door. When the employees refused to open it, the perpetrator attempted to force his way in and in the process inadvertently fired his gun. "Just an accident," he assured them. "Just open the fucking door and nobody will get hurt."

But once the detectives heard the shot, all bets were off. They rushed in with Fallon leading the charge. The heavier gunman was caught by surprise. He yelled, "Don't shoot. I give up," and dropped his weapon. When Fallon saw the gun hit the floor, he ran past him, assuming that Finnegan would retrieve the weapon. It proved to be a fatal mistake. The perpetrator grabbed his gun first. Fallon turned around and fired one shot at him before he was blasted in the chest. Finnegan rushed

He collapsed and died trying to reload his revolver as the perpetrators fled the scene.

forward and took two slugs. He managed to fire off six rounds, but none of them hit his target. He collapsed and died trying to reload his revolver as the perpetrators fled the scene.

The 1962 double murder of Detectives Luke Fallon (left) and John Finnegan was the first time two partners were killed together in a line-of-duty shooting since 1927.

It was the first time in New York City since 1927 that two officers were killed together in the line of duty. The police response to the shooting was fast and furious. The suspect who fired the fatal shots was identified as Anthony "Baldy" Portelli, a portly twenty-five-year-old parolee. He skipped to Chicago, but was arrested within days after being ratted out by a friend.

With cops scouring every corner of the city, the thinner suspect, a twenty-four-year-old ex-convict named Jerome Rosenberg, arranged for Gary Kagan, a neighbor of his parents and a photographer for the New York *Daily News*, to surrender him to the police at the *Daily News* building on East Forty-Second Street. Rosenberg was taken into custody on May 23, 1962, the day of his twenty-fifth birthday.

Two weeks after the murders, Governor Nelson Rockefeller signed a law that limited the death penalty to killers of police officers and prison guards. Portelli and Rosenberg were convicted of the homicides in February 1963 and sentenced to die in the electric chair, only to have Rockefeller commute their sentences to life imprisonment.

Portelli died in prison in 1975, but Rosenberg, despite being an eighth-grade dropout, was a very intelligent man. He took correspondence courses from the Black-stone School of Law in Chicago. He became a renowned jailhouse lawyer who, among other things, was a "legal representative" for inmates during the Attica prison uprising in 1971.

Rosenberg was so enamored of his prison moniker, "Jerry the Jew," he had it embroidered on his prison shirts. However, he became a victim of his own fame. A 1982 biography by Stephen Bello called *Doing Life: The Extraordinary Saga of America's Greatest Jailhouse Lawyer* was made into a television movie four years later starring Tony Danza as Rosenberg. The notoriety from the public quite possibly was the reason he was denied parole every time he became eligible. Not counting the time he spent in prison prior to the Fallon and Finnegan murders, Rosenberg served forty-six straight years on the other side of the wall. At the time of his death in June 2009 at the age of seventy-two, he was the longest-serving inmate in the New York State correctional system. In a postmortem article for the *Huffington Post*, radical New York lawyer Ron Kuby called Rosenberg "the greatest jailhouse lawyer who ever lived."

One person who had an altogether different assessment of him was the daughter of Detective Fallon, Joan Scheibner. As far as she was concerned, "he was the scum of the earth."

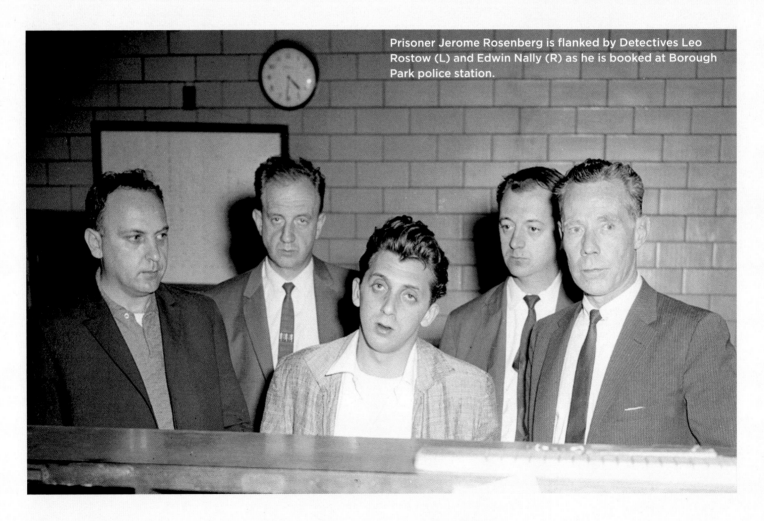

Prisoner Jerome Rosenberg is flanked by Detectives Leo Rostow (L) and Edwin Nally (R) as he is booked at Borough Park police station.

THE CAREER GIRL MURDERS

Year 1963

The murder scene in apartment 3C at 57 East 88th Street on Manhattan's fashionable Upper East Side.

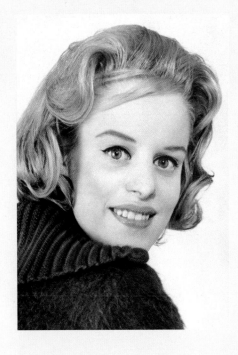

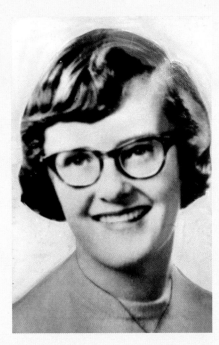

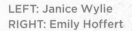
LEFT: Janice Wylie
RIGHT: Emily Hoffert

Wylie and Hoffert both lay dead and bloodied, tied together by strips of torn bedsheets.

In the early 1960s, Manhattan's fashionable Upper East Side was the center of the universe for single men and women. The social scene was vibrant, filled with young people. Among them were Janice Wylie, twenty-one, whom the tabloids called "blond and vivacious"; the bespectacled Emily Hoffert, twenty-three, who was described as "scholarly"; and twenty-one-year-old Patricia Tolles. The three young women resided together in Apartment 3C at 57 East Eighty-Eighth Street, a block from Central Park.

Wylie, the daughter of a New York advertising executive, hailed from a family of successful writers and was a bit of an urban sophisticate. Hoffert was the adopted daughter of a Minnesota physician. She had graduated from the prestigious Smith College with plans of becoming an educator. Tolles was employed by the book division of Time-Life.

On August 28, 1963, the same day that Dr. Martin Luther King Jr. first gave his iconic "I Have a Dream" speech, Tolles came home to find the apartment in shambles. In a panic she telephoned Wylie's father, who lived nearby. He immediately responded and, upon entering the bedroom, discovered a gruesome scene. Wylie and Hoffert both lay dead and bloodied, tied together by strips of torn bedsheets. They had been stabbed multiple times, and Wylie had been sexually assaulted. The press dubbed the carnage the "Career Girl Murders."

The *New York Post* would later describe the case as "the biggest, most sensational, most extraordinary crime and police investigation in New York's history at the time; one that would have a chilling effect on the cops, on the prosecutors, and on the courts nationally."

Kenneth Gross was a young reporter at the *Post* covering the story. He recalled, "The murder, the day of the freedom march in Washington; a lot of things were tied together to remind people that the city and the country were undergoing some transformation. It was a great turning point in the culture."

The police were under tremendous pressure to solve the Career Girl Murders, but none of the thousands of leads they pursued or interviews they conducted produced a viable suspect. Finally, after eight laborious months, detectives believed they finally identified the killer. A

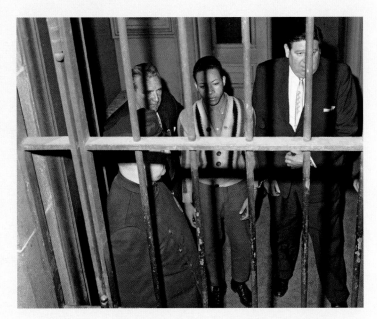

The mild-mannered and simple-minded George Whitmore signed a 61-page confession after several days of interrogation.

mild-mannered and simple-minded nineteen-year-old man named George Whitmore was questioned about an attempted rape in Brooklyn. After twenty-four hours of intense interrogation he admitted to the Brooklyn sex charges, as well as the murders of a black cleaning lady and the career girls.

As if his astonishing sixty-one-page signed confession was not enough evidence, the lead investigator, Edward Bulger, found photos of several females in Whitmore's wallet. Most were black, but one crumpled snapshot showed two white women, one of whom resembled Wylie. Whitmore admitted to removing that photo from the crime scene on the day of the murders.

Despite the fact that Wylie's father and others were steadfast in their admonitions that it was not Janice Wylie in the photo, the police and prosecutors were just as certain that they had the right man. When Whitmore recanted his confession, no one listened. The evidence was too overwhelming.

But a plethora of new evidence was soon uncovered that should have set Whitmore free. Credible witnesses placed him in New Jersey watching the March on Washington on television at the time of the Career Girl Murders. It was also learned that the purported photo of Wylie was actually that of a former classmate of Whitmore's. Moreover, it was believed that Whitmore, who traveled regularly between Brooklyn and Wildwood, New Jersey, had never set foot on the Upper East Side.

Whitmore was tried first for the Brooklyn sexual assault. Despite flimsy evidence, he was found guilty in late 1964. One juror later said "practically everyone" on the jury knew he had been implicated in the Career Girl Murders, which impacted their decision. In April 1965, Whitmore was tried for the murder of the cleaning lady, but the case ended in a mistrial.

Whitmore's fortunes seemed to shift for the better when a drug addict named Nathan Delaney told detectives he knew who the real killer of the career girls was. He said that a fellow heroin addict named Richard "Ricky" Robles, twenty-one, had come to his Spanish Harlem apartment on the day of the freedom march, his shirt covered in blood. Robles told Delaney and his wife that he had just killed two women who happened to return to their apartment as he was burglarizing it for drug money. Robles was arrested for the murders, but Whitmore still faced an uphill legal battle.

The indictment for the murder of the cleaning lady was dismissed in 1966, which was good news. His conviction in the Brooklyn sex case had been overturned, which was

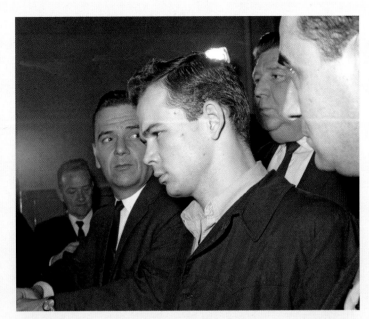

Detectives John Lynch and Nat Laurendi book heroin addict Richard Robles for the Career Girls murders.

also good news for Whitmore, but the district attorney vowed to try him again. This resulted in a legal odyssey that lasted until 1973, as Whitmore underwent what one writer called "a numbing cycle of trials, convictions, overturned convictions, retrials and appeals" before he was finally exonerated of all charges.

Whitmore's travails were among the first to shed light on the unreliability of confessions. His saga also was a contributing factor to the decision to abolish the death penalty in New York State and the implementation of Miranda warnings, where criminal suspects must be advised of their legal rights before being questioned.

When Whitmore was finally freed for good after nine years of legal entanglements, he told the press he held "no animosity." His story formed the basis of the 1973 television movie *The Marcus-Nelson Murders*, which evolved into the *Kojak* series. Whitmore tried his hand at dairy farming and commercial fishing but died poor, relegated to the scrap heap of anonymity, at the age of sixty-eight in October 2012.

Ricky Robles, the real killer of the career girls, was sentenced to twenty years to life in 1966. He has been continually denied parole since first becoming eligible in 1986.

"For years I have watched as people who committed far more brutal murders were released to parole supervision," Robles lamented to the *New York Times* in a 1993 letter. "I've seen serial killers, multiple murderers, even assassins and professional, paid murderers get released. But my time never comes."

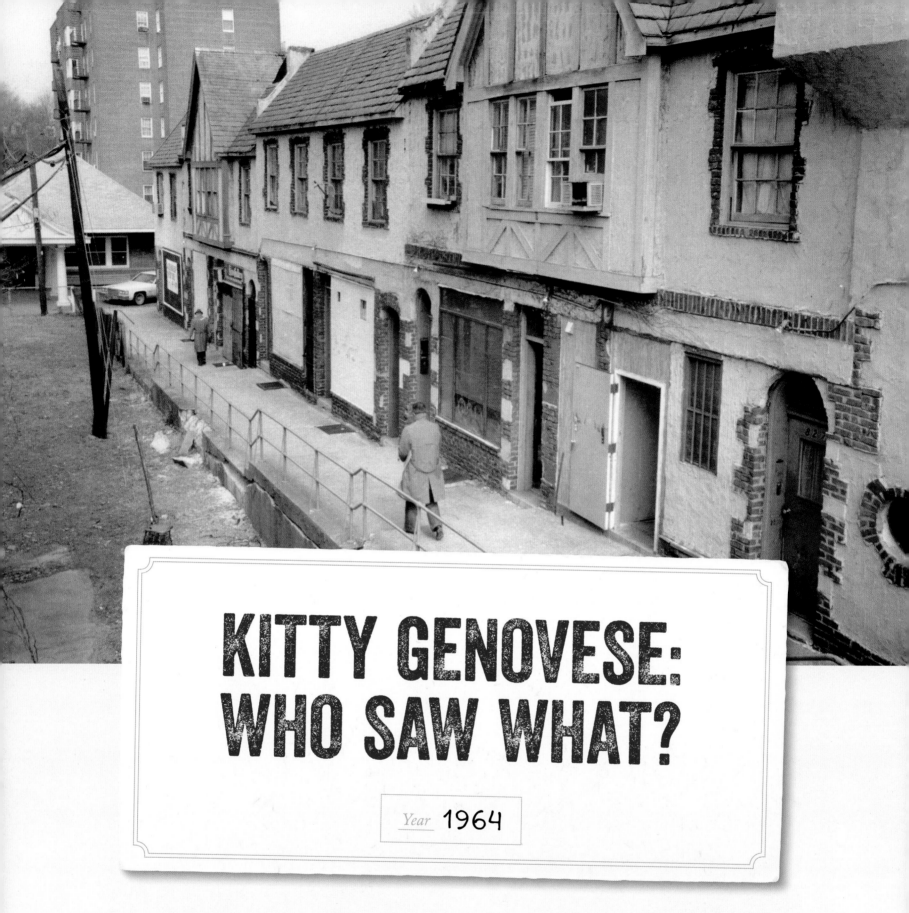

KITTY GENOVESE: WHO SAW WHAT?

Year 1964

One of New York City's most notorious urban legends involves the savage sexual assault and murder of Catherine "Kitty" Genovese, age twenty-eight, during the wee hours of March 13, 1964. Genovese was returning home from her bartending job when she was attacked on the street. She was subse-

quently stabbed to death in the back hallway of her Kew Gardens, Queens, apartment building located in a "good, clean, middle-class neighborhood" inhabited by people a reporter referred to as "respectable, law-abiding citizens."

Genovese, an attractive white girl, had been killed by an unknown black man in what appeared to be a random

act of violence during a period in history when race relations were at an all-time low. However, what garnered bigger headlines than the murder itself was the purported apathy exhibited by dozens of Genovese's neighbors who allegedly heard her blood-curdling screams for help but chose to ignore them.

Shortly after the murder and prior to the arrest of the perpetrator, Winston Moseley, the *New York Times* ran a scathing front page story under the banner: 37 WHO SAW MURDER DIDN'T CALL THE POLICE. The reporter, Martin Gansberg, wrote what appeared to be a meticulously detailed account of the grisly crime which occurred over the course of thirty minutes. Gansberg did report that at least one man yelled at Genovese's assailant, "Leave that girl alone," thinking the two were involved in a domestic dispute of sorts. Moseley slinked off for but a moment, only to return and attack Genovese two more times while thirty-seven of her neighbors failed to call the police or render assistance of any kind.

Although Genovese's murder was one of 636 that occurred in New York City that year, the back story of her death quickly took on a life of its own. The term "bystander effect" made its way into the American lexicon. It was suggested that urban apathy was as much responsible for the murder as Moseley himself. A frightened witness, who saw Moseley sexually assault Genovese and was quoted by Gansberg, seemed to be speaking for many city dwellers when he said, "I didn't want to get involved." The case was described as "Bad Samaritanism," and over the next five decades provided voluminous fodder for scores of psychological and sociological studies into apathy.

Beginning in the early 2000s, what had been accepted as the truth for so long started to unravel. It was true that Moseley, a twenty-nine-year-old computer punch operator, was armed with a hunting knife and cruising specifically for a white female victim that night. He had already killed a black female and wanted to see if there was difference between women of two races. He spotted Genovese driving home from her bartending job at Ev's Eleventh Hour Club and followed her. He watched as she parked her vehicle at the lot for the local Long Island Rail Road train station and began walking toward her building. As he pounced, a male witness yelled from his window for him to leave her alone.

Moseley initially fled the scene while Genovese staggered into one of the back entrance doors to her apartment building, a two-story Tudor-style row house with shops on the ground floor and residential units on the top floor. Shortly afterward, Moseley, emboldened by the fact that

A frightened witness, who saw Moseley sexually assault Genovese and was quoted by Gansberg, seemed to be speaking for many city dwellers when he said, "I didn't want to get involved."

OPPOSITE PAGE: This seemingly tranquil block at 82–70 Austin Street, Kew Garden, Queens, where Kitty was murdered.

BELOW: Kitty Genovese was a popular bartender at Ev's Eleventh Hour Club, from which she was returning home when savagely killed.

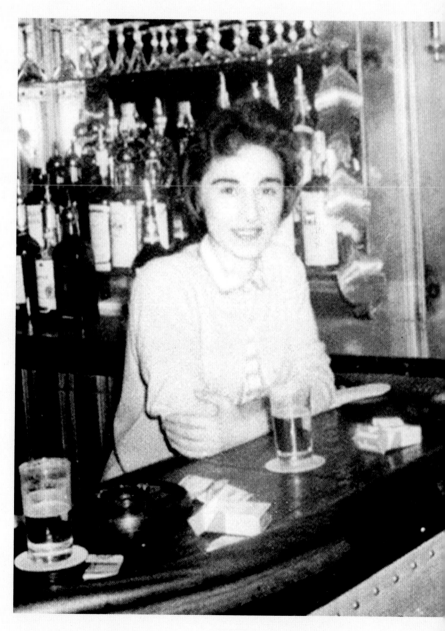

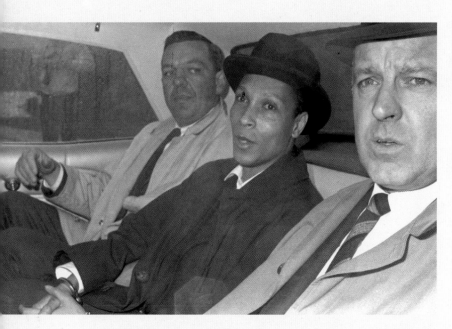

Winston Moseley in police custody after escaping from a prison hospital and embarking on a crime rampage in upstate New York in 1968.

family lived in nearby South Ozone Park. He had a job but subsidized his income by committing burglaries and fencing the goods. The police happened to arrest him five days after the Genovese murder as he carried a stolen television out of a house he had broken into. While being questioned about the theft as well as other burglaries in the area, he admitted to killing Genovese and two other women, whom he had also raped. Moseley's unsolicited confession included complete details of the crimes. The only thing for a jury to decide was whether he was guilty as charged or not guilty by reason of insanity. The jury opted for the former, sentencing Moseley to death. In 1967, the sentence was commuted to twenty years to life in prison.

In 1968, Moseley intentionally injured himself by shoving a can of Spam into his rectum in order to be taken to the hospital for treatment. While there, he overpowered a corrections officer and escaped from the prison ward. During the week he was on the lam, he held a married couple hostage, raped the wife, and stole their car. Then he broke into another house and took a mother and daughter hostage before surrendering to police.

At a parole hearing, he used convoluted logic in an attempt to depict himself as the real victim of his actions. "For a victim outside, it's a onetime or one-hour or one-minute affair, but for the person who's caught it's forever," he stated.

The parole board never bought his argument during the eighteen times Moseley came up for parole. When he passed away at age 81 in March 2016, he was the second-longest-serving inmate in the New York State correctional system.

the police did not respond, returned and began stabbing her until she could no longer offer resistance. Then he sexually assaulted her. By the time he fled the second time, Kitty Genovese was mortally wounded.

But at least two people called the police during the second attack. And, contrary to Gansberg's reporting, when the ambulance arrived on the scene, Genovese was being tended to by a benevolent female neighbor who had responded to her screams for help with no way of knowing if the was killer still lurking about.

Moseley was the married father of two children. His

THE ESTABLISHMENT OF 911 IN NEW YORK CITY

At the time of the Genovese murder, the only option for emergency callers was to phone the operator or call the local precinct directly. The case was integral to the establishment of the nationwide 911 emergency telephone number in 1969. In one of Moseley's pleas for parole, he wrote an op-ed piece for the *New York Times* in which he admitted to taking Genovese's life, but he believed the subsequent establishment of the 911 system warranted favorable consideration. "It did serve society, urging it as it did to come to the aid of its members in distress or danger," he wrote. His parole was denied.

New York City's 911 system, which was established in 1968, now handles more than 11 million calls per year, making it the largest of its kind in the nation.

While onstage, Lenny Bruce engaged in controversial monologues that one critic described as "philosophical claptrap on human nature."

THE CENSORSHIP OF LENNY BRUCE

Year 1964

By the late 1950s long-held social mores were being challenged on a daily basis. President Dwight D. Eisenhower had sent federal troops to Little Rock, Arkansas, to enforce desegregation in public schools. Elvis Presley transformed the music industry by the highly sexualized and energetic manner in which he performed. The Beat Generation had established a foothold in the cultural landscape. The Beats, who would be akin to today's hipsters, questioned and/or rejected materialism and values related to love, marriage, family, culture, and politics.

An iconoclastic leader of the Beats was the comic Lenny Bruce, a Long Island–born social satirist who used taboo language and graphic sexual verbiage and imagery in his routine. Bruce's humor was described as edgy and hip. When he appeared on the nationally televised *Steve Allen Show* in April 1959, the host described him as "the most shocking comedian of our time—a young man who is skyrocketing to fame."

Although Bruce behaved himself on television, he was in perpetual conflict with the authorities while traversing the world's nightclub circuit. He was deported from London and banned from Australia for what was considered to be a blasphemous account of the Crucifixion. He was not allowed to perform in Canada or Detroit.

> **Bruce was vilified by many as a foul-mouthed drug addict whose humor had no redeeming quality.**

He was arrested for obscenity in San Francisco, Chicago, New York, and Los Angeles, where one of the young city attorneys prosecuting his case was Johnnie Cochran, who would successfully defend O. J. Simpson on double murder charges three decades later. Having also been arrested several times for narcotics possession, Bruce was vilified by many as a foul-mouthed drug addict whose humor had no redeeming quality.

With the World's Fair coming to Flushing Meadows–Corona Park in Queens in mid-April 1964, city leaders prepared for the onslaught of international tourists by having the NYPD implement Operation Pornography. Officers converged upon Times Square, arresting smut merchants who were selling anything that might offend puritanical sensibilities. The city enacted a Coffee House Law in an attempt to rein in dissenters who read controversial poetry in Greenwich Village venues. To give the law more sinew, they redefined poetry readings as "entertainment,"

which required the locales to operate under the stringent and easily enforceable guidelines of a cabaret license.

On March 31, 1964, three weeks before the commencement of the World's Fair, Bruce opened at the Café Au Go Go on Bleecker Street. The controversial comic took to the semicircular stage and mused to as many as 350 audience members about his pending court cases, all of which involved either obscenity or drug possession, interspersed with tawdry tidbits that included graphic descriptions of former first ladies.

He commented on Eleanor Roosevelt's breasts and glibly stated that the iconic photo of Jacqueline Kennedy crawling on the trunk of the convertible seconds after her husband, President John F. Kennedy, was assassinated four months earlier, was not to assist him, but to escape the carnage. She "hauled ass to save her ass," opined Bruce. "Just what anyone would likely do under the circumstances."

In a riff Bruce called "Red Hot Enema," he poked fun at Francis Gary Powers, the CIA pilot whose U-2 spy plane had been shot down over Soviet airspace in May 1960. Powers was interrogated by his KGB captors for months, eventually convicted of espionage, and sentenced to ten years in a Russian gulag. Powers was exchanged for a Soviet spy in February 1962. He did not betray any of America's military secrets, which led Bruce to say that "putting a funnel up his ass" containing "hot lead" would make him lose his patriotic swagger. In another refrain,

The sardonic Lenny Bruce is deported from London for a second time. Officials kept him out of the country under the charge of not having a work permit.

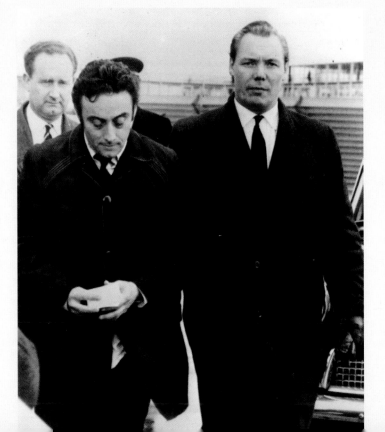

"Guys Are Carnal," Bruce described males as oversexed creatures who would have a one-night stand with anything that moves, including a chicken.

In the audience was a cabaret license inspector named Herbert Ruhe, who fastidiously took notes on Bruce's use of language and masturbatory simulations with the microphone. He described them as "philosophical claptrap on human nature." A few minutes before Bruce was to begin his ten P.M. show on April 3, he was arrested by the NYPD and booked at the Sixth Precinct on West Tenth Street in the heart of Greenwich Village, presumably the most liberal bastion for artistic freedom in the country.

The case aroused widespread controversy. Scores of prominent academics, literati, and entertainers rallied to Bruce's defense, describing him as a satirist as relevant as Jonathan Swift and Mark Twain. The six-week trial, which was heard by three judges and no jury, commenced in June 1964 and had to be moved to a larger courtroom to accommodate the throngs of media and observers.

The defense argued that Bruce's language, while coarse and unconventional, did not inspire the "lustful and lecherous thoughts" that were required by the legal statute. While the defense presented several psychiatric and media experts who testified about Bruce's social relevance, the prosecutor, Richard Kuh, lamented his difficulties finding experts to counter the defense for fear of being considered squares.

In November 1964, three months after the testimony ended, the judges were set to announce their verdict. Prior to that happening, a bedraggled, desperate, and flat-broke Lenny Bruce dismissed his own attorneys and pleaded with the judges, "Don't finish me off in show business. Don't lock up these six thousand words. That's what you're doing, taking away my words, locking them up."

Two of the three judges found Bruce guilty of all charges, explaining that his words were "patently offensive to the average person in the community." On December 16, Bruce returned to court, where he was sentenced to four months in jail. He remained free pending appeal, during which time the Playboy Press published his autobiography, *How to Talk Dirty and Influence People*. Although Bruce's antics would continue to influence people for decades to come, he died of a drug overdose two years later at his Hollywood home on August 3, 1966. He was forty years old.

After Bruce's untimely death, an assistant district attorney involved in his prosecution expressed remorse for the role he played in the case. "I feel terrible about Bruce," said Vincent Cuccia. "We drove him into poverty and bankruptcy and then murdered him. I watched him gradually fall apart. It's the only thing I did in [District Attorney Frank] Hogan's office that I'm really ashamed of. We all knew what we were doing. We used the law to kill him."

Decades later, numerous people, including the late comedian Robin Williams, lobbied Republican New York governor George Pataki to posthumously pardon Bruce. In issuing the first such pardon in the state's history, the staid and conservative Pataki said by doing so it was "a declaration of New York's commitment to upholding the First Amendment."

Attorney Harvey St. Jean represents Jack "Murf the Surf" Murphy and Allan Kuhn during a court proceeding.

MURF THE SURF AND THE AMERICAN MUSEUM OF NATURAL HISTORY JEWEL HEIST

Year 1964

On October 29, 1964, a pair of thieves inspired by the movie *Topkapi* entered the hallowed grounds of the American Museum of Natural History, while a third accomplice acted as a lookout on Central Park West. Displaying tremendous physical strength and athletic acumen, the two men climbed over a spiked, wrought-iron fence, scaled a 125-foot tall brick wall, and entered through an open window to gain access to the J. P. Morgan Hall of Gems, which was otherwise securely locked from the inside. At first the duo utilized a glass cutter to access to the display cases holding the prized Star of India, a 563-carat gem thought to be the largest cut sapphire in the world, the 100.32-carat DeLong Star Ruby, and more than twenty other precious gems. But they soon became impatient and began smashing the glass cases to remove the booty quicker. The alarms never went off. Their total haul was worth an estimated $410,000, which by today's standards would be over $3.1 million.

Afterward, the trio retreated to the Cambridge Hotel on Manhattan's Upper West Side. Early the next morning, two accomplices, Jack Roland Murphy and Alan Kuhn, both twenty-seven, beat a hasty retreat back to their homes in Miami, Florida, but the lookout, twenty-nine-year-old Roger Clark, decided to hang around the city.

Unbeknownst to the three cohorts, the manager of the hotel, a friend of plainclothesman Jimmy Walsh, had told the cop about a garrulous trio who had been hosting wild, drug-fueled parties in their room during the weeks leading up to the theft. When cops showed up to investigate, they were surprised to discover telltale evidence in the empty room linking the occupants to the museum break-in. Among the items recovered were footwear with glass shards embedded in the soles, photographs of museum, guns, burglar's tools, a jewelry scale, as well as recreational drugs and hard liquor. Since the men were still registered as guests at the hotel, Detective John McNally had a hunch they might return, so he hunkered down for the night in their room. He caught a big break the next morning when Clark came back with a male friend who was not involved in the burglary. Both were taken in for questioning.

Clark admitted his role in the robbery and disclosed that his partner in crime, Jack Murphy, had been a teenage violin prodigy and national surfing champion who was best known by the moniker "Murf the Surf." Clark's other partner, Alan Kuhn, was a Navy veteran. After his discharge he found his calling as a prolific jewel thief. Kuhn had amassed enough wealth knocking off hotel rooms to buy himself a white Cadillac, a speedboat, and a sailboat.

It did not take long after Clark's confession for the police to catch Murphy and Kuhn and extradite them to New York. Ironically, the public saw the Hollywood-

A detective examines a smashed jewelry case after the daring heist at the Museum of Natural History.

"Women. Class. Cash. No small-time, no-nonsense thefts for small stakes. Nobody gets hurt. It was beautiful."

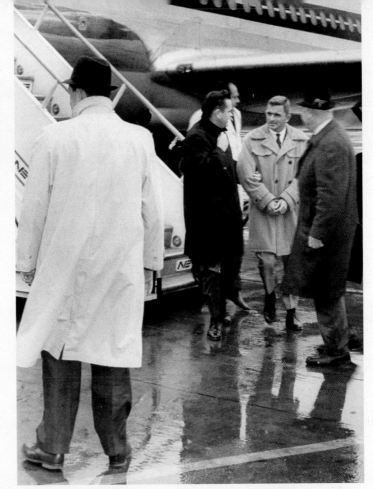

A handcuffed Allan Kuhn is escorted off a plane from Florida by NYPD detectives. To Kuhn's immediate right is Detective John McNally.

handsome thieves as colorful rogues and accorded them folk hero status. Nora Ephron, who would later become an Academy Award–nominated screenwriter, was a twenty-three-year-old Wellesley graduate when she got her first big scoop as a reporter for the *New York Post*. A few months later, she fueled their folk hero status, writing in the *Village Voice*, "They may be burglars, people said, but what class! They arrive in Cadillac convertibles or $10,000 yachts. They pay cash. Women. Class. Cash. No small-time, no-nonsense thefts for small stakes. Nobody gets hurt. It was beautiful." The fact of the matter was that the security at the museum was so lax, it was a wonder that no one had taken the jewels sooner.

Although the thieves were in custody, the jewels were nowhere to be found despite an international hunt for them. After several months in jail, Kuhn finally offered to lead cops to the stolen treasure in exchange for leniency. Detective McNally, two fellow NYPD detectives, and a prosecutor flew to Miami with Kuhn in tow. When they arrived McNally recalled that Kuhn was aghast that the lawmen had rented a black sedan for the occasion.

"He wouldn't be seen dead in that car, and he insisted that we rent a red convertible," McNally recalled. "There was so much pressure to retrieve the jewels that we acquiesced to his wishes."

After a labyrinthine trek though the underbelly of Miami, a three A.M. phone call to Kuhn circuitously directed them to a Trailways bus station, where the investigators recovered two musty bags in a locker. Among the assortment of sapphires, emeralds, and aquamarines was the famed Star of India, which had been mined in Ceylon three centuries earlier. Still missing was the DeLong Star Ruby, which, months later, was offered to a wealthy Florida businessman for $25,000. The go-between, a newspaperman from the New York *Daily News*, was directed to a pay phone at a service area on the Sunshine State Parkway to await instructions.

The phone rang. The reporter picked it up and was told to simply to reach over a ledge to recover the gem.

The next day, The *Daily News* headline blared, HERE'S RUBY! EXCLUSIVE. OUR MAN PICKS UP RANSOMED GEM.

The trio served about two years each in prison for their roles in the museum theft. Afterward, Roger Clark became a golf pro and eventually settled in Vermont, where he worked as a bartender at a French restaurant. He passed away from heart disease in 2007 at the age of seventy-one.

Murphy and Kuhn, however, resumed their criminal ways, first in Florida and later in Los Angeles, where they were arrested for several burglaries. Kuhn finally went straight after serving a year in federal prison. He resides in relative anonymity in Northern California, where he operates a medical marijuana company.

In 1969 Murphy was found guilty of the 1967 murder of a woman who had stolen nearly $500,000 from a Los Angeles brokerage firm. He was sentenced to life in prison for that crime, as well as for the robbery of a wealthy widow. He found God in prison, and his proselytizing enabled him to secure parole in 1986. Since then he has traveled the world, preaching to inmates with the Champions for Life ministry and prison reform group.

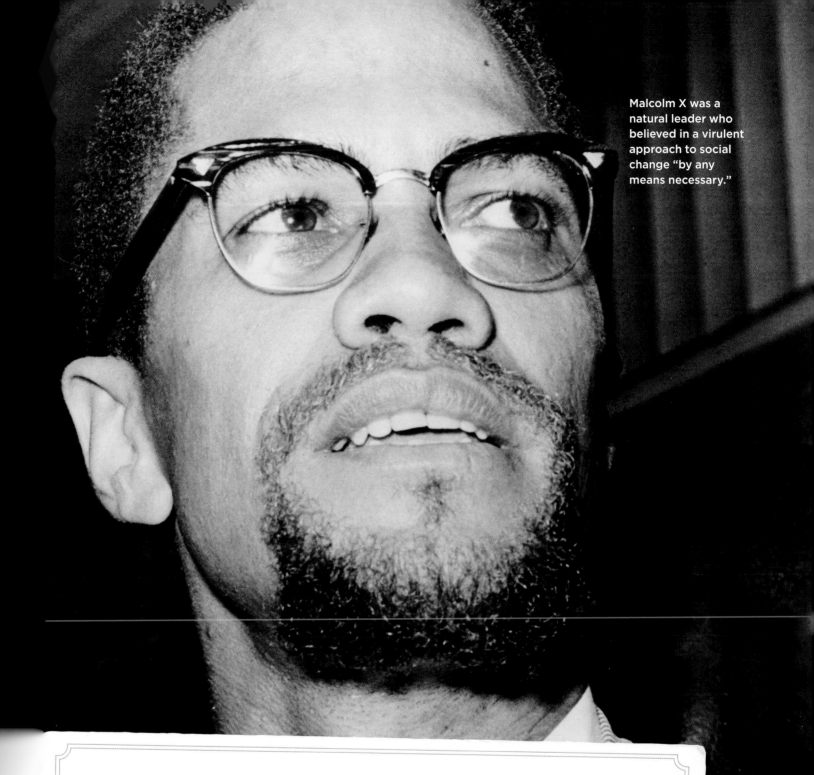

Malcolm X was a natural leader who believed in a virulent approach to social change "by any means necessary."

MALCOLM X: BY ANY MEANS NECESSARY

Year 1965

On the afternoon of February 21, 1965, Malcolm X was preparing to address the Organization of Afro-American Unity at the Audubon Ballroom, which was located at West 165th Street and Broadway in the Washington Heights section of Manhattan. About four hundred people were in attendance to hear another of his impassioned speeches related to the quest for black equality "by any means necessary." While his mantra inspired and mesmerized his followers, it terrified mainstream America.

A black man in the audience yelled at someone, "Get your hand out of my pocket." It may have been a diversionary tactic, because within seconds three other black men rushed the stage firing a sawed-off shotgun and semiautomatic handguns. Malcom X was struck by twenty-one gunshots and ten buckshot wounds. He was rushed to Columbia Presbyterian Hospital, where he was pronounced dead. Tens of thousands of mourners attended his public viewing at the Unity Funeral Home in Harlem. Renowned black actor and social activist Ossie Davis referred to Malcolm X as "our shining black prince."

Malcolm X was born Malcolm Little in Omaha, Nebraska, in 1925. His family was forced to move to Wisconsin and Michigan because his father, Earl, the leader of an early black pride organization called the Universal Negro Improvement Association, had run afoul of local white supremacist organizations. Earl died in a streetcar mishap when Malcolm was six years old, but many people believed that a Ku Klux Klan subsidiary called the Black Legion was responsible for his death. After his mother suffered a nervous breakdown, young Malcolm became immersed in petty crimes. He made his way to New York, where his criminal activities included pimping. His street name was Detroit Red because of the slight crimson hue in his hair.

Malcolm was eventually sentenced to prison in Massachusetts for being part of a burglary ring that targeted wealthy white people. While incarcerated, he became acquainted with the Nation of Islam (NOI), which was then a little-known organization that preached black self-reliance. After being paroled in 1952, Malcolm X thrust himself into the NOI movement, eventually becoming a prominent leader in Harlem, where scores of black men and women were drawn by his unbridled charisma. He rose to national prominence after the arrest of four black men by NYPD officers in 1957. When word spread that the suspects were beaten by the police, Malcolm X led a group of Muslims into the precinct. Before long, more than four thousand followers had assembled outside of the station house. When Malcolm X gave a simple hand signal to

TOP: The spot inside the Audubon Ballroom, where Malcolm X was shot.

BOTTOM: Bullet holes are clearly evident in the walls at the back of the stage where Malcolm X was killed.

disperse the crowd, one officer was quoted in the New York *Amsterdam News*, the city's preeminent black newspaper, as saying, "No one man should have that much power."

Malcolm X believed in a virulent approach to social change. He preached for the separation of the races and, while not outwardly condoning violence, said that it was the duty of black people to defend and advance themselves by "any means necessary."

"No one man should have that much power."

In March 1964, Malcolm X and the NOI parted ways in less than amicable fashion. Malcolm X was especially critical of leader Elijah Muhammad for his philandering with and impregnation of young secretaries. At the time, the NYPD had infiltrated the vast black activist network as early as 1964 with a young undercover officer named Ray Woods, who was credited with uncovering a plot to bomb the Statue of Liberty. Voluminous law enforcement data indicated that attempts were going to be made to have Malcolm X "bumped off." On February 14, 1965, Malcolm X's home in East Elmhurst, Queens, was firebombed, but no one was injured.

On the day of the murder, an undercover officer named Gene Roberts, known as Brother Gene, was photographed trying to resuscitate Malcolm X after he was shot. One gunman, Thomas Hagan, was beaten by the crowd and held for the police. He confessed to the killing but claimed the two other NOI members convicted were not involved. Hagan later named his true conspirators in an affidavit in order to get the two other men freed. They were eventually paroled, but Hagan's accused accomplices were never arrested. The NOI organization was never implicated in the conspiracy.

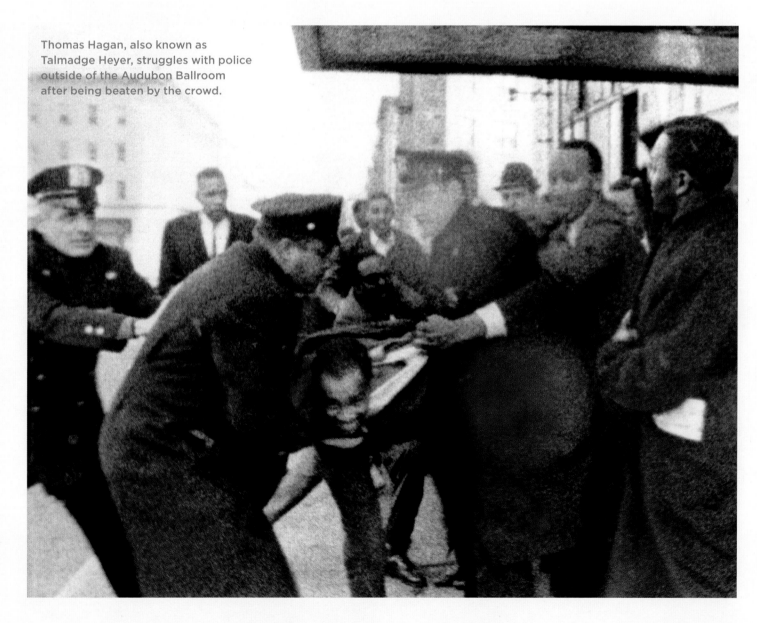

Thomas Hagan, also known as Talmadge Heyer, struggles with police outside of the Audubon Ballroom after being beaten by the crowd.

THE PERSECUTION OF ALICE CRIMMINS

Year 1965

At 9:44 A.M. on the morning of July 14, 1965, a hysterical man called the NYPD's Central Switchboard in Queens. "My name is Crimmins, Eddie Crimmins. My children are missing."

The children in question were his son Eddie, age five, and his daughter Missy, a year younger. They resided with their mother, twenty-five-year-old Alice Crimmins, in a first-floor apartment at the Regal Gardens on Seventy-Second Drive in Kew Gardens, Queens. Eddie and Alice, onetime high school sweethearts, had been married for seven years, but were now embroiled in a bitter divorce. He had moved out of the apartment and was renting a room nearby, mainly to keep an eye on his ex-wife. He was hoping to gather evidence about her carrying on with other men in order to improve his chances to gain sole custody of the children. It turned out he was doing more than watching. He had also bugged her phone and bedroom.

When Alice first called him that morning to inquire about the children's whereabouts, he was not particularly alarmed. Alice had a laissez-faire style of parenting. On one occasion, the children had climbed out of their bedroom window and were spotted by a neighbor playing in the snow wearing only their pajamas. Another time she left the children in the care of a babysitter because she claimed that she got locked in the bathroom on a cruise ship and did not get out until the ship was under way at sea. Even her own mother did not think Alice was a good caregiver. But when Eddie got to the apartment that morning, Alice was so distraught about the children that he called the police right away.

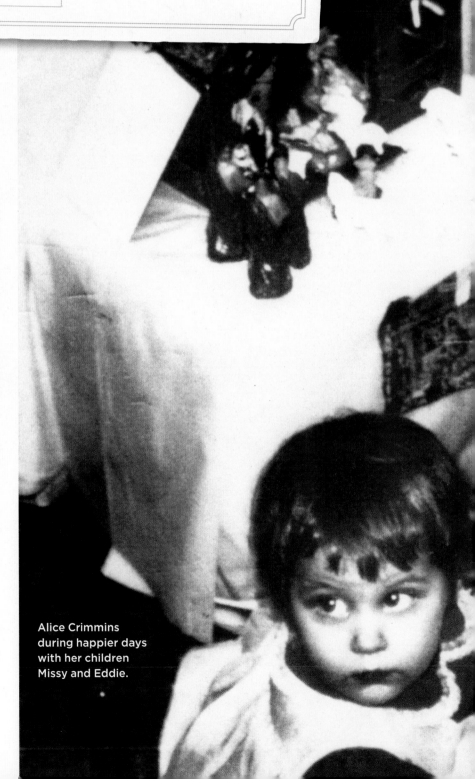

Alice Crimmins during happier days with her children Missy and Eddie.

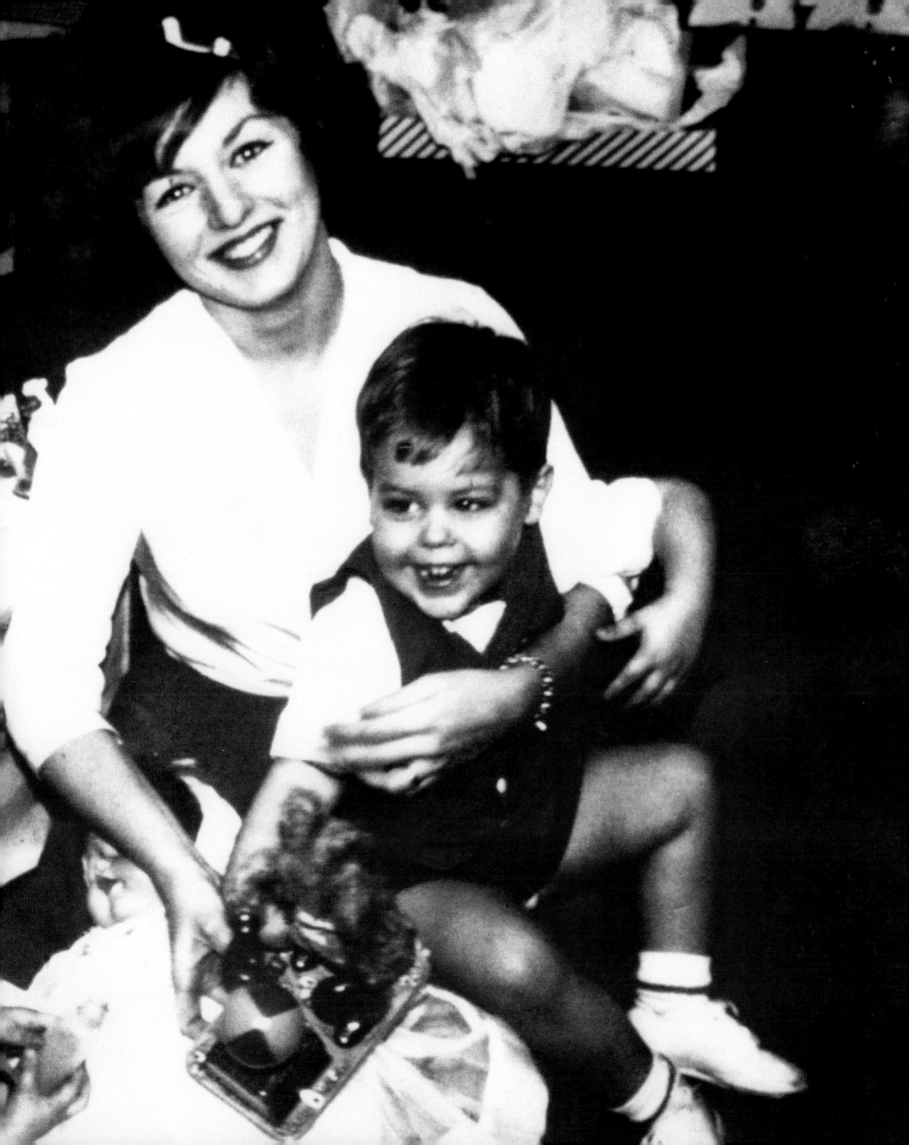

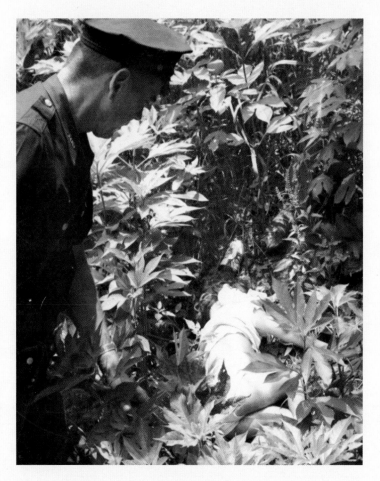

The body of Missy Crimmins was found in a wooded area in a residential neighborhood, not far from her home.

Shortly after their arrival police abandoned the idea that the missing children were part of a ploy by either of them to strengthen their claim for custody, and treated the case as a possible child abduction. But Detective Jerry Piering already had a feeling that Alice knew more about her children's whereabouts than she was letting on. In his mind she did not fit the picture of a grief-stricken mother. She was attractive, even sexy, but she wore a lot makeup that made her look cheap. She dressed provocatively. Her trash can was filled with empty liquor bottles, and the men's names outnumbered the women's four to one in her "little black book." His first impression would taint how he handled the case almost from the onset.

> She was attractive, even sexy, but she wore a lot makeup that made her look cheap.

By early afternoon, police officers in specially fitted sound trucks crisscrossed the streets calling out the children's names over loudspeakers: "Eddie! Missy! Can you hear us?" Aviation Unit helicopters searched from overhead as dozens of police officers fanned out on foot to scour the neighborhood.

It was all for naught. A boy playing in a vacant lot found Missy murdered, with her pajama bottoms knotted around her neck. Eddie Crimmins was inconsolable, but his pretty wife did not shed a tear. Reporters wrote that that Alice was "cold." Five days later, the body of little Eddie was discovered alongside the Van Wyck Expressway. It was so decomposed that it was impossible for the medical examiner to determine the cause of death.

Police considered both parents suspects, but only Eddie submitted to a full polygraph test. Alice quit answering questions in the middle of the interrogation.

For the next eighteen months, police focused their efforts almost entirely on Alice, who in the meantime found work as a cocktail waitress. The job brought her in contact with a variety of different men looking for a good time. The police bugged her phone and kept close tabs on both her and the men she shacked up with, even though Eddie had put the divorce proceedings on hold. The cops did not learn much about what happened to Alice's children, but they found out a lot about her sex life. This information was leaked to the press to the point that the *Daily News* described her as a "veritable garden of vice."

There was very little progress on the homicide case until an anonymous woman wrote a letter to the police. She said that on the night of the children's disappearance she observed a woman she believed was Alice in the company of her son and an unknown man. Alice was carrying what looked to be her daughter wrapped in a blanket. The woman claimed the man urged Alice to hurry up. She admonished him, "Be quiet or someone will see us."

Detectives tracked down the writer. She was Sophie Earomirski, an elderly neighbor of Alice's. After much cajoling, she agreed to testify in court. They also put the squeeze on one of Alice's lovers, a married father of seven named Joseph Rorech, whom she allegedly confided in. Between the two of them, there was enough proof against Alice to go forward.

What the press dubbed as the "Sexpot" trial began on May 9, 1968. Alice was depicted as a modern-day Medea, a sorceress in Greek mythology who killed her children to punish her husband. However, many observers thought that Alice was put on trial for living an amoral lifestyle as much as for killing her children. There was a good reason

for the prosecutor to do this. The prosecution had very little concrete evidence against Alice, so it harped on her wanton sexuality, which in the climate of the times was perceived as an unredeemable sin.

Rorech testified that during a rendezvous with Alice at a suburban hotel, she admitted that she killed her children because her other option would have left them to be raised by Eddie.

Alice leaped from her chair and cried, "Joseph! How could you do this? This is not true. Joseph, you of all people. Oh, my God!"

Alice took the stand in own defense. Rather than ask about her children, the prosecutor emphasized her sexual proclivities. For example, he asked if she ever swam in her lover's swimming pool. She replied that she had. The prosecutor followed up by inquiring what she wore in the pool. Alice said that one time she was wore a bathing suit, another time she did not. When asked where her children were when she was swimming naked, Alice responded tersely, "They were dead."

The all-male jury found her guilty of manslaughter with regards to her daughter. She was sentenced to a prison term of five to fifteen years. However, in December 1969, a new trial was ordered when it was discovered that three jurors had secretly visited the location where Mrs. Earomirski supposedly saw Alice fleeing with her children.

The case was retried in 1971. The second time around, Alice's lifestyle did not carry as much weight as it had before. Moreover, Alice also opted not to testify, which prompted the prosecutor to tell the jury, "She doesn't have the courage to stand up here and tell the world she killed her daughter," to which Alice blurted out, "Because I didn't."

Despite the revised strategy, Alice was not only convicted of manslaughter again in the death of her daughter, but she was also found guilty of murdering her son. While remanded to state prison, the murder charge was overturned on appeal because the prosecution had not proven that young Eddie's death was the result of a criminal act. Alice remained incarcerated for the manslaughter charge but was granted work-release status in 1976. That program allowed her to work as a secretary on weekdays along with a furlough from prison every other weekend.

In August 1977, the *New York Post* disclosed that Alice had spent "many of her balmy summer Sundays of her prison term on a luxury cruiser at City Island" in the Bronx.

But in the intervening years between her children's deaths and her first parole hearing, there had been a seismic shift in America's social and sexual mores. Now the public felt that what Alice did with her body was her business. She was paroled in September 1977 after serving just thirty-nine months in prison. She married Anthony Grace, the wealthy owner of the yacht that she spent so many of her weekends on. He passed away in 1998.

Alice's current whereabouts are unknown. As for her ex-husband, Eddie, he died in 2012 and shares a burial plot with his children in the North Bronx. Despite her conviction, how Alice's children met their deaths remains an unsolved mystery.

BELOW, LEFT: The body of four-year-old Missy Crimmins is carried into a Queens church, followed by her parents.
BELOW, RIGHT: Alice Crimmins leaves Queens Court with her husband, Edmund (left), and attorney Harold Harrison.

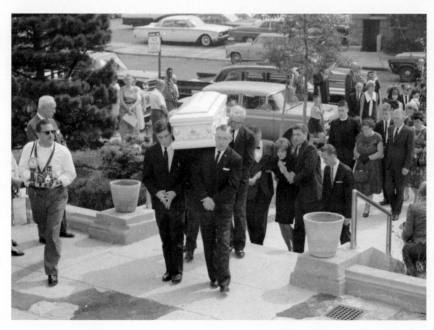

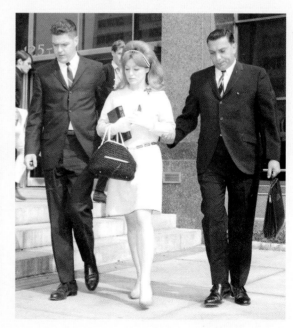

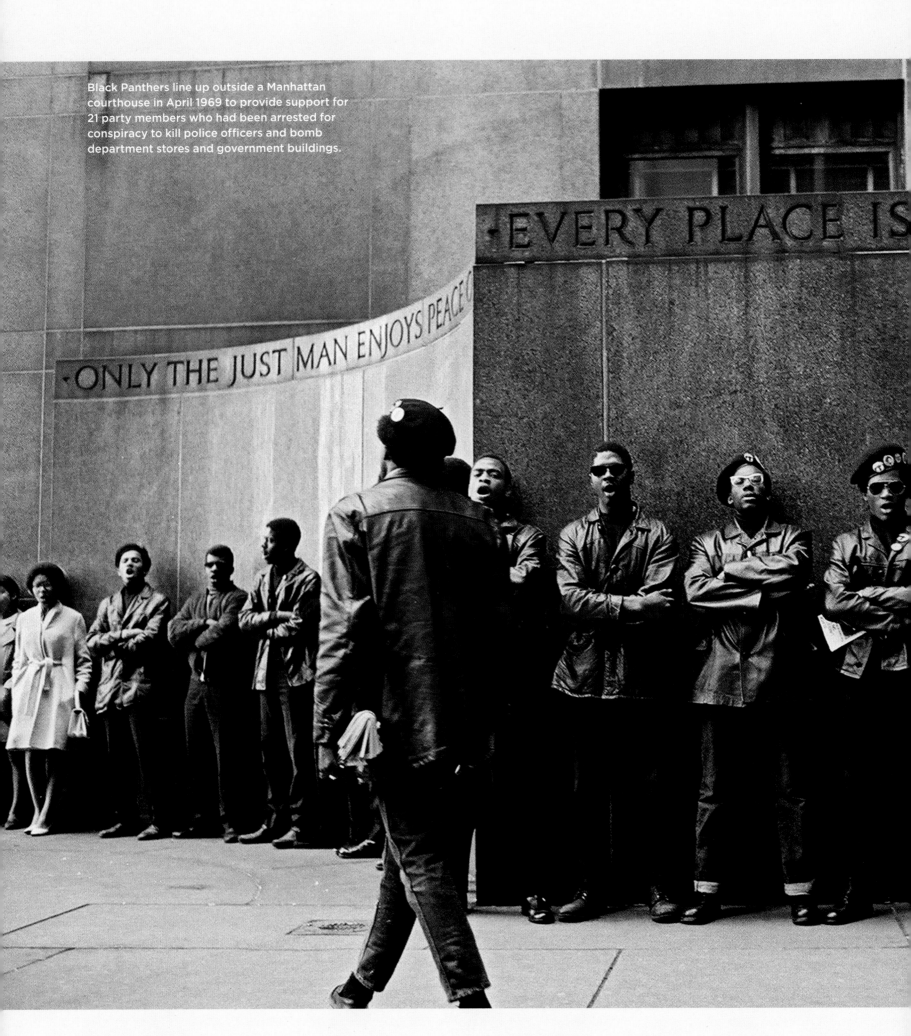

Black Panthers line up outside a Manhattan courthouse in April 1969 to provide support for 21 party members who had been arrested for conspiracy to kill police officers and bomb department stores and government buildings.

THE BLACK PANTHERS IN NEW YORK CITY

Years 1969–1981

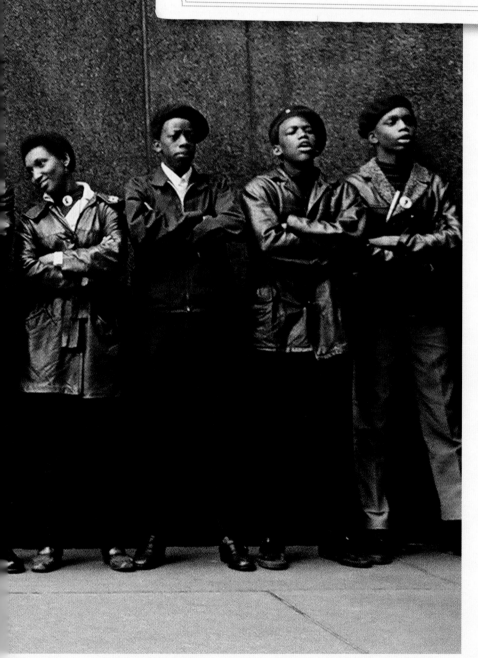

The Black Panther Party was founded in Oakland, California, in October 1966 by an army of radicals. Their objective was to promote domestic insurgency and armed insurrection as a means to gain racial equality. Their initial methodology, while legal, was in no way subtle; it was downright frightening. It was not a crime to carry unconcealed firearms at that time in California, so heavily armed Panthers would roll up on police encounters with the public in order to "monitor" their actions. When future president Ronald Reagan was elected governor of the Golden State in 1967, one of his first orders of business was signing into law the Mulford Act, which prohibited citizens of any color from carrying loaded firearms in public.

Among the founding fathers of the Panthers were Bobby Seale, who served as chairman; Huey P. Newton, the defense minister; and Eldridge Cleaver, the party's minister of information. Their stated goal was black equality and empowerment, both of which would be derived from what they called their Ten-Point Program. The ten points included freedom, employment, better housing, education, exemption from military service, and an end to police brutality. The organization grew quickly and soon had chapters in sixty-eight cities, including New York.

In the early days of the black power movement, FBI director J. Edgar Hoover called the Black Panther Party "the greatest threat to the internal security of the country." Those words proved to be somewhat prophetic.

While the organizational charter called for clothing drives for impoverished blacks, hot breakfast programs

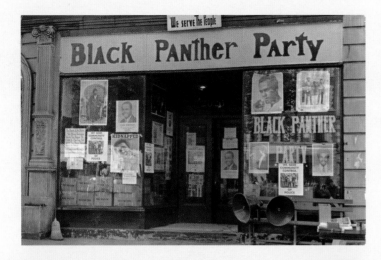

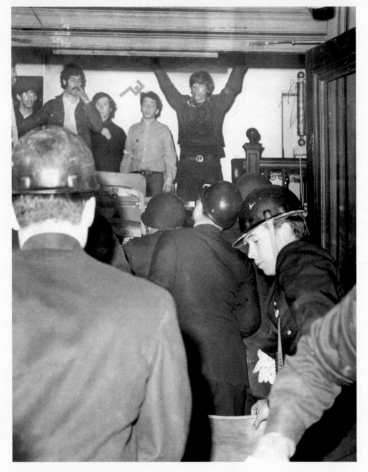

TOP: The New York headquarters of the Black Panthers, which was located at 2026 Seventh Avenue in Harlem.

BOTTOM: Members of the Black Panthers and the mostly white Young Lions engaged in sit-ins at Columbia University before being removed by the specially trained NYPD unit Tactical Patrol Force.

for elementary school children, and specialized classes in politics and economics, it also embraced unbridled violence against what the group perceived to be white oppression. In 1969, in New York City, an indictment was returned against twenty-one Panthers for conspiracy to kill police officers and bomb department stores and government buildings, including the Forty-Fourth Precinct in the Bronx, the Twenty-Fourth Precinct on Manhattan's Upper West Side, and the offices of the Board of Education in Queens. The Bronx attack was thwarted by the timely actions of an undercover police operative. After a tempestuous eight-month trial—at the time the longest and most expensive in New York City history—all of the defendants were acquitted in 1971.

By this time, however, the Panthers had been weakened by internecine squabbles. Newton was arrested and charged with killing an Oakland police officer, while Cleaver, who was involved in the ambush of several Oakland policemen, sought refuge in Cuba and Algeria. As the Panther movement ebbed, its idealogy was embraced by an even more virulent group of dissidents who called themselves the Black Liberation Army (BLA). The BLA's sole purpose was to foster a violent revolution on the streets of America.

Its leaders included Joanne Chesimard, who preferred her revolutionary name of Assata Shakur. *Assata* is an African word for "she who struggles," while *Shakur* is an African word for "the thankful one." The BLA was responsible for scores of bank robberies and cop killings in New Jersey, Atlanta, and San Francisco. Although it had established safe houses throughout the United States, another early member, Thomas "Blood" McCreary, recalled that New York City was earmarked as the organization's "battleground."

On the evening of May 19, 1971, BLA members used a machine gun to open fire on Officers Thomas Curry and Nicholas Binetti. They were guarding the home of Manhattan District Attorney Frank Hogan at 404 Riverside Drive after the house of John Murtaugh, the presiding judge at the Black Panther trial, had been firebombed with three crude Molotov cocktails courtesy of another radical group, the Weather Underground. Both officers were seriously wounded but survived.

Two days later, on May 21, Patrolman Waverly Jones, a black man, and his partner, Joseph Piagentini, who was white, were killed by BLA members outside a Harlem housing project. Both were shot multiple times in the back as they returned to their vehicle after responding to a routine call for service.

On the evening of January 27, 1972, two more officers, Gregory Foster, who was black, and Rocco Laurie, who was white, were shot from behind as they walked a beat on Avenue B and East Eleventh Street in Manhattan's East Village. Both cops were in their early twenties, had served together in the Marine Corps, and had requested to be partners.

> **A Brinks guard and two police officers, one of whom was black, were killed in a raging gun battle.**

The BLA's last major event occurred in 1981, when its members robbed a Brinks truck in suburban New York with the support of the Weather Underground, their white counterparts. In that incident, a Brinks guard and two police officers, one of whom was black, were killed in a raging gun battle.

In the end, a high-ranking Black Panther named Richard Moore was convicted of the attempted murder of police officers Curry and Binetti. However, his conviction was overturned seventeen years later, and he was awarded a $490,000 settlement. Three other BLA members were convicted of the murders of Patrolmen Jones and Piagentini. One of the suspects in the murders of Foster and Laurie was killed in a shootout with police in St. Louis, Missouri. The other was found not guilty after an eight-week trial in New York in 1974.

Chesimard, aka Shakur, was convicted of killing a state trooper during a 1973 traffic stop in New Jersey. She was sentenced to a maximum-security prison, from which she escaped in 1979, and she has been hiding in plain sight in Cuba ever since. She has an active website on which she describes herself as "a 20th century escaped slave."

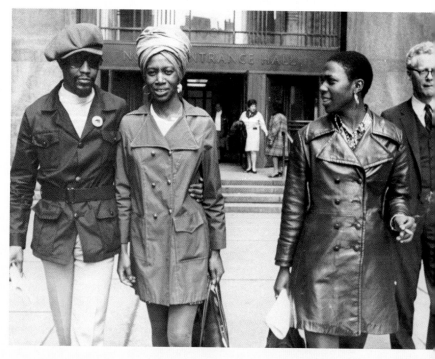

Black Panther members Richard Moore and his wife, Iris, leave court during the trial of the Panther 21.

In January 2012, the Ninth Precinct in the East Village, which has been transformed into an urban paradise for the young, hip, artistic, and upwardly mobile, rededicated a plaque to honor Foster and Laurie. Raymond Kelly, who was by then the police commissioner but had responded to the scene as a young sergeant, encapsulated the changed times during his speech.

"This was a violent neighborhood, no doubt about it, and radical groups like the Black Liberation Army were specifically targeting police officers for assassination," he said. "I remember that night. I remember the horror we all felt at the cold-blooded murder of our fellow officers."

Joanne Chesimard was a high-ranking Black Panthers member who was eventually convicted of killing a New Jersey state trooper in 1973. She escaped from prison in 1979 and has been hiding in plain sight ever since as an exile in Cuba.

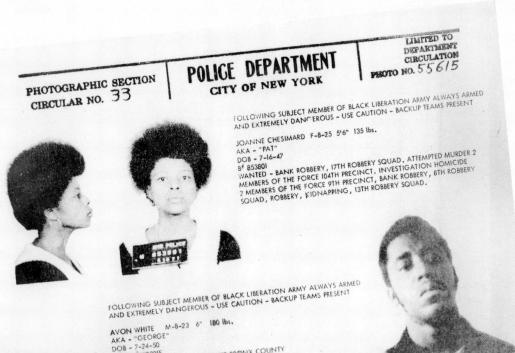

PHOTOGRAPHIC SECTION
CIRCULAR NO. 33

POLICE DEPARTMENT
CITY OF NEW YORK

LIMITED TO
DEPARTMENT
CIRCULATION
PHOTO NO. 55615

FOLLOWING SUBJECT MEMBER OF BLACK LIBERATION ARMY ALWAYS ARMED
AND EXTREMELY DANGEROUS - USE CAUTION - BACKUP TEAMS PRESENT

JOANNE CHESIMARD F-B-25 5'6" 135 lbs.
AKA - "PAT"
DOB - 7-16-47
B# 853801
WANTED - BANK ROBBERY, 17TH ROBBERY SQUAD. ATTEMPTED MURDER 2
MEMBERS OF THE FORCE 104TH PRECINCT. INVESTIGATION HOMICIDE
2 MEMBERS OF THE FORCE 9TH PRECINCT, BANK ROBBERY, 8TH ROBBERY
SQUAD, ROBBERY, KIDNAPPING, 13TH ROBBERY SQUAD.

FOLLOWING SUBJECT MEMBER OF BLACK LIBERATION ARMY ALWAYS ARMED
AND EXTREMELY DANGEROUS - USE CAUTION - BACKUP TEAMS PRESENT

AVON WHITE M-B-23 6' 180 lbs.
AKA - "GEORGE"
DOB - 7-24-50

THE WEATHER UNDERGROUND

Year 1970

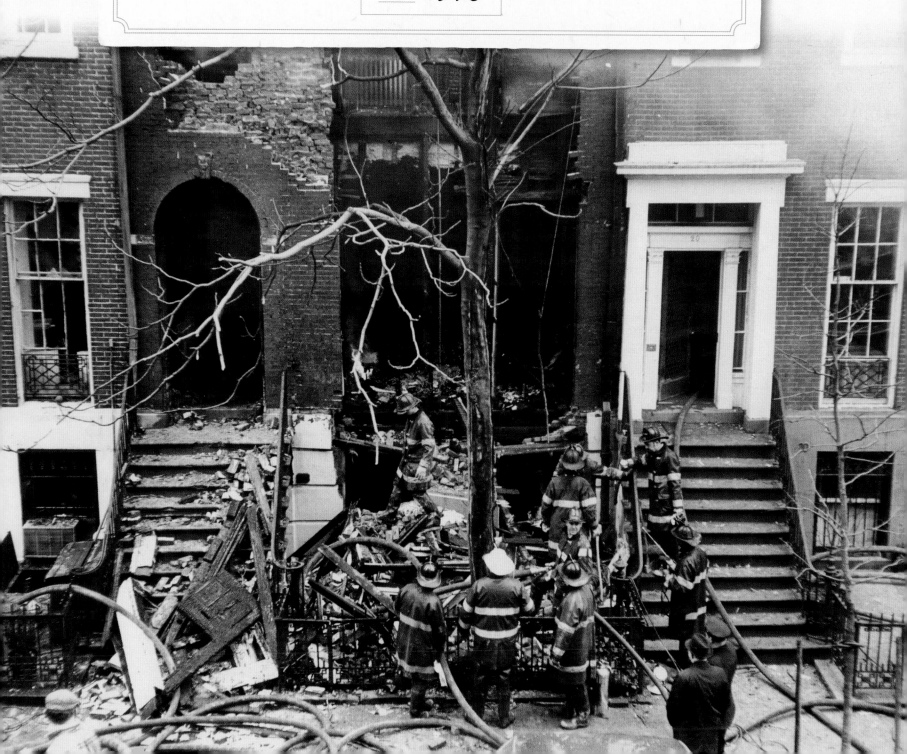

In the late morning of March 6, 1970, there was a deadly eruption at 18 West Eleventh Street when three members of a radical leftist group called the Weather Underground Organization (WUO) were blown to bits while assembling a bomb in the town house's basement. Authorities believed that the bomb, which consisted of dynamite stuffed in water pipes and packed with nails to act as shrapnel, was being made to be detonated at either the Fort Dix Army Base in New Jersey or the Seth Low Library at Columbia University.

Three members of the Weathermen, Diana Oughton, Terry Robbins, and Theodore Gold, were killed instantly. Two others, Kathy Boudin and Cathy Wilkerson, whose parents owned the town house, were seriously injured. Boudin and Wilkerson were aided by first responders, including off-duty police personnel, but managed to escape before authorities realized the explosion was not an accident. A neighbor at the time, actor Dustin Hoffman, was photographed outside the smoldering wreckage in the days after the incident.

Over the course of nine days of sifting through debris, investigators recovered numerous human body parts, as well as an antitank artillery shell, over fifty sticks of dynamite, four pipe bombs packed with explosives and blasting caps, antigovernment literature, and maps of the area in, around, and under Columbia University. A law enforcement spokesperson described the house as a veritable bomb factory.

Ed Mullins, the president of the New York City Sergeants Benevolent Association, grew up on West Eleventh Street within earshot of the explosion and was nine years old when it occurred. "Back then, the West Village consisted mainly of working-class families or bohemians who had no inclinations toward violence," recalled Mullins. "Like so many fathers in the neighborhood, my father was a longshoreman. We were aware of the social upheaval around us, but the explosion was still shocking and unfathomable to us. My friends and I would go by and look at the house for weeks."

The WUO was founded at the University of Michigan at Ann Arbor in 1969 as an offshoot of an organization called Students for a Democratic Society (SDS). The SDS, as well as the WUO, was comprised of radicalized students whose ultimate goal was the overthrow of the United States government, which they viewed as imperialistic and racially oppressive.

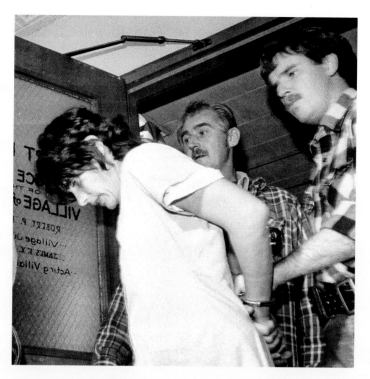

Weather Underground fugitive Kathy Boudin is taken into custody after 10 years on the lam. She was arrested for her participation in an armored car robbery in which two responding police officers and a Brinks guard were killed.

> ## Investigators recovered numerous human body parts, as well as an antitank artillery shell, over fifty sticks of dynamite, and four pipe bombs packed with explosives and blasting caps.

The WUO took its name from a 1965 protest song by Bob Dylan called "Subterranean Homesick Blues," drawn from the singer/songwriter's cynical views of American society, especially those related to political corruption, racial disparities, and unequal wealth distribution. In the context of the song, a particularly profound verse reads, "You don't need a weatherman to know which way the wind blows."

The WUO consisted primarily of white students, many of whom hailed from affluent backgrounds, who aligned themselves with the black power movement to protest racial injustice and American involvement in Vietnam. While their initial plan was to conduct clandestine revolutionary actions, they publicly demonstrated in

OPPOSITE PAGE: Rescue workers respond to a deadly explosion caused by the accidental detonation of a bomb being constructed by the Weather Underground Organization, a group of white activists.

October 1969 during what became known as the Days of Rage. The demonstration, which evolved into a full-scale riot, occurred during court proceedings for the Chicago Seven, a group of white men on trial for domestic insurgency. After Black Panther leaders Fred Hampton and Mark Clark were killed during a police raid in Chicago in December 1969, the WUO issued a "Declaration of War" against the United States government. "I cherished my anger as a badge of moral superiority," one of the group's founders, Mark Rudd, would say decades later.

Rudd and other members, including married couple Bill Ayers and Bernardine Dohrn, would exploit that anger as an excuse to blow up landmarks and make public statements that subverted authority. "We've known that our job is to lead white kids into armed revolution," said Dohrn, who in October 1970 was placed on the FBI's Ten Most Wanted List. "Tens of thousands have learned that protests and marches don't do it. Revolutionary violence is the only way."

The revolutionary violence attributed to the WUO in the 1970s included the detonating of a bomb at the NYPD headquarters, located at 240 Centre Street in downtown Manhattan; exploding three Molotov cocktails outside the home of New York Supreme Court Judge John M. Murtaugh, who was presiding over the trial of twenty-one Black Panthers; and planting explosive devices at the Pentagon, the Capitol Building, and the State Department in Washington, D.C.

While Ayers would maintain in the early 2000s that the WUO was "remarkably successful" at maintaining a system of "checks and balances" that ensured no people were harmed during the group's actions, Harvey Klehr, a professor of politics and history at Emory University, begged to differ. "The only reason they were not guilty of mass murder is mere incompetence," Klehr said.

The WUO engaged in subversive activities for much of the 1970s, but eventually disbanded due to internal disagreements and changing ideologies. Cathy Wilkerson and Kathy Boudin managed to evade justice for a decade after the Greenwich Village explosion. After ten years on the lam, Wilkerson surrendered to police in 1980 and served several years in prison. Upon her release, she became an educator in the New York City public school system for more than twenty years.

Boudin was captured after taking part in the infamous 1981 Brinks armored truck robbery by the Black Liberation Army in Nanuet, a suburb north of New York City. The heist netted $1.6 million but resulted in the deaths of a Brinks guard and two responding police officers. After serving twenty-two years in prison, Boudin became an adjunct professor at Columbia University, the same educational institution she conspired to bomb nearly five decades before.

Mark Rudd, one of the founders of the Weather Underground, and 12 other members were indicted for the blast that claimed the lives of three members. The group had planned to detonate the bombs at Columbia University and an officer's club at the Fort Dix Army base.

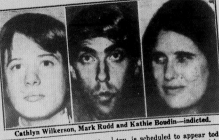

190

Report FBI Brands

The Nation of Islam's Mosque No. 7
at 102 West 116th Street in Harlem.

THE MURDER AT THE HARLEM MOSQUE

Year 1972

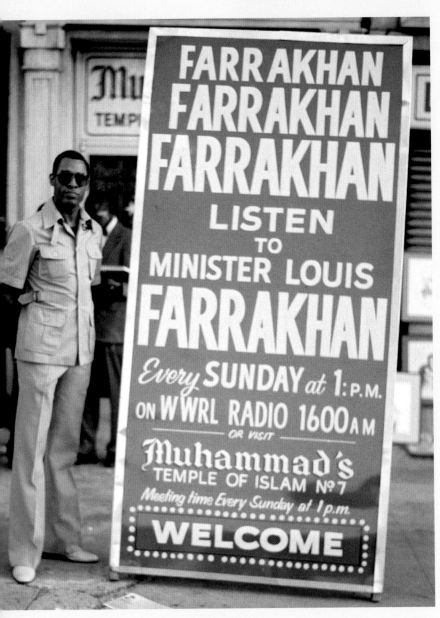

On the afternoon of April 14, 1972, Patrolmen Philip Cardillo and Vito Navarra of the Twenty-Eighth Precinct responded to a 10-13, the radio designation for an officer needing immediate assistance, at 102 West 116th Street in Harlem. The caller identified himself as Detective Thomas and said he was in dire need of help. No mention was made that the building housed the Nation of Islam Mosque No. 7, which was run by the virulently radical minister Louis Farrakhan.

Hearing what sounded like a scuffle inside, Cardillo and Navarra, as well as back-up officers Victor Padilla and Ivan Negron from the neighboring Twenty-Fifth Precinct, rushed into the premises. They were immediately set upon by fifteen to twenty men who dead-bolted the door to trap them inside. During the ensuing melee, Padilla was beaten into semiconsciousness with a blackjack, while Negron managed to draw his revolver and fire several shots.

Another responding officer, Rudy Andre of the Twenty-Eighth Precinct, witnessed the melee from the outside. He broke the glass on the front metal door and fired at the men attacking the officers. His actions allowed Negron to unbolt the door to allow his fellow officers to escape. Amid the chaos they did not realize that Cardillo was still inside, lying on the ground after having been shot with his own gun.

The political machinations that followed remain a travesty to this day. Scores of police officers converged on the mosque. Cardillo was removed to St. Luke's Hospital. Sixteen suspects, including a man named Louis 17X Dupree, who was believed to have shot Cardillo, were being detained when Minster Farrakhan and Congressman Charles Rangel arrived. Angry worshippers accused the officers of having illegally entered the mosque with their guns drawn and interrupting daily prayers.

The highest-ranking uniformed police official at the scene was Chief of Detectives Albert Seedman, a cigar-chomping white man who looked as if he had been dispatched from central casting. Also present was Benjamin Ward, the black deputy commissioner of community affairs. Seedman would later say he asked for reinforcements from Chief Inspector Michael Codd in order to quell the gathering storm outside the mosque. Codd reportedly denied his request and would not take further calls. Seedman and Ward were left in the unenviable position of having to sort things out on their own.

> **The political machinations that followed remain a travesty to this day.**

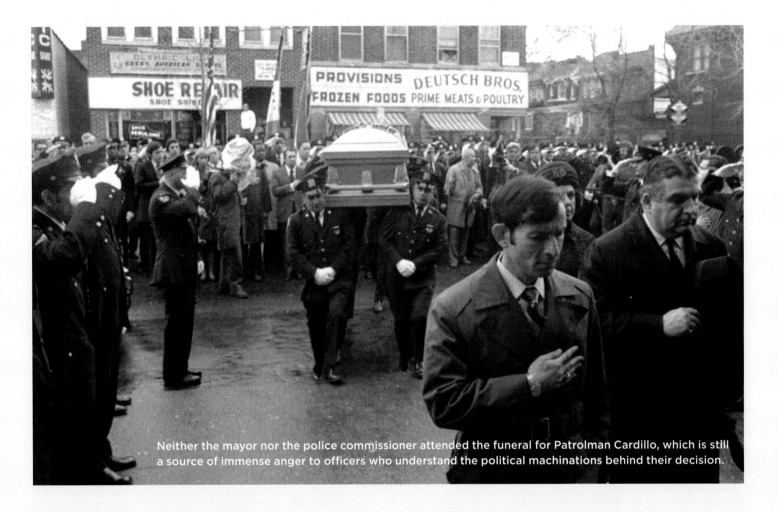

Neither the mayor nor the police commissioner attended the funeral for Patrolman Cardillo, which is still a source of immense anger to officers who understand the political machinations behind their decision.

To put an end to the standoff, a deal was brokered between the police, the politicians, and Minister Farrakhan. The suspects were allowed to leave the mosque with the promise that they would later turn themselves in for questioning. Not surprisingly, not one of them kept their word.

Police officer Cardillo, the thirty-two-year-old father of three small children, died six days later. Neither Mayor John Lindsay nor Police Commissioner Patrick Murphy attended Cardillo's funeral. Chief Seedman, who had proudly served the NYPD since 1942, resigned in disgust the following week.

"I have never seen officers in uniform so dispirited," Robert Tannenbaum, a former prosecutor and best-selling author, told reporter Leonard Levitt. "They were stunned by the audaciousness of the Harlem politicos running around, thinking they could control a criminal investigation into the shooting of a police officer."

To make matters worse, ballistic technicians were not allowed into the mosque that day to collect evidence. This failure would contribute to Louis 17X Dupree's subsequent acquittal.

Although members of the force blamed Benjamin Ward for conspiring with Farrakhan and Rangel to avert further social unrest, an internal memo that was not made public until 1983 disclosed that it was Chief Seedman who allowed the suspects to leave the mosque, not Ward. Seedman insisted he was ordered to remove police from the mosque by Chief Inspector Codd, presumably at the behest of Mayor Lindsay, who had his eyes on the presidency, and the police commissioner who was more concerned with social ramifications than achieving even a modicum of jurisprudence.

"I loved the police department so much that I couldn't drag it through the dirt by saying what those bastards did," Seedman proclaimed in his memoir.

Both Codd and Ward would go on to become police commissioners. Seedman passed away in 2013 at the age of ninety-four.

In 2014, some forty-two years after his death, Cardillo had a street renamed after him near the newly constructed police academy in College Point, Queens. A year later, an NYPD Harbor Unit vessel was named in his honor.

"Patrolman Cardillo was asked to give his all, and he did so," said Police Commissioner William J. Bratton as the new boat was christened. "We did not keep our promise to remember him until now."

Armed with a shotgun, John Wojtowicz peers out from the bank in which he and an accomplice were holding eight hostages during a 14-hour siege.

DOG DAY AFTERNOON

Year 1972

Even by New York standards, the bank robbery that inspired the 1975 movie *Dog Day Afternoon* was bizarre. On August 22, 1972, two men, John Wojtowicz and Salvatore Natuarale, entered the Chase Manhattan bank on the corner of Avenue P and East Third Street in the Gravesend section of Brooklyn. An alleged third accomplice had chickened out at the last minute. Wojtowicz, who was twenty-seven, and the eighteen-year-old Natuarale pulled guns on the manager and announced a stickup.

The initial plan was to steal the loot, lock the bank employees in the vault, and make their escape. What subsequently transpired turned into something more akin to a three-ring circus. Although the thieves quickly grabbed over $200,000 in cash and traveler's checks, the manager was able to activate a silent alarm to alert the authorities. Before Wojtowicz and Natuarale could get away, the bank was surrounded by NYPD followed by FBI personnel, as well as throngs of media and legions of curious onlookers.

The robbers took nine bank employees hostage. Over the next fourteen hours, city residents were riveted to their radios and glued to their television sets, following the drama as it unfolded.

Wojtowicz, a Vietnam veteran, was legally wed to a woman named Carmen, with whom he had two children. After his discharge it became clear to him that he could no longer hide from his sexual inclinations, so he abandoned his wife and became an extremely active and vocal member of the Gay Activists Alliance.

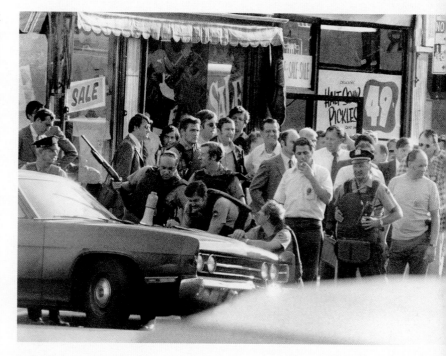

Police barricaded behind a car near the Chase Manhattan Bank on 450 Avenue P in Brooklyn. They were reluctant to charge John Wojtowicz, who had said, "I could kill."

In the process, Wojtowicz found true love in a man named Ernest Aron, who lived as a woman and went by the name Liz Eden. The two were "married" in 1971 in Greenwich Village by a priest who was later defrocked because of his relationship with the gay community.

Wojtowicz's reason for robbing the bank was to finance a sex-change operation for Aron. But once the robbery went bad, Wojtowicz became unhinged and demanded to

> ## Wojtowicz's reason for robbing the bank was to finance a sex-change operation for Aron.

crowd. Before long many of the onlookers began cheering him on as if he was some kind of folk hero. After much negotiation, it was agreed that Wojtowicz, Natuarale, and several hostages would be driven to JFK Airport, where they would board a plane and fly to freedom. Upon their arrival at the airport, however, Natuarale was shot and killed by an FBI agent. Wojtowicz was taken into custody. The hostages were released—shaken and tired—but otherwise unharmed.

speak to Aron. The police retrieved Aron from a hospital that was treating him after a suicide attempt and brought him to the bank.

Carmen Wojtowicz recalled sitting at the beach with her two children when she heard a radio bulletin announce that "an admitted homosexual" was involved in a bank robbery and hostage situation. But it wasn't until she got home and was told by a neighbor that she realized the "admitted homosexual" robbing the bank was her estranged husband. Carmen turned on the television and became even more livid when a photo of Aron was shown and described as Wojtowicz's wife.

On several occasions, Wojtowicz exited the bank to speak with police and throw stolen money toward the

Wojtowicz was sentenced to twenty years in federal prison. In 1977, he wrote a letter to the *New York Times* from a correctional facility in Pennsylvania, in which he claimed that he only robbed the bank "in order to save the life of someone I loved a great deal." Aron, he wrote, "wanted to be a woman through the process of a sex-change operation and thus labeled by doctors as a Gender Identity Problem." Wojtowicz felt Aron was a woman trapped in a man's body. This caused him "untold pain and problems which accounted for his many suicide attempts." While gender identity issues are commonplace today, they were viewed far less liberally in those days, so Wojtowicz was in some ways ahead of his time. Unfortunately, for him, his harebrained scheme to get the money was not.

WOJTOWICZ'S BRUSH WITH FAME

Wojtowicz gained a modicum of notoriety while in prison after Al Pacino's iconic portrayal of him in the film *Dog Day Afternoon.* The picture was nominated for five Academy Awards, including Best Picture, Best Director, Best Actor for Pacino, and Best Actor in a Supporting Role for Chris Sarandon, who portrayed Aron. Sidney Lumet, the quintessential New York director, had high praise for Pacino for tackling such a controversial role in the climate of the times. He said Pacino "was the one at greatest risk" because "no major star that I know of had ever played a gay man."

But Wojtowicz was not as enamored, at least at first. He was bothered by inaccuracies in his depiction and was particularly upset that the ending implied that he betrayed Natuarale to the FBI for the sole purpose of saving his own skin. His take was borne out when the film was screened at the prison. His fellow inmates saw him as a sellout and afterward beat him so badly that he required hospitalization.

Still, after being paroled in 1978, Wojtowicz sought to make the most out of his notoriety and started calling himself "the Dog," after his character. He even approached Chase Manhattan about a security job but was turned down. He looked into starting a limousine service with *Dog Day Afternoon* perpetually playing on a television in the backseat, but his parole officer nixed the idea. He wound up on public assistance, and he often hung out at the scene of his crime wearing a T-shirt emblazoned with the words I ROBBED THIS BANK. One time, when a man asked him if he was the guy played by Al Pacino in the movie, he said, "I'm the bank robber. Fuck Al Pacino."

Wojtowicz died of cancer in 2006.

The 1975 film *Dog Day Afternoon* starred Al Pacino as Sonny, a character based on John Wojtowicz.

The robbery should have taken

10 minutes. 4 hours later,

the bank was like a circus sideshow.

8 hours later, it was the

hottest thing on live TV.

12 hours later, it was history.

And it's all true.

An Artists Entertainment Complex, Inc. Production **AL PACINO**
DOG DAY AFTERNOON

Also Starring JOHN CAZALE · JAMES BRODERICK and CHARLES DURNING as Moretti
Screenplay by FRANK PIERSON · Produced by MARTIN BREGMAN and MARTIN ELFAND · Directed by SIDNEY LUMET
Film Editor DEDE ALLEN · TECHNICOLOR® From WARNER BROS. A WARNER COMMUNICATIONS COMPANY

R RESTRICTED Under 17 requires accompanying Parent or Adult Guardian

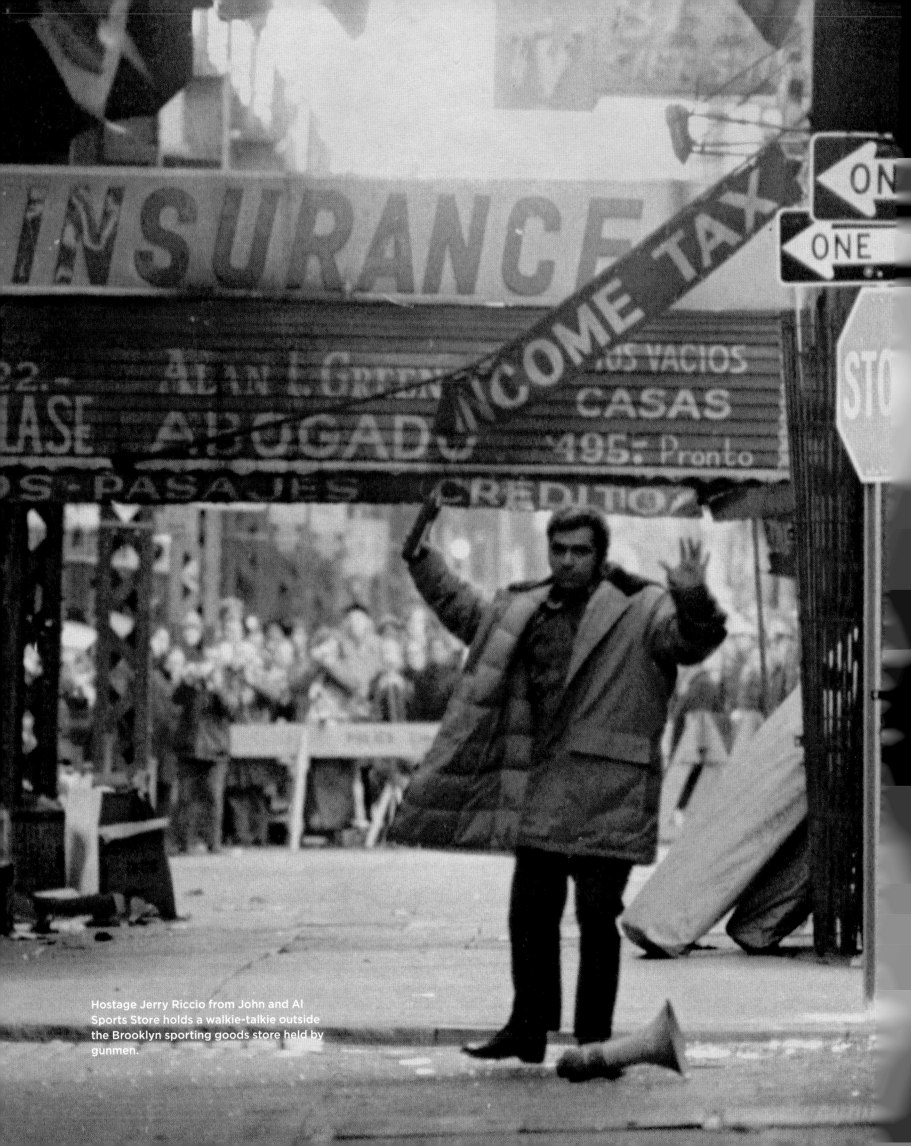

Hostage Jerry Riccio from John and Al Sports Store holds a walkie-talkie outside the Brooklyn sporting goods store held by gunmen.

NEW YORK CITY'S FORGOTTEN FIRST JIHAD

Year **1973**

September 11, 2001, was a turning point in the history of New York City. Eight Muslim hijackers, in a premeditated act of pure jihad, crashed two jets into the Twin Towers of the World Trade Center and killed 2,996 innocent people. Among the dead were twenty-three members of the New York City Police Department who took part in the ill-fated rescue effort. Contrary to what many people think, they were not the first NYPD officers killed by jihadists in New York City. That unfortunate distinction belongs to a twenty-nine-year-old Emergency Service Unit police officer named Stephen Gilroy.

Shortly after nightfall on Friday evening, January 19, 1973, four armed Sunni Muslims led by convert Shuaib Raheem, aka Earl Robinson, entered John and Al's Sporting Goods store on the corner of Broadway and Melrose Street in Williamsburg, Brooklyn. Their plan was to steal enough weapons and ammunition to begin a deadly crusade in the "Borough of Churches."

But an employee managed to trip the silent alarm without their knowledge. Since the store sold guns and ammunition, patrolmen from several different Brooklyn precincts converged on the scene within moments and blocked their escape. Rather than give up, the gunmen took eleven employees and customers hostage and began shooting. The barrage shattered the storefront window and the windows of other businesses in the vicinity. Police officers pinned down behind their patrol cars immediately returned fire, but had to be more discreet in their aim because of the hostages.

As the gun battle was going on, traffic screeched to a halt on Broadway. Panicked pedestrians ran in all directions in search of shelter. Police cordoned off the blocks around the store with rope and wooden barricades. Residents were ordered to stay inside their apartments, and service on the elevated BMT line that passed directly above the store was suspended, stranding thousands of straphangers.

The Emergency Service Unit was called in along with an armored personnel carrier/rescue ambulance to provide a tactical advantage in the event a decision was made to enter the store. Police officer Gilroy was positioned behind a

> Rather than give up, the gunmen took eleven employees and customers hostage and began shooting.

steel pillar under the elevated train tracks. Other officers climbed onto the roof of the store and adjacent buildings. The area was shrouded in darkness, because streetlights had either been shot out or had their electricity cut off, and visibility was limited by pouring rain. Raheem still managed to target Gilroy. When Gilroy shifted his body slightly to get a better view of the store, Raheem squeezed the trigger on a high-powered rifle. A single round struck Gilroy in the head. He died almost instantly. A second patrolman took a bullet to the leg trying desperately to get Gilroy into an ambulance.

The store manager, Jerry Riccio, recalled that after Gilroy went down, Raheem waved his gun and bragged, "We can kill anyone else we want."

Unbeknownst to the police, one of the jihadists, Yusef Abdullah Almussudig, had suffered a serious abdominal wound during the initial exchange of gunfire and required immediate medical treatment if he was to survive. From that point on, the gunmen fired only sporadically, but remained defiant. The police, however, would not shoot another round.

The year before, at the 1972 Olympics in Munich, heavily armed German police stormed the Olympic Village in a futile attempt to save Israeli athletes being held at gunpoint by Palestinian terrorists. The rescue attempt failed miserably, resulting in seventeen deaths. New York City Police Commissioner Patrick Murphy considered the possibility that if a trained hostage negotiator had been present to deal with the terrorists, the outcome might have been different. With that in mind, he ordered a select group of NYPD officers to begin immediate training as hostage negotiators. This was the first time the new tactics would be employed, a literal trial by fire. It was also a drastic departure from the department's past practice.

The siege continued for forty-four more hours. Police hostage negotiators aided by community and religious leaders engaged the gunmen with little success, but as long as the hostages were alive, Deputy Police Commissioner for Community Affairs (and future police commissioner) Benjamin Ward, a black man and former lieutenant, believed that time was on the department's side. Initially authorities communicated with a bullhorn, later with a walkie-talkie, and finally a telephone. A female hostage was the first to be released. She was also the first to inform detectives that a gunman had been shot and that they intended to fight it out until the end. A Muslim minister, who subsequently spoke face-to-face with the jihadists, confirmed her information.

The gunmen released a third hostage the following afternoon. In return the police sent in food, cigarettes, and a black physician, Dr. Thomas Matthew, to treat Almussudig. He and a nurse stayed inside the store for three hours, but neither could convince the Muslims to surrender. Raheem did, however, give the doctor a handwritten statement expressing his views. It read in part that Muslims would continue to fight until all religions in the world were for Allah.

The big break came when the gunmen left the remaining hostages unattended for a few minutes. Store manager Jerry Riccio was able to lead them to an old staircase concealed by a thin piece of sheetrock. He punched through it and led all of them to the roof, where police officers were able to escort them to safety. Without their leverage, the jihadists were left with only two options: shoot it out and die, or come out peacefully and surrender. On Sunday at 4:45 P.M., they chose the latter, thereby ending the forty-seven-hour ordeal.

Although Mayor John Lindsay praised the police commissioner for resolving the hostage crisis without further

BELOW, LEFT: Officer Stephen Gilroy
BELOW, RIGHT: Officers trying to help injured Stephen Gilroy.

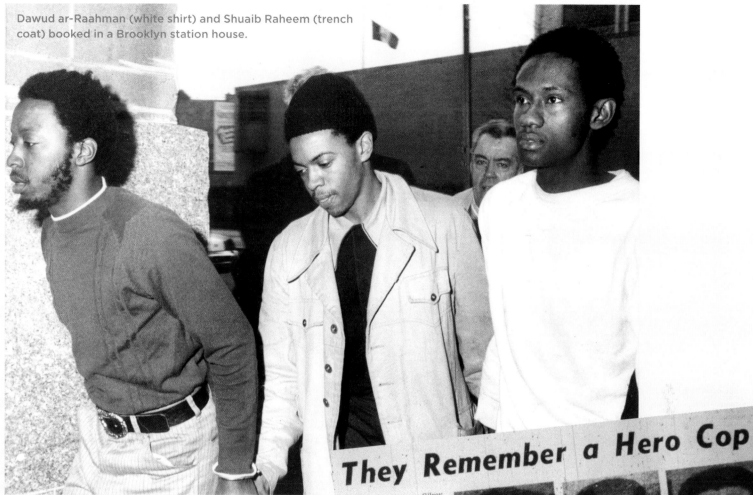

Dawud ar-Raahman (white shirt) and Shuaib Raheem (trench coat) booked in a Brooklyn station house.

bloodshed, many of his fellow officers believed Gilroy died for nothing. Patrolman George Bell said, ""Why should we have let their guys call the shots? We should have flushed them out in any way possible. If it had been me, I would have used bazookas, hand grenades, anything."

The four jihadists were sentenced to long prison terms. Despite continuing to espouse their views while in jail, Yusef Abdullah Almussudig was released on parole in 1998. He died in 2003, two years after the World Trade Center attacks. The group's leader, Shuaib Raheem, was released in 2010 at age sixty. Patrolmen's Benevolent Association president Patrick Lynch called it the worst decision possible by the Parole Board.

Ironically, the tactics that were developed and used successfully over the years as a result of this first confrontation with Muslim jihadists were modified by Police Commissioner William Bratton in 2015. In situations involving active shooters, particularly jihadists who are only interested in causing death and destruction, the NYPD will actively engage them from the start rather than attempt to establish a dialogue first and lose valuable time.

They Remember a Hero Cop

Patrolman Stephen Gilroy, who was shot to death last night in the gun battle in Brooklyn, was described by fellow officers as a "nice fellow" who had won many citations.

The 29-year-old patrolman, who lived at 61-1 Woodside Av. in Woodside, Queens, was married and had been on the police force almost eight years.

Before joining the Emergency Service Squad in October, 1969, Gilroy was attached to the Bedford Av. Station.

A fellow patrolman at the Emergency Service Squad 8, at 211 Union Av., Brooklyn, where Gilroy was stationed, said the dead officer had saved people from jumping off bridges and had been decorated for his actions.

Car Rammed

Shortly after joining the Emergency Service Squad, Gilroy was on his way to go fishing on a day off when he was held up by two thugs who took his service revolver and shield. Gilroy was later "instrumental" in arresting his assailants, his associates said.

The records show that at 5:30 a.m. on Nov. 24, 1969, a car rammed into Gilroy's vehicle, which had stopped for a red light at Driggs Av. and

Leonard St. in Brooklyn. When the off-duty patrolman got out to exchange licenses with the driver, another man, later identified as the driver's brother, put a gun to the officer's head.

The two men relieved Gilroy of his badge and gun, forced him to lie down on the floor of his car and then took off. But Gilroy managed to take down their license plate, and, police say, an investigation showed that the two brothers, Anthony and Lawrence Vitiello, had allegedly taken part in a

holdup spree. Gilroy was a member of a stakeout team at the home of the two suspects until they showed up and were arrested.

Promotion Due

Police said that Gilroy was to have been promoted to sergeant in a few weeks.

Two other patrolmen, Jose Adorno and Frank Carpentier, were wounded in last night's shootout.

Carpentier, 31, who lives in north Seaford L.I. and has been on the force eight years, attached to the Gates Av. station, was taken to Cumberland Hospital with a gunshot

wound in the right knee.

Carpentier was in surgery for more than four hours and a call for B-positive blood donors went out for the wounded patrolman because a bullet had penetrated an artery in his knee. The response for donors was so great that the hospital called off its request for blood shortly afterward.

Adorno, 30, was struck by a bullet in the right arm and taken to Greenpoint Hospital where he was treated and released. He lives in Flushing and is attached to the Gates Av. station.

PTL. STEPHEN GILROY
Shot to death.

PTL. JOSE ADORNO
Wounded in arm.

PTL. FRANK CARPENTIER
Critically wounded.

A *New York Post* article that details the death of Gilroy and the wounding of patrolmen Jose Adorno and Frank Carpentier.

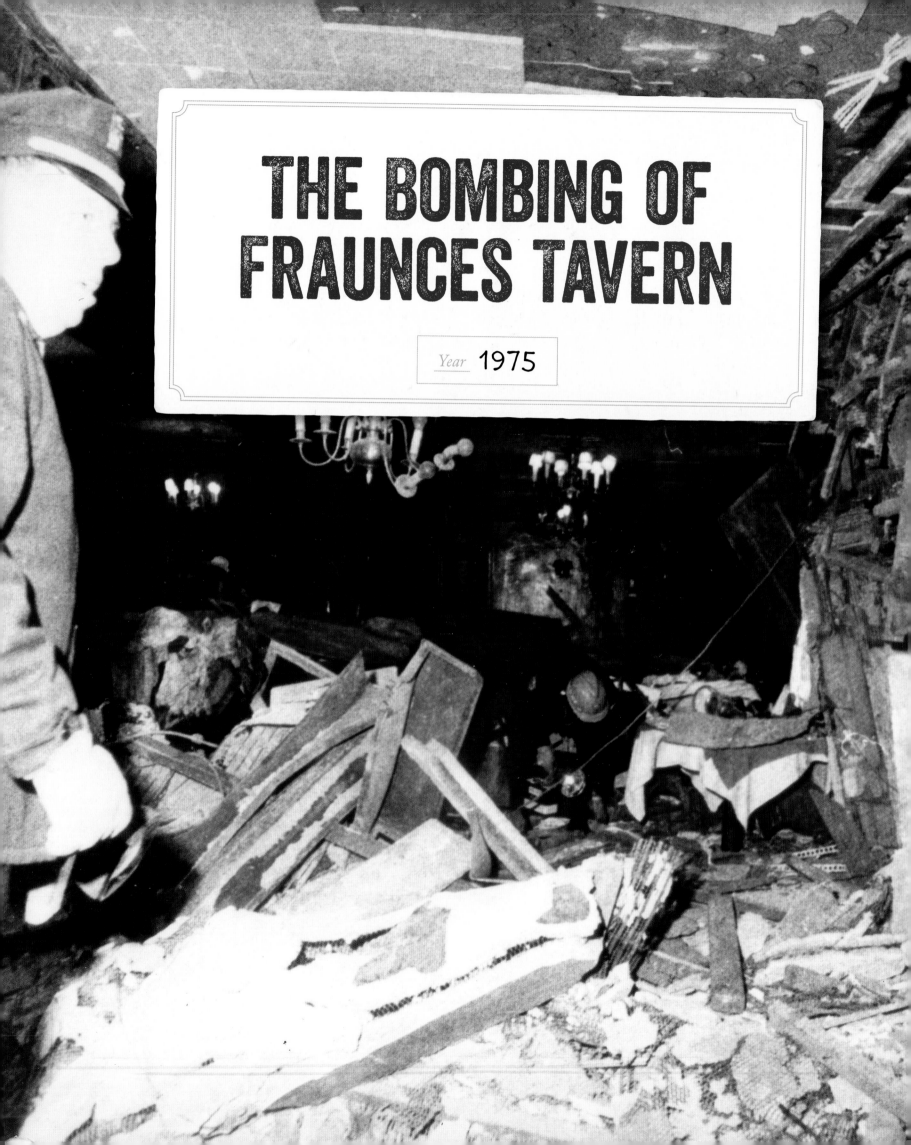

THE BOMBING OF FRAUNCES TAVERN

Year 1975

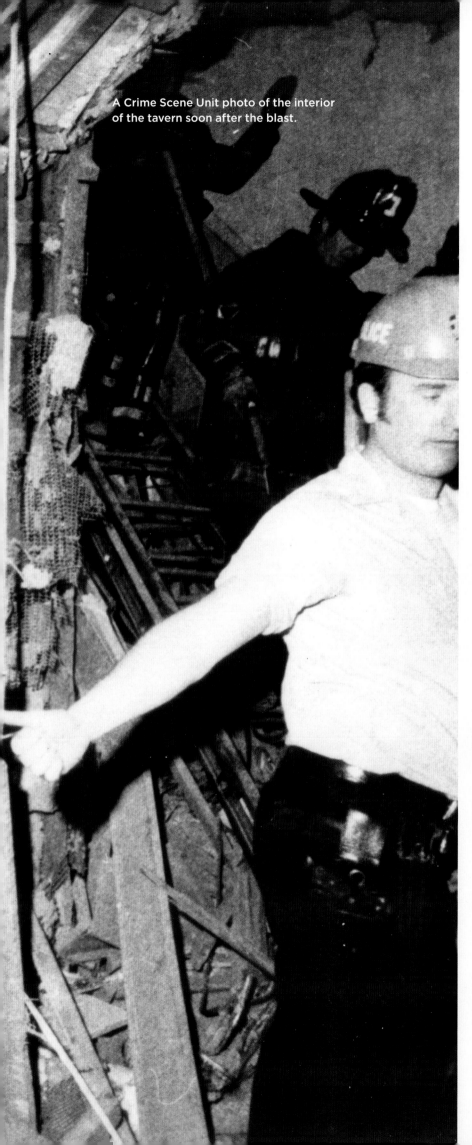

A Crime Scene Unit photo of the interior of the tavern soon after the blast.

Fraunces Tavern, originally built in New York City in 1719, is a landmark of America's colonial past where George Washington bid a tearful farewell to his officers in 1783 after resigning to return to civilian life. At 1:22 P.M. on January 24, 1975, a powerful bomb detonated inside. The victims included tourists eating in the tavern's popular downstairs restaurant and Wall Street honchos dining on the second floor at the Anglers and Tarpon Club.

The explosion was caused by ten pounds of dynamite and a propane tank concealed in a gray duffel bag. The bag had purposely been left next an unused exit door, adjacent to the tavern's entrance hallway and near a wooden staircase that led upstairs. Shortly before the blast, a club member spotted the bag. Worried that someone might trip over it, he pushed it ever-so-slightly away from the front of the staircase with his foot, thus sparing untold numbers of others from possible death or injury.

> ## The blast rocked Lower Manhattan and left a hole in the tavern floor seven feet in diameter.

The blast rocked Lower Manhattan and left a hole in the tavern floor seven feet in diameter. The horrific repercussions were immediately apparent to the first responders. Three men lay dead, and another would die soon afterward. Sixty-three more people were injured. At least one victim's arm was severed. Cutlery from a dining room table was propelled with such velocity that doctors had to remove the silverware from the bodies of at least a dozen diners. A priest from the nearby Church of Our Lady of the Rosary rushed to the scene to administer last rites to several of the critically wounded.

Among those killed was Frank Connor, age thirty-three, an up-and-coming assistant vice president at Morgan Guaranty Trust. He was a married father of two from Fair Lawn, New Jersey. His son Joseph had just turned nine four days earlier. Joe and his brother, Tommy, who turned eleven on January 13, were eagerly awaiting their dad's return that evening for a belated joint birthday celebration.

"My mom, Mary, heard on the radio that there was a bombing in downtown Manhattan—an explosion, actually," Joe recalled. "She called my dad at work and somebody picked up the phone and my mom said, 'Thank God, you're okay!' She thought it was my father picking up the phone, but it was a colleague. He said, 'Frank's not here.' She immediately knew," Joe sighed. "She had a premonition."

Witnesses reported seeing two Hispanic men running from the scene moments before the blast. Fifteen minutes after the explosion, the Associated Press and United Press International received phone calls from the Fuerzas Armadas de Liberación Nacional Puertorriqueña, better known as the FALN—a Puerto Rican nationalist group seeking independence for the island—claiming responsibility for the carnage.

Three photocopies of a note were found in nearby phone booths, in which the FALN stated, "We...take full responsibility for the especially detornated [sic] bomb that exploded today at Fraunces Tavern, with reactionary corporate executives inside." Supposedly, the bomb was in retaliation for the "CIA ordered bomb" that killed three and injured eleven in a restaurant in Puerto Rico.

The FALN went on to conduct a vicious nationwide campaign of bombings, but for three years the plotters remained at large. The first break came on July 12, 1978, when a pipe bomb being constructed inside an apartment by FALN explosives expert William Morales in East Elmhurst, Queens, blew up. Morales fractured his skull and lost six teeth, his right eye, and all his fingers but for a thumb.

An NYPD spokesman described the premises as an "FALN bomb factory"—and for good reason. Police recovered three rifles, two of them M-1 carbines and the third a .45-caliber semiautomatic; a sawed-off shotgun and hundreds of rounds of ammunition. They also seized three unexploded pipe bombs; sixty-eight sticks of dynamite; sixty pounds of potassium chlorate, a chemical used to manufacture low-grade explosives; table tennis balls (used in past FALN bombs); watches; timers; wires; batteries; and enough material, according to NYPD Bomb Squad technicians, to make at least twenty-eight explosive bombs and thousands of incendiary devices.

Most notably, a forensic laboratory examination of other items recovered in the apartment revealed that the copier was identical to the one used to produce communiqués left after the Fraunces Tavern bombing.

Morales faced trials in both Brooklyn Federal Court and Queens Supreme Court and was convicted in both. He was sentenced to a ten-year term for the federal charges and twenty-nine to eighty-nine years for the state case. Ironically, he was never conclusively linked to the Fraunces Tavern bomb, but many in law enforcement felt that he was most likely involved.

Incredibly, despite having no fingers, he was able to

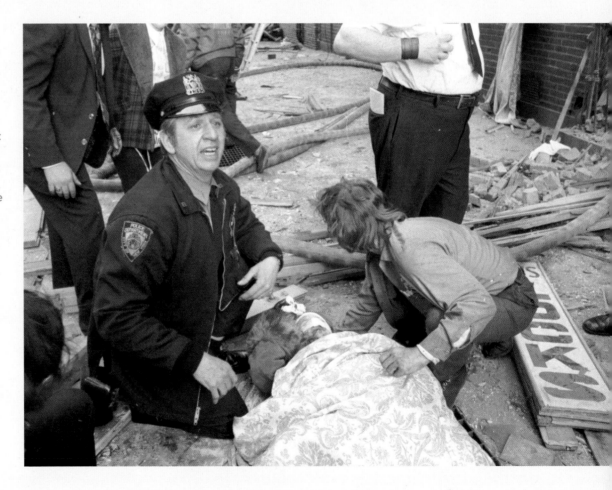

The powerful bomb blast left a swath of destruction in its wake. Here, an NYPD cop provides comfort to a bombing victim.

OPPOSITE PAGE, LEFT: Fraunces Tavern was only one FALN bomb site. In one of several FALN bombings that occurred in Manhattan and Brooklyn on the evening of December 31, 1982, NYPD Officer Rocco Pascarella was severely injured, losing his hearing, some of his vision, and one leg below the knee. Two other NYPD Bomb Squad detectives—Anthony Senft and Salvatore Pastorella—were critically injured later that night while trying to defuse one of two FALN bombs left near the front of the entrance to One Police Plaza, just outside the United States Attorney's office.

RIGHT: William Morales, a key FALN bomb maker who may have constructed the one used at Fraunces Tavern, was critically injured in a July 12, 1978, blast at a Queens bomb factory.

escape from the Bellevue Hospital prison ward in May 1979, using an ACE bandage to descend forty feet to the ground. His accomplices helped him flee first to Mexico and then to Cuba, where he remains in hiding today.

In the early 1980s, sixteen FALN members, including one of the group's original founders, Oscar López-Rivera, were arrested and convicted of plotting to overthrow the government, weapons possession, and related charges.

After his 1981 trial for seditious conspiracy, use of force to commit robbery, interstate transportation of firearms, and conspiracy to transport explosives with intent to destroy government property, López-Rivera received a fifty-five-year sentence. In 1988, he was sentenced to an additional fifteen years for an unsuccessful escape attempt made possible by friends from the outside who intended to use a helicopter, grenades, rifles, plastic explosives, bulletproof vests, blasting caps, and armor-piercing rockets.

In 1999, President Bill Clinton made the controversial decision to offer clemency to a select group of the incarcerated FALN prisoners through an arrangement that required prisoners to abstain from future violence. López-Rivera, however, balked at the precondition and insisted he would not go free unless Carlos Torres, a fellow

FALN prisoner who was not offered clemency, was also released. (Torres wound up being released in July 2010.)

Despite an uncontroverted record as an unrepentant terrorist, López-Rivera has become a cause celebre for the political left, with family members and supporters lobbying for his release on humanitarian grounds while ignoring his criminal past.

At a January 2011 parole hearing at the federal penitentiary in Terre Haute, Indiana, López-Rivera had a tense face-off with victims from the Fraunces Tavern bombing, which included Joseph and Thomas Connor, the grown sons of victim Frank Connor.

During the meeting López-Rivera remained defiant. He expressed no remorse for his actions and refused to acknowledge the collective responsibility borne by the FALN for its vicious campaign of terror.

"We wanted to hear him say, 'I'm sorry. I was a young man. I made mistakes.' But all we got were lies and obfuscations," said Joseph Connor, who like his late father, works in the financial services industry.

López-Rivera was denied parole. He is not eligible for reconsideration until 2021, at which time he will be seventy-eight years old.

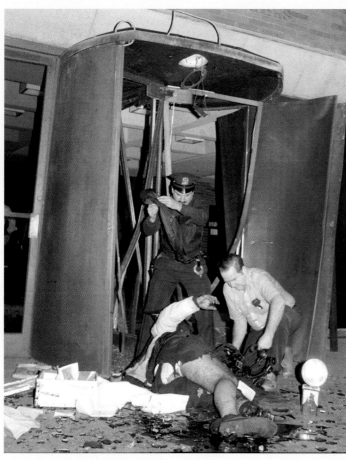
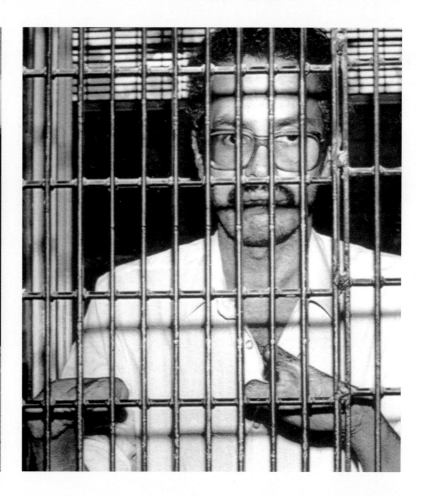

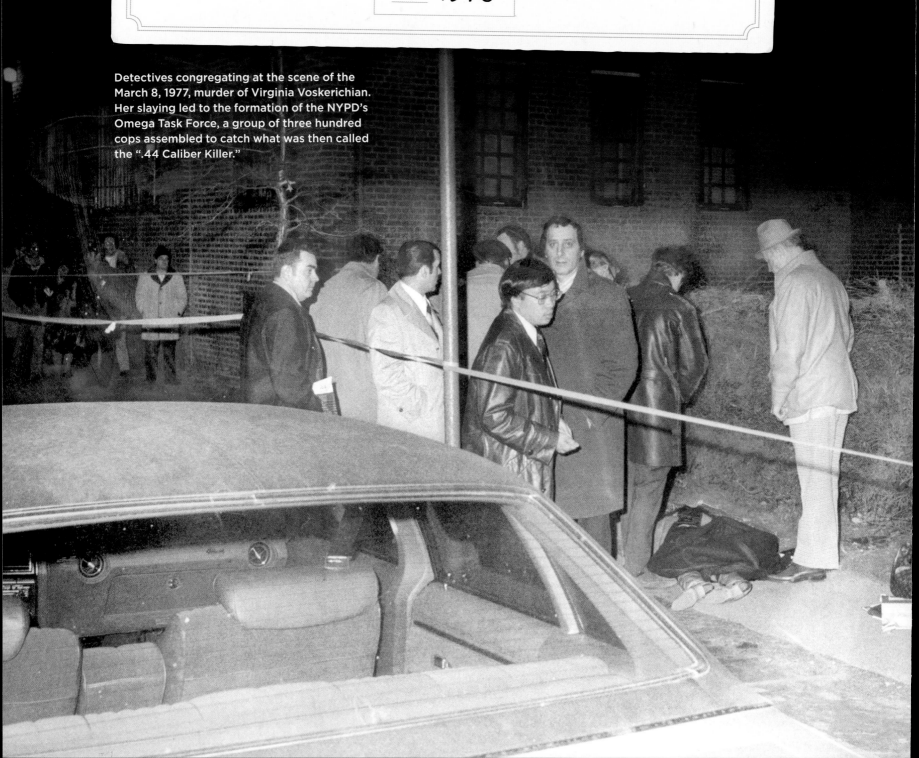

SON OF SAM

Year 1976

Detectives congregating at the scene of the
March 8, 1977, murder of Virginia Voskerichian.
Her slaying led to the formation of the NYPD's
Omega Task Force, a group of three hundred
cops assembled to catch what was then called
the ".44 Caliber Killer."

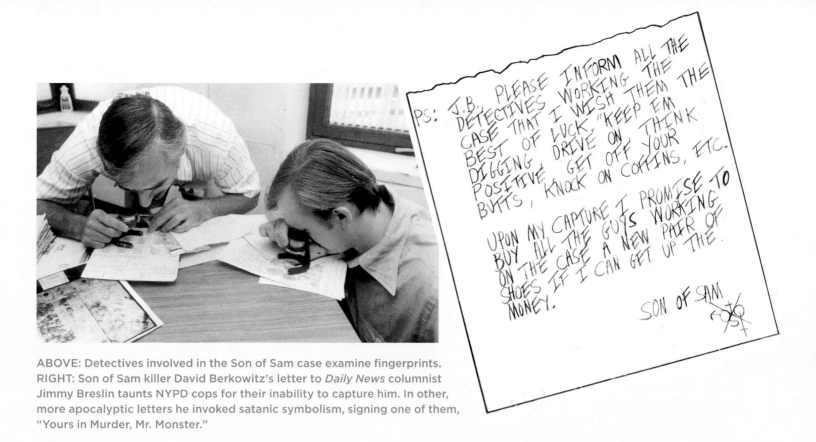

ABOVE: Detectives involved in the Son of Sam case examine fingerprints.
RIGHT: Son of Sam killer David Berkowitz's letter to *Daily News* columnist
Jimmy Breslin taunts NYPD cops for their inability to capture him. In other,
more apocalyptic letters he invoked satanic symbolism, signing one of them,
"Yours in Murder, Mr. Monster."

Serial killer—the two words that NYPD detective supervisors absolutely hate to hear. And yet, during the spring of 1977, those very words not only were being whispered throughout the corridors of power within the NYPD, they were being shouted virtually from every rooftop in the five boroughs by terrified citizens. New York City was being terrorized by a psychopath, a real-life bogeyman.

His moniker was Son of Sam. He was a shape-shifter, a mysterious presence whose apocalyptic pronouncements written in lurid letters changed him from the bland and anonymous ".44 Caliber Killer" into "the Son of Sam," a vengeful, unpredictable, and spectral figure who seemed to have sprung from the pages of a ghastly gothic horror novel.

He would ultimately shoot thirteen people, killing six, in eight separate attacks in the Bronx, Queens, and Brooklyn over the course of a year. The first victims were shot the summer before, on Buhre Avenue in the Pelham Bay section of the Bronx, on July 28, 1976. At about 1:10 A.M., Donna Lauria, just eighteen, and her girlfriend, Jody Valenti, age nineteen, were sitting and talking in Valenti's Oldsmobile when an assailant snuck up, pulled out a gun, and unleashed a volley of high-caliber gunfire. Lauria was hit in the head and killed. Valenti survived a wound to her thigh.

A second attack occurred in the early hours of October 23, when Carl Denaro, twenty-five, and Rosemary Keenan, twenty-one, were seated in Denaro's Volkswagen, on 160th Street near Bowne Park in Flushing, Queens. Five shots rang out. Denaro was struck in the head, requiring

a steel plate to be implanted to replace part of his shattered skull. Keenan was lucky; she suffered only minor cuts from shattered window glass.

The third attack occurred November 27, just after midnight, when teenagers Donna DeMasi, sixteen, and Joanne Lomino, eighteen, were seated on the porch of Lomino's home, on 262nd Street in Bellerose, Queens. They reported that a man in his early twenties wearing military-style garb approached as if to ask directions. Shots followed, leaving DeMasi wounded in the neck. Lomino, hit in the spine, was left a paraplegic.

The public was still unaware of a link between these attacks, as the department hoped to probe the murder pattern without needlessly causing a public panic, but then a fourth shooting occurred just after the New Year. At 12:40 A.M. on January 30, 1977, an engaged couple, Christine Freund, twenty-six, and John Diel, thirty, were seated in Diel's car at Station Square in Forest Hills, Queens. Freund was hit twice in the head and killed. Diel suffered superficial wounds.

On March 8, Virginia Voskerichian, twenty, a brilliant Barnard College student who spoke five languages, was walking on Dartmouth Street in Forest Hills at about 7:30 P.M., not far from her home. It was about one hundred yards distant from where the previous shooting had occurred five weeks before. A gunman approached the Bulgarian national, who reflexively held her textbooks in front of her. The round pierced the books and fatally struck her in her head.

Three days later, as a result of ballistics tests, the city officials finally announced the .44 Caliber Killer was being sought and the Operation Omega task force—seventy-five NYPD detectives and 225 cops—was being assembled to hunt him down.

The task force resorted to an array of techniques designed to capture their elusive quarry, including deploying undercover male and female officers to lover's lanes with teams of backup cops poised nearby. Detective Sergeant Joseph Coffey became convinced that the killer moved from borough to borough. He arranged for officers to monitor the tunnels and bridges if and when another shooting occurred. (Ironically, after being caught, the murderer would admit to Coffey that he was stopped and questioned at a toll booth by two female cops who let him go.)

The suspect struck again on April 17, again in the Bronx, several blocks from the first slaying. This time, Alexander Esau, twenty, and Valentina Suriani, eighteen, were each shot twice in the head and killed as they sat in Suriani's car.

Near the scene, the emboldened killer left behind a chilling note addressed to Captain Joseph Borelli of the task force. The suspect referred to himself as "Son of Sam."

POLICE—LET ME HAUNT YOU WITH THESE WORDS; I'LL BE BACK! I'LL BE BACK!

It was signed, "YOURS IN MURDER...MR. MONSTER."

Daily News columnist Jimmy Breslin was mailed a handwritten letter on May 30 in which the suspect chided police about the looming one-year anniversary of the murder of his first victim, Donna Lauria. He promised further bloodshed.

"Sam's a thirsty lad and he won't let me stop killing until he gets his fill of blood. Mr. Breslin, sir, don't think that because you haven't heard from me for a while that I went to sleep. No, rather, I am still here. Like a spirit roaming the night. Thirsty, hungry, seldom stopping to rest; anxious to please Sam. I love my work." The letter was signed "Son of Sam."

The killer had become a tabloid supernova, a recurring nightmare whose nocturnal exploits were beginning to spark near pandemonium in the social fabric. Those most nervous tended to be young couples and, more specifically, young women with long dark hair. Women suddenly took to dying their dark tresses blonde, cutting their hair short, or resorting to wigs. And, to the consternation of ardent young men, their female counterparts were eschewing romantic entanglements in lover's lanes.

Sam struck again June 26. Sal Lupo, twenty, and Judy Placido, seventeen, were hit by gunfire after leaving Elephas,

a discotheque in Bayside, Queens, at about three A.M. to sit in a car parked nearby. Both were wounded.

On July 31, 1977, three days after the one-year anniversary of the first attack, he struck for his eighth and final time. It was his first foray into Brooklyn. He surprised Stacy Moskowitz and Robert Violante, both twenty, who were seated inside Violante's parked car, kissing under a streetlight on Shore Parkway, in Bensonhurst. From about three feet away, a series of shots rang out. Moskowitz, a blonde, rather than the dark-haired type Son of Sam was thought to favor, was struck in the head. She died several hours later at a local hospital. Violante survived, but lost his left eye and much of the vision in his right eye.

> "Sam's a thirsty lad and he won't let me stop killing until he gets his fill of blood."

Bensonhurst resident Cecilia Davis was out walking her dog Snowball that night. After the murder she came forward and reported that she saw a Ford Galaxie being ticketed by police officer Michael Cataneo for being parked too close to a fire hydrant. Parking spaces were extremely difficult to find in the neighborhood. Police wondered if in his haste to find a parking spot, the killer left his car next to a fire hydrant. A check of parking tickets issued by Cataneo yielded an address on Pine Street in Yonkers for one David Berkowitz, age twenty-four, whose car was illegally parked at around the same time as the shooting took place.

The parking ticket issued to Berkowitz's car led to his capture.

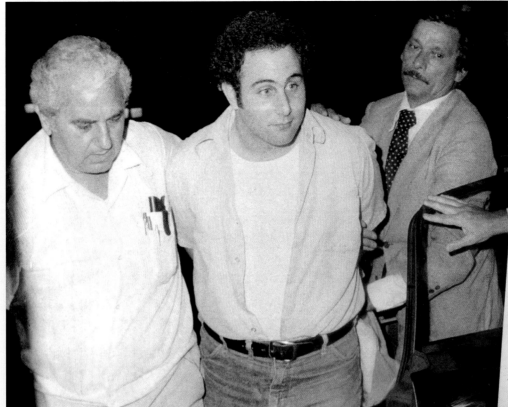

David Berkowitz, the man who terrorized New York City as "Son of Sam," is led away following his August 10, 1977, arrest. Berkowitz (center) was nabbed outside his Yonkers apartment after he approached his Ford Galaxie. He is flanked by NYPD Detective John Falotico (left, in white shirt) and Detective Edward Zigo (right, with mustache).

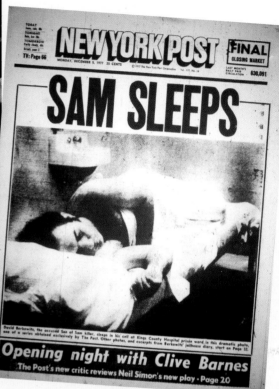

BELOW: Son of Sam, the ultimate tabloid sensation, was depicted in a December 1977 *New York Post* front page four months after his August arrest in an oddly compelling—and assuredly disturbing—grainy photo of him sleeping inside a Kings County Hospital psychiatric ward.

On the evening of August 10, 1977, NYPD police officers surrounded the building where Berkowitz lived. One of them, Detective Eddie Zigo, spotted Berkowitz's Ford on the street and observed the butt of a rifle sticking out from a duffel bag. A further search of the car yielded a .45-caliber semiautomatic Commando Mark III rifle and several high-capacity magazines. In the glove compartment the police found a letter addressed to NYPD Deputy Inspector Timothy Dowd, head of the Omega task force, promising a murderous attack in Southampton, a Long Island summer vacation haven.

The police lay in wait. At ten P.M., the pudgy-faced Berkowitz approached his car. As detectives pounced, he said, "Well, you got me. How come it took you such a long time?" He had a wan smile. A frisk revealed that he was armed with a .44-caliber Bulldog revolver.

Berkowitz, who had been adopted, worked as a security guard and postal clerk after a hitch in the U.S. Army, during which time he had been stationed in Korea. Increased mental instability followed his discharge. He would initially claim to have started his murderous rampage after receiving commands to kill from Harvey, a black Labrador that belonged to a former neighbor, Sam Carr.

Surprisingly, he pleaded guilty to all six murders and on June 12, 1978, was sentenced to twenty-five years to life for each.

Berkowitz would later recant his tale of demonic possession and insist he was part of a satanic cult whose members participated in some of the shootings. Some journalists and NYPD officials believed Berkowitz, and there were enough leads and coincidences to suspect he had not acted alone. The theory led to the case being reopened by the Queens District Attorney's office, but the probe foundered and no new additional criminal charges were ever brought.

Now a prisoner at the Sullivan Correctional Facility, Berkowitz is a born-again Christian who has been deemed a model prisoner. He first became eligible for parole in 2002, but has been repeatedly denied release ever since. Berkowitz has reconciled himself to remaining an inmate for the rest of his life and has found solace in his faith.

Willie Bosket at a sentencing in 1989
for one of his many crimes. Although
small in stature, Bosket was a study in
psychopathic malevolence while a teen.

HOW WILLIE BOSKET CHANGED THE JUVENILE JUSTICE SYSTEM

Year 1978

Willie Bosket's chronicles as a murderous teenaged hellion became a hot-button issue as the 1970s were drawing to a close. His wrongdoings would change the way juveniles in America were treated by a criminal justice system that was never designed to handle his type of wanton violence.

The quick-witted, baby-faced teenager had grown up in Harlem, light years from Reno, Nevada, but exactly like the character in a Johnny Cash tune who shot a man in that Western town just to watch him die, Bosket was imbued with the same icy indifference. He, too, was an unrepentant gunslinger, comfortable shooting an utter stranger just for kicks. He was a self-described monster who had admitted to committing two thousand crimes, including two murders and twenty-five stabbings, by the time he was arrested in New York City at age fifteen.

Although he was well known to the police, it was his murderous eight-day orgy of violence, which began on March 19, 1978, that finally brought him to the attention of the general public. On that day he and his older cousin Herman Spates killed Noel Perez during a robbery on the No. 3 IRT subway at the 148th Street station in Harlem.

Bosket intended to steal Perez's watch while he was sleeping, but the sunglasses Perez had on reminded him of a similar pair worn by a youth counselor he hated, so he pulled out a .22-caliber revolver and blasted Perez through the right lens. Perez awoke and screamed in agony. Bosket silenced him for good with a second shot to the right temple. As Perez lay dying, Bosket took $20 in cash, a ring, and the watch that had initially caught his eye.

Eight days later, Bosket, again in the company of his cousin, killed a second man, Moises Perez (no relation to the first victim), age thirty-eight, aboard the rear car of another No. 3 train, at the 145th Street station—one station away from the first murder. This time Spates asked the victim for money. When Perez claimed that he did not have any, Bosket shot him and then rifled through the dead man's wallet. Perez had been lying. He had two dollars. Bosket took the cash and tossed the wallet.

In between the murders, the pair committed four other robberies; Bosket also shot and wounded a transit worker before he and Spates were finally apprehended. Bosket's case was heard in family court because of his age. It was there that his troubled background came to light. He was born to a single mother who was unable or, as some said, unwilling to curb his unbridled penchant for mayhem. She became so overwhelmed that when her son was nine years old she surrendered him to family court, thereby consigning him to live in group homes and reformatories, where he was sexually abused.

The boy's father, William Bosket Sr., abandoned his mother when she was pregnant, and he had a lengthy criminal record of his own. Among the offenses listed on his rap sheet was a murder conviction for the stabbing deaths of two men in Milwaukee and an armed bank robbery. But he was given a second chance to make good while serving time at Leavenworth Penitentiary. He earned a college degree from the University of Kansas and became the first inmate in U.S. history to be accepted by the prestigious Phi Beta Kappa honor society. But the saying that a leopard cannot change its spots proved true. In March 1985, his escape from a prison hospital ended in a shootout with police. Rather than surrender, he killed his girlfriend and turned the gun on himself.

> **He was a self-described monster who had admitted to committing two thousand crimes, including two murders and twenty-five stabbings.**

What might be referred to as "the Willie Bosket's imbroglio" came at a particularly inopportune time for Governor Hugh Carey, who was up for reelection and being assailed by his opponents for his soft stance on crime. Carey had sought to downplay the accusations, but on June 27, 1978, when the family court sentenced Bosket to only five years in a juvenile home for the two slayings, the wayward teen became the living embodiment of a dysfunctional system.

"When the judge sentenced me to five years," Bosket said years afterward, "I could have jumped on the bench and kissed him."

Meanwhile, his cousin Herman Spates was seventeen at the time the pair committed their crimes. Since he was considered an adult, the best he could do was plead guilty to manslaughter for his part in the murders and accept a sentence of eight and a third to twenty-five years in prison.

Two days after Bosket's sentencing, a story in the *Daily News* finally forced Carey to address juvenile crime. The headline read, HE'S 15 AND HE LIKES TO KILL—BECAUSE IT'S FUN. The article began: "Killing, Willie Bosket tells the people close to him, is fun." It noted that "police officers,

Willie Bosket punching a courtroom security official during his 1984 trial for assaulting a seventy-two-year-old man. Between 1985 and 1994 in prison, he was written up nearly 250 times for disciplinary violations.

"Killing, Willie Bosket tells the people close to him, is fun."

prosecutors and social workers" described Bosket as "the most violent juvenile ever to pass through the city's criminal justice system."

Carey immediately called the state legislature back into special session to pass the Juvenile Offender Act of 1978, better known as the "Willie Bosket Law." The legislation altered how New York would treat its juvenile offenders. Children as young as thirteen years old charged with murder could now be brought to trial as adults, as could fourteen- and fifteen year olds charged with seventeen designated felonies ranging from assault to robbery. New York got the ball rolling. Soon every other state in the country followed suit and toughened up their own laws on juvenile crime.

Bosket finished his sentence at the McCormack Secure Center, in upstate Brooktondale, New York, on December 9, 1983, but three months later he was rearrested for the knifepoint mugging of an elderly, half-blind diabetic man. He was convicted of attempted assault and sentenced to a new term of three and a half to seven years. As prisoner in an adult institution for the first time, Bosket sought to impose his will by making as much trouble as possible within the prison walls. He knifed a guard, set a fire, attempted to escape, and committed other acts of defiance. His feral behavior netted him two life sentences, burnishing his reputation as "the most incorrigible inmate in America."

For better than ten years, he was housed in extreme isolation, inside a Plexiglas cage at the Woodbourne Correctional Facility and under constant video surveillance. He was permitted outside for only an hour a day while shackled. Beginning in 1994, state prison records show that he gradually became more compliant. He has since been transferred to a less restrictive institution, the Five Points Correctional Facility, in Romulus, New York, where he has become a model inmate. He is not eligible for a parole hearing, however, until September 16, 2062, at which time he will be three months shy of his one hundredth birthday.

"Why did I blow those guys away?" Bosket later explained. "I wanted to be bigger and badder than anybody. I wanted to be unique."

BUDDY JACOBSON: A FOOL FOR LOVE

Year 1978

Trainer Howard "Buddy" Jacobson, right, talks to trainer W. C. Freeman, at the Aqueduct Race Track, New York, on April 29, 1969.

On the afternoon of August 6, 1978, a fire company in the Bronx responded to a small fire in a garbage-strewn lot. Fires in the impoverished borough were certainly not unusual. The year before during a Yankee World Series broadcast, sportscaster Howard Cosell noticed flames shooting into the night sky and famously declared to the national television audience, "The Bronx is burning."

As firemen examined what was left of a smoldering wooden crate they discovered human remains inside. NYPD detectives responded to the scene and identified the victim as Jack Tupper, age thirty-four. An autopsy revealed that he had been shot seven times. His skull had deep fractures in two places. A representative from the medical examiner's office would later testify that enough damage had been done to Tupper's corpse to have killed him ten times over.

A witness provided police with the license plate number of yellow Cadillac from which two men had been seen dumping the crate and dousing it with gasoline before setting it ablaze. Detectives traced the registration to a car to Howard "Buddy" Jacobson, age forty-eight.

During the 1960s Jacobson had become wealthy as the top horse trainer in America. Although Jacobson was a wizard at picking winners, winning friends was not his forte. Despite his nickname, the gossip along the backstretch was that he was a "buddy" to no one but himself. He used every trick in the book, legal and otherwise, to bring home winners. Jacobson considered jockeys talentless cogs who were interchangeable with one another. He cared even less about horses, insisting they were little

more than dumb beasts, and once confessed that he did not even like them. "If they put on kangaroo racing," he said, "I'd claim some kangaroos."

Eventually, track officials had enough of Jacobson's shenanigans and banned him from horse racing. It did not seem to bother him. He used his earnings to snatch up a number of investment properties in New York City, and by all reports he was as successful at real estate as he was with the thoroughbreds. He traded four-legged fillies for the two-legged variety and began stabling a bevy of beauties in his East Eighty-Fourth Street property by offering them apartments at below-market rents. He was particularly fond of airline stewardesses, models, and actresses.

One of the doe-eyed innocents who fell under Jacobson's spell and money was eighteen-year-old Melanie Cain, from Naperville, Illinois. Within months of her arrival, the honey-haired, blue-eyed charmer became a Ford model and cover girl for *Seventeen*, *Redbook*, and *Cosmopolitan*, while nabbing several national ad campaigns, including one for Clairol.

The former horse trainer and the comely fashion model took up residence in Jacobson's seventh-floor penthouse. But after five years, love's bloom faded for Cain. On July 20, 1978, she announced that they were quits and that she was moving on with her life and into the loving embrace of Jack Tupper, a handsome, bon vivant bar owner who possessed an abundance of Irish charm. They had met when he moved into an apartment the same floor as Jacobson's. Tupper was athletic and fourteen years younger than Jacobson. More importantly, most everyone agreed that unlike Buddy Jacobson, Jack Tupper was one

Courtroom drawing of murder victim Jack Tupper

Courtroom drawing of Melanie Cain

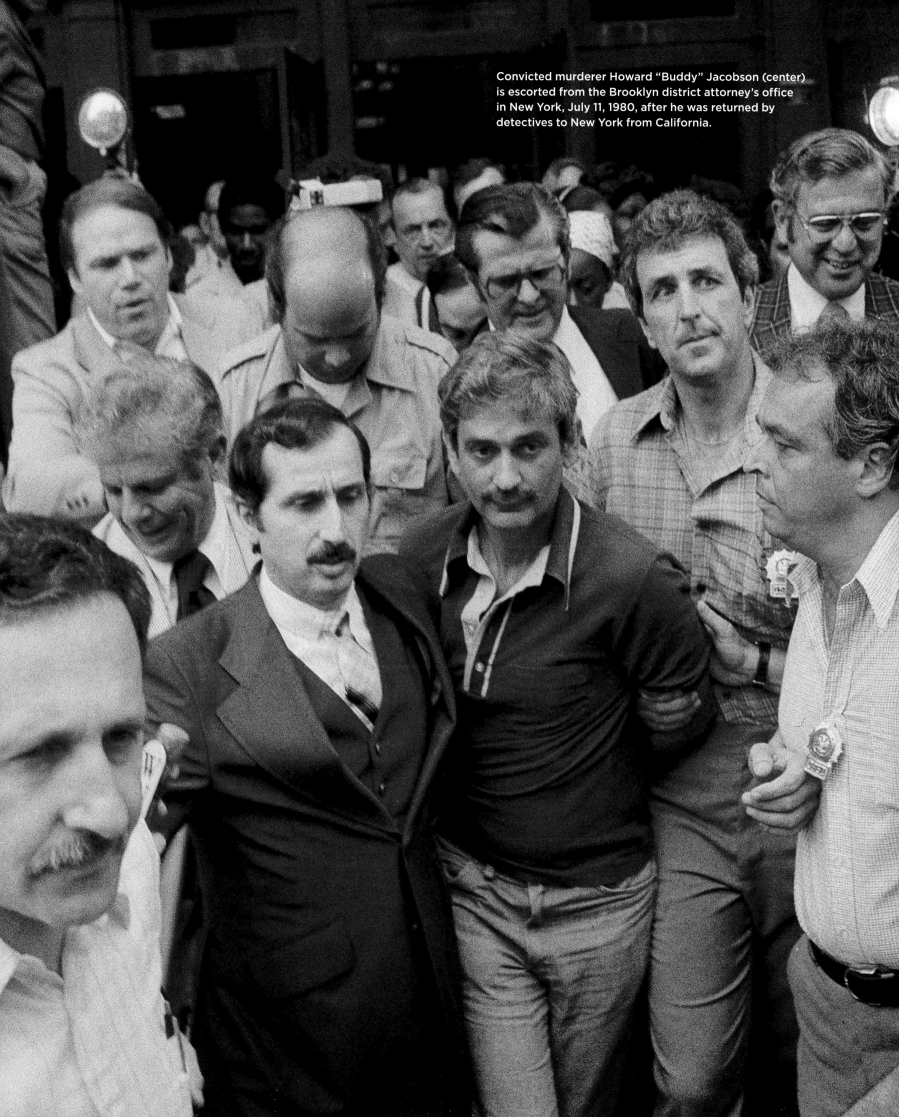

Convicted murderer Howard "Buddy" Jacobson (center) is escorted from the Brooklyn district attorney's office in New York, July 11, 1980, after he was returned by detectives to New York from California.

heck of a nice guy, despite rumors that he dabbled in the cocaine trade.

Once the police learned that Jacobson and Tupper were rivals for Cain's affection, the motive for murder became obvious. Jacobson's sensational eleven-week murder trial began in January 1980 and was the longest and most expensive in Bronx history. The prosecution presented seventy-nine witnesses, but none were more compelling than Cain herself. She painted a damning portrait of Jacobson, testifying that he once told her, "You can't leave me because I own you." She further damaged his defense by claiming that she saw a bloodstained rug in his apartment the day after the murder.

Jacobson's attorney contended that his client was the victim of a frame-up and there was no love triangle, as police speculated, but rather a "quadrangle"—a suggestion that someone else besides Jacobson had been vying with Tupper for Cain's attention.

Jacobson's lawyer did concede that his client and his accomplice had dumped Tupper's corpse in the Bronx, but only as a *favor* to Cain, who had turned to him in desperation after Tupper died during a violent argument over drugs inside Jacobson's apartment that involved Cain, Tupper, and another man—Joseph Margarite. Margarite was a convenient fall guy, because he vanished during the trial. (The jurors did not know that Margarite was one of twenty-five people charged by federal authorities with conspiring to import twenty-one tons of hashish into the United States and had good reason to go into hiding. He wasn't located until August 1982, living in South Carolina, by which time Jacobson's trial was long over.)

On Wednesday, April 9, 1980, after just a single day of deliberation, the jury found Jacobson's accomplice, Salvatore Prainito, not guilty. Two days later, the panel reached a different verdict for Jacobson: guilty.

Three days before Jacobson was to be sentenced for murder, a confederate helped spring him from custody. The scheme was brilliant: Tony DeRosa, a middle-aged bartender who owed Jacobson a substantial amount of money, visited him at the Brooklyn House of Detention wearing one business suit over another. He signed in pretending to be Jacobson's real estate lawyer, Michael Schwartz. Jacobson then donned the outer gray suit that DeRosa had been wearing and signed out as Michael Schwartz. He strode out the front entrance onto Atlantic Avenue, where his new girlfriend, twenty-two-year-old Audrey Barrett, was waiting to drive him away.

Jacobson was sentenced in absentia to a term of twenty-five years to life. Forty days later he was captured at a restaurant in Manhattan Beach, California. In exchange for her cooperation, Miss Barrett was not charged for her role in her lover's escape. DeRosa, however, was found guilty and sentenced from one to four years in jail. As for Melanie Cain, she was later reported to have gotten married and had a child, and was last known to be teaching yoga in Connecticut.

The final coda for Jacobson came on May 16, 1989, when he died of bone cancer at the Erie County Medical Center, in Buffalo, to which he had been transferred from the Attica Correctional Facility. He was fifty-eight years old. Up until the very end, he insisted he had nothing to do with Tupper's murder—he had simply been a fool for love.

'Love slave' or killer? Buddy case goes to jury

By DANIEL O'GRADY and TONY BURTON

The case against former racehorse trainer Howard (Buddy) Jacobson, accused of murdering the man who took cover girl Melanie Cain from him, went to the jury last night after 11 weeks of testimony by 79 witnesses.

The panel had to decide whether Jacobson, 49, was a foolish "love slave" who had been framed for the murder of Jack Tupper, 34, in August 1978, as the defense argued, or whether he was the cold, calculating killer described by the prosecution.

Tupper's body, bludgeoned, shot, stabbed and burned, was found in a lot in the northeast Bronx. Salvatore Prainito, almost forgotten through the long case, is on trial in Bronx Supreme Court with Jacobson, accused of helping transport the body from Jacobson's E. 84th St. apartment to the dumping ground.

In a three-hour summation, defense attorney Jack Evseroff insisted that the murder had been spawned not by Jacobson's jealousy but by restaurateur Tupper's involvement in the drug trade. Tupper was an unindicted co-conspirator in a narcotics trial now in progress in Brooklyn Federal Court.

"Jacobson, the fool?"

Assistant District Attorney William Hrabsky heaped scorn yesterday on the defense contention that Jacobson was a "moron" who had been manipulated by Melanie Cain, with whom he had lived for five years until she moved in with Tupper.

Through a three-hour summation, he continually interrupted his description of the accused's actions with the question: "Jacobson, the fool?"

Prainito's attorney, David Greenfield, argued that no proof of his client's involvement in the murder had been produced.

Jacobson and Tupper occupied adjoining duplex penthouses at the E. 84th St. luxury building, owned by Jacobson, at the time of the killing.

Howard (Buddy) Jacobson—case goes to jury after 11 weeks.

Melanie Cain—switched from Buddy to murder victim Jack Tupper.

Buddy's trial transfixed the city.

SID AND NANCY: A LOVE STORY OF SORTS

Year **1978**

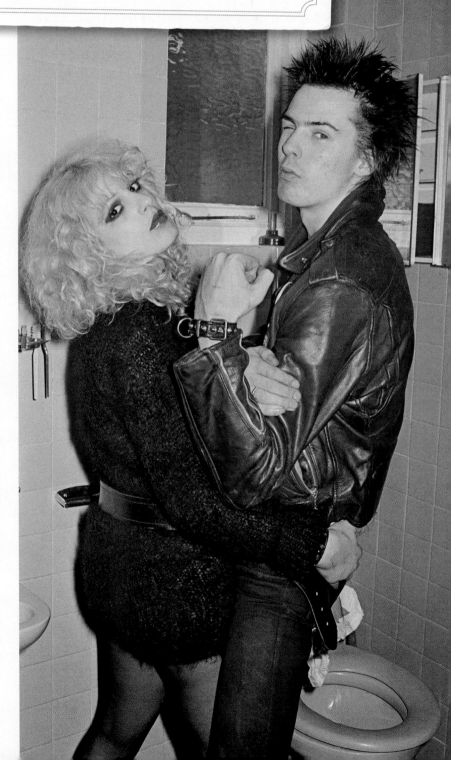

Shortly after eleven A.M. on October 12, 1978, the NYPD responded to a report of trouble inside Room 100 of the Chelsea Hotel. Since the late 1800s, the twelve-story, redbrick Victorian Gothic building had served as a popular waystation for an array of artists, most with bohemian sensibilities and expansive appetites for dangerous intoxicants.

Upon arrival the police found the lifeless body of a twenty-year-old platinum blonde girl lying faceup under the bathroom sink. She was clad only in a lace black bra and panties. Blood was smeared on her legs and torso from a single stab wound near her navel. There was more blood on the bed.

The victim's name was Nancy Spungen, and she was the troubled girlfriend of notorious Sid Vicious (born John Simon Richie), the *enfant terrible* of punk rock and former bass guitarist for the Sex Pistols, a band that had broken up earlier that year.

One need not have been a habitué of Manhattan punk rock citadels to know that Sid and Nancy had a tempestuous relationship replete with frissons of S&M behavior and domestic violence. Nancy (known as "Nauseating Nancy" to those in the punk world who disliked her whiny voice) was now dead and Sid was being grilled. It was tabloid mania. Reporters descended upon the Chelsea Hotel like a wave of locusts, eager to find out what had happened.

There was much that was unclear, but one thing was not: Nancy's death was a depressing coda for punk, which featured unsentimental, fast-paced, and hard-edged songs

with angry and nihilistic undertones. It attracted alienated, working-class kids, initially from England and later from the United States and Australia, but no group embraced its ethos more than the Sex Pistols.

Formed and managed by Malcolm McLaren, a savvy clothing boutique owner, the Sex Pistols were a triumph of form over substance. The band featured lead singer Johnny Rotten (real name John Lydon), whose witty and engaging presence made him the troupe's driving force. The group was renowned for its showmanship and delinquency rather than any pretense of musicianship. Still, there was a rabidly devoted fan base besotted with the band's antics, such as piercing their cheeks with safety pins, vomiting during performances, spitting on or cursing at audience members, and of course, insulting the Queen of England.

Sid had been plucked from obscurity to join the group as a replacement member in February 1977. He was Rotten's childhood friend and an exemplar of the punk aesthetic, as he seemed to have been born in tattered jeans, a ripped T-shirt, and a black leather jacket. He also

had all the physical trappings of a punk rocker. He was six foot two, skeletal, and consumptive looking, with perpetually downcast furtive eyes and the requisite spiky hair. But it was his drug-fueled appetite for self-destruction that made him a punk avatar. That he could not play more than a few chords was of little importance. "If Rotten is the voice of punk, then Vicious is the attitude," McLaren once boasted.

Sid was the product of a broken home and was close to his mother, Ann Beverly, who herself was also a junkie. It was not surprising that he fell for a strong-willed American female doppelganger in her mold.

Nancy had been raised in a Philadelphia suburb by middle-class Jewish parents. Growing up she threw tantrums and engaged in crying fits. By age fifteen she was diagnosed as schizophrenic. Her parents sent her to a private school for troubled children. Teachers described her as brilliant and intellectually gifted. In fact she was so smart that she skipped the third grade. But after being left to her own devices in college, she was expelled during her freshman year in 1975.

Nancy Spungen's body being carried out of the Chelsea Hotel.

"Please shoot me— kill me, my baby is dead," he sobbed.

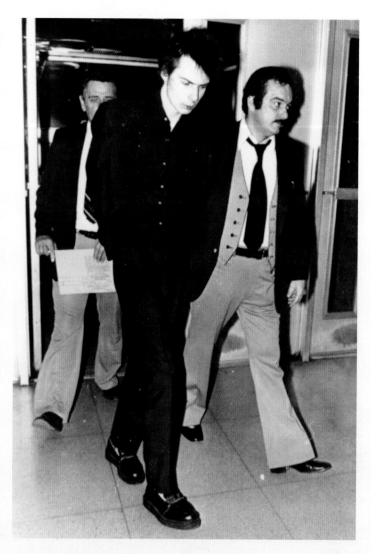

Sid Vicious led away in police custody on a charge of murder after his girlfriend Nancy Spungen was found stabbed to death

At age seventeen she set off to find fame and fortune in New York City the hard way. She bleached her hair white and applied heavy black mascara on her eyes to find work as a stripper in Times Square. On occasion she turned tricks for extra cash. In her free time she immersed herself in the burgeoning downtown punk scene.

The following year, she bolted for London, where she found her soul mate, Sid. They were made for each other. Nancy was brash and assertive. Sid was shy, introspective, and pliable. More important, they shared a love for heroin, general disorder, and high drama.

When detectives showed up at the Chelsea Hotel to question Sid, he was still high on the barbiturates he consumed the previous evening. "Please shoot me—kill me, my baby is dead," he sobbed.

During the interrogation, he initially denied knowing what had happened to Nancy. He said they had gone to bed about one A.M., but before he passed out, he remembered Nancy sitting on the edge of the bed "flicking a knife." (Both of them had a fascination with knives.) When he awoke he found Nancy unconscious on the bathroom floor with a stab wound in her stomach. He assumed that she had fallen on the knife and somehow dragged herself in there. He admitted leaving her alone after he found her to get a shot of methadone. When asked why he had left her, he said, "I did it because I'm a dog. A dirty dog."

Later Sid confessed, "I stabbed her, but I didn't mean to kill her. I loved her, but she treated me like shit."

He was released over the prosecutor's objections on $50,000 bail. Two weeks later, he was rushed to Bellevue Hospital after slicing his wrists with glass from a lightbulb. But Sid could not stay out of trouble. Less than two months after his abortive suicide attempt, he was rearrested for assaulting Todd Smith (the brother of singer Patti Smith) with a broken Heineken bottle. On December 8, 1978, Supreme Court Justice Betty Ellerin revoked his bail.

Whether or not he actually killed Nancy became moot on February 2, 1979. Just thirteen hours after winning his re-release on bail, Sid was found dead of a heroin overdose in the Greenwich Village apartment of his new girlfriend, actress Michelle Robinson.

Sid's mother, Ann, was alleged to have scored the dope that killed her son. Purportedly, she phoned Nancy's mother, Deborah, in an attempt to have Sid buried alongside his beloved Nancy. Mrs. Spungen flatly rejected the notion. This spawned an enduring rumor that Sid's mother snuck into the cemetery and sprinkled her son's ashes atop Nancy's grave so the pair could remain linked forever.

It is a sweet tale, but a more credible account comes from McLaren. He said that Sid's mother accidently kicked over the urn containing her son's remains upon her return to London and inadvertently spread his ashes through Heathrow Airport via the ventilation system.

That account—detailing an unsentimental and existential act of pure cosmic indifference—seems more believable, if only because it is a true distillation of punk's credo: In the end, all is meaningless.

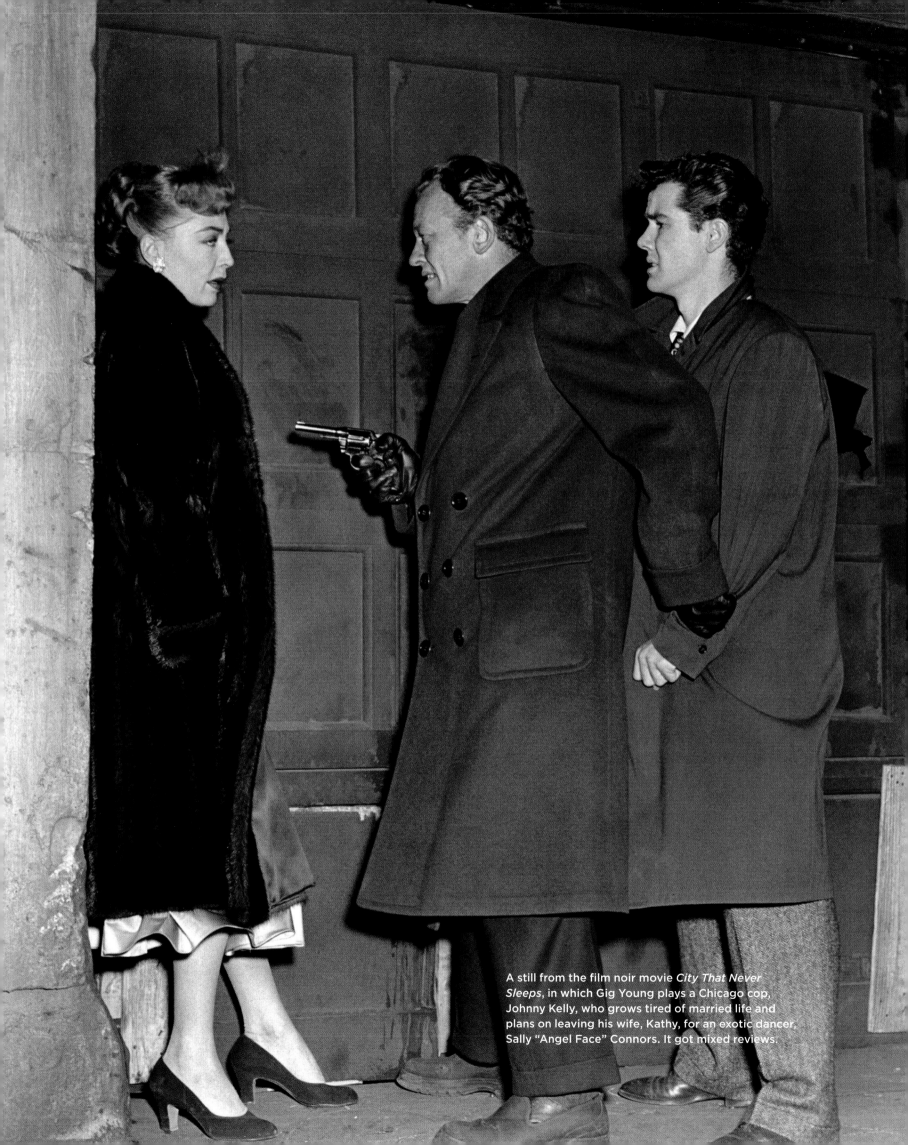

A still from the film noir movie *City That Never Sleeps*, in which Gig Young plays a Chicago cop, Johnny Kelly, who grows tired of married life and plans on leaving his wife, Kathy, for an exotic dancer, Sally "Angel Face" Connors. It got mixed reviews.

THE DEATH OF GIG YOUNG: MURDER OR SUICIDE?

Year 1978

The NYPD has seen its share of misbehaving celebrities over the years, but a murder committed by Academy Award–winning actor Gig Young is one of the most nefarious and perplexing incidents of all. On October 19, 1978, nine years after winning the Oscar for Best Supporting Actor for his role as Rocky, a sleazy dance marathon promoter in *They Shoot Horses, Don't They?*, Young shot his fifth wife to death in their residence at the Osborne Apartment House on West Fifty-Seventh Street. Then he turned the gun on himself. Young was sixty-four, while his spouse, a German art gallery owner named Kim Schmidt, was just half his age.

Why would a man who appeared to have so much success literally blow it all away?

Hours before his death, Young had taped an episode of *The Joe Franklin Show*. To respect Young's memory, Franklin, a New York radio and television mainstay for seven decades, never aired that program. While Young left no suicide note, he did leave his Oscar beside his body. In his estate, which was worth a total of $200,000, he bestowed the Academy Award to his agent, Martin Baum, calling it "the Oscar that I won because of Martin's help."

Young also had a daughter, born in 1964, whom he vehemently denied was his biological offspring throughout a five-year court battle. Although there was no DNA testing in those days, and despite Young's protestations, the court decided that he was, in fact, the girl's father. Young bequeathed her just ten dollars.

It was later learned that Young was being treated by the controversial psychotherapist Eugene Landy, whose list of troubled celebrity clients included musicians Brian Wilson of the Beach Boys and Alice Cooper, as well as actors Richard Harris, Rod Steiger, and Maureen McCormick, who behind the cheery façade of her role as Marcia Brady on the iconic 1970s television show *The Brady Bunch* was suffering from depression, paranoia, and drug abuse. Landy's unorthodox treatment consisted of him, as well as his designees, micromanaging all aspects of the lives of his clients.

The roguishly handsome Young was born Byron Elsworth Barr in 1913 in St. Cloud, Minnesota, and raised in Washington, D.C. He developed a passion for theater in high school, which led to him receiving a scholarship to the lauded Pasadena Community Playhouse in California. He took his acting name from a character he played in a small part in the 1942 film *The Gay Sisters*, which starred Barbara Stanwyck.

Young's looks and raffish charm enabled him to usually garner roles as good-natured "guy next door" types in scores of films. Prior to winning his Oscar in 1969, he had been nominated twice before. In the first film, he showed significant depth playing against type as an alcoholic in the 1951 film *Come Fill the Cup* with James Cagney. He was also nominated in 1958 for his role as a charming cad in the lighthearted romp *Teacher's Pet* with Clark Gable and Doris Day.

What many viewers found most memorable, however, was his role in a classic 1959 episode of the television show *The Twilight Zone*. Young portrayed a beleaguered thirty-

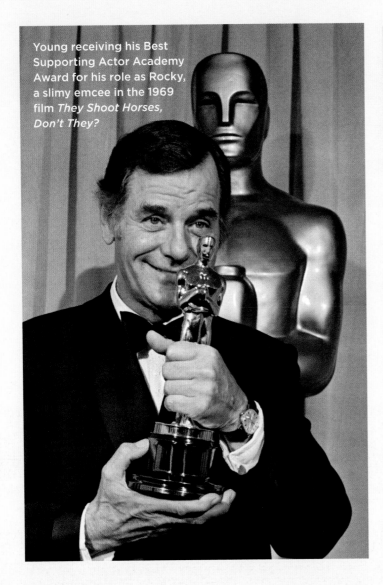

Young receiving his Best Supporting Actor Academy Award for his role as Rocky, a slimy emcee in the 1969 film *They Shoot Horses, Don't They?*

six-year-old advertising executive named Martin Sloan who stops near his boyhood home to have his car serviced and experiences a hauntingly eerie trip back in time.

While adept at lightweight cinematic fluff, the dramatic roles in which Young shined were as troubled or emotionally damaged people, which was probably testament to his own turbulent life. Besides being married five times, it was well known in Hollywood circles that he had a drinking problem so severe it caused him to be fired from the 1974 film *Blazing Saddles* after he collapsed on the set from alcohol withdrawal. The memorable role of the Waco Kid went to Gene Wilder.

Writer and director Mel Brooks recalled the scene where the Young character, an alcoholic, had to be hung upside down, at which time he would begin shaking. Brooks said the shaking did not stop and Young was soon "spewing green stuff" from his mouth and nose. Brooks immediately closed down the set as Young was whisked off to the hospital in an ambulance.

Young's addictions and predilections provided tremendous investigative fodder for homicide detectives.

"That's the last time I'll ever cast anybody who really is that person," said Brooks. "If you want an alcoholic, don't cast an alcoholic."

According to one of Young's spouses, he was an incredibly insecure man who, despite being nominated for three Oscars and winning one, yearned to be recognized for a film that would forever be associated with him as the star, not a supporting player.

"What he was aching for, as he walked up to collect his Oscar, was a role in his own movie—one they could finally call a Gig Young movie," said fourth wife, Elaine Young. "For Gig, [winning] the Oscar was literally the kiss of death, the end of the line."

Young's immense insecurities were spawned by adverse childhood experiences associated with his stern and grim Scottish father always referring to him as "a little dumbbell" and both parents telling him that his birth was the result of "a leak in the safe," meaning a condom. Those neuroses would haunt Young throughout his life, destroying his acting career and rendering him physically and emotionally impotent at the time of his death.

"As an investigator, it is your job to develop a theory and a motive in all homicides, including suicides [such as Young's]," said Tom Nerney, a first-grade detective who served the NYPD from 1966 to 2002 and retired from the Major Case Squad. "Homicide investigators are a dogged bunch, and many of them, including me, often look back years later at what they might have missed, which can be very frustrating. But you work with what you have, and go where the evidence takes you. That's all you can do."

Young's addictions and predilections provided tremendous investigative fodder for homicide detectives, who considered many possible motives for his actions before deciding the most likely was that he and Schmidt had a mutually agreed upon suicide pact. The basis for that theory was the unconventional clinical relationship Young had with Landy, many of whose clients later sued him for promulgating far-out therapeutic techniques that left them in worse shape after treatment than when they started.

THE LUFTHANSA HEIST

Year 1978

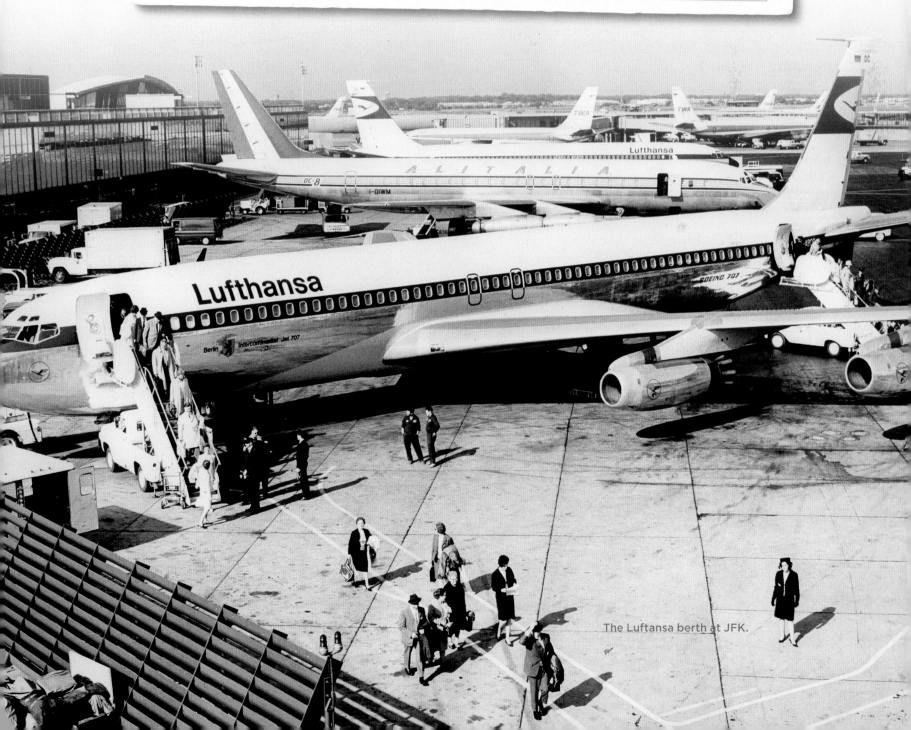

The Luftansa berth at JFK.

It was Monday morning, just after three A.M., on December 10, 1978, and Lufthansa cargo agent Kerry Whalen was working overtime at busy JFK Airport. He had just dropped off some freight at nearby American Airlines and was returning to the German airline's huge cargo facility, commonly known as Building 261. Oddly, a black Ford van was in a restricted area. When Whalen got out of his own truck to investigate, two gunmen jumped out and ran after him, prompting him to desperately call for help, but no one else heard. The pair pistol-whipped him into submission. "If you scream again, we'll kill you," the driver warned.

The two men, each of whom had momentarily dropped their masks to expose their faces, grabbed Whalen and put him in the van. The trio then drove to the warehouse to join four other masked cohorts who were armed with shotguns and automatic weapons. Unbeknownst to Whalen, two other accomplices, sitting in a silver Pontiac idling nearby, were ready to use it as a "crash car" if they needed to thwart any pursuing police cars. Once inside they made their way to the cafeteria and tied up the ten workers on duty.

After the robbery, Whalen told the police it was obvious that the stick-up team had inside knowledge of Lufthansa's security protocols. They stole forty cardboard receptacles the size of safe deposit boxes, each of which contained $125,000 in cash. They also grabbed a cache of jewelry. The entire job took just over an hour, and the haul was $5 million in cash and more than $875,000 in precious gems. At the time it was the largest robbery haul in U.S. history.

> **The entire job took just over an hour, and the haul was $5 million in cash and more than $875,000 in precious gems.**

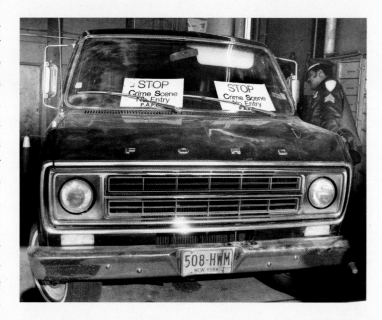

Within days, a small army of investigators turned their gimlet-eyed gaze on Jimmy "the Gent" Burke, forty-seven, an associate of powerful Lucchese crime family capo Paul Vario. Burke was thought to be the brains and brawn behind much of the crime occurring inside the airport, particularly the lucrative truck hijackings. But as frustrated investigators would soon find out, *believing* Burke pulled off the job and being able to *prove* it were two vastly different things.

In the immediate aftermath of the heist, there was growing suspicion that a man named Angelo Sepe, a vicious contract killer for Burke, had driven the black Ford van and that he along with Thomas DeSimone had been the two men who pistol-whipped Whalen. When it became known that Sepe had purchased a new Thunderbird for $10,000 cash shortly after the robbery, the Feds installed a bug in the vehicle. They picked up a few tantalizing tidbits of information, but not enough to move on their prime suspect.

Burke had many traits that made him a successful criminal, but it was his psychopathic ruthlessness that was perhaps most noteworthy, so it was not surprising to the authorities that a bloodthirsty purge of those directly or indirectly involved in the caper soon followed.

"It wasn't long before people started getting whacked," noted now-retired FBI Agent Steve Carbone, who supervised the FBI's probe of the caper.

The first person linked to the heist to die was Parnell "Stacks" Edwards, a Burke flunky, who hung out at Robert's Lounge, a wiseguy joint on Lefferts Boulevard, in South Ozone Park, at the airport's edge. A musician and small-time hustler, Edwards was supposed to take the stolen Ford van to a New Jersey junkyard to be crushed into scrap metal. Instead, he smoked some pot, drove to his girlfriend's residence in Springfield Gardens, minutes from the airport, and parked in front of a fire hydrant. After enjoying an evening that involved snorting cocaine and getting drunk, he awoke to learn that the van had been impounded by cops, who recovered Edwards's fingerprints and half a dozen ski masks inside. A week after the heist, he was found shot dead inside his Queens apartment.

A potential Rosetta Stone for investigators that never panned out should have been Martin Krugman, a local beautician who ran a salon, in Ridgewood, Queens, that provided hairpieces for balding men. Krugman was a

savvy bookmaker, who in the weeks before the robbery, excitedly confided to Henry Hill, a close intimate of Burke's, how millions in cash was theirs for the taking. Piles of U.S. currency, he said, were being funneled once a month through the Lufthansa cargo site from West Germany for distribution to Citibank. His inside dope came from Louis Werner, a Lufthansa cargo worker who was $20,000 in debt to Krugman, and from one of Werner's coworkers, Peter Gruenwald. Werner would agree to provide a detailed diagram of the cargo area and alarm system in return for $80,000 of the stolen loot.

The bookie who helped put the caper together knew all the odds, but he'd badly miscalculated the actuarial tables for his own life. Krugman vanished January 6, 1979, less than a month after the robbery. He was declared officially dead seven years later. The reason for his demise, Agent Carbone later learned, was his decision to hector Burke for his promised $500,000 cut. Hill, the man to whom Krugman had confided and who later became a government informant, told Carbone that Burke did it because "[Krugman] was a pain in the ass because he kept asking for his share."

The three principals in the Lufthansa Heist—Thomas DeSimone, Angelo Sepe, and Burke's twenty-six-year-old son, Frank—would all be killed in separate murders between January 1979 and May 1987. But none of their murders had anything directly to do with the airport heist.

In all more than a dozen people who were tied directly or indirectly to the notorious crime were murdered or vanished without a trace. The lucky ones were arrested:

Werner, the Lufthansa worker, got fifteen years for providing the inside information; his coworker Peter Gruenwald testified against him and was placed into the Federal Witness Protection Program.

Despite numerous leads, Burke was never charged with masterminding the Lufthansa crime, but he did not get away scot free. He developed cancer while serving time for murder in the Wende Correctional Facility in Alden, New York. He died at a Buffalo hospital on April 13, 1996. There were rumors that his daughters accessed his safe deposit box and found it contained between $2 and $4 million. However, this was never proven.

The redoubtable nature of the Lufthansa heist was illustrated on January 23, 2014, when Justice Department officials announced the indictment of Vincent Asaro, age seventy-eight, a resident of Howard Beach, Queens, and a capo in the Bonanno crime family. He was accused of helping Burke plan the Lufthansa job thirty-six years after the fact. In a secretly recorded conversation Asaro was heard complaining how those involved never got their promised share of the loot.

"We never got our right money, what we were supposed to get," Asaro griped. "That fucking Jimmy [Burke] kept everything." Despite the new evidence, he was acquitted.

The heist remains a distinctively New York City tale and has become a cornerstone of Mafia lore. The 1990 big-screen release *Goodfellas*, which detailed the robbery, won actor Joe Pesci an Academy Award for Best Supporting Actor as the fictionalized Thomas DeSimone.

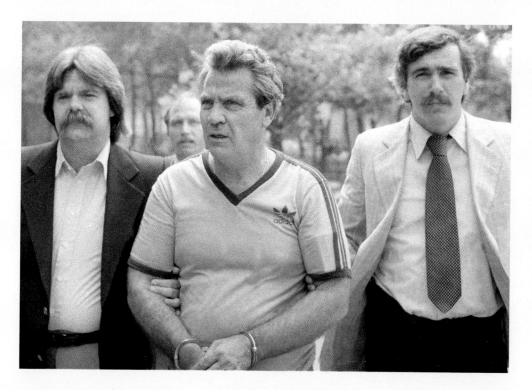

James Burke, the alleged mastermind of the Lufthansa heist, being taken into custody.

OPPOSITE PAGE: The black van impounded by cops in the aftermath of the December 11, 1978, Lufthansa heist at JFK Airport. Parnell "Stacks" Edwards was supposed to take the vehicle to a New Jersey auto salvage yard, where it could be made to vanish. However, buoyed by the success of the heist, Edwards got high and parked the vehicle in a no-parking zone, near his girlfriend's apartment, where cops recovered it. His lapse led to his murder—the first of many surrounding the heist.

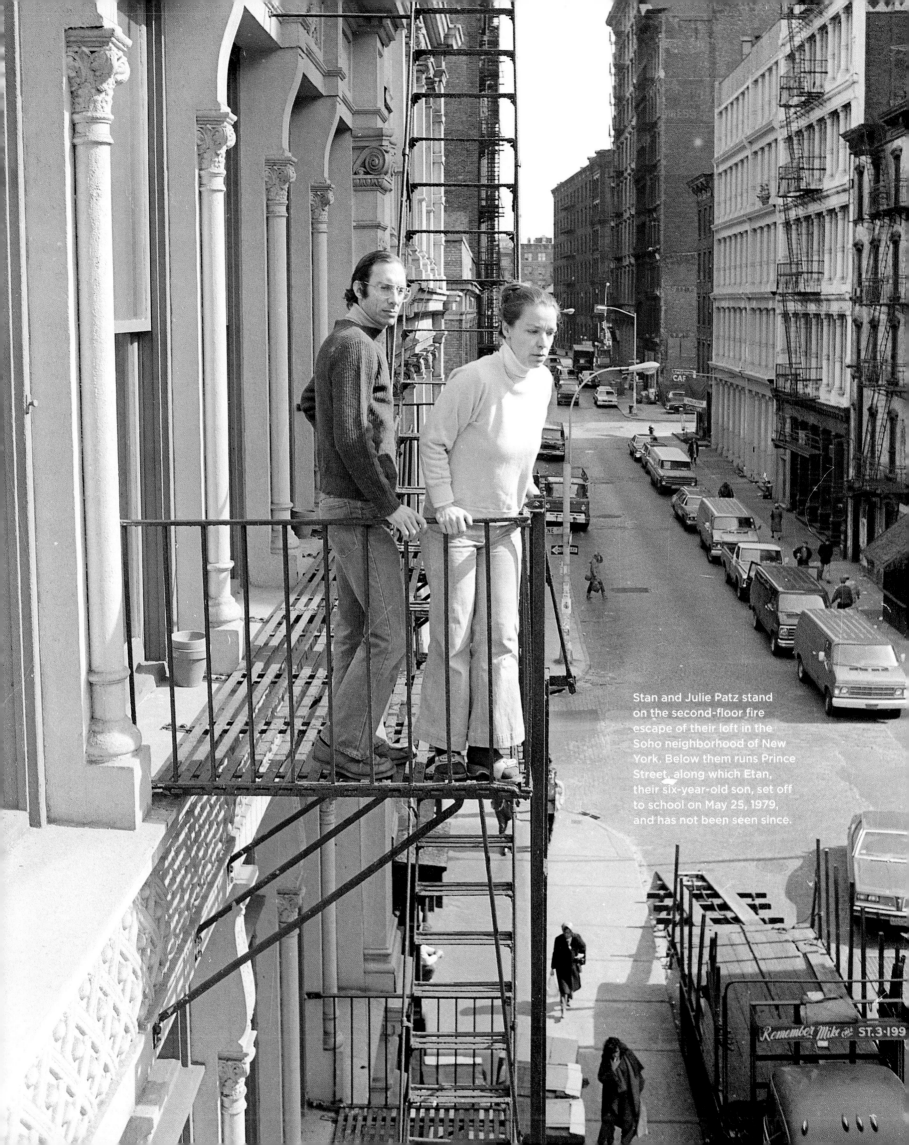

Stan and Julie Patz stand on the second-floor fire escape of their loft in the Soho neighborhood of New York. Below them runs Prince Street, along which Etan, their six-year-old son, set off to school on May 25, 1979, and has not been seen since.

THE DISAPPEARANCE OF ETAN PATZ

Year 1979

In the mid-1960s, WNYW, a small Fox affiliate in New York, began airing a nightly public service announcement with the question, "It's ten P.M. Do you know where your children are?" The catchy phrase implored parents to be more dutiful and diligent in ensuring the safety of their children against an increasingly and seemingly insurmountable tidal wave of urban dangers.

When the slogan first aired, no one thought immediately of accosted or murdered children. That happened on occasion, but it was generally held that the victims were the children of the wealthy who were held for ransom. That all changed on the morning of May 25, 1979, when six-year-old Etan Patz vanished during the short walk from his Prince Street home in Soho to his school bus stop two blocks away. Etan, who was in the first grade, was wearing a pilot's cap and carrying a bag of toys. It was the first time his mother had let him walk to the bus stop alone. The last time she saw him he was walking into a bodega on the corner of Prince Street and West Broadway to buy a soda.

When Etan failed to return home, his panicked parents contacted his school and learned that he never showed up. The police response was immediate and unequivocal. Helicopters hovered over Lower Manhattan, while hordes of volunteers roamed the streets calling Etan's name. Posters with the boy's smiling face were festooned throughout Soho in store windows, on light posts, parking meters, and building walls.

Statistically speaking, the number of abductions of children by strangers then, as today, is rare. According to the National Center for Missing and Exploited Children (NCMEC), in 2013 there were 194 Amber Alerts issued for 243 children. In nearly all those cases, the abductors were family members or people known to the victim.

However, the disappearance of Etan, coupled with the July 1981 abduction and murder of a six-year-old in Florida named Adam Walsh, gave the impression that such instances had reached

> ## "It's ten P.M. Do you know where your children are?"

epidemic proportions. Adam Walsh was the son of John Walsh, who went on to become a victim-rights and missing-children advocate, as well as creator and host of the popular, long-running television program *America's Most Wanted*.

The disappearance of Etan Patz, an only child of a family that was neither wealthy nor famous, transformed literally overnight the way parents kept watch over their children. In May 2015, a mother of an eleven-year-old son in Manhattan told the *New York Times* that she viewed the city streets as a "minefield." She explained her feelings: "It has everything to do with Etan. That is the bogeyman."

Exacerbating the tragedy is the fact that Etan's body was never found, and it took nearly three decades to charge someone with the crime. Investigators initially zeroed in on Jose Antonio Ramos, a mentally disturbed man who

> The disappearance of Etan Patz, an only child of a family that was neither wealthy nor famous, transformed literally overnight the way parents kept watch over their children.

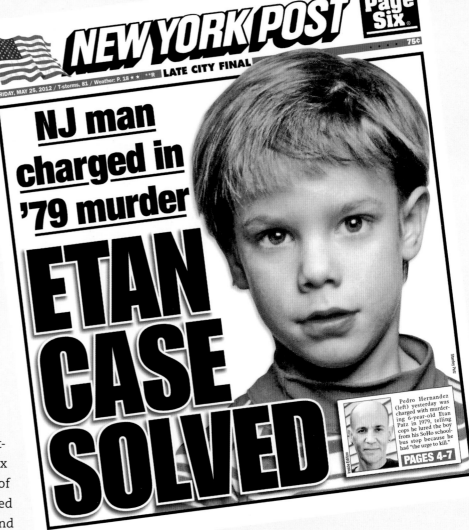

The *New York Post* cover when Pedro Hernandez confessed to killing Etan Patz.

had dated one of Etan's babysitters. He had attempted to lure several young boys into a Bronx drainpipe, where detectives found photos of many youngsters, including some who resembled Etan. Ramos never confessed to killing Etan, and police were unable to obtain sufficient evidence to charge him. He served twenty years in prison for an unrelated child molestation.

In 2012, police charged a fifty-three-year-old man named Pedro Hernandez with killing Etan. The evidence against him seemed to be overwhelming. In addition to Hernandez's wife, the leader of a church group, a child-hood friend, and a former fellow inmate each told detectives that at one time or another since the early 1980s, Hernandez had confessed to killing Etan. Hernandez worked as a clerk at the bodega Etan was last seen entering. Hernandez made a videotaped confession and reenacted the crime in which, he said, he strangled the youngster.

His sole motivation was his fear that Etan would tell someone that he attempted to molest him. As a result, he said, "I tried to let go but my body was shaking and jumping. Something took me over and I squeezed him more and more." Hernandez said that he wrapped the boy's body in a blanket and deposited it in an underground alley nearby on Thompson Street.

The trial of Hernandez for murder and kidnapping commenced in January 2015. In opening statements the prosecutor called it "a crime that changed the face of this city forever." She added, "Etan was dead before his mom even knew he was missing."

The defense argued that Hernandez was mentally ill. He suffered visions and heard voices. Inconsistencies in his statements suggested that he was not guilty of the grisly crime. They argued that his psychosis made anything he said unreliable.

After a four-month-long trial and eighteen days of deliberation, the jury of seven men and five women were deadlocked eleven to one for a guilty verdict. The lone holdout, a male, told reporters that the evidence was too circumstantial for him to convict. The judge declared the case a mistrial. The Manhattan District Attorney's office currently plans to retry Hernandez in the fall of 2016.

The sad irony is that the death of Etan Patz became the impetus for many law enforcement programs, including the formation of the NCMEC, the FBI's Child Abduction Rapid Deployment teams, New York State's Amber Alerts, and increased and improved monitoring of pedophiles and sex offenders. "We have so many more resources as a result of the Patz case," said Robert Lowery Jr. of the NCMEC. "If Etan went missing today, we would have a world of resources to help track him down."

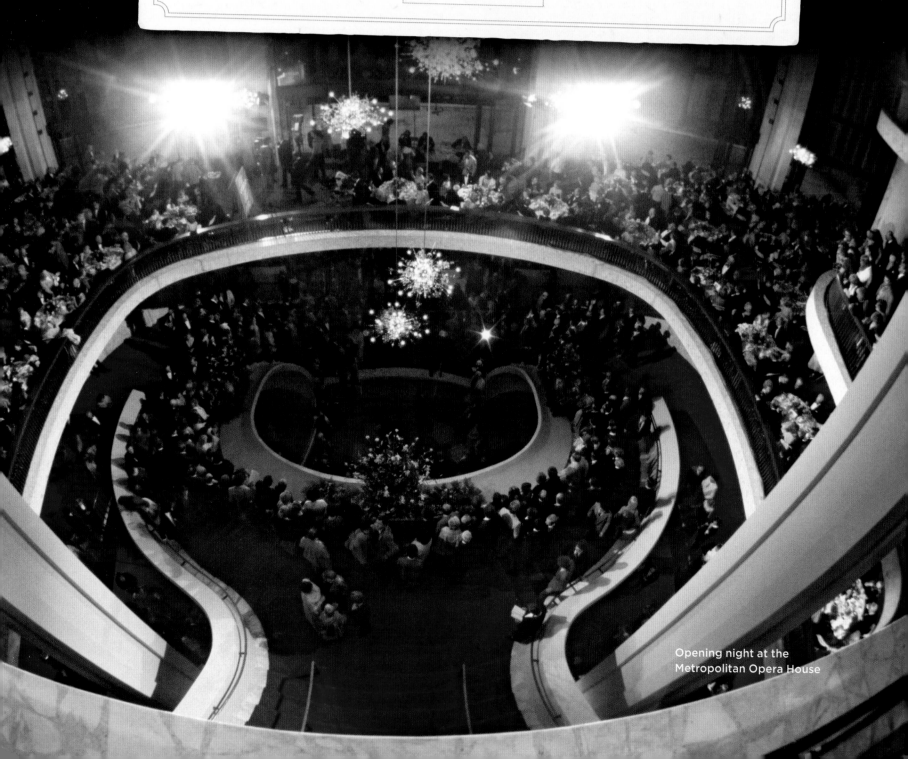

"PHANTOM OF THE OPERA"

Year 1980

Opening night at the
Metropolitan Opera House

On the evening of July 23, 1980, Helen Hagnes Mintiks, a superbly talented thirty-year-old violinist, was performing in the orchestra at the Metropolitan Opera House, in Lincoln Center, on Manhattan's West Side. The Big Apple was a long way from Aldergrove, British Columbia, a tiny suburb of Vancouver where she was born and raised.

Mintiks had been a child prodigy. She earned an undergraduate and a master's degree from the Juilliard School of Music and went on to study in London, Switzerland, and Italy. Along the way, she was mentored by some of the world's most renowned violin virtuosos. Now she was playing at the Met, not only the undisputed crown jewel in the city's cultural firmament, but also the apogee of Western civilization's grandest musical venues. It was a dream come true.

Mintiks played flawlessly during the first two performances by the Berlin Ballet, *The Firebird* and the sublime pas de deux from *Don Quixote*. At the 9:30 P.M. intermission, she left the orchestra pit to stretch her legs. She made a brief stop in the women's locker room, located beneath the stage, and then was seen boarding a backstage elevator in search of the star, Valery Panov, a Soviet defector and principal male dancer for the troupe.

Mintiks was not slated to perform for the third ballet, *Five Tangos*, but when she failed to return for the finale, her colleagues played without her, for even in opera, "the show must go on."

It was only after the final curtain fell that her bandmates became concerned about her whereabouts, as did her husband, Janis, who came after the show to pick her up. Police officers from the nearby Twentieth Precinct were called to the scene and began a painstaking search of every nook and cranny in the ten-floor theater. Eleven hours passed before they found her naked, battered body splayed on a ledge thirty feet below the roof in one of the opera house's six ventilation shafts.

Ropes and strands of torn clothing had been used to tie her hands behind her back and bind her ankles. A gag of napkins was stuffed in her mouth. The medical examiner determined that her death had been caused by multiple fractures of her skull, ribs, and lower extremities. The autopsy also revealed heavy bleeding in her brain, an indication she was alive when she was hurled to her death.

The medical examiner determined that her death had been caused by multiple fractures of her skull, ribs, and lower extremities.

Among evidence that the police recovered was a palm print on a pipe on the sixth floor and the rope used to secure the victim's hands. They noted it had a clove hitch knot, commonly used by stagehands. Detectives were also able to draw a composite sketch of the suspect based on a description that Laura Cutler, an American dancer in the troupe, provided of a man she saw in the elevator with Mintiks before she went missing.

The crime seemed like something plucked from the pages of an Agatha Christie mystery. The media's unrestrained fascination fell somewhere between the sheer brutality of what had occurred and the ethereal qualities imbued by both the victim and the storied venue.

TODAY
Mostly sunny, mid 80s

TONIGHT
Clear, warm, near 70

TOMORROW
Mostly sunny, 85-90
Details, Page 2

NEW YORK POST

FINA
LATEST PRIC

TV listings: P. 43

THURSDAY, JULY 24, 1980 30 CENTS

© 1980 News Group Publications Inc. Vol. 179, No. 210
AMERICA'S FASTEST-GROWING NEWSPAPER

AVERAGE
DAILY
SALES
EXCEED 650

MURDER AT THE MET

Beautiful violinist found bound, slain in air shaft

Show biz greats pay last tributes to Peter Sellers

By JOE COTTER and JEFF WEINGRAD

THE NUDE body of a beautiful young violinist, slain between acts at the Metropolitan Opera last night, was found in a ventilation shaft at the famed hall today.

Helen Hagnes Mintiks, a 31-year-old blonde, was apparently killed while on her way to see Russian ballet star Valery Panov in the dressing room he shares with his wife, Galina Panova.

Mrs. Mintiks' bound body was found lying on a beam in the airconditioner shaft above stage level.

She had plunged down the shaft at least two levels while the performance was going on.

"She either got up to the high level herself or was forced," said Manhattan Chief of Detectives Richard Nicastro.

The mystery killer obviously "had knowledge of the building," the detective said. But Nicastro also said police think the slaying appeared to be the result of a "chance encounter" and was not premeditated.

The blond freelance violinist lived with her husband, Janis, a sculptor, on the West Side.

She was last seen shortly after performing with an American orchestra accompanying the Berlin Ballet in the first act of Firebird.

The musician, who was on a break until she resumed playing for the third act, went to her locker room and told an unidentified dancer she "was going to an artistic meeting with Panov," said Nicastro. "But she never made it."

Nicastro said Panov was "definitely not a suspect" in the slaying. Both Panov and his wife, Galina Panova, defectors from the Soviet Union, danced last night.

Panova, who spoke to reporters as she arrived
Continued on Page 16

FULL COVERAGE ON PAGE 3 AND IN PHOTONEWS, PAGES 28, 41

THE PHANTOM OF THE OPERA, blared the *New York Post*'s front page. A secondary header read, POLICE LOOKING FOR SEX SLAYER AT MET. The *New York Times* seemed equally overwrought. Its lengthy front-page story was headlined VIOLINIST, MISSING AT INTERMISSION, FOUND SLAIN AT MET. Uncharacteristically, the *Times* account was accompanied by a detailed schematic of the opera house's many levels and, most astonishing, a photograph peering down into the abyss of the airshaft, giving readers a lurid opportunity to visualize the victim's death plunge.

The NYPD assigned sixteen detectives exclusively to the case. Another fifty were called in to help interview an estimated one thousand opera house workers. Even so, the investigation dragged on for weeks. Finally, on the morning of August 30, 1980, Twentieth Precinct detective Michael Struk, who caught the case, and Detective Gennaro Giorgio, of the Manhattan Homicide Task Force, announced that they had obtained a confession from a twenty-two-year-old high school dropout named Craig Steven Crimmins, who was employed by the Met as a stagehand. He had a particular fondness for alcohol, which was revealed later at his trial when a defense witness testified that Crimmins had downed approximately twenty beers during the twelve-hour period leading up to Mintiks's disappearance.

Crimmins admitted, "I killed the lady. She was talking to me, trying to be nice. I decided to gag her."

Assistant District Attorney Roger S. Hayes theorized that Crimmins and Mintiks had a chance encounter on the elevator that fateful night. He was inebriated and made a lewd pass at her. Mintiks responded by slapping him in his face. Crimmins became angry. He overpowered Mintiks and dragged her out of the elevator into the sub-basement, where he attempted to rape her, but not before demanding she remove her tampon. Mintiks tried desperately to fend him off. She broke free momentarily, but he caught her in the stairwell and forced her up to the roof on the sixth floor. There he tore off her clothes, bound her hands and feet, gagged her, and ultimately flung her down the ventilation shaft to her death.

Crimmins insisted that he was going to leave her on the roof to make his escape until she began squirming. "As I was walking away, I heard her pouncing up and down, and that's when it happened. I went back and kicked her off [the roof and down the air shaft]."

Crimmins was facing one count of intentional murder and another count of felony murder, the latter being murder in the commission of another crime—in this case,

attempted rape. His lawyer, Lawrence Hochheiser, contended that Crimmins had an IQ of only eighty-three and had been spoon-fed his confession by the police over the course of three days and denied an opportunity to speak to counsel. He painted his client as little more than a patsy who was no match for the incessant badgering he faced from a pair of savvy detectives and a wily prosecutor, all of whom had mercilessly grilled him until he finally broke.

On June 4, 1981, after eleven hours of deliberation, the jury forewoman announced not guilty on the intentional murder count, but the panel of seven women and five men returned a guilty verdict for felony murder. Crimmins's college student girlfriend, Mary Ann Fennell, collapsed in court and had to be taken to the hospital. Edward Crimmins Sr. later told the *New York Post* that his son spent his first night behind bars crying like a baby.

On September 2, 1981, Manhattan Supreme Court Justice Richard Denzer sentenced Crimmins to twenty years to life, while pointing out that the slaying had not been a random act but was meant to cover up the attempted rape. To this day, Crimmins remains a prisoner of the Shawangunk Correctional Facility in Wallkill, New York. He has since obtained a high school diploma and an associate degree in substance abuse counseling. Nonetheless, in May 2014, he was denied parole for an eighth time. In his opinion, he was remanded not so much for the crime that he committed but for the notoriety the crime generated.

Craig Crimmins (right) with his lawyer Lawrence Hochheiser.

"I JUST SHOT JOHN LENNON"

Year 1980

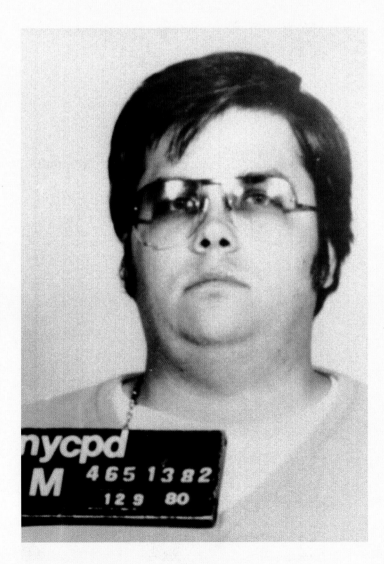

The booking photo of Mark David Chapman, John Lennon's convicted assassin.

The weather was exceptionally mild in New York City on December 8, 1980. Former Beatle John Lennon and his wife, Yoko Ono, had spent the afternoon being photographed together by Annie Leibovitz for the iconic *Rolling Stone* magazine cover, in which a naked and vulnerable John can be seen clinging, literally, to Yoko. The early evening was spent at a recording studio, but by 10:45 P.M., the couple were heading back to their residence in the Dakota, the celebrated co-op on Manhattan's Upper West Side.

After emerging from their limo near the West Seventy-Second Street entrance, Lennon was approached by a pasty-faced man, Mark David Chapman, age twenty-five, a security guard from Honolulu. Six hours earlier Chapman had asked Lennon to sign a copy of his and Ono's newest album, *Double Fantasy*. Lennon graciously obliged.

NYPD Chief of Detectives James Sullivan would later state at a raucous press conference how Chapman had addressed Lennon formally at this second encounter, calling him, "Mr. Lennon." It was an oddly respectful salutation given that Chapman would thereupon assume a combat stance and produce a snub-nosed revolver—a Charter Arms .38-caliber Undercover Special—then empty it into Lennon's body from a distance of approximately ten feet away.

The first bullet missed, but the next four hit their mark. Two entered the left side of Lennon's back and two more penetrated his left shoulder; three of the projectiles exited the rocker's body through the front of his chest. Chapman would later admit intentionally choosing to use hollow point bullets, "because they are more deadly."

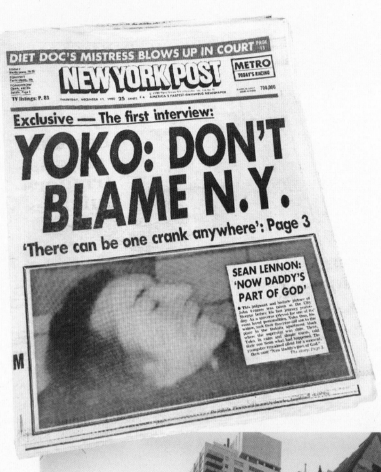

Lennon managed to stagger several steps to the Dakota's reception area and blurted out, "I'm shot. I'm shot," before collapsing in the vestibule.

Yoko began screaming, "John's been shot." The concierge, John Hastings, activated a silent alarm that alerted the NYPD to trouble in the building. Hastings tried applying a tourniquet, but abandoned the idea upon seeing how bad Lennon's wounds were.

Meanwhile the Dakota's doorman, an ex-CIA agent named Jose Sanjenis Perdomo, managed to knock the gun from Chapman's hands and kick it to the side. "Do you know what you've just done?" Perdomo shrieked.

"Yes," Chapman replied coldly. "I just shot John Lennon."

Minutes later NYPD cops Steven Spiro and Peter Cullen arrived on the scene in their radio car. A bystander pointed out Chapman, who was seated calmly on the sidewalk. The revolver lay on the ground a short distance away, where Perdomo had kicked it. Chapman was holding a paperback copy of J. D. Salinger's *The Catcher in the Rye*, the 1951 novel about youthful alienation.

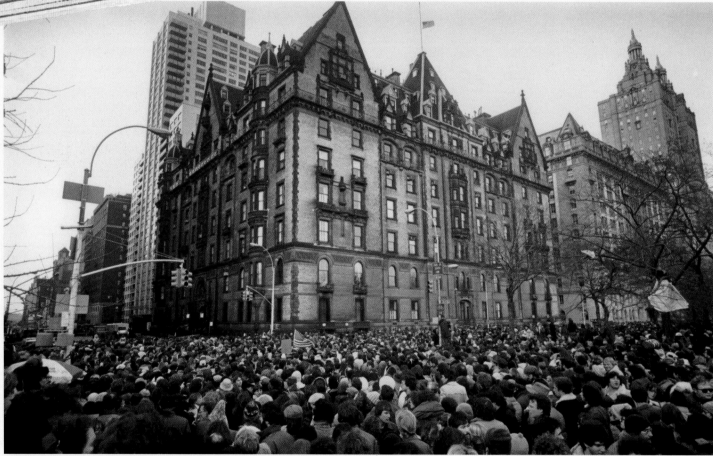

TOP LEFT: Lennon had come to love New York City because he was generally left alone there, despite his luminous fame. The news that he was killed in his adoptive city stunned the world. It first leaked out on a *Monday Night Football* broadcast by Howard Cosell, after an ABC News employee happened to be at the same hospital where Lennon had been taken; the employee then tipped off his employers. BELOW: After John Lennon was gunned down, crowds gathered at the site outside of his home at the Dakota.

The .38 caliber Charter Arms revolver Mark David Chapman used to assassinate John Lennon. The weapon was legally purchased by Chapman in Honolulu. Chapman then flew from Hawaii with the weapon stashed in his checked luggage, first to Atlanta, then to New York City.

Chapman offered no resistance as Spiro and Cullen placed handcuffs on his wrists. They put him in the backseat of their radio car as two other officers, Herb Frauenberger and his partner, Tony Palma, pulled up. They realized immediately they could not wait for an ambulance. Palma took Lennon's arms. Frauenberger took his legs. Together, they lifted Lennon into the backseat of a third police car driven by police officers Bill Gamble and James Moran, who rushed Lennon to St. Luke's–Roosevelt Hospital Center on Tenth Avenue, while Palma drove Yoko Ono.

When they arrived at the hospital, Lennon showed no signs of life. Still Dr. Stephan Lynn worked feverishly with two other doctors in a futile effort to save him, even going so far as to manually massage his heart. It was no use: Lennon, age forty, was declared dead at 11:15 P.M. The cause of death was "hypovolemic shock"—in layman terms, Lennon had simply bled out after losing more than 80 percent of his blood.

The first public disclosure came from sportscaster Howard Cosell on *Monday Night Football*. Somberly, he told viewers how "an unspeakable tragedy" had claimed the performer's life after he had been shot in the back near his Manhattan home. The news prompted spontaneous outpourings of grief by legions of adoring fans at both Roosevelt Hospital and the Dakota. Similar mournful gatherings occurred throughout the world over the next several days, and more than 225,000 New Yorkers converged in Central Park the following Sunday to pay tribute to the slain artist.

Chief Sullivan told reporters Chapman had first arrived in New York City to kill Lennon in October, only to have a change of heart. Chapman, however, could not resist his demons and returned, stalking Lennon for days until the perfect opportunity arose.

"It's an old rule," Sullivan said. "You become as famous as the guy you kill. From now on, anytime there's something with the name Lennon, it's got to have the name Chapman with it. This kind of killing brings names closer together than marriage."

Chapman had financed his murderous trip by selling a Norman Rockwell painting owned by his father-in-law. He acknowledged compiling a list of "six or seven names" of other famous celebrities he contemplated killing, including *Tonight Show* icon Johnny Carson and actor George C. Scott. In the end, his compulsion to kill Lennon proved irresistible.

It was reported that as a kid, Chapman was a devoted Beatles fan but grew incensed at Lennon's remark that the group had become "more popular than Jesus," a comment he termed "blasphemy." Chapman also grew angry by what he perceived as Lennon's hypocrisy as he watched him. Lennon publicly advocated simplicity, peace, and love, but from Chapman's perspective, he enjoyed a luxurious existence in New York City.

Later, Chapman would concede that his actions were selfish attempts to steal Lennon's fame because he felt confused and was drinking heavily. He was depressed and a failure.

Chapman seemed poised to mount an insanity defense, but surprisingly pleaded guilty to murder on June 22, 1981. Two months later, on August 24, Manhattan Supreme Court Justice Dennis Edwards imposed a sentence of twenty years to life.

Chapman remains incarcerated at Wende Correctional Facility, in Alden, New York. He has been denied parole eight times, most recently in August 2014.

He has been married to the same woman, Gloria Abe Chapman, now sixty-four, since June 1979. She still lives in his home state of Hawaii but visits him almost every year; they have shared conjugal visits for the past two decades. For what it is worth, Chapman now insists that he is sorry for his crime and claims that he has since found peace and redemption in his love for Jesus Christ.

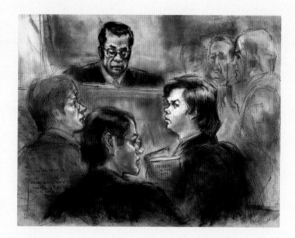

Artist's sketch of Mark David Chapman in court, along with prosecutor Allen F. Sullivan, Justice Dennis Edwards, and defense attorney Jonathan Marks. Chapman read a passage from *The Catcher in the Rye*—a copy of the J. D. Salinger novel was found in his pocket the night he murdered Lennon—during a secret, closed-door hearing in which he pleaded guilty.

THE PALM SUNDAY MASSACRE

Year 1984

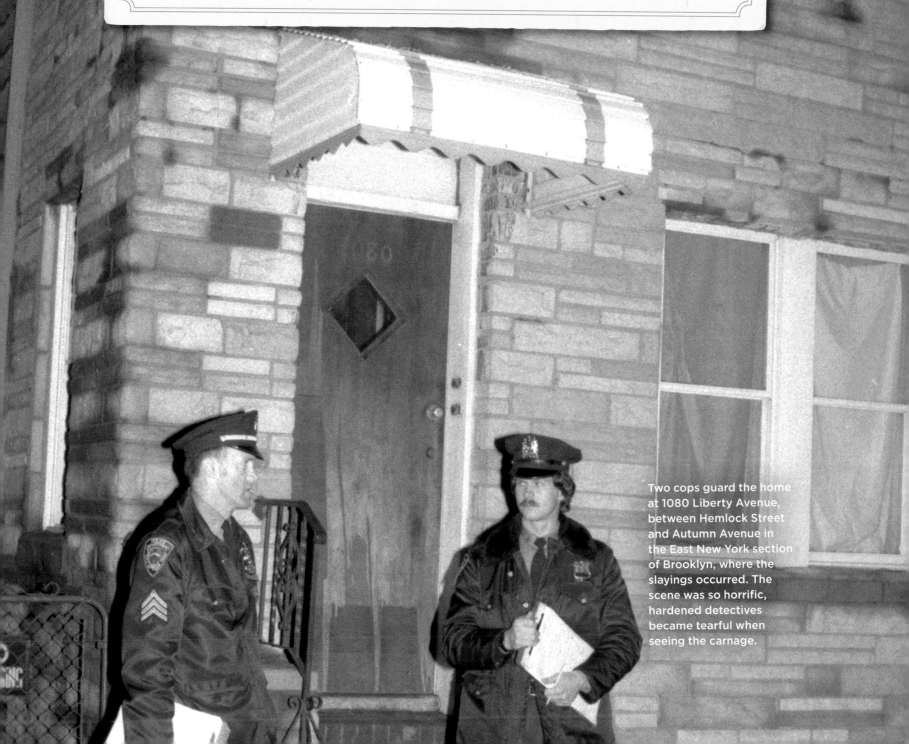

Two cops guard the home at 1080 Liberty Avenue, between Hemlock Street and Autumn Avenue in the East New York section of Brooklyn, where the slayings occurred. The scene was so horrific, hardened detectives became tearful when seeing the carnage.

The Palm Sunday Massacre unfolded in a hardscrabble Brooklyn neighborhood on the afternoon of April 15, 1984. While the day was a solemn and holy one in the Christian calendar, it soon became disturbingly obvious not everyone was carrying only palm fronds that day. Ten victims were found slain early that evening inside a five-room railroad flat, the bottom residence of a two-family home at 1080 Liberty Avenue, a nondescript street in East New York just blocks from the Queens border.

The carnage, up until the March 29, 1990, Happy Land Social Club fire that claimed eighty-seven lives, represented the largest single mass homicide in the city's history. The dead included two adults and eight others between four and fourteen years old. Six were males and four were females. There was just one tiny survivor, a crying, thirteen-month-old girl covered in blood who was found crawling among the dead.

Even the most hardened detectives, inured to seeing the worst in human nature, were disturbed by what they saw. A veteran NYPD captain was spotted with tears welling in his eyes after surveying the surreal crime scene. As the horrific details slowly emerged in the days that followed, the event struck a responsive chord with an outraged public.

A television set had been left on. The victims had all been shot at close range, most in the head. It was described like being in a wax museum, where the dead seemed to have been posed. The victims, investigators believed, had been caught by surprise, leaving them frozen in time, creating an eerie tableau. Seven of those killed were found on couches and chairs in the living room—three on one couch, two on another, and one in an easy chair. One woman, with a fatal bullet wound to her mouth, was grasping a container of chocolate pudding in one hand and a spoon in her other. Nearby sat a dead four-year-old boy, his arms reaching out to her. He had been shot in an eye.

The savagery led the NYPD to initially suspect that the murders were the grisly handiwork of Colombian drug dealers aligned with a vengeful drug cartel. The dead were slain with two guns, a .38 revolver and .22 automatic, leaving police to believe more than one killer was involved.

Within days, detectives—more than forty were assigned—zeroed in on Enrique Bermudez, the home owner and convicted cocaine dealer paroled in 1981, who was not there when the mayhem erupted. Bermudez's girlfriend, Virginia Lopez, twenty-four, who was more than six months pregnant, was among those killed, along with her two kids, Eddie, seven, and Juan, four; two other victims

included Bermudez's daughters from another relationship: Betsey Bermudez, fourteen, and Marilyn Bermudez, ten.

Under a cooperation agreement with Brooklyn prosecutors, Bermudez admitted having had a falling out with Christopher Thomas, thirty-four, who had threatened him and had also run up a $7,000 cocaine debt.

Detectives tracked down two local youths and the son of a local video arcade owner, all of whom said they saw Thomas near the Liberty Avenue premises in the hours before the victims were found. Moreover, one of the youths admitted going to the residence to visit his girlfriend between four and five P.M., walking up to the front door, looking through a window, and seeing Thomas leaning over one of the victims before hearing a gunshot.

Thomas, a dad to two boys, ages four and six, was arrested on the evening of June 19 at a Bronx jail, where he was facing pending criminal charges for sodomizing and attempting to rape his own mother. He was hit with twenty counts of murder—ten for intentional murder and ten more for felony murder, or murder during the commission of another crime, in this case, robbery.

Greed had played a factor, but there was another motive, too, as Thomas was under the deluded impression that his estranged wife, Charmain, was having an affair with Bermudez, and he blamed that for his crumbling marriage. By some accounts, his homicidal frenzy had also been stirred by freebasing cocaine regularly for the past two years.

Prosecutors built their case primarily around the testimony

> **There was just one tiny survivor, a crying, thirteen-month-old girl covered in blood who was found crawling among the dead.**

of the three witnesses who had spotted Thomas at the Liberty Avenue home on the day of the slayings and a Riker's Island prisoner who testified that Thomas confessed to him while they were behind bars together.

On July 19, 1985, after sixteen hours of deliberation over three days, Thomas was convicted of first-degree manslaughter due to extreme emotional disturbance. Jurors accepted defense arguments that Thomas was not culpable of murder because he was depressed over his deteriorating marriage and his long-standing cocaine abuse.

Tough-talking Brooklyn Supreme Court Justice Ronald

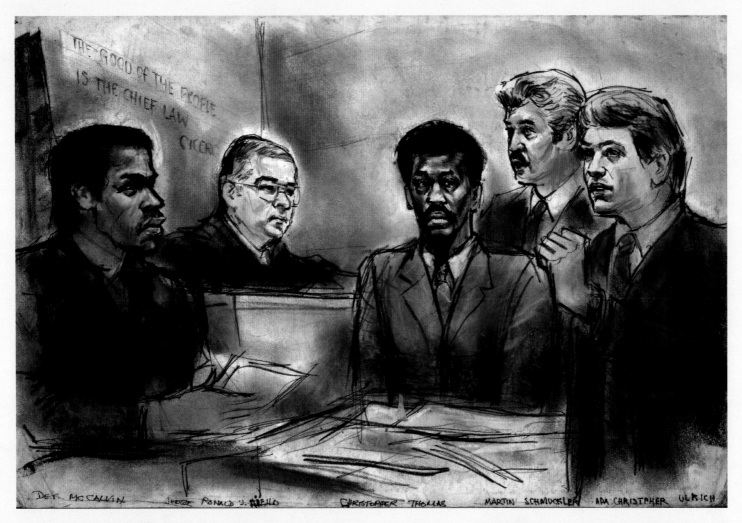

At the sentencing, Judge Ronald Aiello delivered a blistering broadside against the convicted killer, Christopher Thomas, 34, for the April 1984 slayings of the 10 victims, all of whom were either children or young women.

Aiello imposed ten consecutive terms of eight and a third to twenty-five years for each victim on September 10, 1986. "It is this court's intention that you serve every day, every hour, and every minute of the minimum sentence I impose on you," said Aiello. "'Don't let him out.' That is my message to the New York State Parole Board," he thundered, adding, "Your judgment day today is on earth. Your next judgment day will be with the good Lord. Today is a piece of cake, Mr. Thomas, compared to your final judgment day."

Thomas appealed his conviction, challenging an incriminating shell casing recovered from his former Bronx residence. The casing was a ballistic match to one of the guns used in the slayings and had been introduced

before the jury that had convicted him. His legal appeal claimed the shell was the product of an illegal search. A four-judge appellate panel unanimously ruled that there was "overwhelming evidence against the defendant" and "any error in [the shell's casing] introduction into evidence [was] harmless beyond a reasonable doubt."

Thomas was still unrepentant nearly twenty-five years later. In a February 2009 prison interview, he told *New York Post* reporter John Doyle, now an investigative producer for WCBS-TV News, that he was innocent. "I didn't do it," Thomas told Doyle. Drug dealers, Thomas explained, an apparent reference to Bermudez, "had enemies." Thomas remains a prisoner of the Shawangunk Correctional Facility, in Wallkill, and has been repeatedly denied parole.

Christina Rivera, aged 13 months, was found splattered with blood when her 20-year-old mother, her 3- and 5-year-old half-brothers, and several cousins were among the 10 victims killed in the Palm Sunday Massacre.

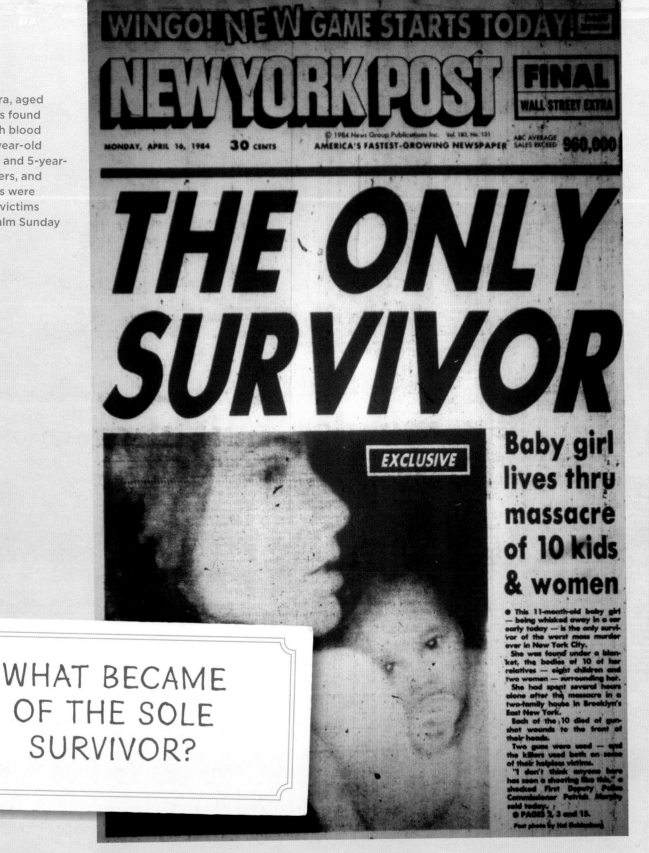

WINGO! NEW GAME STARTS TODAY!

NEW YORK POST
FINAL
WALL STREET EXTRA

© 1984 News Group Publications Inc. Vol. 183, No. 131

MONDAY, APRIL 16, 1984 **30 CENTS** AMERICA'S FASTEST-GROWING NEWSPAPER

ABC AVERAGE SALES EXCEED **960,000**

THE ONLY SURVIVOR

EXCLUSIVE

Baby girl lives thru massacre of 10 kids & women

● This 11-month-old baby girl — being whisked away in a car early today — is the only survivor of the worst mass murder ever in New York City.

She was found under a blanket, the bodies of 10 of her relatives — eight children and two women — surrounding her.

She had spent several hours alone after the massacre in a two-family house in Brooklyn's East New York.

Each of the 10 died of gunshot wounds to the front of their heads.

Two guns were used — and the killers used both on some of their helpless victims.

"I don't think anyone here has seen a shooting like this," a shocked First Deputy Police Commissioner Patrick Murphy said today.

● PAGES 2, 3 and 15.

Post photo by Hal Goldenberg

WHAT BECAME OF THE SOLE SURVIVOR?

Truly ghastly crimes rarely have heart-warming postscripts. This one did. It involved Christina Rivera, the thirteen-month-old infant found alive in the abattoir. Her touching photo had graced the front page of the *New York Post*, along with the headline THE ONLY SURVIVOR, showing her with a pacifier in her mouth while being cradled by then police officer Joanne Jaffe, one of the first responders to the scene.

Christina's mother, Carmen Perez, twenty, and two half brothers, Alberto, five, and Noel, three, as well as several cousins, were among Thomas's victims. But Jaffe, who was later promoted to be the department's highest-ranking female chief, had quietly served as her benefactor and surrogate mom for many years. In 2013, when Christina was thirty, Jaffe fulfilled a personal vow and legally adopted her.

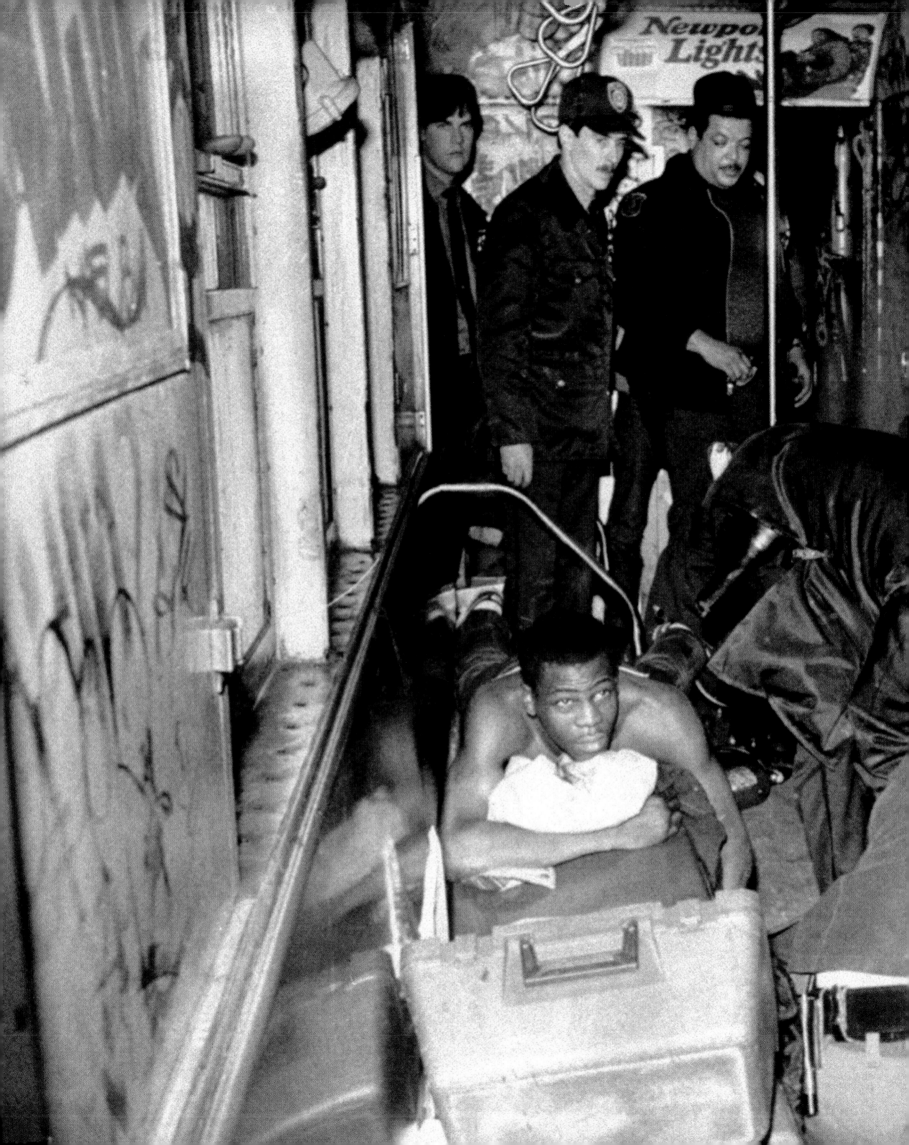

The downtown No. 2 IRT subway car Goetz was riding when he pulled his gun, aimed, and fired five times at a quartet of youths he believed were poised to mug him.

THE "SUBWAY VIGILANTE"

Year 1984

On the afternoon of December 22, 1984, Bernhard Goetz, a bespectacled thirty-seven-year-old white man living on the northern edge of Greenwich Village, boarded a downtown IRT No. 2 express subway train at the West Fourteenth Street station. If he looked like a milquetoast, that was understandable. He was an engineer and had a nerdy look about him. Still, beneath his unassuming appearance, there was a steely resolve. It would be displayed in explosive fashion when he lashed out with a preemptive strike against a perceived threat posed by four black teens, thereby defining the zeitgeist of crime-ravaged 1980s urban America.

Fearing he was about to be mugged on the subway by them, Goetz whipped out an unlicensed Smith & Wesson .38 Special Model revolver. He then fired the gun's five bullets, in less than two seconds, at his intended targets, nineteen-year-olds Barry Allen, Troy Canty, and Darrell Cabey, and eighteen-year-old James Ramseur. It was later determined that each youth was a high school dropout with a criminal record. They were carrying concealed screwdrivers for a trip to a video arcade near Pace University, where they planned to steal quarters.

241

"Sorry—but it had to be done" is what Goetz told a jailer upon being processed as an inmate at a Concord, New Hampshire, jail, following his surrender in that city. Goetz fled to the "Live Free or Die" state after shooting four teens who confronted him on the subway.

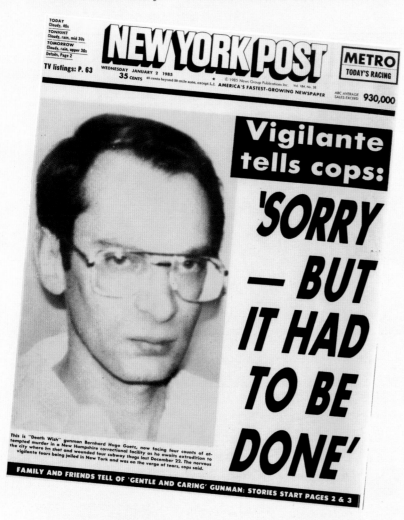

This is "Death Wish" gunman Bernhard Hugo Goetz, now facing four counts of attempted murder in a New Hampshire correctional facility as he awaits extradition to the city where he shot and wounded four subway thugs last December 22. The nervous vigilante fears being jailed in New York and was on the verge of tears, cops said.

FAMILY AND FRIENDS TELL OF 'GENTLE AND CARING' GUNMAN: STORIES START PAGES 2 & 3

When Goetz had stopped firing, the four teens were lying wounded on the subway car floor in puddles of their own blood, while an estimated twenty straphangers froze in horror. Canty was hit in the chest; Allen was struck in the back; Ramseur had a round pass through his arm and rest in his left side; Cabey, who had his spine severed, was left brain damaged and paralyzed from the waist down.

The NYPD initially depicted the incident almost pedantically, as if it was a disagreement between reasonable people. "He was seated. They were horsing around on the train. They approached him and asked him for five dollars. He took objection and he shot them," police spokesman, Sergeant Raymond O'Donnell stated matter-of-factly. This prosaic recitation of events, while technically accurate belied the societal impact of a shooting that would inflame the already fragile racial dynamic within New York City, redefine America's principles of self-defense, and intensify passions over gun control.

Goetz got off between cars as the train stalled between stations and vanished into a darkened tunnel. Dubbed "the Subway Vigilante," his identity would not surface until shortly after noon, on New Year's Eve, when he surrendered to police in Concord, New Hampshire.

Manhattan Assistant District Attorney Susan Braver, along with two NYPD detectives, Michael Clark and Dan Hattendorf, showed up soon afterward. Goetz provided them with a startling two-hour videotaped confession, apart from what he had already told Concord cops.

Goetz, who was born in Queens, had been raised on a dairy farm in upstate New York. He had a bachelor's degree in electrical and nuclear engineering from New York University. He earned a living calibrating electrical equipment for the Navy, among other clients. His world was one of precision and hospital corners—and what took place on the subway had totally upended his tidy little world.

That might explain why Goetz was alternately insulting, apologetic, defiant, aggrieved, and indignant in his videotaped statement. He seemed in need of absolution, noting he had been mugged before. (A January 1981 incident left him with a bum knee and led to him to apply for a NYPD concealed-carry gun permit, which he was denied.) In the end, his statements given freely would only incriminate himself:

> I wanted to kill those guys. I wanted to maim those guys. I wanted to make those them suffer in every way I could—and you can't understand this because it's a realm of reality that you're not familiar with. If I had more bullets I would have shot them all again and again. My problem was that I ran out of bullets. Do I have to go this route? Do do do [sic] you want to hear it one more time?

He insisted he knew the motives of his antagonists: "I saw they were intending…to play with me like a cat plays with a mouse."

People across the country took sides. Some supported him (Senator Alfonse D'Amato offered to be a character witness) as an avenging hero; others condemned him as a racist vigilante. Multiple witnesses on the train agreed the four youths had acted boisterously prior to the shooting, but support or opposition largely fell along racial lines. Amid this furor, there was little thoughtful discourse spent on "legal justification."

For the popular *Chicago Tribune* columnist Mike Royko, who recalled being mugged at gunpoint by several young men himself, any such introspection was silly. "To hell

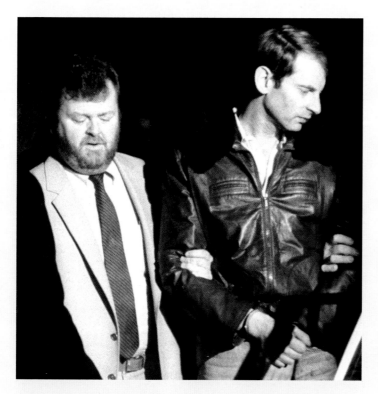

Before his surrender in New Hampshire, nobody knew who was responsible for shooting the teens. Some began to liken the mysterious culprit to the character Paul Kersey, from the 1974 vigilante movie *Death Wish*, who begins killing criminals after his wife is murdered.

with the questions. I'm glad Goetz shot them. I don't care what his motives were or whether he has all of his marbles. The four punks looked for trouble, and they found it. Case closed."

Jury selection started on December 12, 1986. Seven men and five women, ten of whom were white, began hearing the evidence the following April.

Goetz was charged with illegal gun possession, attempted murder, assault, and reckless endangerment. Prosecutor Gregory Waples portrayed him as a hothead with a skewed moral compass. He charged Goetz had shot one of the teens "in the center of the back as he tried to flee," and that Cabey had been left permanently paralyzed, even though he had been "sitting down in a subway seat... absolutely helpless and doing absolutely nothing to threaten or menace Bernhard Goetz."

One of Goetz's more devastating admissions came when he told cops that prior to firing the shot that paralyzed Cabey, he muttered, "You don't look so bad—here's another." The defense would blunt his declaration by offering testimony Goetz merely fantasized making the utterance at the time and that what he said was contradicted by ballistic evidence.

Canty suggested he and his pals were doing little more than panhandling. He told jurors he was three or four feet away from Goetz when he asked him, "Mister, can I have five dollars?" Under cross-examination, however, Canty conceded he perhaps said, "*Give me* five dollars." Canty's assertion that he and his pals were simply looking for a helpful handout was contradicted by police officer Peter Smith, one of the first NYPD cops on the scene. He testified as a defense witness that Canty told him, "We were going to rob him, but he shot us first."

Goetz's lawyer, Barry Slotnick, presented medical testimony that Goetz was on "automatic pilot" after he began firing. He did his best to demonize the four youths, referring to them at various times as "hoodlums," "criminals," "savages," "punks," "low-lifes," and "thugs."

On the afternoon of June 16, 1987, the jury returned not guilty verdicts, except for the gun count, for which Goetz served eight months in jail. In April 1996, a civil jury in the Bronx returned a $43 million verdict against Goetz for injuries he inflicted on Cabey, despite testimony by columnist Jimmy Breslin that Cabey admitted to him in November 1985 how his friends planned to rob Goetz because he looked like "easy bait." (Goetz declared bankruptcy soon afterward; the judgment becomes unenforceable under New York law in 2016.)

In recent years, Goetz has embraced vegetarianism and become involved in efforts to protect squirrels. He has run twice for elected office without an impact. On December 17, 2004, as the twentieth anniversary of the shooting approached, Goetz was asked if he regretted buying the gun.

"No, you can't let yourself be pushed around. You can't live in fear. I mean, some people do live in fear. You can't live in fear. That's no way to live your life," Goetz replied.

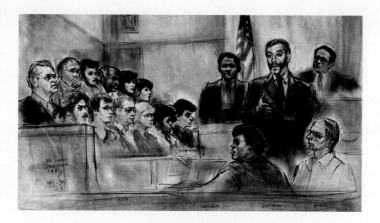

Bernhard Goetz looks on as his defense attorney, Barry Slotnick, cross-examines James Ramseur, one of the four young men he shot. It was Ramseur's angry outbursts that prompted the judge to disallow his testimony and to twice cite him for contempt.

THE ASSASSINATION OF PAUL CASTELLANO AND THE RISE AND FALL OF JOHN GOTTI

Year 1985

December 16, 1985, 5:30 P.M. Paul Castellano, aka Big Paulie, the seventy-year-old head of the Gambino crime family, and Thomas Bilotti, his newly anointed underboss, had just left their lawyer's office and were headed for dinner at Sparks Steak House on East Forty-Sixth Street in Manhattan. Restaurant critic Gael Greene wrote at the time, "The best sirloin around is the deliciously aged beauty at Spark's, where the roster of great American red wines is an aristocratic homage to the beef."

The squat, powerfully built Bilotti pulled the Lincoln Continental into a No Standing zone directly in front of Sparks Steak House. There was not much chance of him getting a parking ticket, because the Seventeenth Precinct was running with a skeletal crew—most of the cops were off that night attending their annual Christmas party.

As Castellano and Bilotti got out of the limo, four men wearing long white trench coats and black Russian-style fur hats approached and unleased a fusillade that caught them completely off guard. Castellano was hit half a dozen times at close range. Bilotti took four bullets and collapsed on the sidewalk next to the driver's-side door. Both mobsters were dead before the police arrived.

Witnesses on the crowded street reported the assassins sped off in separate dark-colored sedans. Meanwhile, John Gotti, now the Gambino crime family heir apparent, triumphantly surveyed the bloody tableau from a safe distance while sitting in his own Lincoln Continental beside his chauffeur, Salvatore "Sammy the Bull" Gravano.

While planning for the coup d'état had only begun two weeks prior, the seeds for the deadly deed had been sown

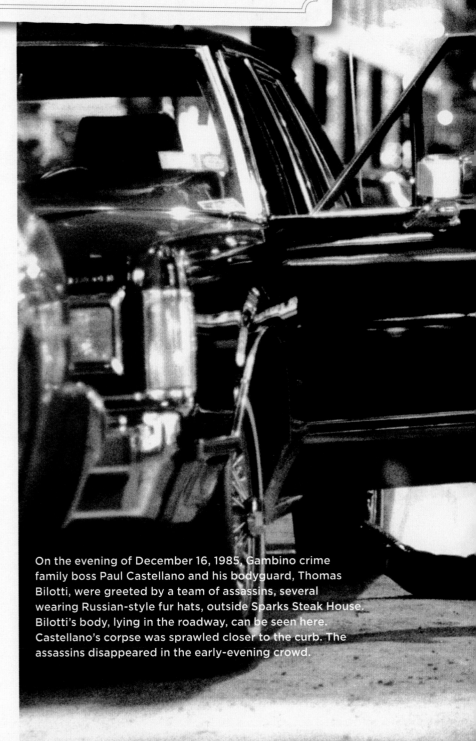

On the evening of December 16, 1985, Gambino crime family boss Paul Castellano and his bodyguard, Thomas Bilotti, were greeted by a team of assassins, several wearing Russian-style fur hats, outside Sparks Steak House. Bilotti's body, lying in the roadway, can be seen here. Castellano's corpse was sprawled closer to the curb. The assassins disappeared in the early-evening crowd.

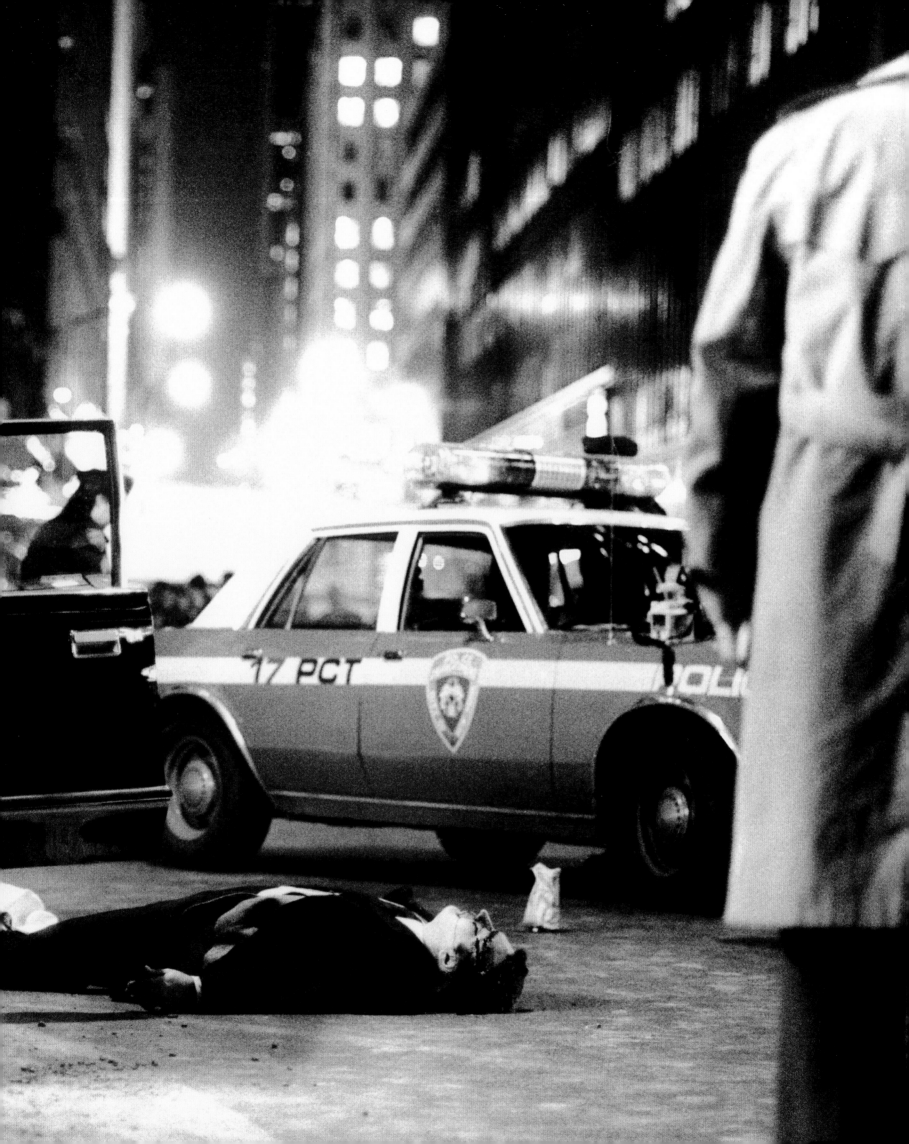

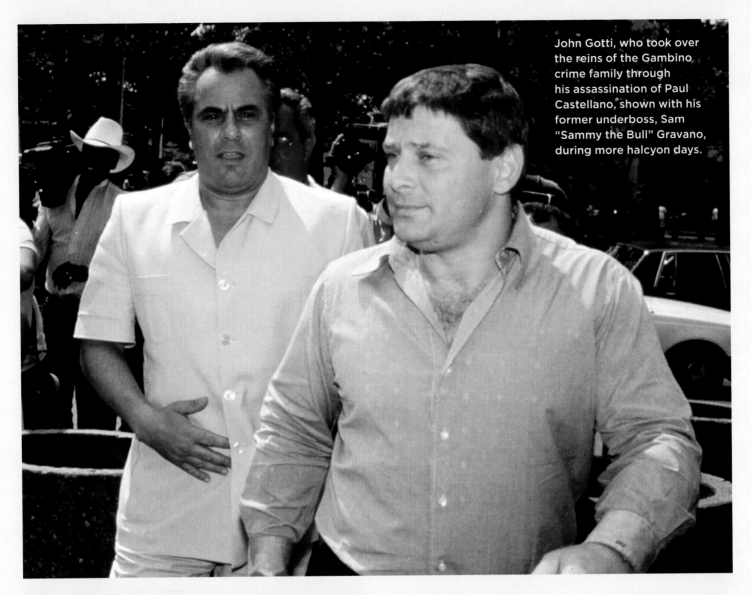

John Gotti, who took over the reins of the Gambino crime family through his assassination of Paul Castellano, shown with his former underboss, Sam "Sammy the Bull" Gravano, during more halcyon days.

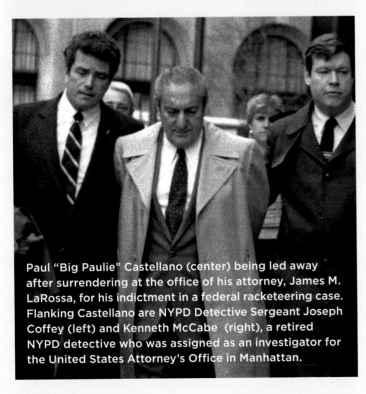

Paul "Big Paulie" Castellano (center) being led away after surrendering at the office of his attorney, James M. LaRossa, for his indictment in a federal racketeering case. Flanking Castellano are NYPD Detective Sergeant Joseph Coffey (left) and Kenneth McCabe (right), a retired NYPD detective who was assigned as an investigator for the United States Attorney's Office in Manhattan.

years before and were inextricably tied to the notorious Gambino crime family, which dominated the city's four other mob clans (the Genovese, Colombo, Lucchese, and Bonanno factions) in terms of influence and power. It was widely considered the most successful criminal organization in the country. (In 1983, an internal NYPD report had pegged the number of "made" Gambino soldiers at 250, with an estimated 550 more family "associates" on the payroll.)

Castellano himself had an impeccable mob pedigree. A generation earlier, he was the youngest attendee at the ill-fated Apalachin Meeting, the infamous November 14, 1957, mob conclave at the upstate New York home of Joseph "Joe the Barber" Barbara. There, approximately one hundred mafiosi from the United States, Canada, Italy, and even Cuba fled into the dense woods after local cops showed up unexpectedly at the secret gathering.

More important, Castellano was blessed to have been the cousin and brother-in-law of the family's eponymous late leader, Carlo Gambino. Under Gambino's reign, a delicate

balance of shared power had existed within the family. Castellano served as one of the underbosses while Aniello Dellacroce, an old-school mobster of legendary ferocity, served as the other. When Gambino died suddenly of a heart attack in his Long Island home on October 15, 1976, at age of seventy-four, it was Castellano who took over, forcing Dellacroce, ever the loyal supplicant, to remain as his underboss.

Under Castellano's stewardship, the family's fortunes thrived, but Castellano's aloofness caused some of his subordinates to grow resentful. Although he was a butcher by trade, he had taken to dressing more like a Swiss banker. He steered clear of drug dealing and instead became immersed in lucrative white-collar crimes, such as labor racketeering, construction industry bid rigging, credit card and securities fraud, and solid waste recycling. He moved into a palatial mansion known as "the White House," in Todt Hill, an exclusive section of Staten Island that sat on the highest elevated piece of land in New York City.

Although Castellano acted like a powerful CEO, he was not particularly beneficent toward his underlings. Word within the ranks was that not only was he *selfish*, but worse, he was *cheap*.

He relegated Dellacroce and his cronies, most notably protégés John Gotti and Sammy Gravano, to serving as muscle for brutish endeavors such as truck hijacking, loan-sharking, pornography, gambling, extortion, and the occasional contract murder.

When Dellacroce lost his battle with lung cancer on December 2, 1986, the underlying tensions between the two camps came to a head after Castellano failed to attend Dellacroce's wake. Then when Castellano named Bilotti as his new underboss instead of Gotti, it further inflamed Gotti's wounded sensibilities. Gotti took matters into his own hands and recruited a team of assassins for the unsanctioned hit while he watched the action from the sidelines. The plan worked. Two weeks after Castellano's murder, Gotti took over as head capo.

He went on to enjoy a relatively short but exceedingly flamboyant reign as Gambino family boss, during which time he forged a reputation first as "the Dapper Don" for his sartorial style (he favored $2,000 Brioni suits) and then as the "the Teflon Don," following three straight victories in a four-year span where he beat federal RICO and state charges of conspiracy, assault, and robbery.

But his shroud of invincibility ended once and for all on April 2, 1992, when his own underboss Sammy Gravano turned state's evidence and ratted him out. Gotti was convicted in Brooklyn Federal Court for racketeering along with the murders of Castellano and Bilotti. Although Gotti was the only person ever charged with the Castellano-Bilotti slayings, Gravano identified the four man hit team Gotti put together as Vinnie Artuso, a Bronx-based heroin dealer; John Carneglia and Eddie Lino, a Gambino soldier and capo, respectively; and Salvatore "Fat Sally" Scala, Lino's brother-in-law.

According to Gravano, Carneglia fired the shots that killed Castellano, while Lino and Scala blasted away at Bilotti. Artuso did not fire his weapon, because his gun jammed.

Gotti was sentenced to life without parole and fined $250,000. Diagnosed with throat cancer in 1998, he died at the United States Medical Center for Federal Prisoners, in Springfield, Missouri, on June 10, 2002, at age sixty-one.

The bough of a tree seems to shroud the partially nude corpse of Jennifer Levin, who was found dead inside Central Park early on the morning of August 26, 1986.

"THE PREPPY MURDER CASE"

Year 1986

On August 26, 1986, Patricia Reilly was out for an early-morning spin on her bicycle in Central Park. As she pedaled the loop behind the Metropolitan Museum of Art, off Fifth Avenue in Manhattan, she spotted the lifeless body of Jennifer Levin, age eighteen, splayed half naked and spread-eagled beneath a stately elm. In newspaper photos, detectives can be seen milling about the crime scene. A leaf-laden bough hovers low to the ground just above her corpse, as if trying to shield her from further indignities.

The first police officers on the scene observed red, angry-looking bruises on Levin's neck and a badly swollen left eye. Her bra and camisole were pulled up around her neck, and the pink miniskirt she'd been wearing was cinched at her waist. Her missing panties were located approximately forty-five feet from her body.

Within hours detectives had a suspect in custody. Nineteen-year-old Robert Chambers had been drinking with Levin at Dorrian's Red Hand, a watering hole frequented by the well-to-do, underaged crowd on Second Avenue and East Eighty-Third Street. They both used fake IDs to get in and buy drinks. Chambers and Levin had met there earlier in the summer and had hooked up on several occasions since. Friends said that Levin was smitten by Chambers. Witnesses told police that they left the bar together at 4:30 A.M., headed to the park for yet another tryst.

At first Chambers claimed the deep scratches on his face were caused by a cat, but detectives did not buy it. After several more hours of questioning, Chambers offered a confession of sorts. According to him, Levin had tied his hands with her panties while they were involved in sexual hijinks in the park and that at some point she "freaked out" and squeezed his testicles. It was so painful that he struck her neck so hard that she flipped over. When she didn't move, he said, "I thought she was kidding, so I went over and shook the body," only to discover his blow had killed her. It was not his fault, he insisted. "She molested me."

New Yorkers were mesmerized by both the crime and the participants. Chambers was handsome, tall, and powerfully built, with chiseled features, thick, dark hair, and a cowlick that only added to his insouciant air of detachment. Although he had been a star athlete in high school and a one-time member of the elite Knickerbocker Greys, a cadet corps of young boys whose past members included former New York City mayor John Lindsay, he had gotten into his share of trouble growing up. Along the way he had flunked out of Choate, one of the nation's premier prep schools, and more recently Boston University in large part due to his heavy drinking and drug use.

His parents sent him to the Hazelden drug treatment clinic in Minnesota in the spring of 1986 to get cleaned up, but the program had little effect on him. No longer a student and without a job, he was partying full-time—and financing his debauchery, police discovered, through petty thefts and residential burglaries. Despite all of the advantages he enjoyed growing up, his future looked dim.

Levin, on the other hand, was a vivacious, five-foot-seven-inch, 120-pound brunette with hazel eyes who was going places. She had been voted "best looking" by her fellow graduates at the exclusive Baldwin School on West Seventy-Fourth Street in Manhattan. She was celebrating with friends at Dorrian's Red Hand that night because in a week was she leaving for Chamberlayne Junior College in Boston to further her education.

> As he twisted a doll's head, he said in a falsetto, "My name is...Oops! I think I killed it."

Jack Litman was hired to represent Chambers. Litman was renowned for his zealous advocacy on behalf of his clients, so much so that he was often lambasted for his over-the-top, "blame the victim" tactics.

It was a point Litman hammered home on Chambers's behalf during his opening remarks to the jury of eight men and four women on January 4, 1988. "What would impel him to take the life of Jennifer Levin?" he asked jurors. Levin had died accidentally, Litman contended, while the two were fooling around in what derisively became known as the "rough sex" defense.

Litman implied that *Levin* was the sexual aggressor and that it was *Chambers* who became an unfortunate victim of circumstances. Litman cross-examined a close friend of Levin's, Alexandra LaGatta, and got her to admit that Levin essentially saw Chambers as a boy toy with whom to have fun.

Prosecutor Linda Fairstein, head of the Manhattan District Attorney's Sex Crimes Unit, tried to keep the jury focused on not *why* Levin died, but *how*. She mocked suggestions that a tall and powerful young man could be victimized by a girl roughly half his size. She told jurors that Chambers was a "consummate liar" and his version of events was a "preposterous story which makes a vibrant eighteen-year-old girl the agent of her own death."

NYPD Sergeant John Mullally provided damning testimony that portrayed Chambers as a narcissist. Mullally told how he overheard conversation between Chambers and his dad, Robert Sr., at the Central Park stationhouse in which the younger Chambers stated: "That fuckin' bitch. Why didn't she leave me alone?"

State Supreme Court Justice Howard E. Bell provided jurors with a dizzying smorgasbord of seven possible criminal verdicts, including two for murder, as well as lesser counts of manslaughter or criminally negligent homicide.

On March 25, 1988, after the jury deliberated nearly nine days without reaching a verdict, Chambers struck a deal and pleaded to first-degree manslaughter in that he had "intended to cause serious physical injury" to Levin and had thus caused her death, and to burglary (for the Upper East Side break-ins), rather than take his chances. He agreed to a five-to-fifteen-year prison sentence to be served concurrently, for both offenses.

At his sentencing on April 15, 1988, he publicly acknowledged his culpability for the first time, although his sincerity was in doubt. "The Levin family has gone through hell because of my actions, and I am sorry. For two years, I have not been able to say I'm sorry, and I wish to have my feelings known." He later pleaded no contest to a $25 million wrongful death suit filed against him by Jennifer Levin's parents.

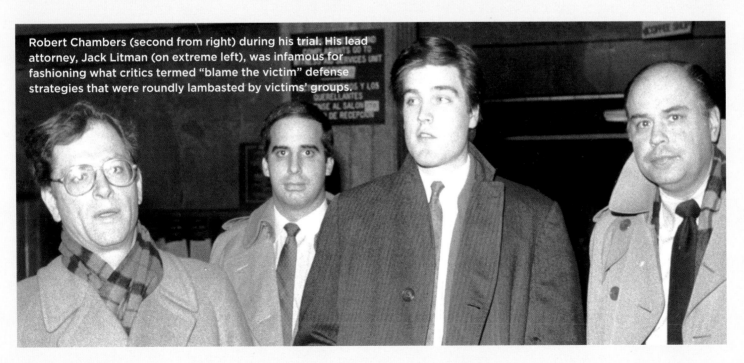

Robert Chambers (second from right) during his trial. His lead attorney, Jack Litman (on extreme left), was infamous for fashioning what critics termed "blame the victim" defense strategies that were roundly lambasted by victims' groups.

A month after his sentencing, the television show *A Current Affair* aired a home video showing Chambers frolicking at a party that had taken place in December, just before his murder trial began. He was cavorting with four scantily clad girls, including his girlfriend, Shawn Kovell. As he twisted a doll's head, he said in a falsetto, "My name is...Oops! I think I killed it."

Chambers was released from the upstate Auburn Correctional Facility on February 14, 2003, after serving the maximum on the manslaughter conviction as a result of twenty-seven separate prison infractions. During the years he was incarcerated, he spent a third of his time in solitary and was rejected for parole five times. He has since returned to jail after pleading guilty to peddling drugs with the same girlfriend who appeared in the infamous videotape with him, Shawn Kovell. He will not be eligible for parole until January 25, 2024. If he gets out he will be fifty-seven years old and long removed from the days he was known as the Preppy Killer.

Shawn Kovell, Robert Chambers's long-suffering girlfriend, met Chambers in 1988, shortly before he went on trial for murdering Jennifer Levin, and fell in love with him. She stayed with him 15 years while Chambers served his sentence for manslaughter, and she was still at his side when they were busted on drug charges in October 2007. He got another 19 years in prison; she received probation.

SLEEPING OFF A MURDER CHARGE

Joe Badalamente, a retired NYPD cop, was a twenty-one-year-old rookie assigned to the Central Park Precinct the night Robert Chambers, aka the Preppy Killer, was brought in as a prisoner at the stationhouse. The pair struck up an unlikely friendship while the accused killer was waiting to be taken to Manhattan Criminal Court for his arraignment.

Badalamente was working that night as the precinct's "broom"—police parlance for the officer assigned to perform mundane custodial chores. He was barely a year older than Chambers. Although the pair were on completely different paths in life, over the course of the next several hours, they shared an easy banter. "I do remember discussing the New York Mets with him. He said he was a Mets fan and I'm a Mets fan, too," remembered Badalamente, who purposely steered clear of any talk about the murder charges Chambers faced.

Badalamente said as the night wore on, Chambers became exhausted and curled up his six-foot-four-inch frame into a ball and dozed off while seated in one of the sturdy but less than comfortable chairs with rolling metal wheels and green vinyl seats that were omnipresent in most NYPD stationhouses.

"I remember thinking that if I was arrested for something I really didn't do, I wouldn't be able to do that." But Chambers had probably been awake for more than twenty-four hours at that point and may have simply been exhausted, Badalamente conceded. "You can be tired and nervous, right?"

Still, given his dire predicament, no matter how tired he might have been, Badalamente thought Chambers's aplomb was remarkable. "It was like he had no nerves. A person going to the dentist to get a cavity filled would be more nervous than he was," he recalled.

When Chambers became aware there was a huge media scrum lurking outside in the stationhouse courtyard that had massed for the proverbial perp walk, he became "delusional," asking if there was a back way out so he could avoid the reporters, newscasters, and photographers waiting to get a look at him. Somehow he thought the murder charges could be kept a secret.

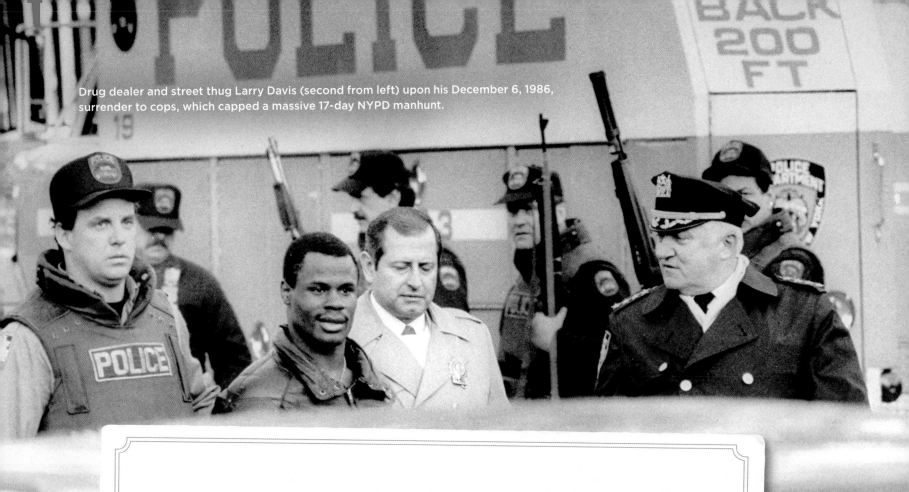

THE INCREDIBLE ESCAPE OF LARRY DAVIS

Year **1986**

arry Davis, a black, twenty-year-old convicted drug dealer from the rough-and-tumble South Bronx was wanted by the NYPD in connection with six murders. From experience the police knew him to be an extremely dangerous thug with a very itchy trigger finger. They planned to move in on him with a small army. Word on the street was that Davis would be ready for them. Shortly before Thanksgiving 1986, he was elevated from street scourge to urban legend.

The showdown between Davis and cops unfolded on Wednesday, November 19, at approximately 8:25 P.M. Twenty-seven police officers and detectives, including several heavily armed Emergency Service Unit cops, con-verged on 1231 Fulton Avenue in the Bronx. Larry Davis was thought to be hiding inside his sister Regina Lewis's first-floor apartment. As Emergency Service Officer Mary Buckley ushered Regina, her three-year-old nephew Joseph, and another man to safety, furious gunfire erupted.

It was never conclusively established as to who fired first. Davis and the cops would blame each other, but no doubt Davis got the jump on the police. Wielding a sawed-off 16-gauge shotgun, a .45-caliber Colt automatic pistol, and a .32-caliber revolver, and using his nephew as a shield, Davis laid down a barrage that forced the cops to retreat.

Police officer Buckley was struck by shotgun pellets that fractured a bone in her mouth and shattered ten

252

teeth. Detective Donald O'Sullivan was grazed in the head and hand. Sergeant Edward Coulter was hit in the right leg and left hand. Detective Thomas McCarren was shot in the neck. (A tracheotomy saved his life.) Police officer John O'Hara was blinded in his left eye. Captain John Ridge suffered a non-life-threatening head wound.

Cops returned fire twenty-four times, including four shotgun blasts, but Davis was able to scamper into the adjacent apartment of another sister before vanishing into the night air unharmed.

NYPD spokesman Detective John Clifford provided an exceedingly benign assessment of what had transpired. "The entire situation will be reviewed, but no one is questioning the tactics employed by the police officers to enter the apartment," he said. Technically, he was correct: No *one* was questioning police tactics—*everyone* was. For the next seventeen days the media chided the NYPD for its incompetence and lauded Davis for his bold escape. In his home borough of the Bronx, Davis had become Billy the Kid, John Dillinger, and Clyde Barrow all rolled up in one.

Davis was finally captured by police on Saturday morning December 6, 1986, after a tense seventeen-hour standoff. He had gone to the Twin Parks housing complex at 365 East 183rd Street, in the Fordham section of the Bronx, to visit his sister Margaret, but in his desperate attempt to elude the police he ended up in another apartment, taking Sophia Sewer, her husband, and two young children hostage. Cops were able to rush into the apartment after he fell asleep.

At trial, Davis continued to be elusive. He was charged with murdering four suspected drug dealers inside a first-floor apartment at 829 Southern Boulevard, in the South Bronx, one of the many reasons police were looking for him in the first place. Despite forensic evidence that incriminated him, defense lawyers William Kunstler and Lynne Stewart argued (without presenting any proof) that Davis had been framed by cops. Surprisingly, he was acquitted of all charges related to those murders in March 1988.

Next up was the trial involving the attempted murders of the six cops. The sixteen-week ordeal concluded November 20, 1988, one day past the second-year anniversary of the shootout. A jury of ten blacks and two Hispanics ended thirty-eight hours of deliberation over five days by finding Davis not guilty of nine counts of attempted murder and six counts of aggravated assault. Davis was found guilty only of lesser charge of gun possession and received a five-to-fifteen-year prison sentence.

Davis's attorneys, his family, and his supporters cheered, but everyone else was gobsmacked by the fact that the jury bought Davis's unsupported claims that he had shot at racist cops in self-defense because he feared that they intended to assassinate him for revealing their involvement in drug-dealing activities.

"I am shocked. Every policeman in New York—white, black, Hispanic, or Asian—must be horrified," said Mayor Ed Koch. Thomas McCarren, the most seriously injured of the officers, called the verdict racist and added, "I think the jury should be ashamed of themselves."

Phil Caruso, president of the Patrolmen's Benevolent Association, was equally appalled. "Welcome to the Bronx, where you can shoot six cops and become a folk hero," he muttered.

Davis's good fortune ended March 14, 1991, when he was finally convicted for the August 5, 1986, killing of another drug dealer, Ramon Vizcaino. He was given twenty-five years to life the following month by Justice Stephen Barrett, to whom a defiant Davis hurled a string of vile insults.

While in jail, Davis had been knifed and beaten several times by fellow convicts, yet managed to survive each attack. Nevertheless, he met an ignominious end on the evening of February 20, 2008, inside the Shawangunk Correctional Facility. During a recreational break, inmate Luis Rosado plunged a nine-inch metal shank into Davis multiple times. Davis was taken to a local hospital with stab wounds to his head, chest, arms, back, and legs, and declared dead just forty-six minutes after the assault.

Rosado, like Davis, was serving twenty-five years to life. He pleaded guilty to manslaughter for killing Davis on February 25, 2009, and had ten years added to his term. He remains incarcerated at Five Points Correctional Facility, in Romulus, New York. According to state records, he is eligible for parole in January 2018.

Larry Davis flashes a smile as his lawyer, William Kunstler (right) sits beside him during Davis's trial at the Bronx County Courthouse, on November 18, 1988.

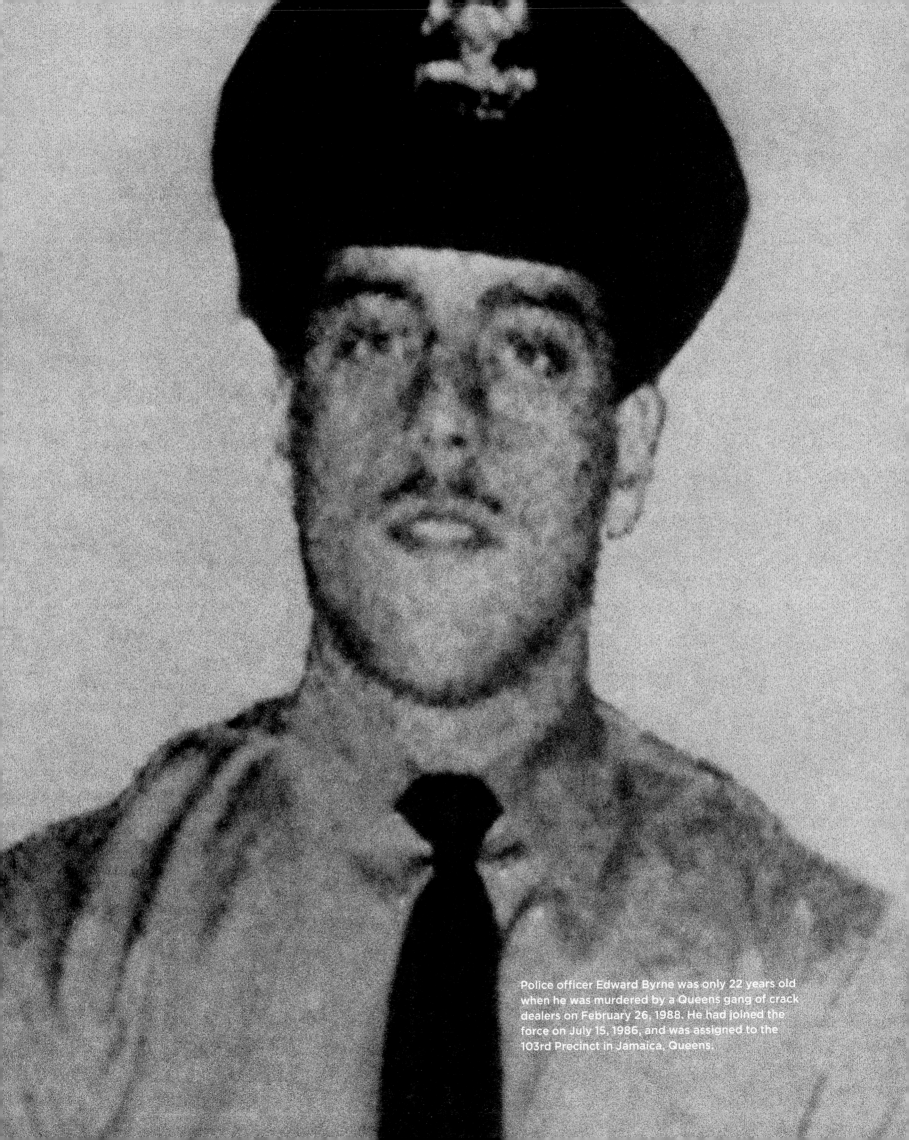

Police officer Edward Byrne was only 22 years old when he was murdered by a Queens gang of crack dealers on February 26, 1988. He had joined the force on July 15, 1986, and was assigned to the 103rd Precinct in Jamaica, Queens.

THE ASSASSINATION OF POLICE OFFICER EDWARD BYRNE

Year **1988**

The assassination of Police officer Edward Byrne occurred at 3:30 A.M. on February 26, 1988, and became a symbol of the utter devastation wrought by the crack epidemic on urban America. The twenty-two-year-old rookie was ambushed as he sat in a parked NYPD radio car on a quiet residential street in South Jamaica, Queens. Byrne was protecting the home of a witness in a drug case, a Guyanese immigrant known only as Arjune. In retaliation for his prior complaints about crack dealing near his home, thugs had hurled Molotov cocktails at his front porch on two occasions the previous November.

As an accomplice of the assassin approached one side of the car to distract Byrne, his partner silently slithered up behind and pumped five bullets from a .357 magnum into the young cop's upper body, an area where his bullet-resistant vest offered no protection. The gunman was whisked from the scene by a getaway driver and a fourth conspirator.

"The officer had no chance to do anything," lamented a visibly anguished Police Commissioner Benjamin Ward at a press conference at Mary Immaculate Hospital, where Byrne was pronounced dead.

Byrne's father, Matthew, a retired NYPD lieutenant who practiced law in Long Island, was suitably outraged. "My son Eddie was executed last Friday by people who don't even deserve to be called people," he railed after the slaying, as he stood on the steps of O'Shea Funeral Home, in Wantagh, a New York City suburb, flanked by his wife,

Ann, and his three other sons: Lawrence, a prosecutor in the Manhattan U.S. Attorney's office (Lawrence would go on to become the deputy commissioner of legal matters for the NYPD in 2014); Stephen, a Marine Corps second lieutenant; and Kenneth, a college student.

"An attack on a cop is an attack on society. We're going to do more here because the killing was in connection with drug trafficking. That's the added ingredient," vowed Mayor Ed Koch.

Outrage over Byrne's death reverberated throughout the country: President Ronald Reagan had called the Byrne family to express his personal condolences. Vice President George H. W. Bush took to carrying Byrne's police shield during his 1988 presidential campaign after the slain officer's father presented it to him.

> **An attack on a cop is an attack on society.**

Detectives working around the clock soon learned that Byrne's assassination was not in retribution against Arjune as originally thought. Instead it was part of a murder-for-hire contract initiated by an imprisoned drug dealer named Howard "Pappy" Mason, a top lieutenant in the drug empire of Lorenzo "Fat Cat" Nichols. Mason was incensed at *another* cop (not Byrne) who had disrespected him in public by demanding that he cover his open beer with a brown paper bag. From his jail cell, he decided that somebody on the police force would have to pay.

Within two weeks cops had four suspects in custody—Todd Scott, nineteen; Scott Cobb, twenty-four; David McClary, twenty-two; and Philip "Marshall" Copeland, twenty-two. All were minions in Mason's street gang, known as the Bebos, whose members sported flashy jewelry with gang-specific designs and spoke in a variant of pig Latin, and all four offered versions of the event that portrayed each of them in the best possible light under the circumstances.

Two of the top prosecutors in Queens, A. Kirke Bartley and Eugene Kelly, laid out the case before two separate juries weighing the fates of three of the four defendants. (Due to legal reasons, two of the suspects, Scott and Copeland, were being tried by one jury while Cobb was being tried simultaneously in the same courtroom by a different jury. McClary was tried separately.)

Prosecutors alleged that Mason had passed the murder contract on to his main enforcer, Philip Copeland, who hired the other three. "The order given from jail was carried out; the message was delivered," Bartley claimed. "Five bullets shattered his head, ending his life…[It was] a message of death to Eddie Byrne."

The most devastating evidence against them came from Scott Cobb's seventy-minute videotaped confession in which he admitted to driving the getaway car but denied knowing that a cop was to be the target.

Scott Cobb said he had been listening to music when he heard gunshots and drove Todd Scott and David McClary from the scene. Todd Scott laughed about how he had witnessed McClary shooting Byrne. (McClary claimed Scott had been the one who shot Byrne.)

"Dave [McClary] was telling Todd [Scott] that after he [McClary] fired, Todd was standing there laughing. Todd was leanin' on the car…[saying]

> "Brains. I [Scott] seen the cop's brains come out. I seen the brains."

The shocking nature of Officer Edward Byrne's assassination led to a massive outpouring of grief and stunned the nation. President Ronald Reagan called the Byrne family to express his condolences, and Vice President George H. W. Bush was given Byrne's badge (no. 14072) by the slain officer's father, Matthew, an NYPD lieutenant turned lawyer. Bush carried it with him on the campaign trail in 1988.

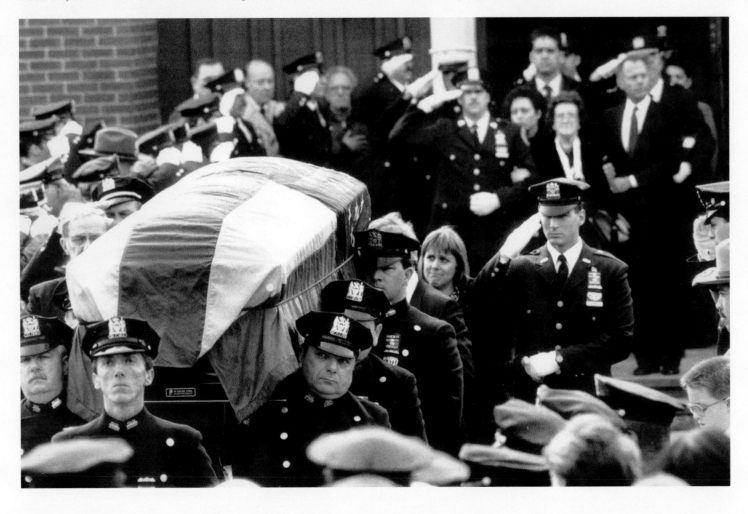

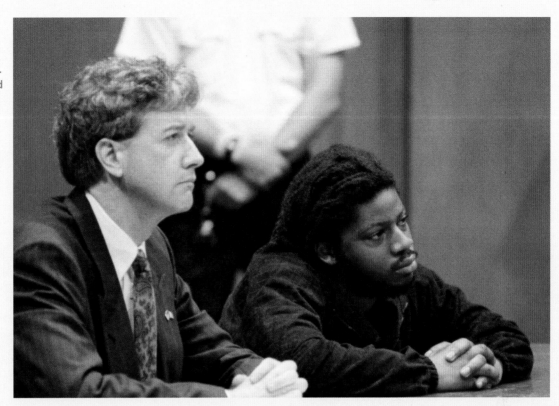

Philip Copeland (right) was one of four defendants charged with murder for Officer Byrne's assassination. All would be found guilty and be sentenced to life, which prompted thunderous applause from about 150 police officers in the courtroom.

'Hee-hee. Oh, you blew his brains out'...He [Scott] said it like a joke. He said he [McClary] shot the cop. 'Brains. I [Scott] seen the cop's brains come out. I seen the brains,'" Cobb said, quoting Scott, in his videotaped statement. "He says that's what he [Scott] was laughing at."

Todd Scott's own videotaped confession was no less disturbing: "I seen the first bullet hit him. I saw his head down and his hair flying like, you know, a blow dryer. I seen the blood and stuff."

The defense was unpersuasive. A girlfriend of Philip Copeland insisted that he was in bed with her when the slaying occurred. Todd Scott acknowledged being at the murder scene but denied approaching Byrne's police car; he maintained he had been beaten by cops to make his videotaped statement. Scott Cobb testified he drove Todd Scott and David McClary to the scene but knew nothing of any plot to kill Byrne. The state's witnesses, the defendants' lawyers argued, were an unsavory bunch out for a piece of the $130,000 in reward money.

On the evening of March 29, 1989, a jury of eight men and four women found Scott Cobb guilty of Byrne's murder; nearly ninety minutes later, a second jury, comprised of six men and six women, found Philip Copeland and Todd Scott guilty of the same crime. The fourth suspect, David McClary, was convicted by a separate jury of murdering Byrne on June 6, 1989.

Queens Supreme Court Justice Thomas Demakos sentenced each man twenty-five years to life and recommended they never be paroled. All four are still serving their sentences.

Howard "Pappy" Mason was indicted on federal racketeering charges in Brooklyn Federal Court, which included the Byrne murder. He was found guilty on December 11, 1989, and sentenced to life in prison by Brooklyn Federal Court Judge Edward Korman on January 7, 1994.

Two other suspects were convicted of firebombing Arjune's home. As for Arjune, he was relocated under the federal witness program to Spokane, Washington, until a dispute with local cops led to him to be moved once more, to another secret locale.

Lorenzo "Fat Cat" Nichols, Mason's onetime boss, pleaded guilty to drug-related charges in a secret proceeding before the same Judge Korman on September 28, 1989. Although he became a federal informant, he is still serving a life sentence in Clinton Correctional Facility, in Dannemora, New York.

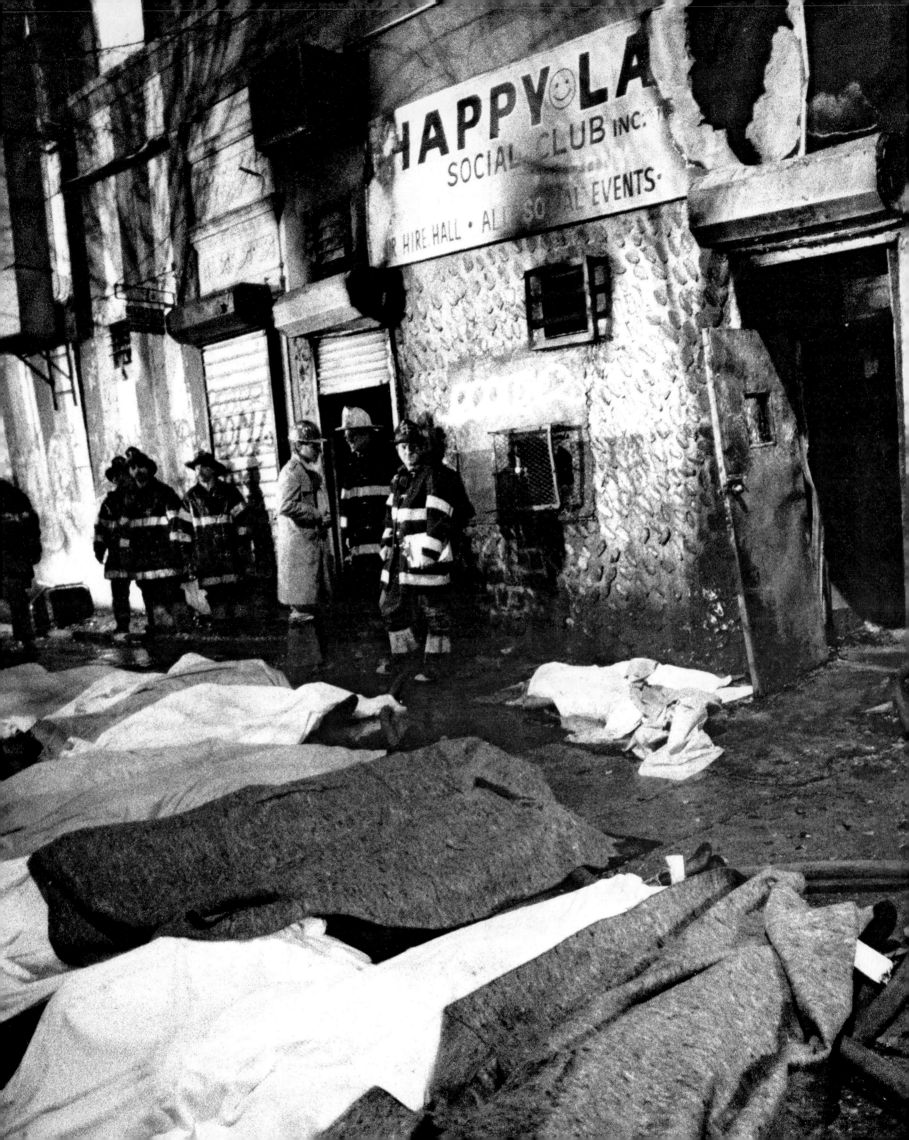

The fatalities in the Happy Land blaze were so numerous, victims had to be laid out in the street, in a particularly grisly display, to enable arson investigators to conduct their crime scene and arson probe.

THE HAPPY LAND SOCIAL CLUB FIRE

Year 1990

Cuban emigre Julio Gonzalez was twenty-six years old when he arrived in Florida on the Mariel boatlift in 1980. He eventually made his way to New York City and settled into an $80-a-week furnished room in University Heights. For several years his life revolved around a woman ten years older than he was named Lydia Feliciano. She worked as a coat-check girl at an unlicensed premise on Southern Boulevard in the Bronx called the Happy Land Social Club.

Although his landlord described him as well mannered, his girlfriend could not deal with his persistent mood swings. She finally left him in October 1989. Five months after that, he lost his job at a warehouse in Long Island City. With no friends to turn to for consolation, he became despondent and began to harbor delusions of getting Feliciano back.

He paid a visit to the Happy Land Social Club on March 29, 1990, hoping to reconcile with Feliciano. The crowd that

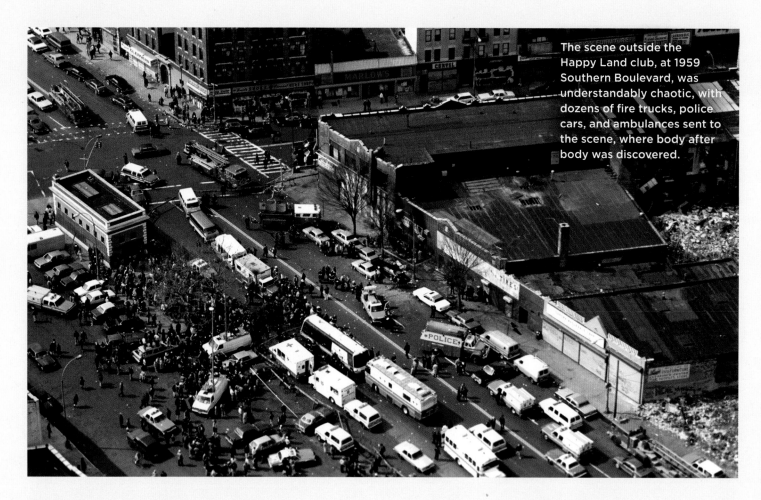

The scene outside the Happy Land club, at 1959 Southern Boulevard, was understandably chaotic, with dozens of fire trucks, police cars, and ambulances sent to the scene, where body after body was discovered.

The heat was so intense that it fused several bodies together.

night was comprised largely of Honduran immigrants who showed up for an evening of dancing, cheap cocktails, and, just maybe, a bit of romance.

After knocking back several drinks, Gonzalez worked up the nerve to approach Feliciano, but his drunken behavior caught the eye of a bouncer who ushered him out shortly after three A.M.

"I will be back!" the jilted swain shouted as he stormed off. According to Bronx District Attorney Robert Johnson, Gonzalez was consumed with revenge and planned to return to "put the club out of business" for good.

Gonzalez staggered in a drunken stupor to an Amoco station a few blocks away at 174th Street and Southern Boulevard. Despite his condition, he convinced Edward Porras, a twenty-three-year-old Lehman College freshman working his first overnight shift, to fill an empty antifreeze container with a dollar's worth of gasoline. Gonzalez returned to the social club forty minutes later and poured the fuel by the separate entrance and exits located at either end of

the two-story redbrick and stucco building. Then he put a match to the gasoline. The fire fueled by wind quickly penetrated the club floor like a giant serpent's tongue. Gonzalez watched the fiery spectacle from a safe distance for several minutes before driving off.

The blaze spread so quickly that most victims were dead by the time the first firemen gained access to the club interior. "Oh, my God, we're standing on bodies," screamed one firefighter.

The scene was horrific. In total eighty-seven people perished that night. Nineteen bodies were found on the first floor. Sixty-eight more were trapped above a narrow staircase leading to the second floor. One victim was clutching a fire extinguisher. Others had died beneath their seats at the bar, their feet entwined around bar stools. The heat was so intense that it fused several bodies together.

Firefighter Frank Curtin, a twenty-two-year Fire Department veteran and a former infantryman in Vietnam, said the scene was reminiscent of a firefight. "There were bodies on top of bodies," he said.

"Some looked like they were sleeping," added firefighter Richard Harden. "Some looked horrified. Some looked like they were in shock. There were some people holding hands. There were some people who looked like they were

trying to commiserate and hug each other. Some people had torn their clothes off in a panic to get out."

Tragically, records showed that the city bungled earlier attempts to close the club. The Buildings Department issued an order to vacate in November 1988, citing the premises as "an imminent danger to safety and life of the occupants" because it lacked a second exit, a fire alarm, and a sprinkler system, but no follow-up action was taken.

Eleven families lost more than one relative; one family lost six. Five of the dead were high school students who should not have even been there. To help families identify the dead, nearby Public School 67 was turned into a crisis center, where survivors surveyed photos to determine if they had been spared heartache or needed to plan one or more funerals.

Lydia Feliciano, the target of Gonzalez's wrath, somehow managed to escape. But when she showed up at P.S. 67 seeking information about a missing niece, her presence nearly caused a riot as grief-struck relatives of the dead demanded to know how she eluded death when their loved ones had not. Two officers had to escort her away. She was subsequently placed under around-the-clock protection by the NYPD.

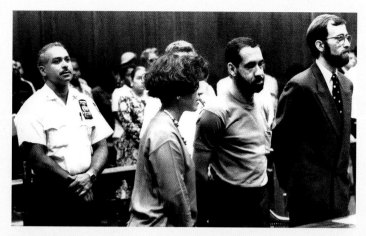

Julio Gonzalez (center) appearing in in a Bronx courtroom on July 25, 1990.

Gonzalez was arrested just hours after the fire was extinguished. His sneakers still reeked of gasoline. In a confession he stated, "I got angry. The devil got into me, and I set the place on fire."

Richard Berne, his defense attorney, argued that Gonzalez suffered brain injuries and was not guilty by reason of insanity. On August 19, 1991, after four days of deliberation, the jury found Gonzalez guilty of eighty-seven separate counts of arson and murder.

A month later, Bronx Supreme Court Justice Burton Roberts sentenced him to fifty years in prison for each victim, for a total of 4,350 years behind bars. But since all the deaths occurred as the result of a single criminal act, under state law Gonzalez became eligible for parole in March 2015. His bid for freedom was denied.

A $5 billion lawsuit against the club owners, the landlord, and the city filed on behalf of victims and their families was settled on July 6, 1995, for $16 million. Each plaintiff received approximately $171,000. Most of the funds came from the insurance carrier of Jay Weiss, the property leaseholder, who was at the time the husband of actress Kathleen Turner.

Until the destruction of the World Trade Center on September 11, 2001, the Happy Land fire was the largest mass homicide in New York City history, supplanting the Palm Sunday Massacre of 1984. (Ironically, the inferno occurred on the seventy-ninth anniversary of the infamous 1911 Triangle Shirtwaist Factory fire in Greenwich Village, which claimed 146 victims, but that had been deemed an accident, not arson.)

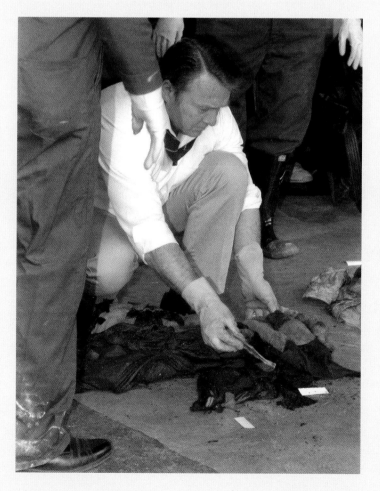

An NYPD detective can be seen sifting for clues at the Happy Land arson fire, in the Bronx, which erupted on March 25, 1990.

NEW YORK POST

FOUNDED IN 1801 BY ALEXANDER HAMILTON

METRO EDITION

TUESDAY, SEPTEMBER 4, 1990 / Sunny, mid 70s today; increasing clouds, low 60s tonight / Details, Page 2

40¢ in New York City 50¢ elsewhere

Tourist stabbed to death as mom & dad watch

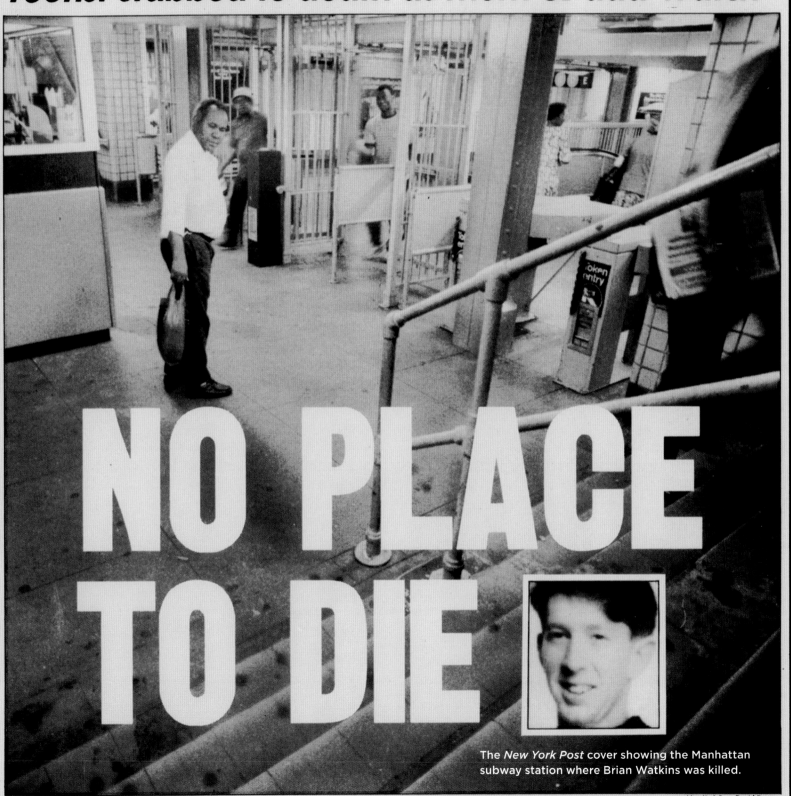

NO PLACE TO DIE

The *New York Post* cover showing the Manhattan subway station where Brian Watkins was killed.

New York Post: David Rentas

Brian Watkins, 22, (inset) died in his mother's arms in the subway station at 53rd Street and Seventh Ave. Pages 4 & 5.

THE SENSELESS MURDER OF A UTAH TOURIST

Year 1990

The September 2, 1990, slaying in New York City of Brian Watkins, a twenty-two-year-old tourist from Provo, Utah, helped define an era.

Watkins was stabbed to death inside a Midtown Manhattan subway station trying to protect his parents from a "wolf pack" of young muggers. The slaying became emblematic of a rudderless and out-of-control city, one where the rule of law seemed to be an anachronism, the police commissioner and the mayor were being seen ever more frequently as impotent figureheads, and as a frightening totem, one that had led a growing segment of the populace to wonder if they had any reasonable expectation of public safety whatsoever.

The slaying occurred in the most murderous year in New York City's history, when a staggering 2,245 homicides were tallied, an average of 6.15 daily. (In 2014 *another* homicide record was set in New York City—the *fewest ever* in a single calendar year, with 328 recorded, an average of .089 per day.)

Watkins, a high school tennis star, had come to the Big Apple with his family to attend the U.S. Open. After spending much of Sunday afternoon watching John McEnroe rally from two sets down to defeat Spain's Emilio Sanchez in five sets, the family went back to their hotel rooms at the Hilton on West Fifty-Third Street to change. They then headed out for a late-night bite at a Greenwich Village Moroccan restaurant that a hotel employee had recommended.

It was 10:20 P.M. Watkins had gone to purchase some subway tokens for himself and other family members. At the same time, some forty to fifty young men and women who had traveled by subway from Queens were heading to Roseland, a popular dance club located at 239 West Fifty-Second Street. Several were members of a loose-knit street gang known as FTS, an abbreviation for "Fuck That Shit." Most were Hispanic, and witnesses described them as rowdy.

A smaller group of at least six, although possibly more, had a problem that demanded a quick solution: They didn't have enough money to pay the fifteen-dollar cover charge to the club. It was a time-sensitive quandary, as the cover charge was due to soar to twenty-five dollars by 11:30 P.M. Those in this penurious group devised a quick plan to sneak back into the subway and find a victim to mug so they could rejoin their friends who had already gained admission to Roseland.

The Watkinses knew nothing of these machinations as the family obliviously descended onto the downtown platform. As the family stood awaiting a downtown E train, a group of FTS gangbangers formed a semicircle around them and demanded money. Brian's father, Sherwin Watkins, was knocked to the ground and slashed with a box cutter, opening a pants pocket and slicing the top rear of his leg.

Sherwin's wife, Karen, tried to intervene, but the gang knocked her to the ground and kicked her in the face.

As Brian and his older brother, Todd, moved to protect their parents, Brian was stabbed in the chest with a four-inch blade wielded by Yull Gary Morales, aka "Rockstar."

The box-cutter attack on the elder Watkins's pocket freed up $200 in bills and some credit cards that fell to the

platform. One of the gangsters scooped up the cash and yelled out, "We got it!"

Brian Watkins heroically ran up two flights of stairs in pursuit of his assailants, only to collapse near a token booth, the result of a severed pulmonary artery. He died in an ambulance on his way to St. Vincent's Hospital at 10:43 P.M. His father received stitches for the slash to his leg. His mother was treated for injuries to her mouth.

The crime was shocking, even in a city where residents were inured to random bloodshed. The crime, the eighteenth murder in the subway that year, had occurred in the middle of a decade-long crack epidemic, when murderous

> **The crime, the eighteenth murder in the subway that year, had occurred in the middle of a decade-long crack epidemic.**

drug gangs had transformed the five boroughs into Dodge City. By the end of July, there had already been fourteen innocent bystanders killed in New York City for the year. Four of them were under the age of sixteen. The phenomenon showed no sign of abating, as six children had been shot and killed by stray bullets in the eight-week period of July

22 through September 23, 1990, according to police data.

Frightened mothers in city housing projects had adopted a surreal strategy to keep their kids safe: they made their young ones sleep in apartment bathtubs, rather than their bedrooms, a stratagem designed to thwart the trajectory of errant bullets careening through apartment windows with alarming regularity.

Fueling the palpable sense of apprehension was a growing suspicion that those at the helm did not seem to have the requisite mettle to set things right.

Police Commissioner Lee Brown, who had been appointed that January, was an academic, a man whose penchant for traveling to conferences outside of Houston when he was the top cop there had earned him the moniker "Out of Town Brown." His absences from his new job, at One Police Plaza, seemed likely to ensure that the derisive sobriquet would follow him. Even more troublingly, his boss who handpicked him, Mayor David Dinkins, had a genteel and courtly bearing but a disengaged managerial style that did little to inspire confidence during times of crisis.

The slaying seemed to suggest a new Rubicon had been crossed, that Watkins's murder represented a nadir in urban lawlessness—a sentiment the *New York Post* was quick to seize upon. On a seminal front page, the paper pleaded

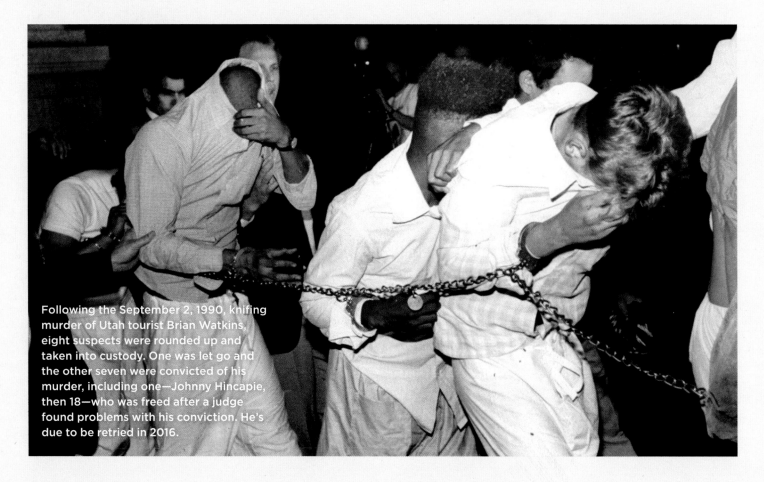

Following the September 2, 1990, knifing murder of Utah tourist Brian Watkins, eight suspects were rounded up and taken into custody. One was let go and the other seven were convicted of his murder, including one—Johnny Hincapie, then 18—who was freed after a judge found problems with his conviction. He's due to be retried in 2016.

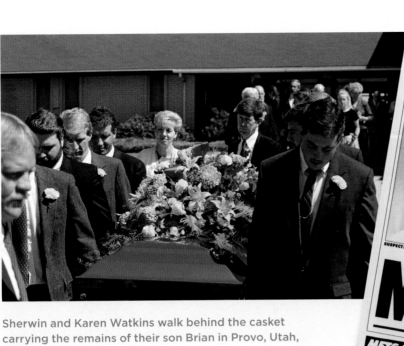

Sherwin and Karen Watkins walk behind the casket carrying the remains of their son Brian in Provo, Utah, September 8, 1990.

with Dinkins to rouse himself from his torpor by printing a subheadline stating CRIME-RAVAGED CITY CRIES OUT FOR HELP. Beneath were three plaintive words in giant red type:

DAVE,

DO

SOMETHING!

The *Post*'s indignation captured the larger zeitgeist. *Time* magazine ran a cover story that month titled "The Rotting of the Big Apple." Syndicated *Chicago Tribune* columnist Bob Greene wrote a jeremiad FOR NEW YORK THE END IS HERE, painting the slaying in near-apocalyptic terms and intimating that it was the capstone to a precipitous slide of a once-great metropolis.

A small army of cops and detectives were dispatched to find those responsible for murdering Watkins—and within twenty-four hours, eight suspects, most plucked out of Roseland, were charged with crimes. Seven of the eight suspects provided incriminating videotaped statements, admitting various levels of culpability. All were tried, convicted of murder, and sentenced to twenty-five years to life. (The eighth suspect, Luis Montero, was indicted and jailed for eighteen months before the Manhattan District Attorney's office opted to drop the charges.)

The case roused Dinkins from his apparent lethargy, as he became instrumental in getting the New York legislature to support a tax hike to fund the Safe City, Safe Streets Program, under which an estimated six thousand more cops were hired, a development that sparked an unprecedented twenty-five-year plunge in major crime in New York City.

Two men who later became mayor of New York City—Rudolph Giuliani and his successor, Michael Bloomberg—would each claim responsibility for quarterbacking New York's renaissance as "the safest big city in America"—but their well-documented achievements were made possible only by what Mayor David Dinkins set in motion.

The Watkins family sued the city for $100 million, claiming that Watkins was the victim of a "wrongful death" because the Transit Authority "failed to provide a competent, adequate and safe place for the general riding public" and for transporting Watkins to St. Vincent's Hospital forty blocks away, rather than one just ten blocks from the stabbing scene. In September 1998, the family reluctantly settled the case for $300,000.

On October 6, 2015, Manhattan Supreme Court Justice Eduardo Pedro tossed out the murder conviction against one of the eight convicted, Johnny Hincapie, after an evidentiary hearing in which three witnesses claimed Hincapie had not been on the subway platform when Watkins was slain. Hincapie testified he was beaten by cops who forced him to give a false confession. As of April 2016, Manhattan District Attorney Cyrus Vance Jr. was awaiting a legal appeal of the judicial decision that ordered a new trial for Hincapie that resulted in him being set free. The DA plans to retry Hincapie for his role in Brian Watkins's murder if necessary.

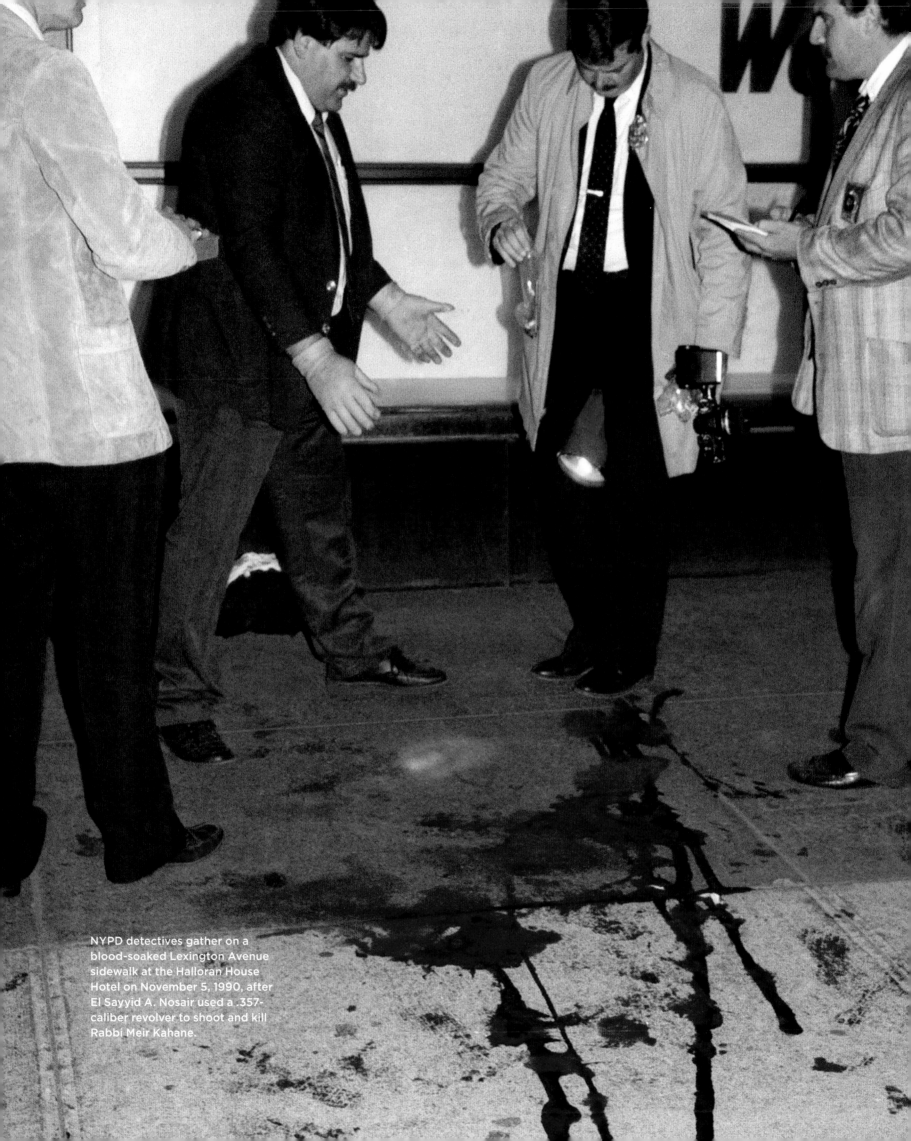

NYPD detectives gather on a blood-soaked Lexington Avenue sidewalk at the Halloran House Hotel on November 5, 1990, after El Sayyid A. Nosair used a .357-caliber revolver to shoot and kill Rabbi Meir Kahane.

THE KILLING OF RABBI MEIR KAHANE

Year 1990

Meir Kahane, fifty-eight, the Brooklyn-born Orthodox Jewish rabbi and ultra-Zionist who had long advocated the use of violence to fight anti-Semitism, had just finished a fiery speech on the evening of November 5, 1990, inside a second-floor ballroom of the New York Marriott East Side Hotel on Lexington Avenue. The lion's share of people in the audience who had come to hear him speak about his Zionists Emergency Evacuation Rescue Operation were young Orthodox Jewish males.

Rabbi Kahane, raised in Flatbush, Brooklyn, was the son of a rabbi himself, Charles Kahane. As a boy Kahane was known as Martin, a bookish, sensitive, and sentimental sort. That all changed when he began high school. By the time he was fifteen years old he had been arrested for his extremist Zionist activities.

By the late 1950s, he had earned a law degree, although he never passed the New York bar exam. For a while he led a congregation in Howard Beach, Queens, but his overly strict adherence to Orthodox theology led to his being let go.

In 1968, he seemed to have found his calling. He formed the militant Jewish Defense League (JDL) to protest the mistreatment of Jews in the Soviet Union and raise Jewish identity at home. The group's motto, "Never Again," became a rallying cry for those who would otherwise forget the lessons of the Holocaust. Its logo was a clenched fist inside a Jewish star. Kahane, however, soon adopted an even more pugnacious slogan, "Every Jew a .22," an exhortation for his followers to carry .22-caliber rifles.

There were dark and seemingly hypocritical sides to his personality as well. Long before he founded the JDL, he

The fiery and charismatic Meir Kahane

NYPD detectives gather on a blood-soaked Lexington Avenue sidewalk at the Halloran House Hotel on November 5, 1990, after El Sayyid A. Nosair used a .357-caliber revolver to shoot and kill Rabbi Meir Kahane.

took on an alter ego, "Michael King," and began telling people he was a Presbyterian. He was a serial adulterer, an FBI informant, and, most incongruously, like the notorious Jewish gangsters of the 1930s who had formed profitable alliances with Mafiosi, Kahane had formed a mutually beneficial relationship with his own notorious mob boss, Joseph Colombo Sr. He also became involved in a love affair with a part-time model who was twelve years his junior, Estelle Donna Evans, whose real name was Gloria Jean D'Argenio. When he proposed to her, he failed to mention that he was a married rabbi with four kids of his own. After he broke the news to her on the eve of their scheduled nuptials, she became so despondent that she leaped to her death from the Queensboro Bridge.

El Sayyid Nosair in an undated file photo.

In spite of such deep character flaws he was a gifted orator with a devoted following. His rabble-rousing antics very much worried both the NYPD and the FBI. His ardent supporters would routinely confront those they perceived as their enemies—neo-Nazis, Arabs, Soviet apparatchiks, and even Jewish moderates living in New York City.

On July 23, 1971, he received a five-year suspended sentence for his role in a bomb plot. Soon afterward he moved to Israel, where he formed the anti-Arab Kach Party. After several failed attempts to gain office, he was elected to the Israeli Knesset in 1984 before his party was banned in 1988. Nevertheless, he returned to America to warn Jews to move to Israel before it was too late, implying they were no longer safe in this country.

After he spoke that night, a man in the crowd wearing a yarmulke stepped forward. He was an Egyptian-born emigre named El Sayyid Nosair, age thirty-four, an engineer by trade who worked as a $30,000-a-year air conditioner repairman in the Manhattan Criminal Court building. The yarmulke was a ruse. Nosair was a fanatical Muslim. He pulled out a .357 magnum revolver and, without uttering a word, fired two shots at Kahane from point-blank range.

> **Without uttering a word, Nosair fired two shots at Kahane from point-blank range.**

Nosair started to flee, but an elderly bystander, Irving Franklin, attempted to stop him. Nosair shot him in the right thigh and then ran from the hotel lobby to Lexington Avenue, where he tried to commandeer a taxi in front of a post office at gunpoint.

On-duty United States Postal Service Police officer Carlos Acosta saw what was happening and drew his gun. He ordered Nosair to freeze, but Nosair turned toward him and fired, hitting the cop in the left side of his chest. Fortunately, Acosta was wearing a bulletproof vest. He returned fire and struck Nosair in the chin.

All of the wounded were taken to Bellevue Hospital. Kahane was declared dead at 10:57 P.M., the result of a fatal gunshot wound to the left side of his neck. Acosta recovered. Surprisingly, Nosair survived his injury. Detective Gordon Haight, one of the Seventeenth Precinct cops assigned to the case, said, "It was the kind of wound that good guys usually die from."

Kahane had long been a lightning rod for controversy and was known to have had many enemies. NYPD detectives and local law enforcement officials in New Jersey carted away a trove of evidence from Nosair's Jersey City home. Although they were later proved wrong after the 1993 World Trade Center bombing, authorities were quick to insist that there was nothing found to suggest that the plot to kill Kahane involved terrorism.

At his murder trial, Nosair's lawyer, William Kunstler, despite overwhelming evidence to the contrary, argued that his client was innocent not only of killing Kahane, but also of wounding the other two men.

The slain rabbi, Kunstler insisted, died due to a "terrible dispute" with some of his followers over "missing funds," and the internecine battle that followed had nothing to do with his client.

Surprisingly, in a December 1991 verdict, the jury acquitted Nosair of murder, but found him guilty of gun possession, assault, and coercion. On January 29, 1992, he was sentenced to a maximum term of seven and a third to twenty-two years in prison by Manhattan Supreme Court Justice Alvin Schlesinger, who sharply criticized the jury's findings, insisting it "was devoid of common sense and logic."

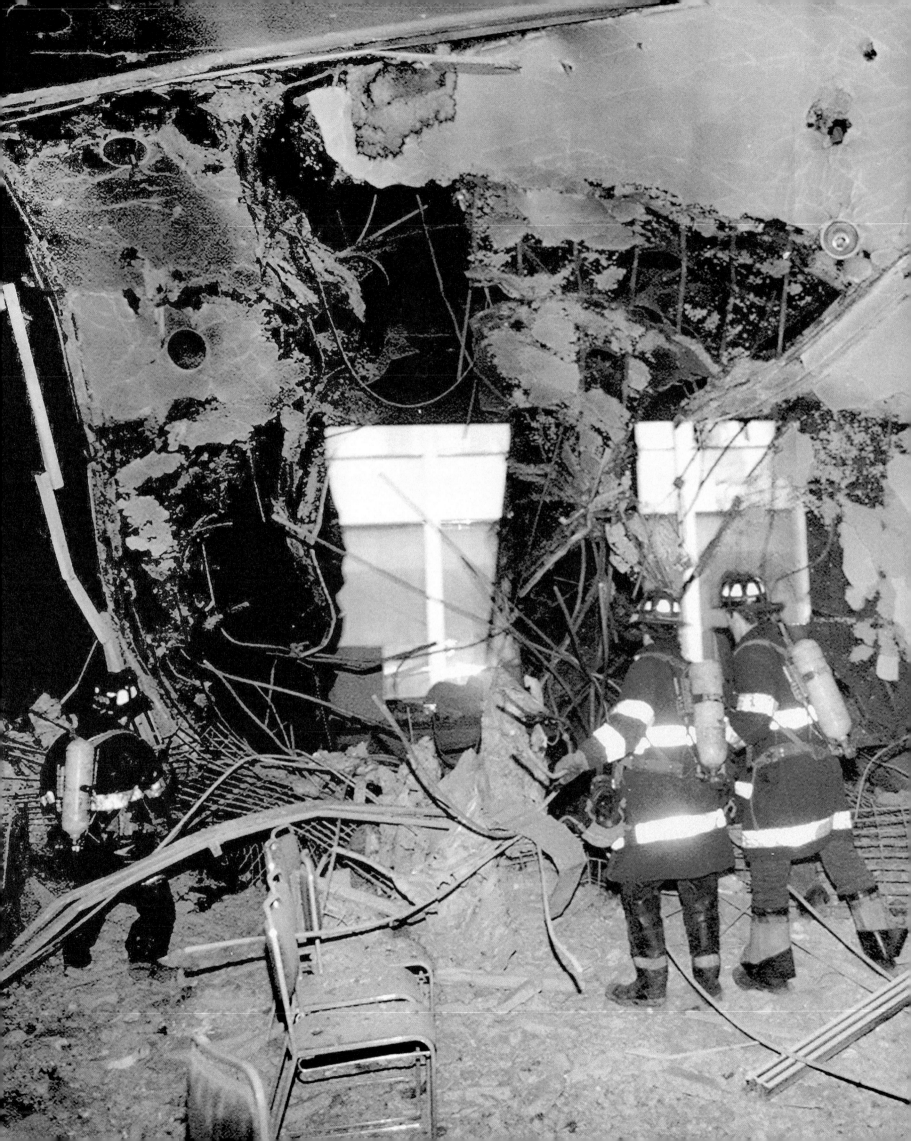

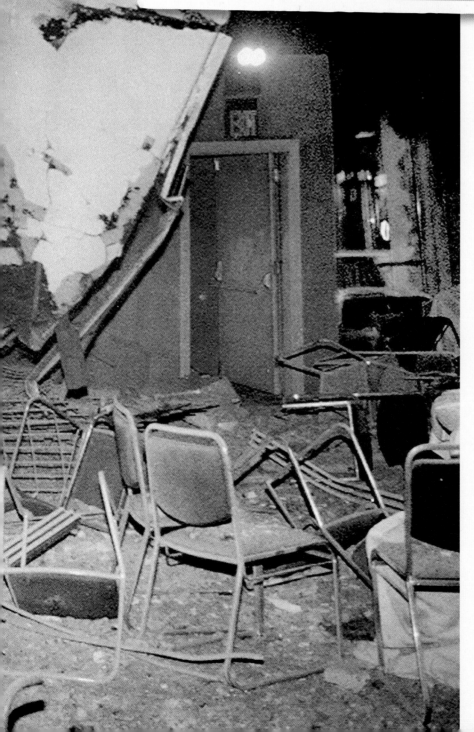

FIRST ATTACK ON THE WORLD TRADE CENTER

Year **1993**

On Friday, February 26, 1993, at exactly 12:18 P.M., a powerful blast erupted from the bowels of the North Tower, Building No. 2 of the World Trade Center in Lower Manhattan. Initially it was thought that a transformer in the basement blew up. Thick, black, acrid smoke billowed from the lower portion of the 110-story skyscraper, forcing the evacuation of an estimated fifty thousand people from the building and its twin counterpart. The explosion created a gaping underground hole at the base of the North Tower and caused the ceiling of the subterranean PATH train station to collapse onto the tracks.

Police Commissioner Raymond Kelly arrived at the scene within minutes and immediately took charge of the situation. Although it was not made public, by evening it was evident that the explosion had nothing to do with a transformer. The truth was much more ominous. In the days that followed, authorities confirmed that it was a terrorist attack. A bomb had been deliberately set off, presumably to topple the tower. It injured 1,042 people. Remarkably, despite all of the damage it caused, there were only six fatalities, but one victim was eight months pregnant.

A joint task force that included members of the NYPD, the FBI, and the Bureau of Alcohol, Tobacco and Firearms was assembled from around the country to apprehend

The underground garage within the World Trade Center, where the explosive-laden truck showed extensive damage after detonation.

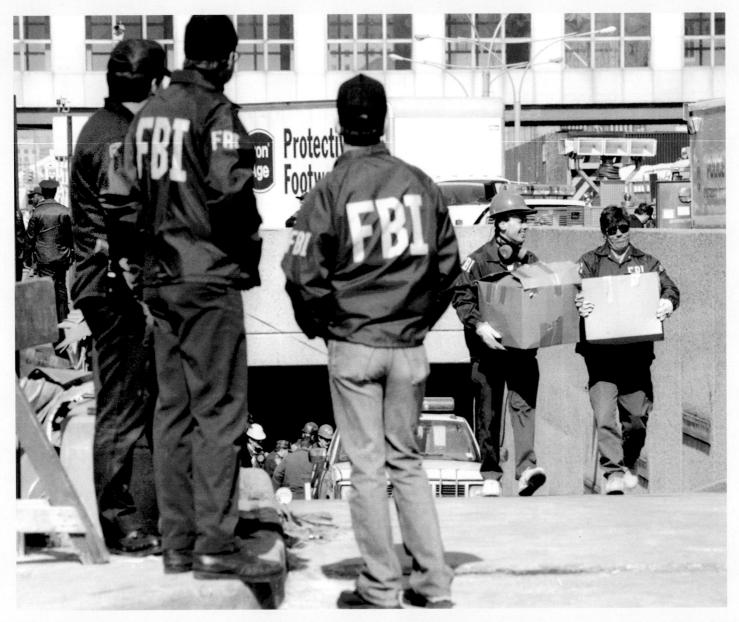

The FBI—and the NYPD—descended upon West Street in the aftermath of the February 26, 1993, bombing inside a garage of the North Tower, which killed six victims and injured more than 1,000 others. The break in the case emerged when the NYPD was able to trace the vehicle identification number of a Ford Econoline van to a Ryder truck rental location in New Jersey that led investigators to the conspirators.

those responsible for the deaths and destruction. It took almost two days for everyone to arrive on the scene.

Late Sunday afternoon, Detective Donald Sadowy of the NYPD Bomb Squad led a team of federal agents into the sixty-foot-deep pit for their first look. While they were taking it all in, Sadowy noticed that most cars on the B2 level were crushed, but there were gears to an automobile differential standing alone that appeared to him to have been blown out of the rear axle of a vehicle. Nearby he spotted a piece of a twisted, charred metal that he recognized as part of an automotive undercarriage. He told an ATF agent that it belonged to the vehicle that had been at the epicenter of the explosion. Sadowy had also graduated

from Brooklyn Automotive High School, so he knew the frame contained a confidential identification number.

But he had been warned by the FBI leader not to disturb evidence. He was also concerned that if word got out that the authorities had traced the source of the explosion to a specific vehicle, the people responsible would go into hiding. He arranged to place the auto parts into a body bag and have them carried out on a Stokes stretcher so it looked to reporters like the police had found human remains. The FBI boss, however, was not happy with Sadowy's actions and made it known.

Fortunately, examination of the frame by the NYPD Police Lab revealed the confidential vehicle identification

The van contained 1,200 pounds of urea nitrate (a compound formed from the chemical reaction of urea with nitric acid), four bottles of nitroglycerine, and three pressurized tanks of hydrogen.

number: LHA75633. By entering the VIN into a comprehensive national motor vehicle database, the task force was able to determine the make and model of the vehicle: a 1990 Ford Econoline van owned by the Ryder Truck Rental Company, registered in Alabama and leased across the Hudson River in Jersey City.

According to experts who analyzed debris recovered at the scene and the damage, the van contained 1,200 pounds of urea nitrate (a compound formed from the chemical reaction of urea with nitric acid), four bottles of nitroglycerine, and three pressurized tanks of hydrogen. The device was detonated by blasting caps attached to the nitroglycerine bottles. The caps themselves were linked to twenty-foot fuses encased in surgical tubing that took twelve minutes to burn after being lit.

The driver of the van was the same person who rented it, twenty-six-year-old Mohammed Salameh, a Palestinian who entered the country legally in 1988 but overstayed his six-month visa. He admitted that he and two other men drove the Ford van into the six-floor public garage underneath the World Trade Center and parked it on level B2. After a few moments, they exited the van and got into a waiting getaway car driven by a fourth accomplice. Twelve minutes later the bomb went off.

Later that afternoon, he returned to the Jersey City Ryder rental facility seeking a refund of his $400 cash security deposit by claiming the vehicle had been stolen. The counter agent was not aware of Salemeh's role in the bombing but told him that he needed come back with a police report to get his deposit. When Salemeh returned on Thursday, March 4, FBI Agent Bill Atkinson, posing as a Ryder employee, was waiting for him. After verifying Salameh's identity, Atkinson handed him half of his original deposit. As soon as Salameh took the money, FBI agents placed him under arrest. Salameh told them that he was in dire need of cash to buy a one-way plane ticket out of the country. Two of his cohorts had already escaped the night of the bombing on separate flights.

One was Eyad Ismail, age twenty-two, a Jordanian citizen born in Kuwait, who arrived in the United States in 1989 on a student visa. He had loaded the explosives into the van.

The other, Ramzi Yousef, was a twenty-four-year-old Pakistani, educated in Britain. He had a degree in electrical engineering and had supervised the construction of the bomb. Yousef, investigators would discover, was a peripatetic traveler involved in a dizzying array of terrorist bombing plots all over the globe. He was also the nephew

FAR LEFT: This undated photo shows Eyad Ismail, 26, one of the conspirators in the 1993 WTC bombing plot. LEFT: Mohammed Salameh

of the al-Qaeda terrorist mastermind Khalid Sheikh Mohammed, the hirsute man in the white T-shirt who would later be charged with plotting the 9/11 terror attacks.

Search warrants were obtained and executed throughout the metropolitan area, particularly in Brooklyn and New Jersey, based on information gleaned from Salameh. Among those arrested was forty-two-year-old Ibrahim A. Elgabrowny, an Egyptian-born contractor and a cousin of El Sayyid Nosair, the man accused of assassinating Rabbi Meir Kahane in November 1990.

In addition to Salameh, three other men were arrested for their roles in the bombing plot: Ahmad M. Ajaj, twenty-six, a Palestinian national who had spent time in the United Arab Emirates and was an alum of the Osama bin Laden–funded Khladen terrorist training center, near Peshawar, Pakistan; Nidal A. Ayyad, a Kuwait-born chemical engineer; and Mahmud Abouhalima, thirty-four, a former New York City cab driver known as "Mahmud the Red," for his red hair. Abouhalima was arrested in Egypt on March 24, 1993, and turned over to American authorities.

Several of the plotters were devotees of Omar Abdel-Rahman, the so-called Blind Sheik, a Muslim firebrand whose fervent anti-Western rhetoric was winning hearts and minds of jihadists around the world.

On June 24, 1993, just four months after the WTC bombing, Abdel-Rahman and nine co-conspirators were arrested in connection with the so-called day of terror. They had made plans to blow up the United Nations headquarters, the Lincoln and Holland Tunnels, the George Washington Bridge, and 26 Federal Plaza, a government building that housed the FBI. (Abdel-Rahman was convicted of seditious conspiracy, and sentenced to life in Butner, North Carolina.)

On March 4, 1994, the four primary suspects implicated in the WTC conspiracy—Salameh, Ayyad, Abouhalima, and Ajaj—were convicted by a Manhattan Federal Court jury after a five-month trial. All are now serving life terms.

A fifth conspirator, Abdul Rahman Yasin, thirty-three, was an American citizen born in Bloomington, Indiana, and raised in Iraq. He was picked up by the FBI in the immediate aftermath of the bombing and released after questioning. He fled the country before investigators learned that he was intimately involved in the plot. He resurfaced in Iraq in 2002, but disappeared soon afterward. Nevertheless, he was indicted. The United States posted a $25 million reward for his capture, but he remains a fugitive, his whereabouts unknown.

In February 1995, Ramzi Yousef was arrested at a hotel in Islamabad, Pakistan. Eyad Ismail was caught in August 1995 by Jordanian authorities. Both were extradited to the United States and were convicted on November 12, 1997. Each is serving life.

For his pivotal role in helping to solve the crime, Sadowy received a promotion to detective second grade at a private ceremony along with his partners in the Bomb Squad. He also received an apology from the FBI.

Although the bomb did not function exactly as intended—that is, to weaken the foundation enough to cause the skyscraper to topple into the adjacent South Tower of the World Trade Center and cause *that* structure to fall down, too—it was far from the abject failure some claimed it to be. It shut the World Trade Center down for a month and cost over $500 million to repair the damage. Moreover, the legacy of the 1993 WTC bombing plot is likely this: The conspirators failed to accomplish what they hoped, but their fellow jihadists learned an invaluable lesson, one that led directly to the complete destruction of the Twin Towers on September 11, 2001.

After the February 26, 1993, bombing of the World Trade Center, it became clear that Nosair was not a lone gunman who killed Rabbi Meir Kahane at all and that local and federal officials had missed important clues. The first tip-off came when Nosair's cousin, Ibrahim A. Elgabrowny, was arrested in the days following the explosion. Federal agents found forged Nicara-guan passports for Nosair and his family in Elgabrowny's home, documents that fueled suspicions that his friends were plotting to bust Nosair out of Attica prison.

THE BLIND SHEIK

The NYPD immediately ordered a reexamination of the Kahane case, and it soon became obvious that more than forty boxes of evidence originally seized at Nosair's residence had never been fully vetted. A more thorough analysis showed Nosair had been in possession of classified U.S. military-training manuals and hit lists, with the names of targeted judges and prosecutors on it. The material had originally been turned over to the Manhattan DA's office and then funneled to the FBI for analysis, but since much of it was in Arabic,

nobody in the Bureau bothered to translate it after Nosair was convicted.

The renewed investigatory vigor paid off on October 1, 1995, when a Manhattan Federal Court jury found Omar Abdel-Rahman, the Blind Sheik, guilty of directing a conspiracy to wage a war of urban terrorism against America and plotting to kill Egyptian president Hosni Mubarak.

Rahman, a fiery Egyptian cleric, had preached at a mosque in Brooklyn and another in Jersey City where Nosair prayed. He, Nosair, and the other eight defendants were found guilty of seditious conspiracy, a criminal plot to violently overthrow the United States government.

Although Nosair had already escaped conviction on state charges for killing Kahane, under an exception to the double jeopardy rule, he was subsequently tried and convicted in federal court of murdering Rabbi Kahane as part of a racketeering conspiracy.

Rahman is currently serving his life sentence at the Butner Federal Medical Center in North Carolina. Nosair is serving a life sentence at the United States Penitentiary in Terre Haute, Indiana.

Eleanor Hill, director of the Senate Intelligence Committee, investigated pre–September 11, 2001 intelligence failures. Her report revealed that none other than Osama bin Laden himself had footed Nosair's legal bills during his first trial, more evidence that Nosair was part of a vast underground network of people who intended to do America harm.

Omar Abdel-Rahman smiles inside an iron cage at the opening of a court session on August 6, 1989 in Cairo.

A Compstat report showing a drop in crime statistics

JACK MAPLE AND COMPSTAT

CompStat, the NYPD's vaunted computerized analysis system credited with helping reduce crime to record lows, started off as the brainchild of Jack Maple, a New York City Transit cop who came over to the NYPD when his former boss in the Transit Police Department, Chief Bill Bratton, was appointed police commissioner by Mayor Rudy Guiliani in January 1994. As a brash young lieutenant, Maple had created a unique pin map system for charting crime in the New York City subway system. It caught Bratton's attention when he took over the Transit Police in the early 1990s. Maple called his system "Charts of the Future." Bratton credited it with reducing violent subway crime during his tenure by 27 percent.

Pin maps were certainly nothing new in the NYPD. The first policeman who thought to use them was Fourth Deputy Commissioner Arthur Woods in 1908 when he oversaw the Detective Bureau. He stuck different colored thumbtacks in precinct maps to track and categorize burglaries. In the years that followed, nearly every police commander had some form of crime tracking system in place, but for the most part they did not communicate with their counterparts in other precincts. Other than having the information, little was being done with it.

CompStat changed all of that. Police Commissioner Bratton, as part of his efforts to reengineer the NYPD, acquired funding for a new computer system and promoted Maple to deputy commissioner in charge of crime reduction strategies. As new crimes were logged into the citywide reporting system at the precinct level, the information was forwarded instantaneously to the new CompStat Unit at Police Headquarters, where it was collated and analyzed. Each week commanders were brought into the eighth-floor conference room at Headquarters to be grilled about crime conditions in their precincts. Information in the forms of graphs, charts, and even pictures of drug addicts loitering on corners was projected onto a large overhead screen for all to see.

Maple was one of the trio of inquisitors, along with the chief of department, and the police commissioner. In one instance, as a precinct commander was fumbling for answers, Maple projected a cartoon of Pinocchio on the giant screen with his nose growing. Word spread around the department like wildfire. Most commanders were not amused, but Maple made his point—be prepared or suffer the consequences.

Good or bad, commanders were expected to have answers. If it was good news, they had to explain how they were achieving their crime reductions. If it was bad news, they had to explain how they were going to reduce crime. Successful commanders proffered advice to their colleagues and were promoted. Unsuccessful commanders were forced out. Under CompStat, the department focused police resources on particular problems in order to achieve a positive outcome. As a result, across the five boroughs police commanders experienced more success than failure.

In the two years Maple was in charge, serious crime in New York City dropped an unheard-of 33 percent, while homicides were reduced by nearly 50 percent. Maple left the post shortly after Bratton resigned in April 1994, and he became a police consultant. He passed away from colon cancer in 2001. He was only forty-eight years old. Bratton, however, never forgot Maple's contributions, and when he returned as police commissioner in 2014, he renamed the refurbished CompStat Center after him.

A HEIST AT TIFFANY'S

Year 1994

Police in front of Tiffany's
in New York City.

> *What I found does the most good*
> *is just to get into a taxi and go to Tiffany's.*
> *It calms me down right away, the quietness*
> *and the proud look of it; nothing very bad*
> *could happen to you there, not with those kind men*
> *in their nice suits, and that lovely smell*
> *of silver and alligator wallets.*

—HOLLY GOLIGHTLY, IN TRUMAN CAPOTE'S 1958 NOVELLA *BREAKFAST AT TIFFANY'S*

Despite Holly Golightly's charming notion that Tiffany's was an eternal beacon of tranquility, something decidedly unpleasant was taking place inside the renowned Fifth Avenue emporium on Sunday night, September 4, 1994—it was being robbed by a pair of gun-toting thieves.

The company was founded in 1837 by Charles L. Tiffany and John B. Young as a "stationery and fancy goods store." It had several physical iterations over its storied history before landing in the hallowed Art Deco building at 727 Fifth Avenue. The store, now focused on jewelry, had a reputation for impregnability, even though there had been nine previous criminal incidents involving scam artists, shoplifters, and larcenous schemers of various description who victimized the firm at one time or another with varying degrees of success. This robbery, however, was the worst one by far. Over the course of one hour, 420 separate pieces of jewelry worth approximately $1.9 million were stolen from the premises.

The crime unfolded at approximately 11:40 P.M. Sunday as the first of two Tiffany security guards on a midnight-to-eight-A.M. shift reported to work to relieve the evening shift.

The incoming guard was accosted by an armed man a short distance from the employee entrance on Fifty-Seventh Street. Moments later, a second, slightly older and taller perpetrator joined the gunman. The pair escorted the guard to the steel entrance door, which, for added security, was outfitted with a viewport, two intercoms, and a buzzer. Only authorized employees were supposed to be let in. But the guard was coerced at gunpoint to convince the guards inside that his two cousins needed to use the bathroom. Once the perpetrators were in, they used duct tape to tie

In *Breakfast at Tiffany's*, Audrey Hepburn plays Holly Golightly, who extols the calming influence of the world-famous jewelry emporium, noting how "... nothing very bad could happen to you there." The suspects caught in a real-life heist there might disagree.

up all of the guards, including the hapless fourth guard who had arrived for work completely unaware that a robbery was under way.

Next the bandits disabled the alarms and retrieved the key to a main retail salesroom. As one robber kept watch over the four guards, his confederate rifled through the display cases, stealing only the most valuable pieces of jewelry, those studded with diamonds, rubies, and other precious stones.

Once he was done, he returned and in a menacing tone asked the four guards, "Who's going to take me upstairs?"

The thief wanted to access the second-floor security office, where the video recording equipment was kept. When none of the guards volunteered, he flashed the pistol and threatened, "Don't let me ask again."

At that point, the guard who had originally been approached on the street agreed to take the perpetrator upstairs to retrieve the security tapes. Before they fled, the robbers warned the four security guards: "We know who you are and where you live, so if you say anything to the police we're going to get you."

The panache exhibited by the thieves was recounted the next day in a *New York Times* article that cited the "trickery, threats, precision timing and a dash of bravado" employed by the talented duo who were able to pull off such a brazen crime without firing a single shot.

Even the NYPD detective supervisor in charge of the investigation, Captain Salvatore Blando, had to admit, "It was a very, very professional job."

> **Over the course of one hour, 420 separate pieces of jewelry worth approximately $1.9 million were stolen from the premises.**

But Blando already had ideas about who was responsible and arranged for Mark Bascom, the guard who claimed that he was accosted at gunpoint, to be tailed around the clock. Within a week detectives had six men in custody, including Tiffany's security supervisor, Scott Jackson, the alleged mastermind behind the heist (he called in sick the night of the robbery), and his inside man, Mark Bascom. Scott Jackson recruited two cousins to pull off the actual robbery—Derrick Jackson and Mark Klass. Two other cohorts, Theodore Johnson and Charles Gillyard, were charged with criminal possession of stolen property.

The thieves, it turned out, were not the master criminals the *New York Times* had envisioned. They hatched the plan almost on a whim at a family picnic three weeks earlier, but overlooked the most important detail—how to dispose of the hot goods. Shortly after the robbery, cops began receiving tips that Johnson and Gillyard were trying to peddle expensive jewelry on the streets of Harlem for a fraction of its true value.

Police tracked Johnson to a building at 234 West 132nd Street, where he lived with Gillyard and Derrick Jackson. Cops set up a stakeout and nabbed Gillyard first, at 3:30

A.M. He was in possession of a stolen Tiffany ring and a bracelet. Johnson had three Tiffany rings on him when he was picked up at seven A.M. Derrick Jackson was arrested an hour after that. A search of their apartment turned up a roll of duct tape linked to the crime and a .25 automatic, as well as two more Tiffany bracelets and a security guard uniform similar to the type worn by Tiffany employees.

Detectives subsequently implicated Scott Jackson in an earlier robbery of a Tiffany merchandising coordinator. In July 1992, Hillary Miller was robbed in an elevator while carrying $750,000 worth of jewelry that was to be photographed for the Tiffany catalogue.

On April 19, 1995, a Manhattan Supreme Court jury surprisingly acquitted Jackson of orchestrating the Tiffany heist, despite sworn testimony against him provided by his accomplices. He was, however, convicted of second-degree robbery for his role in setting up the Miller stick-up three years earlier.

As Justice Edwin Torres sentenced him to a maximum of fifteen years in jail, he said, "Consider yourself quite fortunate." Had Jackson been found guilty of the Tiffany's robbery, Torres was prepared to sentence him up to forty years in prison.

Some of the pricey baubles sold in Tiffany's.

REWARD
$11,000

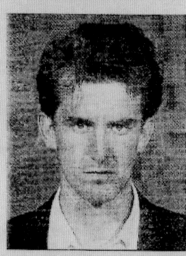

Mayor Giuliani has implemented local law 48 of 1993 and a reward of $10,000 has been posted for information leading to the whereabouts of Mrs. Irene Silverman, and the conviction of those responsible for her disappearance.

Anyone having information regarding the above vehicle (1997 dark blue/green Lincoln) or persons in the vicinity of 20 East 65th Street on or about July 4 through July 5, 1998, please contact Manhattan Detectives at (212) 694-3018. If you wish to remain anonymous, please call 1-800-577-TIPS for a reward up to $1,000.

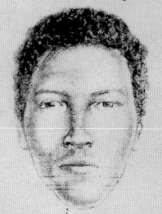

The person in the sketch to the left is wanted for QUESTIONING. If you can provide information, please call the above numbers.

"THE DEADLY GRIFTERS"

Year 1998

On June 14, 1998, a handsome and well-dressed man in his early twenties rang the doorbell to 20 East Sixty-Fifth Street, a six-story town house off Fifth Avenue on Manhattan's tony Upper East Side, seeking an apartment. He said his name was Manny Guerrin. The residential property, worth an estimated $8 million, belonged to Irene Silverman, age eighty-two, a vivacious and eccentric former ballet dancer, born Irene Zambelli in New Orleans to modest circumstances.

In her youth Silverman had studied under famed Russian ballet instructor Michel Fokine prior to joining the Radio City Music Hall's Corps de Ballet in 1933, where she performed for a decade. She left the troupe to marry Sam Silverman, who became one of America's most successful mortgage brokers.

Years later, the aging widow remained surprisingly vibrant. She enjoyed champagne, growing gardenias, and taking on interesting tenants, running her palatial residence like a fin de siècle French salon, with those renting from her often becoming friends and confidants, rather than just renters.

Guerrin flashed his glib and disarming smile and announced his hope to rent an apartment within Silverman's premises. Although he had no ID or immediate references, he dropped the names of several people she knew. Silverman, rather uncharacteristically, let her guard down when he opened his wallet and forked over $6,000 cash along with a promise to provide those pesky references the next day. The ordinarily cautious Silverman was beguiled enough to show him apartment 1B, in the back of the house, and she gave him the keys.

Silverman soon rued her decision. Almost immediately Guerrin became uncommunicative and went out of his way to avoid her. He refused to allow her maids to perform routine house-cleaning tasks inside his apartment. There were some shifty-looking characters stopping by, including a rather coarse middle-aged woman who seemed eager to shield herself from the building's security camera whenever she stopped by for a visit. He too, seemed to be ducking the surveillance camera. More alarming, he developed a suspicious habit of lurking near her private offices and ignored her constant reminders to produce the promised references.

The house keys of widowed Upper East Side socialite Irene Silverman were found on murder suspect Kenneth Kimes when he was arrested by cops.

The NYPD offered a reward of $11,000 for information on the whereabouts of the missing Irene Silverman.

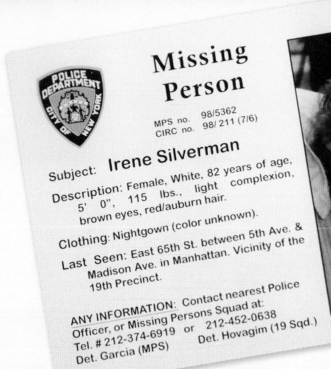

Missing Person

POLICE DEPARTMENT · CITY OF NEW YORK

MPS no. 98/5362
CIRC no. 98/ 211 (7/6)

Subject: **Irene Silverman**

Description: Female, White, 82 years of age, 5' 0", 115 lbs., light complexion, brown eyes, red/auburn hair.

Clothing: Nightgown (color unknown).

Last Seen: East 65th St. between 5th Ave. & Madison Ave. in Manhattan. Vicinity of the 19th Precinct.

ANY INFORMATION: Contact nearest Police Officer, or Missing Persons Squad at:
Tel. # 212-374-6919 or 212-452-0638
Det. Garcia (MPS) Det. Hovagim (19 Sqd.)

An undated missing-person poster shows wealthy widow Irene Silverman.

After only a week Silverman became convinced that her new tenant was up to no good and demanded he leave. "He smells like jail," the feisty redhead reportedly told a friend. Despite her intuition, the fiercely independent dowager resisted entreaties of concerned friends and employees to call the NYPD, as she hoped to amass more compelling evidence of his wrongdoing in order to evict him.

On the evening of July 4, she dined with friends in her basement kitchen. The following morning, her maid saw her briefly, but when she could not find Silverman by early afternoon, she grew suspicious and contacted two of her associates. Police were soon called and told that Silverman, a quintessential homebody, had mysteriously disappeared.

Police detectives would come to learn that Guerrin was actually Kenneth Kimes, the twenty-three-year-old son of Sante Kimes, the sixty-three-year-old dissolute-looking woman who kept showing up at the Silverman town house and taking pains to avoid showing her face to the camera. Together, they were real-life grifters who bore frightening resemblances to the celluloid mother and son characters in *The Grifters*, a Martin Scorsese–produced film released in February 1990 that was based upon the novel of the same name written by Jim Thompson.

The Kimeses were as deadly and treacherous a pair of flimflam operators as could be conjured up by Thompson's twisted imagination. They preferred old-style bunco, or confidence schemes, separating unsuspecting senior citizens, banks, auto dealerships, or insurance companies from their funds or assets through smooth-talking palaver, forged documents, and practiced pen strokes. Together, they had more angles than the Pentagon, but what made them most formidable was their take-no-prisoners style

> # The Kimeses were as deadly and treacherous a pair of flimflam operators as could be conjured up by Thompson's twisted imagination.

and a willingness to murder, with cold-blooded detachment, any mark or rube they had fleeced if they suspected it might better serve their interests.

When Kenneth Kimes first approached Silverman, he and his mother were on the run from authorities. Cops in Nevada, California, Florida, Louisiana, Utah, and the Bahamas were looking to question them for multiple scams and two murders

Sante Kimes, born Sandra Louise Singhrs, was a thrice-married woman with a high-wattage personality. She had a penchant for Cadillacs, jewelry, and dressing in ensembles designed to maximize her vague resemblance to Elizabeth Taylor. The daughter of an Oklahoma prostitute, she was first arrested in Sacramento in 1961 for stealing a hair dryer; in 1985, she swiped a $6,500 mink out of a Washington, D.C., piano bar. In 1986, she was convicted in Las Vegas federal court for holding illegal alien domestic workers as virtual slaves, a rap that landed her a five-year sentence. She also emerged as a suspect in several arson-for-profit schemes. It appeared she had ample financial

NYPD cops emerge from the Silverman town house at 20 East Sixty-Fifth Street following news of Irene's mysterious disappearance.

resources but engaged in rampant criminality because she enjoyed it. Her pliable son, Kenneth, had a fierce temper and was her loyal liege.

On July 5, 1998, a day after Silverman was reported missing, the pair was picked up by the FBI at the New York Hilton on a Utah fraud warrant. They had been tooling around town in a 1997 green Lincoln Town Car, paid for by a bogus $14,000 check; it wasn't until Tuesday, July 7, that an NYPD detective realized Kenneth bore a striking resemblance to a sketch of the mysterious Manny Guerrin, who was being sought in conjunction with Silverman's disappearance.

A search of their car and luggage unearthed a trove of evidence suggesting they were looking to swindle Silverman out of her home or worse. There was paperwork indicating that at least one of them had been practicing Silverman's signature by copying it repeatedly from a rent receipt; there was $25,000 in cash, all $100 bills; blank deeds and forms for wills; a stun gun; a 9-mm handgun; a box of ammunition; hypodermic needles; and a set of brass knuckles. In addition to Silverman's Social Security card and passport, there were tapes of illegally recorded conversations the pair had made of Silverman's private telephone calls.

Silverman's body remained frustratingly missing. It was an open secret within the corridors of One Police Plaza that NYPD Police Commissioner Howard Safir, irritated by the lack of progress, pestered his detective commanders regularly with the recurring query—"Where's Irene?"

Although it is exceedingly rare to successfully prosecute murder cases lacking a body, the evidentiary impediment did not prevent the Manhattan District Attorney's office from bringing an indictment. Mother and son were convicted May 18, 2000. New York State Supreme Court Justice Rena K. Uviller branded Sante Kines a "sociopath" of "unremitting malevolence" and "the most degenerate defendant ever to set foot in this courtroom" before imposing a prison sentence of 120⅔ years to life. She deemed Kenneth "a remorseless predator" and hit him with an even longer sentence, 125⅓ years to life.

Five months later, on October 10, 2000, Kenneth, who was hoping to prevent his mother's extradition to California for a murder that he, too, was implicated in, put a pen to the neck of Court TV producer-reporter Maria Zone inside the Clinton Correctional Facility and held her hostage for nearly four hours before guards overpowered him. His harebrained scheme resulted in eight years in solitary confinement.

By November 2003, Kenneth was facing the possibility of the death penalty in the California murder case and agreed to plead guilty, accept a life sentence without parole, and, most importantly, testify against his mother.

The following June, Kenneth told jurors inside a Los Angeles courtroom how, at his mother's behest, he shot businessman David Kazdin, sixty-three, in the head and left his corpse in a dumpster near LAX Airport in March 1998 to tie up loose ends after defrauding a bank out of $280,000.

Kenneth also told jurors how he had murdered Syed Bilad Ahmed, a missing Cayman Island banker with whom he and his mom had done business, by drowning him in a bathtub in September 1996 before dumping his body offshore. (Neither of the Kimeses were prosecuted for that crime.)

Jurors weighing Sante Kimes's guilt in the Kazdin murder were also provided with graphic testimony from Kenneth detailing their respective roles in Irene Silverman's slaying. He testified that although Silverman had grown suspicious of them, he and his mother kept their focus on killing her so they could steal her mansion.

The end came quickly, Kenneth Kimes admitted, after he overpowered the petite Silverman and forced her back into her bedroom.

"I walked up to the bed with Irene Silverman, and my mom turned the TV on," he said. "And my mom had a stun gun and hit her in the head with the stun gun and then said, 'Do it.'"

> "And my mom had a stun gun and hit her in the head with the stun gun and then said, 'Do it.'"

He strangled Silverman and wrapped her body and bedding in garbage bags that he crammed inside a duffel bag and dumped in an isolated trash bin somewhere in Hoboken, New Jersey.

Sante Kimes was convicted for the Kazdin murder July 7, 2004, and sentenced to life. She died of natural causes at New York's Bedford Hills Correctional Center on May 19, 2014. She was seventy-nine. Kenneth Kimes is serving life at the Richard J. Donovan Correctional Facility, in San Diego, California.

The World Trade Center being attacked on September 11, 2001. It remains the worst attack on American soil in history.

ATTACK ON THE TWIN TOWERS

Year 2001

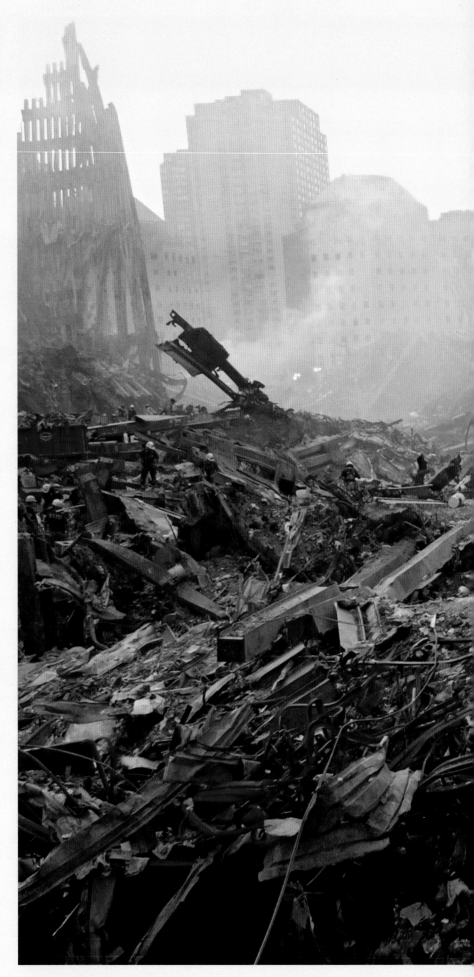

The summer was winding down. Autumn was just ten days away and the sky over New York City, Tuesday morning, September 11, 2001, was crystal clear. Inside the 110-story Twin Towers of the World Trade Center, thousands of employees were reporting to work.

In the Windows of the World restaurant on the 106th and 107th floors of the North Tower, seventy-two employees were busy serving breakfast to an invitation-only crowd. The offices of the financial services firm Cantor Fitzgerald, with over six hundred employees, occupied five floors directly below the restaurant. Most were already at their desks getting a head start on their workday.

At 8:46 A.M., American Airlines Flight 11, a Boeing 767 with eighty-one passengers and eleven crew members aboard, smashed into the North Tower between the ninety-third and ninety-ninth floors.

Stunned pedestrians on the plaza below craned their necks upward toward the spectacular fireball produced by burning jet fuel. Most had the same thought: *What a horrible accident.*

Hundreds of personnel from the NYPD, FDNY, and Port Authority converged on the scene within minutes and immediately began implementing rescue procedures. But radio communications between the departments was problematic, because each agency used different radio frequencies, making it difficult to coordinate their efforts.

Among the many hundreds of first responders who took part in the rescue were police officer Robert Fazio; his partner, Moira Smith, from the Thirteenth Precinct; police officer John Perry, who had filed for retirement earlier that morning; and Dectective Joseph Vigiano and his brother, firefighter John Vigiano. Retired detective Donald Sadowy, who had helped solve the 1993 World Trade Center bombing, worked across the street at the World Financial Center as a security director. He rushed to the scene to offer his assistance.

Meanwhile, employees whose offices were below the impact zone began the evacuation process and made their way down almost ninety flights of stairs aided by coworkers and first responders. But on the uppermost floors, searing heat and blinding smoke was spreading quickly. The plane crash severed the elevator shafts. Debris from the explosion blocked the staircases, trapping those still alive. Without hesitation, Emergency Service Unit cops and firefighters donned heavy life-saving equipment and began the long, arduous climb up the North Tower stairs to rescue survivors and battle the blaze.

New York City mayor Rudy Guiliani, Police Commissioner

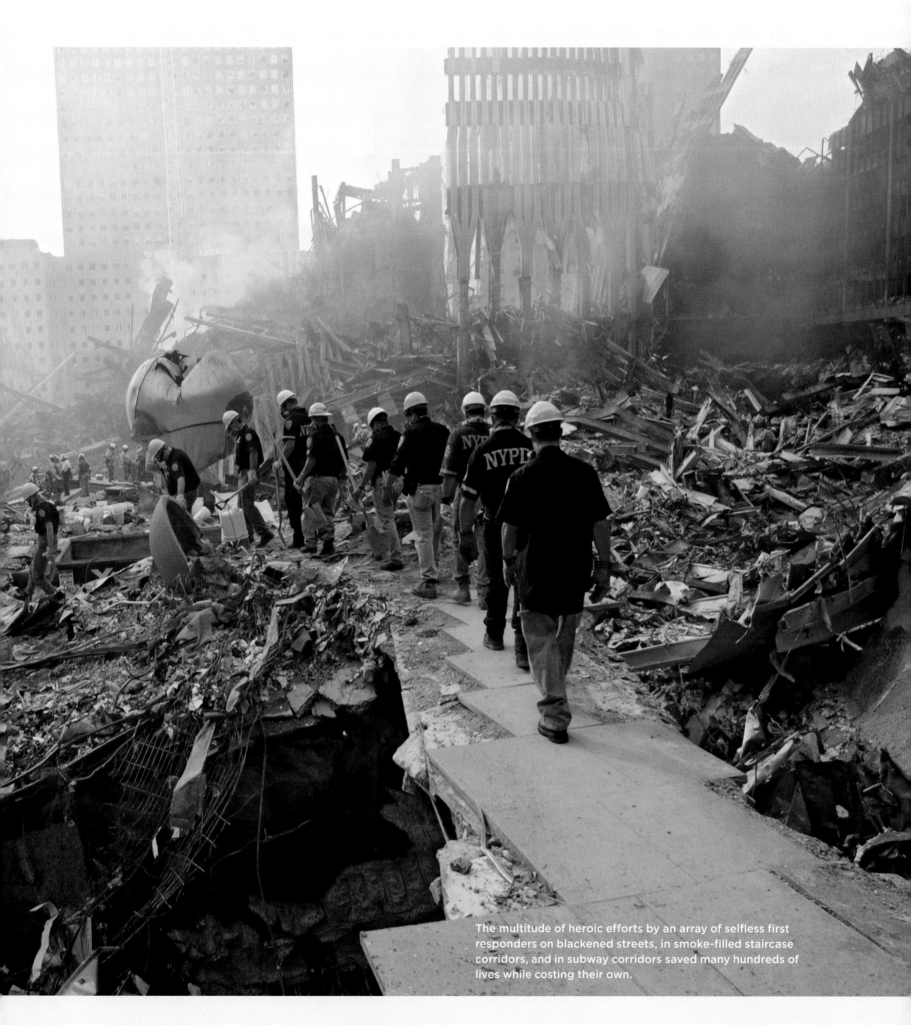

The multitude of heroic efforts by an array of selfless first responders on blackened streets, in smoke-filled staircase corridors, and in subway corridors saved many hundreds of lives while costing their own.

Bernard Kerik, and Fire Commissioner Tom Von Essen arrived at the World Trade Center complex to confer with the chiefs of the Police Department and Fire Department.

Seventeen minutes after the first crash, at 9:03 A.M., television audiences across the country watching the live broadcast witnessed a second commercial airliner slam into the South Tower between the seventy-seventh and eighty-fifth floors. It was another Boeing 767 with fifty-six passengers and nine crew members. As hard as it was to fathom at the time, it suddenly became painfully obvious that the first crash had been no accident. It was a deliberate act of terrorism.

Many of the people who worked above the impact floors in the South Tower made it out alive because they defied orders to stay put after the first plane struck the North Tower. An evacuation was already under way when the second attack occurred. There was also one staircase in the South Tower that remained clear. Unfortunately, some tenants did not realize it was possible to go down, so they went up to the roof, believing a police helicopter would be able to pluck them off the top of the building. But it was not possible. The wind was too strong and the smoke too thick for the helicopter to get close enough to even try a desperation rescue attempt.

Police emergency telephone lines were overwhelmed with pleas for help from trapped survivors in both towers. The only thing the 911 operators could tell them was that help was on the way, but the heat became so intense that many of them could not wait any longer. A quick death was preferable to the flames around them. They began to jump out of the towers, sometimes in pairs holding hands, landing ten seconds later on the street with sickening thuds.

At 9:59 A.M., the South Tower, the building that was hit second, toppled, belching out thick clouds of acrid smoke and debris. At the last second, Donald Sadowy dove for cover beneath a fire truck. He made it. A man next to him did not. One of the larger pieces of falling glass sheared him in half.

Rather than flee, firefighters and ESU police officers in the North Tower continued their ascent. Twenty-nine minutes later, at 10:28 A.M., the North Tower imploded, killing them and nearly everyone else still inside. Cantor Fitzgerald lost 658 employees: two-thirds of its New York City workforce. In the South Tower, 924 of the estimated 1,100 people who worked for insurance giant Aon, a company whose offices were above the impact zone, escaped to tell their stories.

A third structure, a forty-seven-story skyscraper known as 7 World Trade Center, was damaged by falling debris and beset by fire. By the time it collapsed at 5:21 P.M., all its occupants had been evacuated.

The attacks were not limited to New York City. A third passenger jet slammed into the Pentagon at 9:37 A.M. A fourth plane was heading toward Washington, D.C., but rather than quietly await their fate, the passengers confronted the hijackers. During the struggle, the jet crashed into a field in Shanksville, Pennsylvania, at 10:03 A.M.

The early death toll was estimated to be a staggering 2,600, of which 343 were FDNY firefighters and paramedics and a fire marshal. Twenty-three were New York City police officers, including Robert Fazio, John Perry, Moira Smith—the only NYPD female killed—and police and fireman brothers Joseph and John Vigiano. In addition, thirty-seven Port Authority police officers lost their lives along with three court officers, an FBI agent, and a Secret Service agent. Also killed was John P. O'Neill, a former assistant director of the FBI who helped capture 1993

The NYPD set up a temporary headquarters in a Burger King on Liberty Street. The city's emergency command center, located nearby at 7 World Trade Center, was destroyed in the aftermath of the Twin Towers collapse. A confidential 1998 NYPD memo had recommended that the emergency command center not be located within the 47-story building due to "significant points of vulnerabilities," including the building's history as a terrorist target. The city chose to ignore the recommendation.

288

The attacks upon the Twin Towers destroyed many vehicles of first-responders, including the New York Police, the Port Authority Police Department, and New York Fire Department, which alone lost more than 100 such vehicles.

World Trade Center bomber Ramzi Yousef. He had retired from the Bureau weeks earlier to start a new job as head of security for the World Trade Center. He was last seen in the North Tower helping with the evacuation. Six thousand more were injured that day. (By 2016 the death count rose to almost 3,000 and continues to rise as a result of injuries suffered by first responders and survivors who breathed in the toxic fumes.)

Within days authorities determined al-Qaeda, a Muslim terrorist organization operating out of Afghanistan and led by Saudi millionaire Osama bin Laden, was responsible for the carnage. The attack had been carried out by a fervent band of nineteen Sunni Muslim extremists who had taken flying lessons at schools in the United States. The plan, three years in the making, had been performed with military precision. It was the most deadly attack on American interests since the bombing of Pearl Harbor, and like then, it was a prelude to war.

Fifteen of the nineteen plotters were Saudis; and in the years since the attack, a growing furor has arisen over the realization that they were likely aided by members of the Saudi government and possibly the Royal Family. Twenty-eight still-censored pages from the 9/11 Commission Report deal with this very topic, although James Clapper, the director of National Intelligence, indicated in April 2016 that he hoped to declassify some of this material in

the months ahead. Mayor Guiliani did everything he could to rally New Yorkers and in the process became a national figure. President George W. Bush stood on the pile at Ground Zero surrounded by first responders and pledged to bring the attackers to justice.

Even as the dead were being laid to rest, surviving fire-fighters, police officers, and tradesmen toiled ten to twelve hours a day for months at Ground Zero recovering the remains of fallen comrades and nameless civilians. The unsung heroes, members of the military and volunteers from construction companies and fire and police departments, came from across the country to pitch in and help.

On May 2, 2011, Osama bin Laden was finally tracked down and killed by U.S. Special Forces at his hideout in Abbottabad, Pakistan. Four years later, on May 21, 2014, the National September 11 Memorial and Museum opened to pay homage to victims from ninety countries who were murdered in the 9/11 attacks at the World Trade Center, at the Pentagon, and in the crash in the Shanksville, Pennsylvania, field, as well as the six people who perished in the February 1993 World Trade Center attack. The fire truck Donald Sadowy dove under that saved his life is there on display. Twin reflecting pools sit within the footprints where the towers once stood, and the name of every person who died is inscribed into bronze panels edging the pools so that they will never be forgotten.

THE SLAYING OF COUNCILMAN JAMES DAVIS

Year 2003

I n the aftermath of the September 11, 2001, terrorist attacks on the World Trade Center, incoming mayor Michael Bloomberg and Police Commissioner Raymond Kelly initiated numerous measures to enhance public safety in New York City. Although Bloomberg had campaigned to make city government more open and accessible to the public, the terrorist attacks resulted in a mayoral edict that all visitors to City Hall pass through metal detectors. Elected officials, however, were not subjected to the same scrutiny.

On the afternoon of July 23, 2003, an enigmatic African-American Democratic councilman named James E. Davis, age forty-one, reported to City Hall for a two P.M. council meeting accompanied by Othniel Askew, a thirty-one-year-old African-American political neophyte who once had plans of his own for elected office.

Davis represented the racially and ethnically diverse Fort Greene section of Brooklyn, which also had a large and politically influential gay community. The receptive and astute Davis had assisted a local gay church in finding a place to worship, sponsored a gay pride event, voted for transgender rights, and signed a bill requiring companies to offer domestic-partner rights to employees, all things that attracted Askew to him. The pair developed a relationship in which Davis acted as a mentor, but over time Askew came to view him as a rival.

A frame from surveillance video shows Councilman James E. Davis (left) and Othniel Askew (center) entering City Hall moments before Askew would shoot Davis dead. Both were able to bypass City Hall's detector, due to Davis's standing as an elected official.

OPPOSITE PAGE: Two uniformed NYPD cops stand guard outside the casket of Brooklyn Councilman James E. Davis as he lies in state inside City Hall following his assassination. An estimated 7,000 mourners paid their respects.

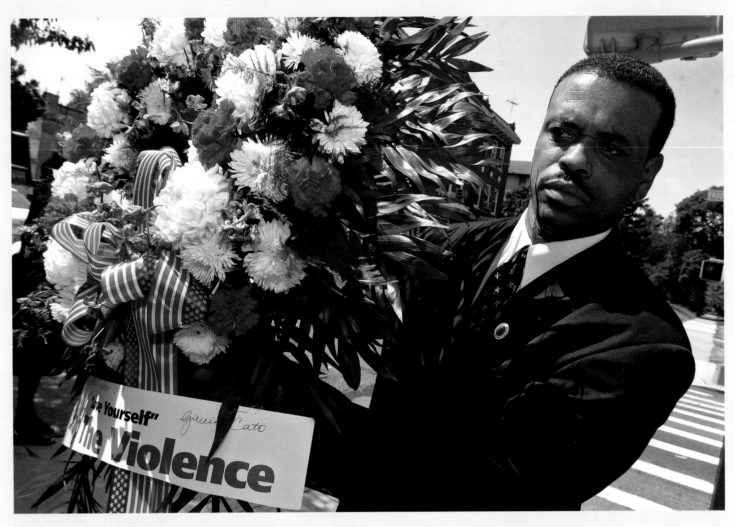

ABOVE: City Councilman James Davis is shown laying a wreath at the corner of Brooklyn Avenue and President Street, in honor of Yankel Rosenbaum, 29, and Gavin Cato, 7. Cato was killed on the evening of August 19, 1991, by a Hasidic motorist in a funeral procession. The incident fueled tensions between black and Orthodox Jewish residents in Brooklyn's Crown Heights and led to the stabbing death of Rosenbaum and three days of rioting.

Othniel Boaz Askew in an undated campaign photo

Because Davis was a retired NYPD officer, he was armed but was not required to pass through the metal detectors. Although Askew had not yet acquired any political bona fides, the fact that he was Davis's guest enabled him to enter City Hall without being searched.

Several month earlier, Askew filed papers with the city's Campaign Finance Board to challenge Davis for his council seat. When he failed to garner the requisite number of signatures to get his name on the ballot, he asked Davis for a job in his administration. By midsummer, the two appeared to have patched up their differences, at least as far as Davis was concerned, because he agreed to take Askew to City Hall with him that afternoon. He even bragged to a fellow councilman on the way in, "This guy was against me, now he's with me."

The main item on the agenda was related to the city's plans to build new public toilets. Afterward, Davis intended to propose a resolution aimed at preventing violence in the workplace. The usually loquacious Davis never got a chance to speak that day. He was preparing to leave the balcony to go down to the chamber floor when Askew produced a .40-caliber pistol that he carried right past security and blasted him in the back. Davis lay defenseless on the floor, unable to unholster his own weapon. Askew continued firing in front of the horrified onlookers.

> ## "This guy was against me, now he's with me."

Police officer Richard Burt, a thirty-four-year-old member of the City Hall security detail, was posted on the floor of the chamber. As chaos raged all around him, he called on his training, drew his service revolver, and from a distance of about forty-five feet, fired six times at Askew. He struck him five times, mortally wounding him. Both Askew and Davis were rushed by ambulance to Beekman Downtown Hospital and declared dead.

It was later determined that Askew led a duplicitous and troubled life. He referred to himself as Jewish, but he had been raised as a Jehovah's Witness. He was a closeted homosexual who told his closest friends that he yearned to meet a woman and have a child. He was also known to be jealous and controlling, and he had been arrested in 1996 for beating a lover with a hammer.

Askew had also contacted the FBI and reported that Davis had made personal threats against him if he did not drop out of the primary. Among the threats Davis was alleged to have made was to publicly expose Askew's homosexuality. An FBI spokesperson stated that on the morning of the murder, "a caller who identified himself as Askew alleged that he was the victim of harassment by Councilman Davis in connection with the upcoming primary election." The spokesperson added that Askew had not indicated any intent to cause harm to the councilman.

The usually unflappable Mayor Bloomberg, who was in his office during the shooting, initially described Askew's actions as "an attack on democracy," but later amended his opinion to say what happened was the result of a personal and political dispute. He also offered immense praise for Officer Burt, whom the mayor said he had always viewed as "a friendly guy who was doing a tough job," but he would now forever "think of him as a hero."

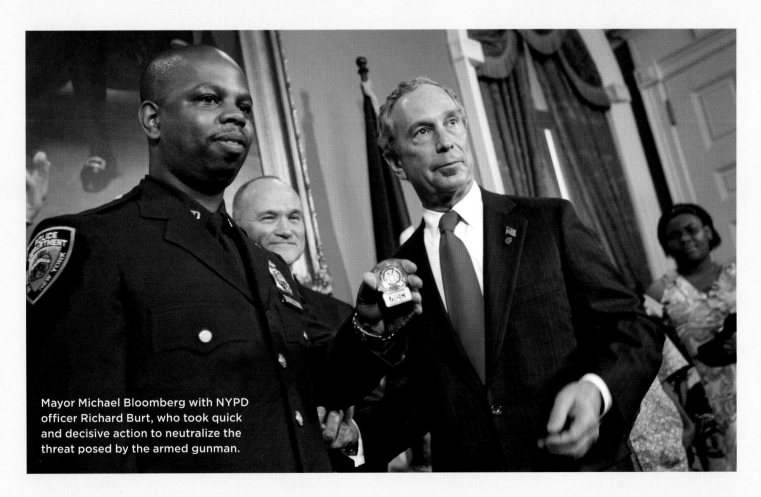

Mayor Michael Bloomberg with NYPD officer Richard Burt, who took quick and decisive action to neutralize the threat posed by the armed gunman.

Two faces of Anna Nicole

PHOTO, STORY: PAGE 3

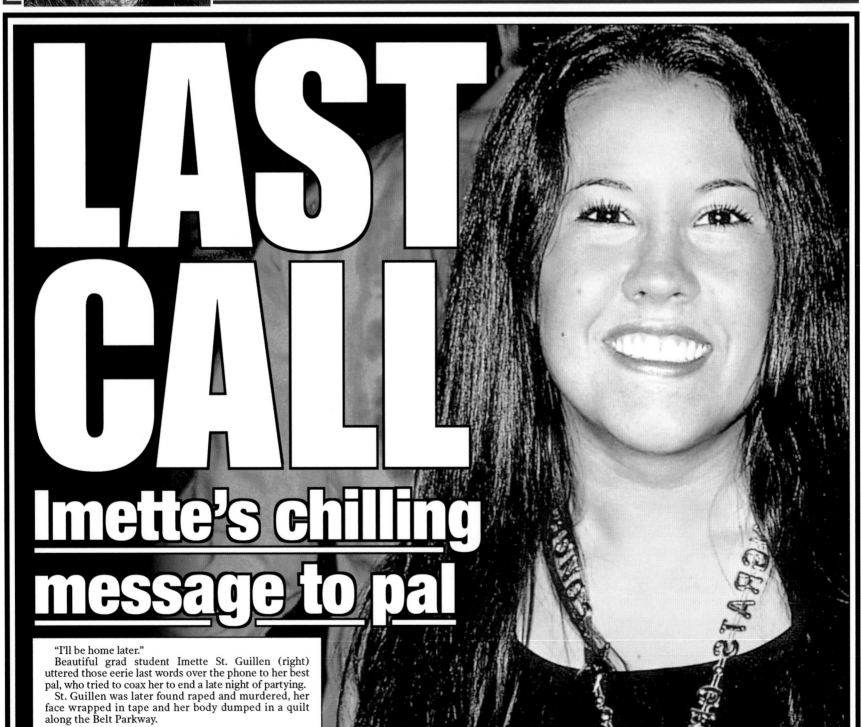

LAST CALL

Imette's chilling message to pal

"I'll be home later."

Beautiful grad student Imette St. Guillen (right) uttered those eerie last words over the phone to her best pal, who tried to coax her to end a late night of partying.

St. Guillen was later found raped and murdered, her face wrapped in tape and her body dumped in a quilt along the Belt Parkway.

FULL STORY: PAGES 4-5

THE MURDER OF IMETTE ST. GUILLEN

Year **2006**

The last time that Claire Higgins saw her best friend, Imette St. Guillen, was in the early morning hours of Saturday, February 25, 2006, outside of a bar on Manhattan's Lower East Side. The two had been drinking rum and Cokes for several hours, and Higgins, who described herself and her friend as inseparable since the eighth grade, wanted to call it a night. But St. Guillen, a twenty-four-year-old graduate student at John Jay College of Criminal Justice with dreams of becoming a criminologist, insisted upon staying out. Higgins thought that they already had enough to drink and should go home. Their argument attracted the attention of a stranger, who pulled up in his car and asked them if everything was all right.

Higgins reluctantly got into a cab and left. She called St. Guillen a short time later. Her friend sounded happy and made no reference to the argument they just had. St. Guillen had made her way to another bar but would not tell Higgins its name or location. It was the last time they spoke.

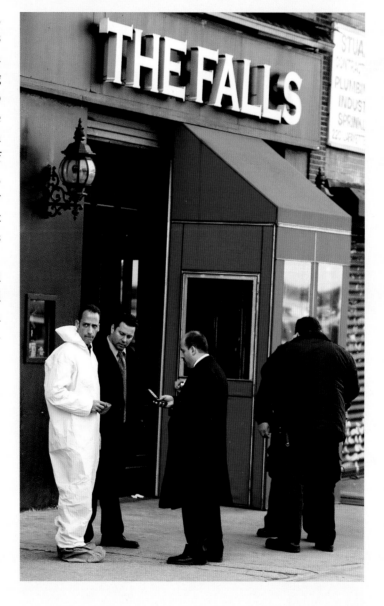

OPPOSITE PAGE: The *New York Post* cover of the murder of Imette St. Guillen.

THIS PAGE: Cops searching The Falls bar, where Imette St. Guillen met the murderous bouncer, Darryl Littlejohn, who was on parole, making him ineligible for such work. Publicity from the St. Guillen slaying led to the Falls losing its liquor license.

St. Guillen's family, who lived in the Boston area, grew concerned when they could not reach her Saturday. They filed a missing-person report. Higgins began canvassing bars on the Lower East Side and the surrounding area with photos of St. Guillen. While at a Soho bar called The Falls, Higgins received a call from St. Guillen's sister saying that her body had been found in Brooklyn at around seven P.M.

Higgins broke down and began sobbing. Dan Dorrian, the manager of The Falls, came out of a back office to see what all the commotion was all about. Higgins would recall that Dorrian simply folded his arms and told her, "New York can be a tough town."

What Dorrian did not tell her he was that he had instructed his bouncer to escort St. Guillen out when the bar closed that morning at four A.M. St. Guillen had put up some resistance. She'd wanted to finish her drink first. Initially, Dorrian even held back this information from the police when they came to question him.

A subdued Claire Higgins, 27, who had been Imette St. Guillen's closest friend since they were in eighth grade.

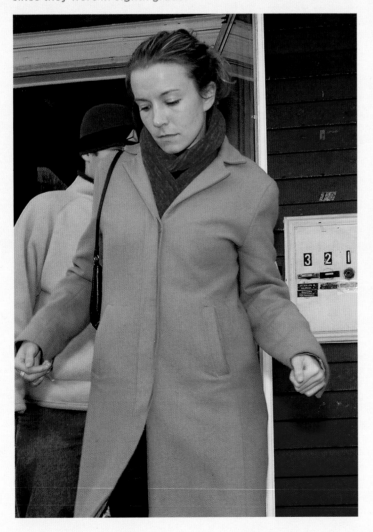

An anonymous caller directed police to a desolate stretch of road in East New York, Brooklyn, where they found St. Guillen's naked body wrapped in a blanket. Her wrists were bound behind her back with plastic ties. A sock stuffed in her mouth was held in place with packing tape. Her broken fingernails indicated that she had not gone easily.

Detectives learned that a security guard en route to work at about seven P.M. had seen a van parked near the location where St. Guillen's body was found. The guard said the windows were tinted, but he could see the glow of a cell phone inside the vehicle. Detectives obtained St. Guillen's cell phone number and determined that her phone had registered at the cell towers nearest to where her body was recovered.

Police were able to link the bouncer, Darryl Littlejohn, who was forty-one years old, to the horrific crime after a homeless man sleeping in Petrosino Square, a small park near The Falls, told them that he saw Littlejohn help a teetering woman get into a van before the two of them drove off. The case was further strengthened by the fact that DNA evidence obtained at the crime scene, in the van, and in Littlejohn's apartment matched the defendant and St. Guillen.

Littlejohn was a career criminal who had previously served five separate prison sentences since 1981. He did not take the stand in his own defense. The jury convicted him of kidnapping and other charges after fewer than seven hours of deliberations, and he was sentenced to life in prison without the possibility of parole. Evidence from the St. Guillen case led to Littlejohn being implicated in three other abductions, one of which occurred in 2005 and for which he is currently serving a separate sentence of twenty-five years to life.

In a particularly poignant moment, St. Guillen's mother, Maureen, who attended the trial every day, looked over at the lead investigator on the case, Detective Sean McTighe of the Brooklyn North Homicide Squad, as the jury announced their guilty verdict and tearfully mouthed "Thank you" to him.

Littlejohn's attorney, the respected Joyce David, vowed to appeal by arguing that Littlejohn was framed to protect Danny Dorrian, The Falls's manager, whose politically connected father owned Dorrian's Red Hand, the Upper

> # Her broken fingernails indicated that she had not gone easily.

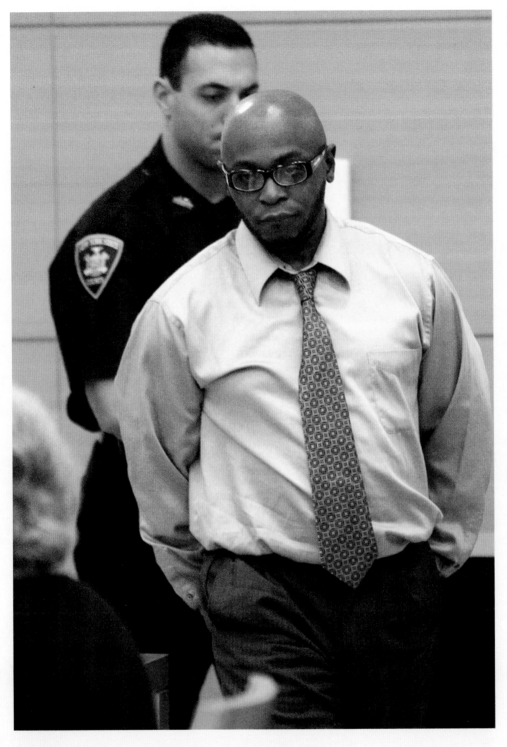

East Side bar where eighteen-year-old Jennifer Levin was last seen alive prior to being strangled by Robert Chambers in Central Park in the equally notorious preppy murder case in 1986.

The killing of St. Guillen spurred a host of new legislation to ensure the safety of patrons at popular nightspots throughout the five boroughs. Bouncers and doormen must now undergo background checks and be duly licensed. Clubs must install cameras at all exits and entrances, and scanning machines must be utilized to identify false IDs being used by underage customers.

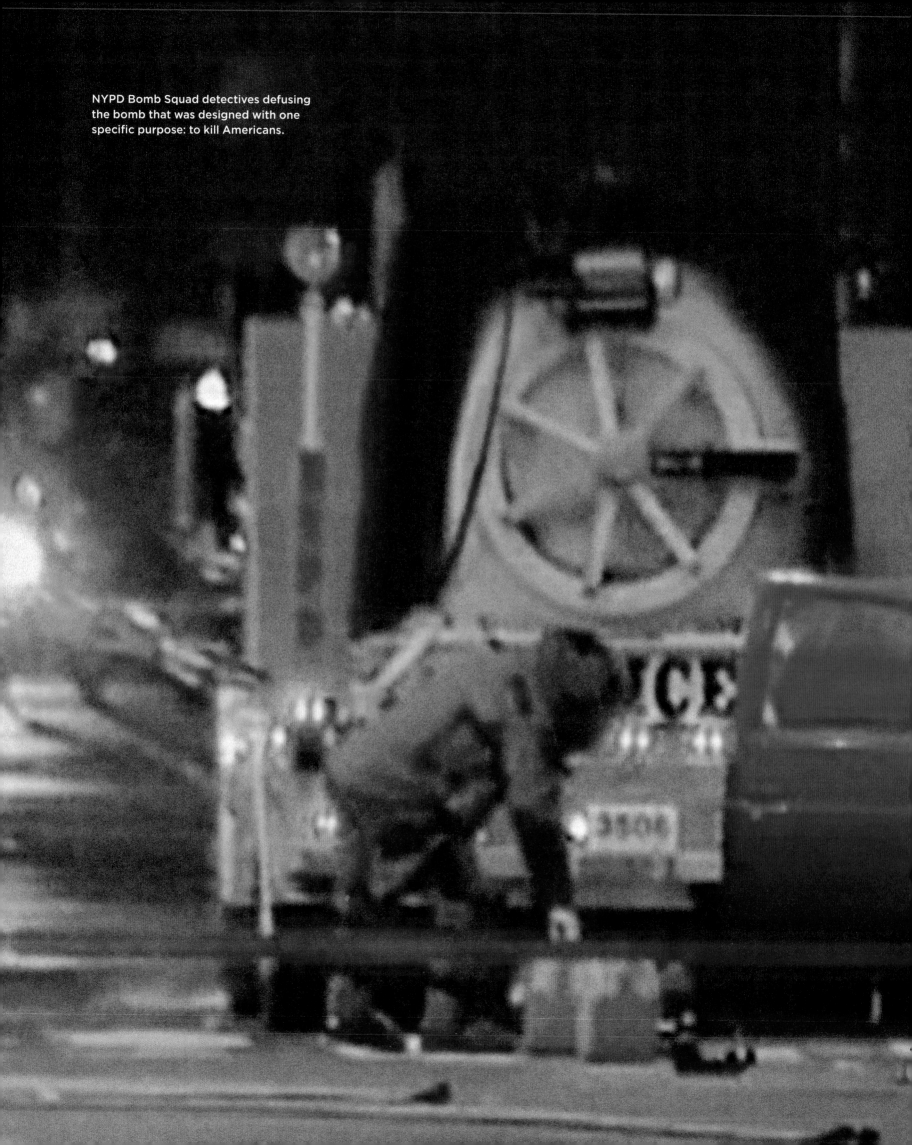

NYPD Bomb Squad detectives defusing the bomb that was designed with one specific purpose: to kill Americans.

"SEE SOMETHING, SAY SOMETHING"

Year 2010

Although Faisal Shahzad, thirty-one years old, was born in Pakistan, by most accounts he was living the American Dream. The son of a career Pakistani military man, Shahzad had grown up and been educated at Air Force academies in his native country. He moved to Connecticut to attend college at the University of Bridgeport and earned two degrees, including a master's in business administration. After graduation he found work as an account analyst, married a woman from his home country, bought a house, and seemed happy.

Neighbors recalled that his primary topic of conversation was his desire to start a family in America. But when the housing bubble burst in 2008, Shahzad was forced to take out a second mortgage and became disillusioned. During a trip to Pakistan in the summer of 2009, he sought out the Taliban. He spent five days learning rudimentary bomb making before returning to Connecticut.

On Saturday evening, May 1, 2010, Shahzad, by then a naturalized United States citizen, drove a dark green 1993 Nissan Pathfinder that he had purchased on Craigslist to West Forty-Fifth Street and Broadway in the heart of Times Square. The area was packed with tourists and theatergoers. Shahzad parked the vehicle near the *Lion King* marquee and walked to Grand Central Station, where he caught a commuter train back to Connecticut.

Shortly after Shahzad's departure, an eagle-eyed T-shirt vendor observed smoke emanating from the vehicle, which inexplicably still had its engine running and hazard lights flashing. The vendor, Lance Orton, a Vietnam veteran

The interior contained three canisters of propane, two five-gallon cans of gasoline, a metal locker crammed with shopping bags of fertilizer, and consumer-grade fireworks, all of which were wired to two battery-operated alarm clocks.

and adherent to the "See Something, Say Something," philosophy, immediately notified NYPD Mounted Police officer Wayne Rhatigan. But the dark-tinted windows of the SUV prevented Rhatigan from determining what was causing the smoke. He assumed the worst and initiated the rapid response of personnel from the Bomb Squad, the

Counter-Terrorism Unit, and the Fire Department. After cordoning off the area, a member of the Bomb Squad broke one of the windows, and a remote-controlled robotic device was used to peer inside the vehicle. The interior contained three canisters of propane, two five-gallon cans of gasoline, a metal locker crammed with shopping bags of fertilizer, and consumer-grade fireworks, all of which were wired to two battery-operated alarm clocks. The crude but potentially deadly incendiary device appeared to have detonated, but fortunately not as intended. Although the explosive itself was later described as "amateurish," given its location, as well as the time and the day of the week it had been planted, it would have killed and maimed hundreds had it worked. The vehicle and the device were safely removed by the Bomb Squad to the NYPD Outdoor Firing Range in the Bronx, where it was destroyed.

"We are very lucky," said Mayor Michael Bloomberg at a 2:15 A.M. press conference in Times Square. "We avoided what could have been a deadly event."

Although the plates on the vehicle belonged to another

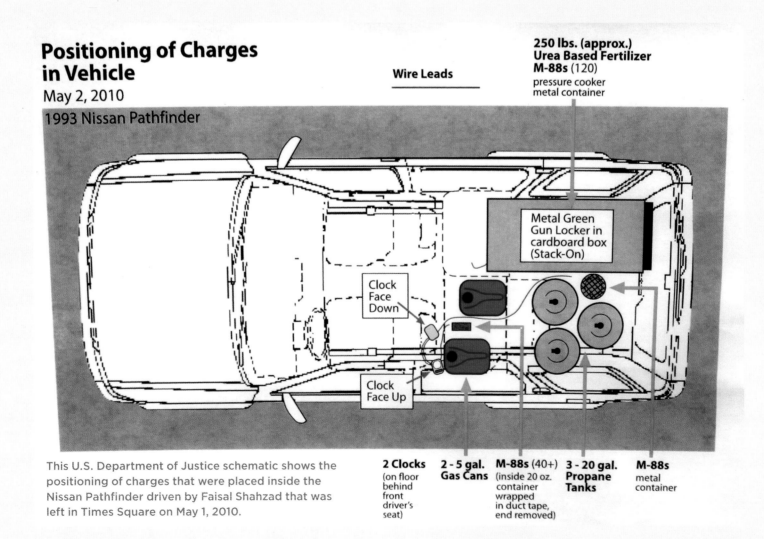

Positioning of Charges in Vehicle

May 2, 2010

1993 Nissan Pathfinder

Wire Leads

250 lbs. (approx.) Urea Based Fertilizer M-88s (120) pressure cooker metal container

Metal Green Gun Locker in cardboard box (Stack-On)

Clock Face Down

Clock Face Up

This U.S. Department of Justice schematic shows the positioning of charges that were placed inside the Nissan Pathfinder driven by Faisal Shahzad that was left in Times Square on May 1, 2010.

2 Clocks (on floor behind front driver's seat)

2 - 5 gal. Gas Cans

M-88s (40+) (inside 20 oz. container wrapped in duct tape, end removed)

3 - 20 gal. Propane Tanks

M-88s metal container

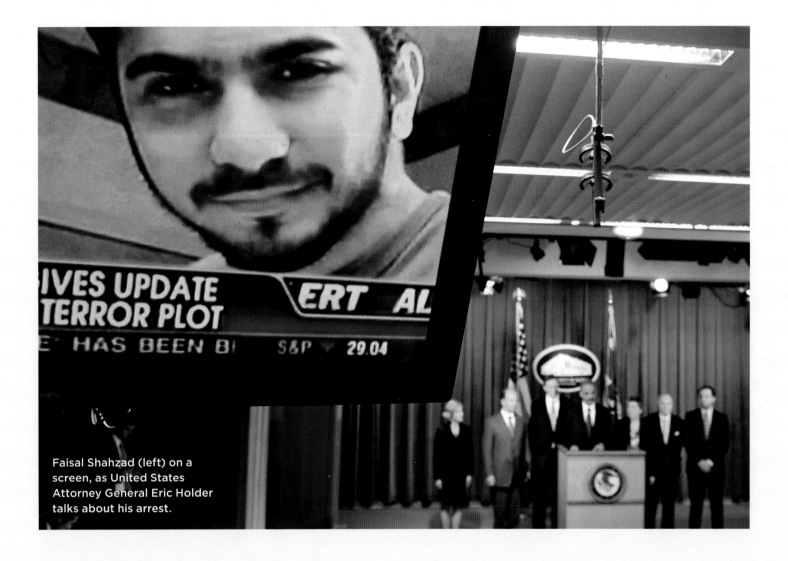

Faisal Shahzad (left) on a
screen, as United States
Attorney General Eric Holder
talks about his arrest.

car and the dashboard vehicle identification number (VIN) had been purposely defaced, police identified the last known owner by locating concealed VIN numbers on the SUV. That person, a nineteen-year-old female college student, told investigators she had sold the vehicle two weeks earlier to a man (Shahzad) at a Connecticut mall. He had paid her in cash with thirteen $100 bills. Although Shahzad had used an alias for the transaction, investigators quickly determined his identity by tracking the cell phone he initially used to contact the seller.

After being questioned by the police, the girl posted on her Facebook page, "I hope they find that bastard."

Authorities located Shahzad late Monday night, just over forty-eight hours after he first parked the Pathfinder in Times Square. They pulled him off a jetliner bound for Dubai at JFK Airport. The doors were closed on the airplane, and the pilot was awaiting clearance to take off. United States Attorney General Eric Holder said, "It's clear that the intent behind this terrorist act was to kill Americans."

Shahzad pleaded guilty to scores of terrorism-related charges on June 21, 2010, just six weeks after his arrest and confession. At his sentencing, Shahzad railed about what he called the American occupation of Muslim lands. He warned Americans to "brace yourselves" and described himself as the "first droplet of the flood that will follow me."

Federal magistrate Miriam Goldman-Cedarbaum was unmoved by Shahzad's admonitions and sentenced him to life without the possibility of parole. He is currently serving his sentence at the supermax prison in Florence, Colorado.

Billy Wilkerson, a police sergeant from Jacksonville, Florida, was a chaperone for a high school senior trip to the Big Apple. He and his charges were confined inside a Times Square seafood restaurant during the bomb scare until police determined the danger had passed. When they were finally allowed to leave, a reporter asked Wilkerson how he thought the NYPD had handled the situation. He replied, "I just sat back and learned a lot."

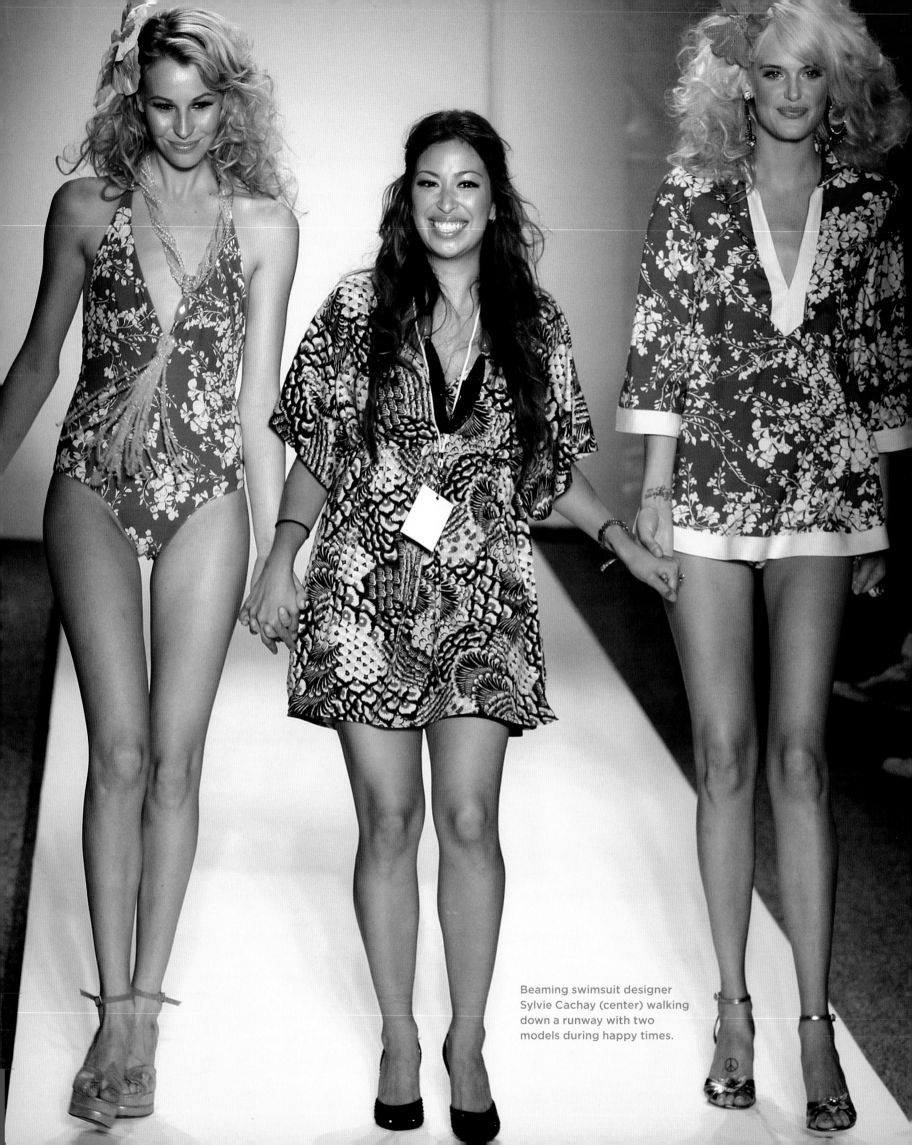

Beaming swimsuit designer Sylvie Cachay (center) walking down a runway with two models during happy times.

THE MURDER OF A FASHION DESIGNER

Year 2010

To NYPD homicide detectives, the death seemed wrong. Sylvie Cachay was thirty-three, a young and effervescent Peruvian-American fashion designer who had taken the swimsuit industry by storm. Her body was found lying in an overflowing bathtub in her room at the swank Soho House Hotel. An empty bottle of prescription pills lay nearby, but a closer look suggested what had befallen her was not an accidental drug overdose.

Cachay and her swain, twenty-three-year-old Nicholas Brooks, had checked into their hotel room shortly after midnight on December 9, 2010. Earlier that night, the pair had finished having sex in the bedroom of her apartment, on West Tenth Street. After taking some sleep medication, Cachay dozed off. At some point a burning candle tipped over, igniting her bed and singeing her hair. Brooks extinguished the blaze, but the mattress was ruined and the apartment reeked of smoke. They needed someplace else to sleep and took advantage of Cachay's membership in the Soho House, several blocks away in the Meatpacking District.

When they arrived Cachay was still woozy and barely able to walk. Brooks filled out the registration, and with the help of a hotel staffer got her into bed. Then he went downstairs, came back to the room, and went out again.

The victim's lifeless body was discovered at about three A.M., after guests in the floor below complained of water leaking from the ceiling. Cachay was floating faceup in the tub wearing a black turtleneck sweater and panties. Her Rolex was still on her wrist. There was also a red mark on Cachay's neck that Manhattan District Attorney Cyrus Vance would describe as clear evidence of strangulation.

Cachay had been raised in Lima, Peru, and McLean, Virginia. She was the daughter of Dr. Antonio Cachay, a prominent ear, nose, and throat surgeon, and Sylvia Cachay, a painter. With a large and expressive mouth and sultry good looks, she was not simply beautiful, but industrious, too. She had worked for several prominent designers, including Tommy Hilfiger, Marc Jacobs, Victoria's Secret, and most recently as head designer for the Anne Cole Collection. She had been forced to mothball her fledgling bathing suit line, Syla, a few years back when the economy soured, but things seemed to be back on track just before her death. She had new financial backers, and her designs had appeared in *Vogue*; *Elle*; *O, The Oprah Magazine*; *Women's Wear Daily*; and *Lucky*, as well as in a *Sport Illustrated* swimsuit issue. Those who knew her were convinced she was going places.

For most of his young life, Nicholas Brooks coasted by

> **The victim's lifeless body was discovered at about three A.M., after guests in the floor below complained of water leaking from the ceiling.**

on his genial nature and boyish charm. Although he graduated in 2005 from the Horace Mann School, one of the finest private schools in the country, he waited three years before enrolling at the University of Colorado. He lasted several semesters before dropping out.

When he reappeared at the hotel at around 5:30 A.M., he was so wasted, he could barely hold a conversation. He said that he had met a jazz musician in the hotel and the pair left to have drinks at a West Village club and to do some cocaine. Detective Robert Moller termed Brooks as "extremely intoxicated," and added that "when we started to ask him questions, he tried to play it off and did not seem terribly concerned."

For Cachay's devastated friends and family, her demise was as difficult to explain as her pairing with the callow Brooks. Their romance began inauspiciously. On their first date, Cachay's miniature poodle ran off while being taken for a walk and was killed by a car. Brooks was very tender and supportive in those initial moments, but soon revealed himself to be little more than a cad and an indolent, pot-smoking layabout who patronized escorts and was content to soak up whatever succor Cachay might provide him while offering little in return.

Before the autopsy was complete, Nicholas Brooks was arrested for attempted murder and strangulation, charges that would later be upgraded to murder. On the way to his arraignment Detective Moller recalled Brooks asked him, "'How long am I going to get for this?' I took it to mean, 'How long am I going to get for this crime?' I told him, 'It depends, we're nowhere near that point.'"

Brooks expressed further concern about his life behind bars, according to Moller: "He said to me, 'Do I have to pay for protection?' I said, 'What are you talking about?' He said, 'I like that show *Oz*, and I'm afraid of the white supremacists.'" The HBO television show depicted the harsh and often brutal life of incarcerated prison inmates. "I told him, 'You're not going to 'Oz'—you don't have to pay for protection. You're going to be arraigned before a judge and you'll meet your attorney and you'll take it from there.'"

On May 22, 2011, as Nicholas Brooks was awaiting trial, his seventy-three-year-old father, Joseph Brooks, the Oscar-winning songwriter who penned the 1977 hit "You Light Up My Life," took his own life by inhaling helium. The elder Brooks was a four-times-married musical composer and movie director, who earned millions writing snappy advertising jingles for clients such as Pepsi ("You've

FAR LEFT: The exterior of the Soho House on December 11, 2010, in New York City, two days after rising fashion designer Sylvie Cachay was murdered there.

LEFT: Joseph Brooks, the talented musical impresario who wrote the monster pop tune "You Light Up My Life," was the father of Nicholas, who was charged with the murder of his girlfriend, designer Sylvie Cachay.

Nicholas Brooks (right) is led into Manhattan Criminal Court on May 6, 2013, following his re-arrest, on an impersonation offense relating to improper phone calls he was making from jail.

Got a Lot to Live"), "Maxwell House coffee ("Good to the Last Drop Feeling"), Dial soap, Dr Pepper, and others. One of his wives and Nicholas's mother was model Susan Paul, the cover girl for the September 1978 issue of *Playboy* magazine. Brooks had also written music for such Hollywood movies as *Eddie and the Cruisers* (1983) and *The Lords of Flatbush* (1974).

He had been battling his own serious legal problems and was out on $1.5 million bail at the same time a dark cloud of suspicion swirled around his son's head regarding Cachay's demise. Joseph Brooks had been indicted by the Manhattan District Attorney's office for a series of "casting couch" rapes that were alleged to have occurred between 2005 and 2008 in his Upper East Side apartment.

The list of victims would total thirteen aspiring starlets, ranging in age from eighteen to thirty, most of whom he recruited on Craigslist to audition for a movie. The women would show up at the composer's apartment, where he would serve drinks and bedazzle them with his shiny Oscar. The starstruck women would then audition for the role of a wine-drinking prostitute only to find themselves drugged and sexually compromised, a scenario very similar to the allegations made against Bill Cosby.

His suicide did not derail the charges pending against his wayward son. Joseph Hoffman, the defense attorney who represented both of them on their separate charges, tried to introduce medical testimony that the red mark on Cachay's neck was actually the result of rough sex, or what was termed "erotic choking." But Manhattan Supreme Court Justice Bonnie G. Wittner barred the argument, insisting there was no credible evidence to support the assertion that such activities had occurred. The defense was also precluded from introducing medical testimony that Cachay had not been forcibly drowned.

With their options limited, Defense Attorney Hoffman suggested that five drugs found in Cachay's system, most of which had sedative effects, had led to an accidental overdose. "Our position," he recalled, "was that after [Brooks left the room], she [Cachay] went into the tub and zonked out. Our expert testified that the combination of drugs caused her to slip under the water and drown."

But Nicholas Brooks was not a sympathetic defendant. The prosecution introduced evidence that he had cheated on her with prostitutes, that Cachay had suspected he'd ripped her off for $30,000 in credit card advances in the weeks before her death, and that she was planning to break things off and have him arrested.

The jury needed little more than two days of deliberation before finding Nicholas Brooks guilty of murder. On September 23, 2013, he was sentenced to twenty-five years to life by Justice Wittner, who accused him of compounding his "horrific act" by seeking to cover it up and denying any responsibility for it. The trial, she insisted, showed how the pair were involved in a "disturbing and volatile relationship that was in many ways extremely one-sided."

Susan Karten, a lawyer representing the Cachay family, blasted Brooks as "a scoundrel, an abuser and a murderer" and filed a wrongful death action on behalf of the slain woman's parents. In an August 2014 decision, Manhattan Supreme Court Justice Martin Schoenfeld issued a $12.5 million judgement against Brooks, who is now an inmate at the Sullivan Correctional Facility in Fallsburg, New York. He will first become eligible for parole on December 4, 2035, by which time he'll be forty-eight years old.

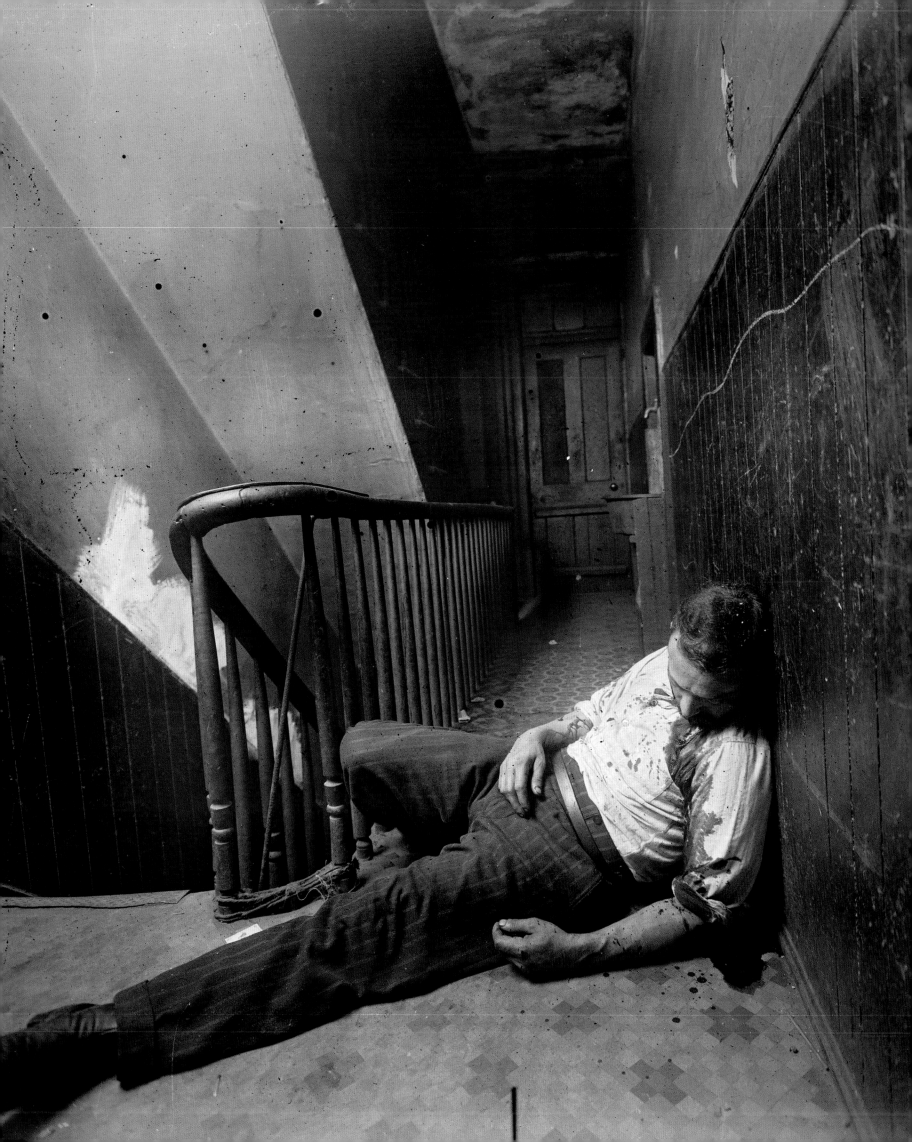

ACKNOWLEDGMENTS

No book of this type can be written without the cooperation and input of many people. In this regard, the authors would like to thank the following:

Our publisher at Hachette Books / Black Dog & Leventhal, JP Leventhal. Our editor, Dinah Dunn. Our literary agent, Robert Wilson. Photo editor, Lauren Robinson.

Former Police Commissioner Raymond W. Kelly. Former Chief of Detectives Joseph Borelli.

Current Chief of Detectives Robert Boyce, Lieutenant Patricia Feeley, Sergeant Edward Mullins, President Sergeants Benevolent Association, Sergeant Paul Capotosto and Detective Frank Bogucki, 17 Precinct.

Retired members of the NYPD: Detective Donald Sadowy, Bomb Squad, Detective Gordon Haight, 17 Squad, Police Officer James Burke, 17 Precinct, Police Officer Richard Conte, 13 Precinct, Police Officer Joseph Baldamente, Central Park Precinct, Lieutenant John O'Donohue, Detective Paul Dellaconna, Detective Randy Jurgensen, Detective Arthur Perry, Detective John McNally, Detective Thomas Nerey.

Pat Bailey, spokesman for New York City Department of Corrections.

Carl J. Pelleck, reporter, *New York Post* retired. David Boyle, photo editor, *New York Post*.

New York Post librarian Laura Harris and her crackerjack staff of assistants.

Eric Warner, former Bronx Assistant District Attorney.

J. Gilmore Childers, former Assistant Unites States Attorney—Southern District.

Joseph Connor, son of victim from the Fraunces Tavern bombing.

Edward A. McDonald, former Attorney-in-Charge, Federal Organized Crime Strike Force in New York. Special Agent Richard Hahn, FBI retired. Supervisory Special Agent Stephen Carbone, FBI, retired.

Retired New York Supreme Court Justice Edwin Torres.

Family members Margot Mladinich and Jon Whalen.

Lastly, the authors would like to acknowledge the tremendous assistance provided by many other former and current members of the NYPD, and those in other branches of law enforcement who for reasons of their own asked that their names not be mentioned. Their contributions were greatly appreciated.

SELECTED BIBLIOGRAPHY

Arons, Ron, *The Jews of Sing Sing*, Barricade Books, Fort Lee, NJ, 2008.

Astor, Gerald, *The New York Cops: An Informal History*, Charles Scribner's Sons, New York, 1971.

Bailey, William G., ed., *The Encyclopedia of Police Science*, Garland, New York and London, 1995.

Beavan, Colin, *Fingerprints: The Origins of Crime Detection and the Murder Case That Launched Forensic Science*, Hyperion, New York, 2001.

Bouza, Tony, *Bronx Beat: Reflections of a Police Commander*, Office of International Criminal Justice, University of Illinois at Chicago, Chicago, 1990.

Burrough, Bryan, *Days of Rage: America's Radical Underground, the FBI, and the Forgotten Age of Revolutionary Violence*, Penguin Press, New York, 2015.

Butterfield, Fox, *All God's Children: The Bosket Family and the American Tradition of Violence*, Knopf, New York, 1995.

Byrnes, Thomas, *1886 Professional Criminals of America*, reprint of 1886 ed., Chelsea House, New York, 1969.

Carey, Arthur A., with Howard McLellan, *Memoirs of a Murder Man*, Doubleday, Doran, Garden City, NY, 1930.

Collins, James H., *The Great Taxicab Robbery: A True Detective Story*, John Lane, New York, 1912.

Conway, J. North, *The Big Policeman: The Rise and Fall of America's First, Most Ruthless, and Greatest Detective*, Lyons Press, Guilford, CT, 2010.

Cook, Kevin, *Kitty Genovese: The Murder, the Bystanders, the Crime That Changed America*, W. W. Norton, New York, 2014.

Costello, A. E., *Our Police Protectors: History of the New York Police from the Earliest Period to the Present Time*, New York, 1885.

Crater, Stella, with Oscar Fraley, *The Empty Robe: The Story and Legend of the Disappearance of Judge Crater*, Doubleday, Garden City, NY, 1961.

Cunningham, Barry, with Mike Pearl, *Mr. District Attorney: The Story of Frank S. Hogan and the Manhattan D.A.'s Office*, Mason/Charter, New York, 1977.

Daley, Robert, *Target Blue: An Insider's View of the NYPD*, Delacorte Press, New York, 1973.

Dalton, David, *El Sid: Saint Vicious*, St. Martin's Press, New York, 1997.

Dash, Mike, *Satan's Circus: Murder, Vice, Police Corruption, and New York's Trial of the Century*, Crown, New York, 2007.

Douglas, John E., et al., *Crime Classification Manual: A Standard System for Investigating and Classifying Violent Crimes*, John Wiley and Sons, Hoboken, NJ, 2013.

English, T. J., *The Savage City: Race, Murder, and a Generation on the Edge*, William Morrow, New York, 2012.

Esposito, Richard, and Ted Gerstein, *Bomb Squad: A Year Inside the Nation's Most Exclusive Police Unit*, Hyperion, New York, 2007.

Gado, Mark, *Killer Priest: The Crimes, Trials, and Execution of Father Hans Schmidt*, Praeger, Westport, CT, 2006.

Gilje, Paul A., *The Road to Mobocracy: Popular Disorder in New York City, 1763–1834*, University of North Carolina Press, Chapel Hill, NC, 1987.

Greenberg, Michael M., *The Mad Bomber of New York: The Extraordinary True Story of the Manhunt That Paralyzed a City*, Union Square Press, New York, 2011.

Gross, Kenneth, *The Alice Crimmins Case*, Knopf, New York, 1975.

Havill, Adrian, *The Mother, the Son, and the Socialite: The True Story of a Mother-Son Crime Spree*, St. Martin's Paperbacks, New York, 1999.

Houck, Max M., and Jay A. Siegel, *Fundamentals of Forensic Science*, 3rd ed., Academic Press, San Diego, 2015.

Jurgensen, Randy, and Robert Cea, *Circle of Six: The True Story of New York's Most Notorious Cop Killer and the Cop Who Risked Everything to Catch Him*, Disinformation, New York, 2006.

Kelly, Ray, *Vigilance—My Life Serving America and Protecting Its Empire City*, Hachette Books, New York, 2015.

King, Jeanne, *Dead End: The Crime Story of the Decade—Murder, Incest and High-Tech Thievery*, M. Evans, New York, 2002.

Kirchner, L. R., *Robbing Banks: An American History, 1831–1999*, Sarpedon, Rockville Center, NY, 2000.

Lardner, James, and Thomas Reppetto, *NYPD: A City and Its Police*, Henry Holt, New York, 2000.

Leibowitz, Robert, *The Defender: The Life and Career of Samuel S. Leibowitz, 1893–1933*, Prentice-Hall, Englewood Cliffs, NJ, 1981.

McQuillan, Alice, *They Call Them Grifters: The True Story of Sante and Kenneth Kimes*, Onyx, New York, 2000.

Miller, Marvin D., *Wunderlich's Salute*, Malamud-Rose, Smithtown, NY, 1983.

Mitchell, Elizabeth, *The Fearless Mrs. Goodwin: How New York's First Female Police Detective Cracked the Crime of the Century*, Byliner, San Francisco, 2011.

Mooney, Michael Macdonald, *Evelyn Nesbit and Stanford White: Love and Death in the Gilded Age*, William Morrow, New York, 1976.

Moore, Robin, *The French Connection*, Little, Brown, Boston, 1969.

Newton, Michael, *The Mafia at Apalachin, 1957*, McFarland, Jefferson, NC, 2012.

Pasley, Fred D., *Not Guilty! The Story of Samuel S. Leibowitz*, G. P. Putnam's Sons, New York, 1933.

Pietrusza, David, *Rothstein: The Life, Times, and Murder of the Criminal Genius Who Fixed the 1919 World Series*, Carroll and Graf, New York, 2003.

Raab, Selwyn, *Five Families: The Rise, Decline, and Resurgence of America's Most Powerful Mafia Empires*, Thomas Dunne Books, New York, 2005.

Reynolds, Quentin, *I, Willie Sutton: The Personal Story of the Most Daring Bank Robber and Jail Breaker of Our Time*, Farrar, Straus and Giroux, New York, 1999.

Reynolds, Robert Grey, *The Bathtub Murder of Crime Club Founder Nancy Evans Titterton: Good Friday April 10, 1936*, Smashwords, 2015.

Roberts, Sam, *The Brother: The Untold Story of the Rosenberg Case*, Random House, New York, 2003.

Salmon, Patricia M., *Staten Island Slayings: Murder and Mysteries of the Forgotten Borough*, History Press, Charleston, SC, 2014.

Schechter, Harold, *The Mad Sculptor: The Maniac, the Model, and the Murder That Shook the Nation*, New Harvest, New York, 2014.

Seedman, Albert A., and Peter Hellman, *Chief! Classic Cases from the Files of the Chief of Detectives*, A. Fields Books, New York, 1974.

Spungen, Deborah, *And I Don't Want to Live This Life*, Villard Books, New York, 1993.

Sutton, William, and Edward Linn, *Where the Money Was*, Viking Press, New York, 1976.

Tofel, Richard J., *Vanishing Point: The Disappearance of Judge Crater, and the New York He Left Behind*, Ivan R. Dee, Chicago, 2004.

Tosches, Nick, *King of the Jews*, Ecco, New York, 2005.

Tunney, Thomas J., as told to Paul Merrick Hollister, *Throttled! The Detection of the German and Anarchist Bomb Plotters in the United States*, Small, Maynard, Boston, 1919.

Turkus, Burton B., and Sid Feder, *Murder Inc.: The Story of the Syndicate*, Farrar, Straus and Young, New York, 1951.

Uruburu, Paula, *American Eve: Evelyn Nesbit, Stanford White, the Birth of the "It" Girl, and the Crime of the Century*, Riverhead Books, New York, 2008.

Valentine, Lewis J., *Night Stick: The Autobiography of Lewis J. Valentine*, Dial Press, New York, 1947.

Walling, George W., *Recollections of a New York Chief of Police*, Caxton Book Concern, New York, 1887.

Whalen, Bernard, and Jon Whalen, *The NYPD's First Fifty Years: Politicians, Police Commissioners, and Patrolmen*, Potomac Books, Lincoln, NE, 2014.

Willemse, Cornelius W., George J. Lemmer, and Jack Kofoed, *Behind the Green Lights*, Alfred A. Knopf, New York, 1931.

Willis, Clint, *Crimes of New York: Stories of Crooks, Killers, and Corruption from the World's Toughest City*, Thunder's Mouth Press, New York, 2003.

X, Malcolm, as told to Alex Haley, *The Autobiography of Malcolm X: As Told to Alex Haley*, Ballantine Books, New York, 1964.

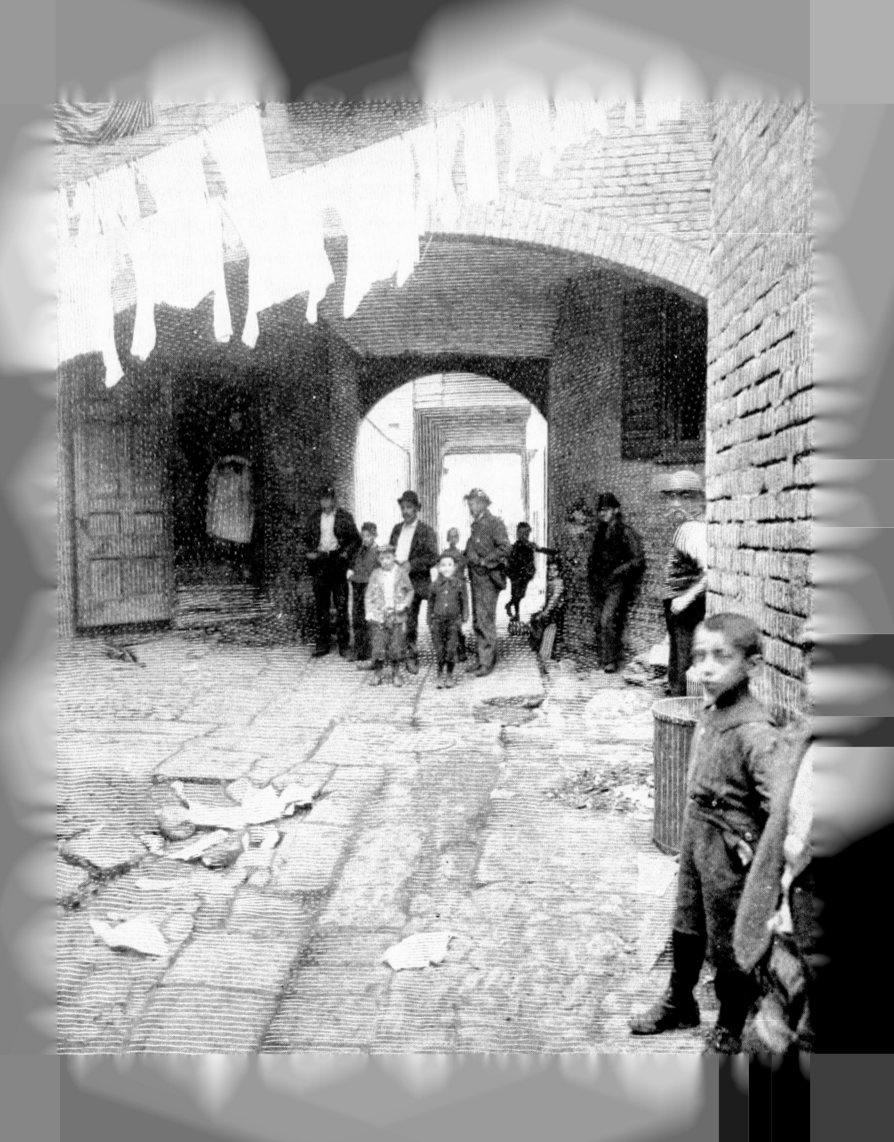

PHOTO CREDITS

INDEX

Page numbers in italics refer to illustrations and photographs.